DISCOURSES ON ART

Sir Joshua Reynolds

DISCOURSES ON ART

EDITED BY ROBERT R. WARK

PUBLISHED FOR THE PAUL MELLON CENTRE FOR
STUDIES IN BRITISH ART (LONDON) LTD.
BY YALE UNIVERSITY PRESS · NEW HAVEN AND LONDON

Library of Congress catalog card number: 74-17647
International standard book number: 0–300–01823–1 (cloth)
0–300–02775–3 (paper)

Printed in Great Britain at the University Press, Oxford,
by Eric Buckley, Printer to the University.

Published in Great Britain, Europe, Africa, and Asia (except Japan)
by Yale University Press, Ltd., London.

Distributed in Australia and New Zealand
by Book and Film Services, Artarmon, N.S.W.,
Australia; and in Japan by Harper & Row, Publishers,
Tokyo office.

PREFACE

THE present edition of Reynolds' *Discourses* was undertaken with five principal objectives in mind. The first is to provide an accurate text of the work as Reynolds left it and presumably wished it to stand. For this purpose the edition chosen as a base was that of 1797, the last with which Reynolds himself was directly concerned. That text is presented here as accurately as possible, with changes to correct only obvious typographical errors.

Reynolds reworked the discourses as they passed through successive editions during his lifetime. The changes the text underwent during these printings are of interest to scholars. A collation listing all word changes made by Reynolds has accordingly been added to this edition.

The third objective of the present edition is to furnish a body of plates to illustrate the problems Reynolds discusses. Wherever possible, photographs of objects specifically mentioned in the *Discourses* have been chosen; many of them are of sculpture and paintings that were in Reynolds' private collection.

Annotations have been added to the text in an attempt not only to explain references that may be obscure but also to indicate specific sources for Reynolds' observations and statements, wherever these are known. The task of annotating a text such as the *Discourses* is never complete, and it is inevitable that more should remain to be done in this area.

The comments and marginalia with which authors such as Blake, Hazlitt, and Ruskin covered their copies of the *Discourses* have not been included in the annotations, except in the few instances where these comments serve to elucidate Reynolds' text.

Finally, an introductory essay outlines certain aspects of the context of the *Discourses:* the academic setting for which they were intended; their position in eighteenth-century art criticism; and their relation to Reynolds' practice as a painter. The intention is to direct this essay toward the general reader rather than the scholar. Hence much of the scholarly apparatus frequently found in such introductions has been eliminated and placed instead in the annotations to the main body of the text.

A new edition of a standard text is always a work of co-operative scholarship. It is built on the contributions of previous editors, extending and amending their work in the light of subsequent research. Of the many editions of the *Discourses* issued after that of 1797 the most useful in the preparation of this one were three that appeared in quick succession at the end of the nineteenth century and the beginning of the twentieth: those of E. Leisching, 1893 (in German); Roger Fry, 1905; and Louis Dimier, 1909 (in French). The Leisching and Dimier editions provide the most scholarly annotations that have been available for the *Discourses*. Fry's edition will always remain of interest to students because of his sensitive and perceptive introductory remarks about the lectures.

During the twentieth century there has been a modest amount of scholarly writing about the *Discourses*. The major contributions have been made by F. W. Hilles of Yale, who has devoted many years to the study of Reynolds as an author. Of the several books and articles Mr. Hilles has written on the subject, the central volume is *The Literary Career of Sir Joshua Reynolds*. The book is a mine of information about the *Discourses* and an indispensable tool for every serious student of Reynolds. Much of the material in the annotations to the present edition has been culled from or suggested by this volume.

The debt I owe to Mr. Hilles extends far beyond what can be attributed to his published work. He has given constant encouragement and valuable advice as the task progressed. And he has, with great generosity, supplied additional information for the annotations from his own notes and his superb library of material related to Reynolds.

In the work of collating the various texts of the *Discourses*, I have been preceded by George L. Greenway, who privately published the results of his research in 1936. But, as Mr. Greenway's brochure is not readily available and does not constitute a complete collation, there need be no apology for doing the job again.

It is a pleasure to recall the generosity with which many scholars have answered queries, both written and oral, in their special fields; the annotations have been enriched by the comments of these "learned and ingenious men." I am particularly grateful to several colleagues in aesthetics and art history who read the introduction in draft and gave me the benefit of their criticisms at a time when the essay could still profit from their suggestions: W. J. Hipple, Jr. of the University of Florida, Joseph Burke of the University of Melbourne, and Charles

Mitchell and E. H. Gombrich of the Warburg Institute. In addition, my special thanks are due to David Wright and to E. Louise Lucas of the Fogg Museum, Harvard, for help in the wearisome task of tracking down photographs for the plates.

The publication of the book was made possible through the generosity of the trustees of the Henry E. Huntington Library and Art Gallery.

Robert R. Wark

San Marino, California
January, 1959

PREFACE TO THE 1975 EDITION

THIS printing is a photographic reprint of the 1959 edition, and changes have accordingly been held to a minimum. There have, however, been additions or corrections to a few annotations: p. 111, note to 588-589; p. 149, note to 128; p. 180, note to 169-172; p. 181, note to 180; p. 242, note to 425n. I am indebted to F. W. Hilles and E. K. Waterhouse for this additional information.

Two Appendixes have been added to this reprint, containing Blake's marginalia to and Hazlitt's essays on the *Discourses*. As stated in the Preface to the 1959 printing, this material does not serve to elucidate Reynolds' text, and consequently has no reason for being included in the annotations to the *Discourses*. But the Blake and Hazlitt comments are among the best-known rebuttals to Reynolds' arguments and consequently are of interest to students studying the *Discourses* within the general flow of art criticism. Blake's marginalia are published with the cooperation of the Oxford University Press, Hazlitt's essays with the cooperation of J. M. Dent and Sons, Ltd.

R. R. W.

San Marino, California
May, 1974

CONTENTS

	Page
List of Illustrations	xi
Introduction	xv
The Discourses	
Dedication to the King	3
Reynolds' Table of Contents for the Discourses	5
Discourse I	9
Discourse II	23
Discourse III	39
Discourse IV	55
Discourse V	75
Discourse VI	91
Discourse VII	115
Discourse VIII	143
Discourse IX	167
Discourse X	173
Discourse XI	189
Discourse XII	205
Discourse XIII	227
Discourse XIV	245
Discourse XV	263
A Note on the Text and Collation	283
Appendix I: Blake's Annotations to the Discourses	284
Appendix II: Hazlitt's Essays on the Discourses	320
Plates	
Selected Bibliography	337
Index	343

LIST OF ILLUSTRATIONS

Plate Number

1. ANNIBALE CARRACCI I
 "Polyphemus Hurling Rocks at Acis"
 Farnese Gallery, Rome

2. ANNIBALE CARRACCI I
 Preparatory drawing for figure of Polyphemus
 Royal Collection, Windsor Castle

3. LODOVICO CARRACCI II
 "The Birth of St. John the Baptist"
 Pinacoteca, Bologna

4. "APOLLO BELVEDERE" III
 Vatican

5. RAPHAEL AND ASSISTANTS IV
 "St. Paul Preaching at Athens"
 Victoria and Albert Museum, London

6. FILIPPINO LIPPI V
 "St. Paul Visiting St. Peter in Prison"
 S. Maria del Carmine, Florence

7. G. L. BERNINI VI
 "David" (detail)
 Borghese Gallery, Rome

8. G. L. BERNINI VI
 "Neptune and Triton" (detail)
 Victoria and Albert Museum, London

9. G. L. BERNINI VII
 "Apollo and Daphne"
 Borghese Gallery, Rome

10. JAN STEEN VIII
 "Sacrifice of Iphigenia"
 Rijksmuseum, Amsterdam

11. RUBENS IX
"Landscape by Moonlight"
Count Antoine Seilern, London

12. CLAUDE LORRAINE X
"Marriage of Isaac and Rebecca"
National Gallery, London

13. SALVATOR ROSA XI
"Jacob's Dream"
Devonshire Collection, Chatsworth

14. PARMIGIANINO XII
"Moses Breaking the Tables"
S. Maria della Steccata, Parma

15. MICHELANGELO XIII
"Isaiah"
Vatican

16. POUSSIN XIV
"Ordination"
The Earl of Ellesmere

17. POUSSIN XIV
"Triumph of Bacchus"
Nelson Gallery, Kansas City, Missouri

18. REMBRANDT XV
"Man in Armour"
Glasgow Art Gallery, Glasgow

19. VERONESE XVI
"Marriage at Cana"
Louvre, Paris

20. TITIAN XVII
"Bacchus and Ariadne"
National Gallery, London

21. PIERRE LEGROS II XVIII
"St. Luigi in Glory"
S. Ignazio, Rome

22. RUBENS XIX
"Marriage of St. Catherine"
Church of St. Augustine, Antwerp

23. SEBASTIAN BOURDON XX
"The Return of the Arc"
National Gallery, London

24. SIR JOHN VANBRUGH XXI
Vanbrugh Castle, Greenwich

25. REYNOLDS XXII
"Theresa Parker"
Henry E. Huntington Library and Art Gallery,
San Marino, California

26. REYNOLDS XXIII
"Mrs. Siddons as the Tragic Muse"
Henry E. Huntington Library and Art Gallery,
San Marino, California

27. GAINSBOROUGH XXIV
"Lady Petre"
Henry E. Huntington Library and Art Gallery,
San Marino, California

28. GAINSBOROUGH XXIV
"Lady Petre" (detail)
Henry E. Huntington Library and Art Gallery,
San Marino, California

INTRODUCTION

I

THE works of Sir Joshua Reynolds form one of the most instructive documents in the history of European art during the second half of the eighteenth century. Nowhere else do the distinctive features of the period find more comprehensive and eloquent presentation.

To many it may appear parochial to push Reynolds' claims for attention among the major European artists of the middle and late eighteenth century; for within the span of Reynolds' productive years (1750-1790) there was much going on elsewhere that appears, superficially at least, more beguiling and exciting than the work of this English portraitist. In Italy, during the early part of Reynolds' career, Tiepolo and Canaletto were still painting; France was enjoying the magic of Fragonard and Chardin. Before Reynolds died, the French were startled by the propaganda paintings of David, the Spanish encountered the first works of Goya, and the Italians saw the monuments of ancient Rome reflected through the eyes of Piranesi.

The mere mention of such names immediately indicates in some measure the changes that were taking place in European art between the time Reynolds started to paint in the middle of the eighteenth century and the day in July 1789 when his failing sight obliged him to lay aside his brush. The shift was from a decorative and predominantly gay type of art to one generally more emotional, from an art of striking uniformity in style and intention to one of great individuality and variety. The extent to which Reynolds reflected this change in his work has not been generally recognized. His painting and writing have usually been considered apart from their European context. Yet there were few more clearly aware than he of the shifting temper of the time. And one doubts whether there was any artist who strove more conscientiously to reconcile the developing attitudes with what he considered best in the tradition he inherited.

In Reynolds' writings, and particularly in the *Discourses*, one senses clearly the dilemma confronting the artists of the late eighteenth century. The *Discourses*, or lectures on art delivered to the Royal Academy, are the most important and imposing part of Reynolds' literary output. They were well received in his own day and have stood virtually unscathed through the ensuing vicissitudes of taste. Many of the discourses were translated into Italian, French, and German during

xv

Reynolds' lifetime, and they have appeared in more than thirty English editions since their author's death. No other body of art criticism by an Englishman has enjoyed such widespread and sustained respect.

The *Discourses* contain the most extensive and carefully developed of Reynolds' observations on art; but they were composed for a special purpose, and if the lectures are to be read sympathetically and interpreted accurately today, the circumstances surrounding their composition must be kept clearly in mind. They were prepared as formal lectures to the students and members of the Royal Academy. They were delivered, at first each year and later every other year, on the occasion of the annual prize giving, from the establishment of the academy in 1769 until Reynolds' retirement in 1790. Read by the president before his colleagues and students, the *Discourses* were tantamount to a statement of policy for the young institution.

Reynolds was well aware of the weight the circumstances gave to his words, and there is every reason to suppose that this awareness influenced both what he said and the way he said it. In his last discourse, when speaking of his earlier lectures, he is explicit about his attitude: "I thought it indispensibly necessary well to consider the opinions which were to be given out from this place, and under the sanction of a Royal Academy. . . . In reviewing my Discourses, it is no small satisfaction to be assured that I have, in no part of them, lent my assistance to foster *newly-hatched unfledged* opinions, or endeavoured to support paradoxes, however tempting may have been their novelty, or however ingenious I might, for the minute, fancy them to be; nor shall I, I hope, any where be found to have imposed on the minds of young Students declamation for argument, a smooth period for a sound precept" (XV, 101 ff.). The reader should expect, accordingly, restraint and even reticence in the lectures, together with a deliberate curbing of free or fanciful speculation.

The academic setting did more than impose a general air of sobriety on the *Discourses*. They were intended for students; but these students (as Reynolds more than once observed) ranged all the way from near beginners to fully trained artists. Material suitable for a lecture to one group of students might be too advanced or too elementary for another. "It is not easy," Reynolds said in his third discourse, "to speak with propriety to so many Students of different ages and different degrees of advancement. The mind requires nourishment adapted to its growth; and what may have promoted our earlier efforts, might retard

us in our nearer approaches to perfection" (III, 1 ff.). The full measure of Reynolds' problem becomes evident when he explains elsewhere the various stages into which he divides the education of an artist and describes the types of instruction appropriate to each. The first stage, which he likens to the mastery of grammar in literature, is devoted to gaining simple facility with the tools the artist is to use: "The power of drawing, modelling, and using colours. . . . When the Artist is once enabled to express himself with some degree of correctness, he must then endeavour to collect subjects for expression; to amass a stock of ideas, to be combined and varied as occasion may require. He is now in the second period of study, in which his business is to learn all that has been known and done before his own time. . . . The third and last period emancipates the Student from subjection to any authority, but what he shall himself judge to be supported by reason" (II, 27 ff.).

There is no doubt that Reynolds, especially in his early discourses, was aware of these different stages of attainment among the students he was addressing, and that his dicta and instructions must constantly be interpreted in relation to the level of the student toward whom the remarks are directed. It is clear that the early discourses must be taken as progressive. The first is directed to students (or teachers of students) on the primary level, the second to those in the intermediate stage, the third (and most subsequent ones) to the more advanced students. Many apparent shifts in opinion and inconsistencies in the *Discourses* dissolve at once when the passages are read in context, with due attention to the level of the student to whom they are addressed.[1]

Thus the academic atmosphere in which the *Discourses* were prepared and delivered left a strong imprint upon them. A less conscientious man than Reynolds might not have worried so much about his immediate responsibilities to the academy and his students and directed his remarks simply to the intelligent general public. But Reynolds took these responsibilities very seriously, and the *Discourses* themselves were affected accordingly.

[1]Elder Olson draws attention to this point in his brief introduction to *Longinus on the Sublime . . . and Sir Joshua Reynolds Discourses on Art* (Chicago, 1945), p. xiv. The problem is expanded and examined in more detail by Walter J. Hipple, Jr. in "General and Particular in the *Discourses* of Sir Joshua Reynolds," *The Journal of Aesthetics and Art Criticism*, XI (1953), 231-247. Hipple's essay has been subsequently republished in a slightly modified form as Ch. ix of his book *The Beautiful, the Sublime, & the Picturesque in Eighteenth-Century British Aesthetic Theory* (Carbondale, Ill., 1957).

II

Reynolds states his controlling ideas concerning art in a fine sweeping passage at the close of the ninth discourse: "The Art which we profess has beauty for its object; this it is our business to discover and to express; but the beauty of which we are in quest is general and intellectual; it is an idea that subsists only in the mind; the sight never beheld it, nor has the hand expressed it: it is an idea residing in the breast of the artist, which he is always labouring to impart, and which he dies at last without imparting; but which he is yet so far able to communicate, as to raise the thoughts, and extend the views of the spectator; and which, by a succession of art, may be so far diffused, that its effects may extend themselves imperceptibly into publick benefits, and be among the means of bestowing on whole nations refinement of taste: which, if it does not lead directly to purity of manners, obviates at least their greatest depravation, by disentangling the mind from appetite, and conducting the thoughts through successive stages of excellence, till that contemplation of universal rectitude and harmony which began by Taste, may, as it is exalted and refined, conclude in Virtue" (IX, 71 ff.).

This is the essence of Reynolds' claim for art; most of the basic ideas of the *Discourses* are at least implicit in the passage. But clearly there is much here that calls for elucidation. The crux of the matter lies in understanding what Reynolds means by "beauty."

To the twentieth-century mind, nurtured on nonrepresentational values in art, it may be a little disconcerting to be told that Reynolds' criteria of beauty are phrased almost entirely in terms of the image (the physical object the artist has chosen to represent) and the ethical and moral properties of that image. Reynolds is perfectly able to consider such elements as line, shape, light, and color apart from any image they may form. For him, however, the primary importance of these elements lies in the extent to which they may be controlled by the artist in giving embodiment to his perception and understanding of the world around him. The thought that painting might exist without a direct and immediately perceivable point of contact with the world about us is quite alien to Reynolds, although some of his contemporaries were beginning to explore that possibility.

The artist, then, must derive his ideal of beauty from the physical world. Just how this is to be done is a problem that occupies a great deal of Reynolds' time throughout the *Discourses*. In the passage

already quoted from the ninth discourse it is evident that Reynolds believes this ideal of beauty is not directly seeable. It is rather a sublimation in the mind of the artist of what he has already observed in the world about him. To abstract from these direct observations the ideal, which for Reynolds is true nature, is a problem involving much study and understanding.

In attempting to lead his students toward the perception of this ideal, Reynolds propounds the theory of what he calls *general* as opposed to *particular* nature. "All the objects," he says in the third discourse, "which are exhibited to our view by nature [i.e., *particular* nature], upon close examination will be found to have their blemishes and defects. The most beautiful forms have something about them like weakness, minuteness, or imperfection. But it is not every eye that perceives these blemishes. It must be an eye long used to the contemplation and comparison of these forms; and which, by a long habit of observing what any set of objects of the same kind have in common, has acquired the power of discerning what each wants in particular. This long laborious comparison should be the first study of the painter, who aims at the greatest style. By this means, he acquires a just idea of beautiful forms; he corrects nature by herself, her imperfect state by her more perfect. His eye being enabled to distinguish the accidental deficiencies, excrescences, and deformities of things, from their general figures, he makes out an abstract idea of their forms more perfect than any one original; and what may seem a paradox, he learns to design naturally by drawing his figures unlike to any one object. This idea of the perfect state of nature [i.e., *general* nature], which the Artist calls the Ideal Beauty, is the great leading principle, by which works of genius are conducted. ... Thus it is from a reiterated experience, and a close comparison of the objects in nature, that an artist becomes possessed of the idea of that central form, if I may so express it, from which every deviation is deformity" (III, 106 ff.).

The line of reasoning that Reynolds here follows had a long and venerable tradition going back to Plato and Aristotle. The assumption was that by generalizing from the particular, by eliminating what is specific and individual, we proceed to a "higher" more universal truth and we approach the abstract idea embodied in a family of forms. Truth and beauty were thus identified with the general. It is a concept at the core of most Renaissance theories of art, although the writers do not always agree about the precise way in which this general idea

is to be obtained. Reynolds is more empirical than many of his predecessors; that is, he relies more on direct observation and a sort of averaging process rather than on what might be called inspiration. The question of whether or not beauty and truth should be identified with the general is a philosophical problem that has been much debated during the nineteenth and twentieth centuries.[2] But Reynolds certainly accepted the proposition as true, and his aesthetic system cannot be understood without that assumption.

Although the physical world is the source from which all knowledge of beauty must ultimately be derived, the artist should avail himself of the achievements of his predecessors in their approaches to that general idea of nature abstracted from the particular. In this way, Reynolds felt, the road to excellence could be shortened a little and needless repetition of effort avoided. But a moot problem arises in the selection of those predecessors who may most suitably be taken as models. Making and justifying this selection is one of the major tasks Reynolds assumes in the *Discourses*. His voice is given for the sculpture of Greek and Roman antiquity and for the painting of the High Renaissance in Italy, especially that of Raphael and Michelangelo and their seventeenth-century Bolognese and French followers. In their use of materials derived from the physical world, these artists achieved something that approached Reynolds' ideal general nature, and they were accordingly the most valuable models for students to study.

There can be no doubt, from what has already been said about his concept of beauty and how it is to be discovered, that Reynolds considered hard work and disciplined thinking essential for any artistic achievement. He makes the point in the first discourse and returns to it again in nearly all the later ones: "The impetuosity of youth is disgusted at the slow approaches of a regular siege, and desires, from mere impatience of labour, to take the citadel by storm. They wish to find some shorter path to excellence, and hope to obtain the reward of eminence by other means, than those which the indispensible rules of art have prescribed. They must therefore be told again and again, that labour is the only price of solid fame, and that whatever their force of

[2]On modern criticism of the theory see E. H. Gombrich, "Meditations on a Hobby Horse" in *Aspects of Form*, ed. Lancelot L. Whyte (London, 1952); also "*Icones Symbolicae,*" *Journal of the Warburg and Courtauld Institutes*, XI (1948), 187.

genius may be, there is no easy method of becoming a good Painter"
(I, 145 ff.).

Although the theme of disciplined work and industry as prerequi-
sites of achievement is a leitmotiv that runs through all the discourses,
in the later ones, when Reynolds is addressing more advanced students,
he elaborates the idea, introducing qualifications. In the initial phases
of learning an art, Reynolds concedes, the labor is to a great extent
mechanical, directed simply toward acquiring a command over the
tools. Thereafter, however, the labor is mental; the knowledge and
intelligence of the student then become the factors of importance.
Likewise, as the student's own understanding matures, dependence on
imposed rules and dogma relaxes. Reynolds emphasizes that "an im-
plicit obedience to the *Rules of Art* . . . should be exacted from the
young Students" (I, 92 ff.). But he later admits that "There are some
rules, whose absolute authority, like that of our nurses, continues no
longer than while we are in a state of childhood" (VIII, 289 f.).

And yet for Reynolds the creative act, even in the fully developed
artist, is always clearly deliberate and conscious, operating according
to a rational and discoverable pattern. "It must of necessity be, that
even works of Genius, like every other effect, as they must have their
cause, must likewise have their rules; it cannot be by chance, that excel-
lencies are produced with any constancy or any certainty, for this is
not the nature of chance; but the rules by which men of extraordinary
parts, and such as are called men of Genius work, are either such as
they discover by their own peculiar observations, or of such a nice
texture as not easily to admit being expressed in words; especially as
artists are not very frequently skilful in that mode of communicating
ideas. Unsubstantial, however, as these rules may seem, and difficult
as it may be to convey them in writing, they are still seen and felt in
the mind of the artist; and he works from them with as much certainty,
as if they were embodied, as I may say, upon paper" (VI, 151 ff.).

Having given voice on many occasions to his conviction that intel-
lectual effort is essential for achievement in the arts, Reynolds feels
obliged to discuss how far constant application will in itself, apart
from innate talent, be effective in producing great art. It is a question
he returns to many times, and, one must admit, he does not always seem
to give the same answer. Reynolds may well have found himself here
in something of a dilemma. The whole existence of the institution of
which he was president rested on the assumption that disciplined train-

ing is necessary in order to create anything of value in the arts. He naturally wished to encourage the students to pursue that training with as much ardor as possible. On one occasion he permits himself to say: "Nothing is denied to well directed labour: nothing is to be obtained without it. Not to enter into metaphysical discussions on the nature or essence of genius, I will venture to assert, that assiduity unabated by difficulty, and a disposition eagerly directed to the object of its pursuit, will produce effects similar to those which some call the result of *natural powers*" (II, 326 ff.). Yet at another time Reynolds says equally emphatically: "It is of no use to prescribe to those who have no talents; and those who have talents will find methods for themselves, methods dictated to them by their own particular dispositions, and by the experience of their own particular necessities" (XII, 59 ff.).

It is not easy to reconcile the implications of these two statements, even when one admits the qualification, which Reynolds himself immediately applies to the second, that this doctrine is not to be extended to the younger students. They, like other schoolboys, must necessarily live a life of restraint. However, if it is not entirely clear what Reynolds feels may be achieved by mere industry in the absence of talent, it is evident that he is never shaken in his belief that talent without disciplined training, directed from without or within, will achieve nothing.

The broad line of Reynolds' thought as outlined thus far is this: the ultimate function or the end of art is moral and ethical; art seeks to achieve this end through the pursuit of beauty; beauty is an ideal distillation from the objects in the physical world and can be approached only through intense study both of those objects and of the work of previous artists who have striven toward the same goal. In this train of reasoning there is nothing that would in any way surprise Reynolds' contemporaries and predecessors, nothing that they would regard as bizarre or deviating from a sane, well-tempered version of most current opinion on such matters. Reynolds himself would be the first to disclaim originality for his ideas. If one were to seek grounds for praise, he would much rather it would be for the Augustan virtue of expressing clearly and well what others had thought in a nebulous or partial fashion. In his last discourse he states his claim directly: "I have pursued a plain and *honest method*; I have taken up the art simply as I found it exemplified in the practice of the most approved Painters. That approbation which the world has uniformly given, I have endeavoured

to justify by such proofs as questions of this kind will admit; by the analogy which Painting holds with the sister Arts, and consequently by the common congeniality which they all bear to our nature. And though in what has been done, no new discovery is pretended, I may still flatter myself, that from the discoveries which others have made by their own intuitive good sense and native rectitude of judgment, I have succeeded in establishing the rules and principles of our Art on a more firm and lasting foundation than that on which they had formerly been placed" (XV, 135 ff.).

The judgment of posterity has generally substantiated Reynolds' claim. The *Discourses* are considered one of the most eloquent, as well as one of the last, presentations of the ideas that dominated European art criticism and theory from the mid-fifteenth to the mid-eighteenth century; they are regarded as a sort of coda in which the principal themes of the movement are given a final statement before another, or perhaps a variant, subject is developed.

Clearly Reynolds had read a considerable amount of the literature on art produced during the three hundred years preceding the composition of his *Discourses*, and the ideas thus far discussed are all derived from these sources. The books he consulted most frequently appear to have been those by French and British writers of the seventeenth and eighteenth centuries. There is little evidence that he read extensively in Italian Renaissance art theory, although he did, of course, know and use such standard sources as Vasari.[3]

It is an extremely difficult and, one may venture to say, not a particularly important task to attempt to discover the particular source for any one of Reynolds' ideas. Nearly all his controlling precepts were so widely shared by his predecessors that he could not read far without encountering most of them more than once. There are occasions when a strikingly similar thought sequence or verbal relation makes it probable that Reynolds, when writing, had such and such a book before him. These specific borrowings are revealing, and they have been indicated in the footnotes to the text of this edition wherever they are known to exist.[4] But without such additional corroboration the

[3]For an analysis of Reynolds' library see Frederick W. Hilles, *The Literary Career of Sir Joshua Reynolds* (Cambridge, [Eng.], 1936), Ch. vii.

[4]See, for instance, notes to II, 333-335; III, 136-137, 236-239; IV, 272-275; V, 201-204; VI, 43-47, 485-489; VII, 369-371, 384, 477-482, 616-619, 644-654; VIII, 333-336; XII, 298-300; XV, 507-508.

ideas themselves cannot be convincingly connected with specific sources.

Even if one were certain of the exact written sources for Reynolds' central precepts, it would be difficult to be sure just how the ideas reached him. For it is evident that he supplemented what he discovered in his own reading with what could be gleaned from the "conversation of learned and ingenious men," a source of information he recommended to his students as "the best of all substitutes for those who have not the means or opportunities of deep study" (VII, 35 ff.). Certainly few artists have numbered a more distinguished galaxy of intellectuals among their intimate friends. Johnson, Burke, Goldsmith, and many others were all on close terms with Reynolds, and there can be little doubt that his patterns of thought were formed and tested in their company. But there can also be little doubt that influential as Reynolds' friends may have been in the formation of his ideas, his *Discourses* are his own; there is no evidence to suggest that his learned literary associates did more than give a touch of polish to the wording here and there.[5]

III

From what has already been said of the substance of the *Discourses* Reynolds appears as a rationalist, with a clear, coherent conception of the nature of art and the creative process, the lectures themselves as "what oft was thought, but ne'er so well express'd." This is the way the *Discourses* are generally assessed, and it is, by and large, a valid assessment. But the picture, viewed in detail, is in fact more complicated. The ideas with which Reynolds is dealing are so broad that within the main stream there is ample opportunity for many eddies and even crosscurrents. During the three hundred years when these ideas dominated European art criticism, refinements and qualifications are constantly occurring in the thought patterns that reflect the changing temperament of individual theorists and the phases into which European thought falls from the fifteenth to the eighteenth century. Reynolds is no exception in giving expression to the particular idiosyncrasies of his period, and there is much in the *Discourses* that stamps them clearly as late eighteenth-century documents. They reveal their time

[5]For a careful study of the extent to which Reynolds was assisted by his friends in the composition of the *Discourses* see Hilles, *Literary Career,* Ch. viii and passim.

of origin not so much in particular statements as in the emphasis and relative importance given to variations on the principal theme. For the historian of art and art criticism these deviations from the general pattern are of great interest. They are most evident in the emphasis Reynolds places on association as a factor in aesthetic response, in his insistence that art must appeal to the imagination, and in his willingness to accept considerable individualism in the matter of style. None of these ideas is intrinsically new. All of them can be located within the writings of Reynolds' predecessors. But they are ideas fundamentally at variance with the main current of thought he inherited and were ultimately to displace it. The emphasis Reynolds gives to these ideas and, in particular, his efforts to strike a compromise between them and the major traditional tenets, are characteristic of the man and his generation.

The increasing stress on association of ideas as a consideration that may enter into and even govern our response to a work of art is one of the primary factors enforcing a transformation of the outlook that dominated European art criticism from 1450 to 1750. The thought certainly did not originate with Reynolds. It was so widespread by the time he wrote (at least in English criticism) as to be an earmark of the period.

Reynolds indicates clearly what he means by the concept when he talks about architecture: "as we have naturally a veneration for antiquity, whatever building brings to our remembrance ancient customs and manners, such as the Castles of the Barons of ancient Chivalry, is sure to give this delight. Hence it is that *towers and battlements* are so often selected by the Painter and the Poet, to make a part of the composition of their ideal Landskip; and it is from hence in a great degree, that in the buildings of Vanbrugh, who was a Poet as well as an Architect, there is a greater display of imagination, than we shall find perhaps in any other; and this is the ground of the effect which we feel in many of his works, notwithstanding the faults with which many of them are justly charged. For this purpose, Vanbrugh appears to have had recourse to some principles of the Gothick Architecture; which, though not so ancient as the Grecian, is more so to our imagination, with which the Artist is more concerned than with absolute truth" (XIII, 410 ff.).

Reynolds even goes so far as to imply that our whole idea of beauty is strongly influenced by association and custom. When speaking

of the architectural orders inherited from Greek and Roman antiquity, he states that "if any one . . . should . . . invent new orders of equal beauty, which we will suppose to be possible, they would not please; nor ought he to complain, since the old has that great advantage of having custom and prejudice on its side" (VII, 711 ff.). This type of preference Reynolds considers to be based on *apparent* rather than *real* truth. "However, whilst these opinions and prejudices, on which it [apparent truth] is founded, continue, they operate as truth; and the art, whose office it is to please the mind, as well as instruct it, must direct itself according to *opinion*, or it will not attain its end" (VII, 185 ff.).[6]

The admission that the response to a work of art may be influenced by custom and the associations the object can arouse is of great importance. One sees its effect particularly clearly in the attitude of artists toward the work of their predecessors. We have already discovered Reynolds advocating the study of the masters as a means of acquiring the wisdom that has accumulated concerning an art, thus leading one's own work toward perfection. Now he suggests that in addition it is possible to borrow directly from earlier works or allude to them in such a way that a train of thought will be aroused through association that will enhance the appeal of the later work. This idea opens possibilities not entirely compatible with the first attitude. They are, to be sure, rather equivocal possibilities, and they led eventually to some of the features of mid-nineteenth-century art most distressing to modern critics. In the writings of Reynolds and his contemporaries, however, the concept is just beginning to unfold and is held firmly in place by other considerations.

One of the principal factors contributing to the emphasis Reynolds and his contemporaries placed on the doctrine of association of ideas was a renewed wave of subjectivism and emotionalism in art, after the rationalism dominant for the previous hundred years. Reynolds himself fought a rear-guard action against this development all his life; yet its positive influence is felt in many ways throughout his work. Another manifestation, in addition to the emphasis on association, is his constant

[6]Probably the most emphatic statements Reynolds has to make about the importance of custom and association in determining our ideal of beauty are in the "Idler," No. 82, and in a letter to James Beattie, March 31, 1782 (*Letters of Sir Joshua Reynolds*, ed. F. W. Hilles [Cambridge, (Eng.), 1929], pp. 90-93).

insistence that the aim of art is to be accomplished through an appeal to the spectator's imagination (IV, 82; XIII, 384). And it is clear that what Reynolds means is an appeal going beyond what can be immediately rationalized in the mind of the spectator (XIII, 36 ff.). Reynolds is much taxed to explain just how this conception is to be reconciled with his convictions about the cerebral and intellectual side of artistic activity. He concludes that although the appeal may transcend anything reason can explain at once, yet there are factors determining this appeal that may with patience be unearthed and understood. One should not, therefore, distrust imagination and feeling, for they are to be regarded as a type of suprareason. "Reason," Reynolds insists, "without doubt, must ultimately determine every thing; at this minute it is required to inform us when that very reason is to give way to feeling" (XIII, 88 ff.).

The line of thought is becoming rather tenuous. Here, as in the suggestion that our ideal of beauty may be influenced if not determined by association, there is a tug against the main current of rationalistic thought concerning art and beauty that is the foundation of Reynolds' aesthetic. Art is a rational and intellectual pursuit, yet it is to appeal to the spectator in a way that is emotional rather than intellectual. The dilemma is present to greater or less degree in most theories of art and has provoked periodic minor explosions from writers on the subject. The problem had flared up very clearly at the end of the seventeenth century in France. At that time the rationalist point of view, under the auspices of the French academy, reached a particularly extreme position in advocating the study of line, composition, and those facets of painting that could be directly controlled by reason and precept. In the inevitable reaction, championed in particular by Roger de Piles, stress was placed on color, fancy, and imagination. The dispute, often called the Poussinist-Rubenist controversy (for the artists who were the favorites of the opposing factions), was alive through much of the eighteenth century, and Reynolds has clearly been touched by the arguments of both sides. Most of Reynolds' immediate predecessors would have thrown the balance more unequivocally than he does in favor of reason and insisted on the sense of complete intellectual control in both painter and spectator. Reynolds' successors, however, were much more inclined than he to distrust the power of simple reason to supply or explain that which they valued and considered most essential in art. William Blake, for instance, in the spiteful marginalia with which

he belabored his copy of the *Discourses*, reveals a complete lack of sympathy with the rationalist component of Reynolds' thinking about art. The compromise Reynolds seems to strike between the two attitudes, reliance on simple reason, on the one hand, and on emotion and instinct, on the other, is a solution characteristic of a late eighteenth-century mind.

A third manifestation of the same broad shift in emphasis appears in the way in which Reynolds treats the problem of style and the different schools or species of painting, sculpture, and architecture, which are defined in terms of differences in style. From the sixteenth century on, the various regional schools of painting in Europe had been recognized, and fairly accurate, though not always sympathetic, investigations of the differences in style among them had been made. A hierarchic scale of values had been established that comprehended both the manner, or style, in which the work was executed and also the theme or subject matter. Where painting was concerned, the High Renaissance in Rome, particularly as exemplified in the work of Raphael, was placed at the top of the ladder. The evident order and clarity of the style, the adherence to the precepts of general or ideal nature, the lofty subject matter, all gave to this painting the most likely opportunity to fulfill the high ethical aim Reynolds and his predecessors set for art. The more sensuous character of Venetian and Flemish paintings placed them below the Roman in the scale of values, while the lack of discrimination in approaching the problem of general nature placed Dutch painting, with its very direct empirical approach to the world around it, even lower. Painting that dealt with portraiture, landscape, genre, and still life was also low in the scale of values, for the subject matter lacked the intellectual dimension considered necessary for the greatest art.

Reynolds generally subscribed to this system of hierarchic scaling established by his predecessors. Yet he gives a distinctive twist to the problem. Whereas for most of the earlier theorists the final outcome of academic training was supposed to be an ability to combine the most desirable features of many masters and schools into one composite style, for Reynolds the third and last period in the development of an artist takes on a different complexion: "In the former period he sought only to know and combine excellence, wherever it was to be found, into one idea of perfection: in this [the last period], he learns, what requires the most attentive survey and the most subtle disquisition,

to discriminate perfections that are incompatible with each other" (II, 53 ff.).

Time and again in the *Discourses* one senses in Reynolds the recognition of the validity of a type of individualism in art that would have puzzled many of his predecessors. Although he agrees with the traditional judgment that the Roman school, for instance, is "greater" than the Venetian, he insists much more strongly than had been customary that the two groups are not attempting to do comparable things and suggests, at least by implication, that comparisons of their relative merits are not always possible or relevant.[7] In dealing with the problem Reynolds establishes his own categories of style and artistic intention. His principal divisions are the "grand" or the "great" style and the "ornamental," typified by the Roman and Venetian schools, respectively. He also admits a third category, the "characteristic," which runs across the first two. In this third bracket he includes all artists, however different their intentions, who have strongly marked individual characteristics or manners. Thus Poussin, Rubens, and Salvator Rosa come together in this group. That Reynolds was able to recognize and accept the artistic integrity of three such completely different artists suggests a catholicity of taste that is rare in his predecessors.

Reynolds' inclination toward this type of individualism and the acceptance of various styles and artistic intentions as legitimate is kept firmly in check by his general adherence to the old hierarchic system. On many occasions, however, one senses an impatience with the established dogma, especially when it interferes with the enjoyment of fine paintings in other than the grand style. "Indeed perfection in an inferior style may be reasonably preferred to mediocrity in the highest walks of art" (VII, 424 f.). Reynolds also asks more than once that the performance be judged according to the intention (IV, 200 ff.; VII, 430 ff.) and not according to some rule applied indiscriminately to all art.

Once again, in weaving his way between intense individualism and academic insistence upon conformity to a clearly established pattern of values, Reynolds attempts a compromise that is evidence of a late

[7]Once again, however, one must avoid confusing emphasis with originality. The idea of incompatible excellencies appears before Reynolds' time but with less insistence and development (see Denis Mahon, "Eclecticism and the Carracci: Further Reflections on the Validity of a Label," *Journal of the Warburg and Courtauld Institutes*, XVI [1953], 312).

eighteenth-century, and particularly a late eighteenth-century English, outlook.

It is probably not particularly important what labels are attached to the two attitudes between which Reynolds constructed a compromise. That which concerns individualism, imagination, and the value of association is usually called "romanticism"; the other, involved with uniformity, reason, and ideal form is usually called (at least by historians, philosophers, and students of literature) "classicism." The difference between the two (as between most such outlooks) is, in the last analysis, one of degree; and it would be difficult to find a man whose work is a pure example of one untouched by any suggestion of the other. Romanticism and classicism as states of mind may, and do, occur at any time and in endless combinations. It is artificial and inaccurate to attempt to confine them within chronological limits. Nevertheless it is true that classicism was the prevalent and dominant outlook during the late seventeenth and early eighteenth centuries, just as romanticism predominated at the end of the eighteenth and the beginning of the nineteenth centuries. This preponderance of opinion justifies, to some extent, calling the earlier period the Enlightenment, or Age of Reason, and the later one the Romantic period. In the main framework of his thought about art there can be little doubt that Reynolds appears strongly imbued with the ideas of the earlier outlook, the Age of Reason; and this is the estimate of the man that has generally prevailed. But the latter part of this essay has emphasized that there is also a generous component of what may be called romanticism in his thought.

One naturally wonders if the time element involved in the writing of the *Discourses* may help to explain this duality, if the outlook of the Enlightenment dominates in the early discourses, and that of the Romantic period in the later. When one remembers that the *Discourses* were written over a period of twenty years, some evolution in outlook might be expected. But the fact is that close examination reveals very little change in point of view, or even shift in emphasis. The three elements in Reynolds' thought that have been singled out as leaning toward a romantic outlook are all present in the early discourses and even in the three essays that Reynolds contributed to the "Idler" in 1759, years before the opening of the academy. Likewise in the humorous little "Ironical Discourse" that Reynolds wrote at the end of his career, it is clear that he still gives strong adherence to the traditional doctrines of general nature and the efficacy of rules and hard work for

the production of art.[8] Furthermore the evidence supplied by the revisions Reynolds made in the *Discourses* as they went through successive editions indicates that his basic ideas underwent very little change.[9] This is not to say that Reynolds does not polish and sharpen his thoughts as he goes along. Certainly his ideas are much more neatly and persuasively formulated in the *Discourses* than in the "Idler" papers. But there is little evidence of any fundamental shift in his point of view.[10] As far as Reynolds is concerned, the combination of these elements from classicism and romanticism appears to represent a genuine compromise that persists throughout his entire career, a compromise in outlook, incidentally, shared by many of his English contemporaries in other areas of the arts.[11]

One finds further substantiation for this estimate of Reynolds' position in his paintings. The relation between Reynolds' theory and practice of painting has not received the attention it deserves.[12] Most critics have contented themselves with the observation that Reynolds urged his students to pursue "history" painting, as the highest and noblest branch of the art, while he himself followed the much more remunerative and less arduous genre of portraiture. Roger Fry has some intelligent and sympathetic observations to make about this situation.[13] Reynolds himself alludes to the discrepancy more than once and reminds the

[8]The text of the "Ironical Discourse" was first published by F. W. Hilles in *Portraits by Sir Joshua Reynolds* (London, 1952), pp. 123-146.

[9]See, for example, III, 146 ff.

[10]On this question I differ with some other students of the *Discourses*, notably Wilson O. Clough and Walter J. Bate, who find a shift in emphasis toward romantic ideas in the later discourses (see "Reason and Genius—An Eighteenth Century Dilemma," *Philological Quarterly*, XXIII [1944], 33-54; and *From Classic to Romantic* [Cambridge, (Mass.), 1946]). Such a shift, or lack of it, is an elusive and intangible thing to measure, but the meager specific evidence that can be mustered seems to me to indicate that Reynolds' basic position remains surprisingly constant.

[11]See Bate, Ch. vi, "The English Romantic Compromise."

[12]There have been a few notable essays on the relation between Reynolds' theory and practice of painting: Edgar Wind, "Humanitätsidee und heroisiertes Porträt in der englischen Kultur des 18 Jahrhunderts," *Vorträge der Bibliothek Warburg*, 1930-31; Charles Mitchell, "Three Phases of Reynolds's Method," *Burlington Magazine*, LXXX (1942), 35-40; E. H. Gombrich, "Reynolds's Theory and Practice of Imitation," *Burlington Magazine*, LXXX (1942), 40-45.

[13]*Discourses . . . by Sir Joshua Reynolds*, ed. Roger Fry (London, 1905), p. viii.

student that many painters are obliged to practice not what they esteem the best but what is best suited to their talents and capabilities (XV, 548 ff.).

For the art historian, probably the most fascinating and at the same time the most puzzling feature of Reynolds' painting is the variety in style found within his work. Gainsborough put the issue succinctly with his well-known comment about his great rival's portraits: "Damn the man, how various he is." The measure of this variety can be quickly grasped through comparison of two portraits such as those of Theresa Parker and Mrs. Siddons (Pls. XXII and XXIII). These paintings are contemporaneous, both dating from the mid-1780's.[14] It is very unusual in earlier periods to find an artist capable of executing two such radically different paintings at the same time. There, the assumption generally is that at a given time a given artist has a single definable way of treating pictorial problems. One does not expect to find him controlling a repertory of styles. In these two paintings, however, Reynolds has approached the problem of portraiture in quite different ways.

The portrait of Theresa Parker is direct and empirical. The figure, although broadly painted, is, one feels, close to a visual equivalent of what Reynolds actually saw. Everything about the figure suggests a strong desire on the part of the artist to approximate in paint the visual sensation his eye encountered: the various textures of the fabrics, the different qualities of light, the bright fresh colors of the little girl's dress.

The portrait of "Mrs. Siddons as the Tragic Muse," by contrast, is a highly contrived and sophisticated affair. She is draped in a curious nondescript gown that bears very little relation to any dress she ever in fact did wear. The whole painting is in somber tones of brown. The figure sits on a throne suspended in clouds and assumes a pose clearly meant to remind the spectator of Michelangelo's prophets and sibyls on the Sistine ceiling (see Pl. XIII). Everywhere through the picture the artist's hand has been controlled by a concept or idea that he wished

[14]"Theresa Parker" was exhibited in the Royal Academy of 1787; "Mrs. Siddons as the Tragic Muse" is signed and dated 1784, but Reynolds was probably working on the replica at Dulwich in 1788 or 1789. I suggested a similar comparison to Sumner McK. Crosby for use in his edition of Helen Gardner's *Art through the Ages* (New York, 1959), p. 440. A great number of such comparisons could be made through Reynolds' career. The standard and indispensable book for any study of the chronology of Reynolds' paintings is Ellis K. Waterhouse, *Reynolds* (London, 1941).

to embody in the portrait. The impression, so strong in the portrait of Theresa Parker, that the painting is a record of a direct visual experience is absent.

There is much in the *Discourses* that helps us to explain and understand the problems posed by these two paintings. Logically enough, those factors in Reynolds' thought that deviate from the simple academic pattern hold the key to the explanation for those quirks in practice that set him off from his predecessors in painting.

Reynolds speaks directly about the problem of portraiture in several of the discourses. He feels that portraits normally occupy a rather low place in the hierarchy of subject matter; their attractions are ordinarily those of paintings in the "ornamental" class, where "The art of colouring and the skilful management of light and shadow, are essential requisites . . . these petty excellencies are here essential beauties; and without this merit the artist's work will be more short-lived than the objects of his imitation" (IV, 424 ff.). Generally speaking, the "grand" or "great" style lies outside the realm of portraiture, as the generalities in which the great style deals tend automatically to defeat the most important end of a portrait, capturing a likeness (IV, 469 ff.). But Reynolds concedes that "if a portrait-painter is desirous to raise and improve his subject, he has no other means than by approaching it to a general idea. He leaves out all the minute breaks and peculiarities in the face, and changes the dress from a temporary fashion to one more permanent, which has annexed to it no ideas of meanness from its being familiar to us" (IV, 462 ff.).

The two approaches to portraiture and the measures recommended for each come into clear focus in the comparison already made between the portraits of Theresa Parker and Mrs. Siddons. The crux of the matter lies in Reynolds' suggestion that the artist can change at will his manner of painting as his intention may change. There is not for Reynolds only one acceptable style of painting but several, the particular one chosen at any time depending on the end in view.

These two portraits are by no means isolated examples of stylistic variety in Reynolds' work. Instances can be found at almost any point throughout his career. And the range he can control is even wider than is suggested by this initial comparison. He is particularly fond of borrowing from earlier artists. Often this activity is carried out in a playful and inventive way, as in the reminiscence of Holbein in the portrait of Master Crewe, and of Caravaggio in the "Young Fortune Teller"; but

sometimes the borrowing approaches mimicry, especially in one or two of the early Rembrandtesque self-portraits, the essays in the style of Van Dyck, and the portrait of Mrs. Sheridan in the manner of Domenichino.[15]

What Reynolds hoped to achieve by this procedure is at least partially explained by the doctrine of association of ideas. In the seventh discourse he mentions in particular the fashion during the 1760's and 1770's to dress sitters for portraits in the so-called Van Dyck habit of over a century earlier. "By this means," he says, "it must be acknowledged very ordinary pictures acquired something of the air and effect of the works of Vandyck, and appeared therefore at first sight to be better pictures than they really were; they appeared so, however, to those only who had the means of making this association; and when made, it was irresistible. But this association is nature, and refers to that secondary truth that comes from conformity to general prejudice and opinion; it is therefore not merely fantastical" (VII, 694 ff.).

To be sure, this type of allusion to the painting of his predecessors is not the full explanation for Reynolds' use of the work of earlier artists. More important (as has already been pointed out) were the lessons the masters could offer the student in meeting various pictorial problems. Yet the doctrine of association of ideas surely accounts for Reynolds' occasional essays in direct mimicry of the styles of earlier painters.

The underlying factor that urged Reynolds toward the stylistic variety that characterizes his work, as well as his occasional mimicry of other painters, was surely the third romantic facet of his thinking, his insistence that art must appeal to the imagination, that it must arouse the spectator. If one places Reynolds' portraits beside those of his predecessors during the first half of the eighteenth century, men like Hogarth, Nattier, or Crespi, what emerges at once is the depth and variety of characterization in the later pictures. Reynolds' portraits are frequently no more successful pictorially than those of his predecessors and are generally less effective decoratively. But there can be no doubt about the greater emotional range and variety that Reynolds attempts to communicate. Surely there is a connection between this evident intention and the stylistic variety that is such a striking feature of his work. One suspects that the desire to strike the imagination and enlarge the emotional range of the portraits spurred the development of a repertory of

[15]For reproductions see Waterhouse, Pls. 16, 162, 165, 173, 175.

styles, including direct borrowings from the devices developed by earlier artists.

In his practice of painting as in his theory of art Reynolds maintained a balance between the classical ideals that had dominated the thought of his predecessors and the romantic ones that were to assume such importance in the production of early nineteenth-century artists. Although he felt free to manipulate his style in accordance with changing aims, his variations were nearly always in terms of the precursors he admired, and the variety he sought never degenerated into that carnival of styles of which Pugin complained in English architecture some fifty years after Reynolds' death. Likewise in his exploitation of the associative values of an image he never forgot the formal values of painting on which his predecessors placed such stress.

Thus the positions Reynolds takes up in the theory and practice of art are closely related and completely consistent one with the other. He stands in both as a figure particularly probable in the late eighteenth century, a man deeply sensitive to the value of a tradition that was waning in popular estimation, but sympathetically aware of the shifts in opinion and outlook taking place around him.

THE DISCOURSES

THE KING

THE regular progress of cultivated life is from necessaries to accommodations, from accommodations to ornaments. By your illustrious predecessors were established marts for manufactures, and colleges for science; but for the arts of elegance, those arts by which manufactures are embellished, and science is *5* refined, to found an Academy was reserved for Your Majesty.

HAD such patronage been without effect, there had been reason to believe that Nature had, by some insurmountable impediment, obstructed our proficiency; but the annual improvement of the Exhibitions which Your Majesty has been *10* pleased to encourage, shews that only encouragement had been wanting.

To give advice to those who are contending for royal liberality, has been for some years the duty of my station in the Academy; and these Discourses hope for Your Majesty's accep- *15* tance, as well-intended endeavours to incite that emulation which your notice has kindled, and direct those studies which your bounty has rewarded.

May it please Your MAJESTY,
Your MAJESTY'S
Most dutiful servant,
and most faithful subject,
JOSHUA REYNOLDS.

[1778.]

In both the 1797 and 1798 editions Malone placed the dedication to the king at the front of volume one, before his memoir of Reynolds, and the dedication to the members of the Royal Academy after the title page of the first discourse.

The dedication was written for Reynolds by Dr. Johnson and was prefixed to the 1778 collected edition of the first seven discourses. It was probably written on April 18, 1778. See Frederick W. Hilles, *The Literary Career of Sir Joshua Reynolds* (Cambridge, [Eng.], 1936), p. 49. Reynolds, who was apparently sensitive about the assistance he had received, subsequently asked Boswell to cancel a page in the *Life of Johnson* in which Boswell had hinted that the dedication had been written by Johnson (*Literary Career*, p. xvii).

7-9 There was speculation in the 18th century about the influence of climate and weather on national temperament and creative talent. DuBos, Montesquieu, and Winckelmann all sought to explain on these grounds what they took to be the paucity of English achievement in the arts. The discussion prompted James Barry to publish in 1775 an elaborate refutation entitled *An Inquiry into the Real and Imaginary Obstructions to the Acquisition of the Arts in England* (London).

CONTENTS*

DISCOURSE I

The advantages proceeding from the institution of a Royal Academy. —Hints offered to the consideration of the Professors and Visitors; —that an implicit obedience to the Rules of Art be exacted from the young Students;—that a premature disposition to a masterly dexterity be repressed;—that diligence be constantly recommended, and (that it may be effectual) directed to its proper object. **Page 9**

DISCOURSE II

The Course and Order of Study.—The different stages of Art.—Much Copying discountenanced.—The Artist at all times and in all places should be employed in laying up materials for the exercise of his Art. **Page 23**

DISCOURSE III

The great leading principles of the Grand Style.—Of Beauty.—The genuine habits of Nature to be distinguished from those of Fashion. **Page 39**

DISCOURSE IV

General Ideas, the presiding principle which regulates every part of Art; Invention, Expression, Colouring, and Drapery.—Two distinct styles in History-Painting; the Grand, and the Ornamental.—The Schools in which each is to be found.—The Composite Style.—The Style formed on local customs and habits, or a partial view of nature. **Page 55**

*This table of CONTENTS was drawn up by the Author, (on the Editor's [Malone] suggestion,) a few months before his last illness.
[This note is omitted in the 1798 edition.]

DISCOURSE V

Circumspection required in endeavouring to unite contrary excellencies.—The expression of a mixed passion not to be attempted. Examples of those who excelled in the Great Style;—Raffaelle, Michael Angelo. Those two extraordinary men compared with each other.— The Characteristical Style.—Salvator Rosa mentioned as an example of that style; and opposed to Carlo Maratti.—Sketch of the characters of Poussin and Rubens. These two Painters entirely dissimilar, but consistent with themselves. This consistency required in all parts of the Art. Page 75

DISCOURSE VI

Imitation.—Genius begins where Rules end.—Invention;—acquired by being conversant with the inventions of others.—The true method of imitating.—Borrowing, how far allowable.—Something to be gathered from every School. Page 91

DISCOURSE VII

The reality of a standard of Taste, as well as of corporal Beauty. Beside this immutable truth, there are secondary truths, which are variable; both requiring the attention of the Artist, in proportion to their stability or their influence. Page 115

DISCOURSE VIII

The Principles of Art, whether Poetry or Painting, have their foundation in the Mind; such as Novelty, Variety, and Contrast; these in their excess become defects.—Simplicity. Its excess disagreeable.—Rules not to be always observed in their literal sense: sufficient to preserve the spirit of the law.—Observations on the Prize-Pictures. Page 143

DISCOURSE IX

On the removal of the Royal Academy to Somerset-Place.—The advantages to society from cultivating intellectual pleasure. Page 167

Contents

Discourse X

Sculpture.—Has but one style.—Its objects, form, and character.—Ineffectual attempts of the modern Sculptors to improve the art.—Ill effects of modern dress in Sculpture. Page 173

Discourse XI

Genius.—Consists principally in the comprehension of A WHOLE; *in taking general ideas only.* Page 189

Discourse XII

Particular methods of study of little consequence.—Little of the art can be taught.—Love of method often a love of idleness. Pittori improvvisatori *apt to be careless and incorrect; seldom original and striking. This proceeds from their not studying the works of other masters.*
 Page 205

Discourse XIII

Art not merely imitation, but under the direction of the Imagination. In what manner Poetry, Painting, Acting, Gardening, and Architecture, depart from Nature. Page 227

Discourse XIV

Character of Gainsborough;—*his excellencies and defects.* Page 245

Discourse XV

The President *takes leave of the Academy.—A Review of the Discourses.—The study of the Works of* Michael Angelo *recommended.*
 Page 263

DISCOURSE I

Delivered at the Opening of

The Royal Academy,

January 2, 1769

THE MEMBERS
THE ROYAL ACADEMY

GENTLEMEN,

THAT you have ordered the publication of this discourse, is not only very flattering to me, as it implies your approbation of the method of study which I have recommended; but likewise, as this method receives from that act such an additional weight and authority, as demands from the Students that deference and respect, which can be due only to the united sense of so considerable a BODY of ARTISTS.

I am,

 With the greatest esteem and respect,

GENTLEMEN,

 Your most humble,

 and obedient Servant,

 JOSHUA REYNOLDS.

The dedication "To the Members of the Royal Academy" was written at the time of the printing of the first discourse in 1769, but was also included in the 1778, 1797, and 1798 editions.

DISCOURSE I

Gentlemen,

AN Academy, in which the Polite Arts may be regularly culti-
vated, is at last opened among us by Royal Munificence. This
must appear an event in the highest degree interesting, not only to the
Artists, but to the whole nation.

It is indeed difficult to give any other reason, why an empire like
that of Britain, should so long have wanted an ornament so suit-
able to its greatness, than that slow progression of things, which natu-
rally makes elegance and refinement the last effect of opulence and
power.

An Institution like this has often been recommended upon consid-
erations merely mercantile; but an Academy, founded upon such
principles, can never effect even its own narrow purposes. If it has
an origin no higher, no taste can ever be formed in manufactures; but
if the higher Arts of Design flourish, these inferior ends will be
answered of course.

We are happy in having a Prince, who has conceived the design
of such an Institution, according to its true dignity; and who promotes
the Arts, as the head of a great, a learned, a polite, and a commercial
nation; and I can now congratulate you, Gentlemen, on the accom-
plishment of your long and ardent wishes.

In the 1798 edition Malone inserted imme-
diately after the title of each discourse a re-
print of the summary of each discourse as it
appeared in the Contents.

13 69 and 78S formed in it, which can be
useful even in manufactures

17 69 and 78S and promotes

1-2 On the rather involved history of art "academies" in England prior to the foundation of
the Royal Academy see William Sandby, *The History of the Royal Academy of Arts* (Lon-
don, 1862), Vol. I, Ch. ii; Walter R. M. Lamb, *The Royal Academy* (London, 1951), pp. 2-8.

19 The first discourse was presumably delivered only to Reynolds' fellow academicians.
The instrument for the foundation of the academy was signed by the king on Dec. 10, 1768.
The first discourse was delivered on Jan. 2, 1769. Subsequent discourses were read before the
assembled academicians and students on the occasion of the awarding of prizes.

THE numberless and ineffectual consultations which I have had with many in this assembly, to form plans and concert schemes for an Academy, afford a sufficient proof of the impossibility of succeeding but by the influence of MAJESTY. But there have, perhaps, been times,
25 when even the influence of MAJESTY would have been ineffectual; and it is pleasing to reflect, that we are thus embodied, when every circumstance seems to concur from which honour and prosperity can probably arise.

THERE are, at this time, a greater number of excellent Artists than
30 were ever known before at one period in this nation; there is a general desire among our Nobility to be distinguished as lovers and judges of the Arts; there is a greater superfluity of wealth among the people to reward the professors; and, above all, we are patronized by a Monarch, who, knowing the value of science and of elegance, thinks
35 every Art worthy of his notice, that tends to soften and humanise the mind.

AFTER so much has been done by HIS MAJESTY, it will be wholly our fault, if our progress is not in some degree correspondent to the wisdom and generosity of the Institution: let us shew our gratitude
40 in our diligence, that, though our merit may not answer his expectations, yet, at least, our industry may deserve his protection.

BUT whatever may be our proportion of success, of this we may be sure, that the present Institution will at least contribute to advance our knowledge of the Arts, and bring us nearer to that ideal excellence,
45 which it is the lot of genius always to contemplate and never to attain.

21 78S consultations that I

35-37 69 the mind.
It has been observed, that the Arts have ever been disposed to travel westward. *Greece* is thought to have received them from her more eastern neighbors. From the *Greeks* they migrated into *Italy;* from thence they visited *France, Flanders,* and *Holland,* enlightening, for a time, those countries, though with diminished lustre; but, as if the ocean had stopped their progress, they have for near an age stood still, and grown weak and torpid for want of motion. Let us for a moment flatter ourselves that they are still in being, and have at last arrived at this island. Our Monarch seems willing to think so, having provided such an Asylum for their reception, as may induce them to stay where they are so much honoured.
After so

21-24 The extent to which Reynolds was involved in the discussions preceding the foundation of the academy is not clear. According to most accounts he had very little to do with the negotiations. See Robert Strange, *An Inquiry into the Rise and Establishment of the Royal Academy of Arts* (London, 1775), p. 98; Sandby, I, 48.

36 Hilles, *Literary Career*, p. 47, suggests that the paragraph cut from the original edition at this point may have been omitted because of a scoffing reference to it in an anonymous pamphlet published at London in 1774, entitled *Observations on the Discourses Delivered at the Royal Academy. Addressed to the President.*

THE principal advantage of an Academy is, that, beside furnishing able men to direct the Student, it will be a repository for the great examples of the Art. These are the materials on which Genius is to work, and without which the strongest intellect may be fruitlesly or deviously employed. By studying these authentick models, that idea of excellence which is the result of the accumulated experience of past ages, may be at once acquired; and the tardy and obstructed progress of our predecessors may teach us a shorter and easier way. The Student receives, at one glance, the principles which many Artists have spent their whole lives in ascertaining; and, satisfied with their effect, is spared the painful investigation by which they came to be known and fixed. How many men of great natural abilities have been lost to this nation, for want of these advantages! They never had an opportunity of seeing those masterly efforts of genius, which at once kindle the whole soul, and force it into sudden and irresistible approbation.

RAFFAELLE, it is true, had not the advantage of studying in an Academy; but all Rome, and the works of MICHAEL ANGELO in particular, were to him an Academy. On the sight of the CAPELLA SISTINA, he immediately from a dry, Gothick, and even insipid manner, which attends to the minute accidental discriminations of particular and indi-

50

55

60

65

46 69, 78S and 98 that, besides furnishing 56 69 and 78S they come to be

50-51 69 models, those beauties which are
the result

46-48 The idea that the academy should have a collection of works by the masters with which to supplement instruction was frequently put forward during the first half century of that institution's existence. The establishment of the National Gallery in 1824 was to some extent the result of this continuing request. Reynolds himself offered his distinguished collection to the academy about 1791 at a low price, but the offer was rejected. James Barry, professor of painting at the academy, attempted without success to persuade his colleagues to buy the Orleans collection when it was offered for sale in London during 1798.

61-67 Reynolds' main point, that Raphael's art developed rapidly after he had studied the work of other artists, is certainly true. But his statement of the facts is inaccurate. The major changes in Raphael's art took place in Florence before he went to Rome. It was in Florence that he first studied carefully the works of Michelangelo, Leonardo, and Fra Bartolommeo. The error is a curious one, for Reynolds' sources of information, such as Jonathan Richardson (*Works* [London, 1792], p. 147), state the issue correctly. But see also Giorgio Vasari: "The sight thus afforded to him [of the Sistine Chapel] caused Raphael instantly to paint anew the figure of the prophet Isaiah, which he had executed in the Church of Sant'Agostino . . . and in this work he profited to so great an extent by what he had seen in the works of Michelangelo, that his manner was thereby inexpressibly ameliorated and enlarged, receiving thenceforth an obvious increase of majesty." *Lives of the Most Eminent Painters, Sculptors, and Architects,* trans. Mrs. Jonathan Foster (London, 1878-81), III, 23.

64 The word "Gothick" had several meanings by the mid-18th century: (1) respecting the country of the Goths; (2) denoting a particular kind of architecture; (3) rude, uncivilized. Clearly it is the last of these meanings that Reynolds intended here.

vidual objects, assumed that grand style of painting, which improves partial representation by the general and invariable ideas of nature.

EVERY seminary of learning may be said to be surrounded with an atmosphere of floating knowledge, where every mind may imbibe somewhat congenial to its own original conceptions. Knowledge, thus obtained, has always something more popular and useful than that which is forced upon the mind by private precepts, or solitary meditation. Besides, it is generally found, that a youth more easily receives instruction from the companions of his studies, whose minds are nearly on a level with his own, than from those who are much his superiors; and it is from his equals only that he catches the fire of emulation.

ONE advantage, I will venture to affirm, we shall have in our Academy, which no other nation can boast. We shall have nothing to unlearn. To this praise the present race of Artists have a just claim. As far as they have yet proceeded, they are right. With us the exertions of genius will henceforward be directed to their proper objects. It will not be as it has been in other schools, where he that travelled fastest, only wandered farthest from the right way.

IMPRESSED, as I am, therefore, with such a favourable opinion of my associates in this undertaking, it would ill become me to dictate to any of them. But as these Institutions have so often failed in other nations; and as it is natural to think with regret, how much might have been done, I must take leave to offer a few hints, by which those errors may be rectified, and those defects supplied. These the Professors and Visitors may reject or adopt as they shall think proper.

66-67 69 which unites precision and correctness with the general

69-70 69 may gather somewhat

77-78 69 emulation which will not a little contribute to his advancement.
But it is needless to enumerate all the benefits that will result from this Institution. The world seems already satisfied, that the Arts must be protected in order to flourish; at least,

I believe, this assembly will not be disposed to think them unworthy of the regard and protection with which His Majesty has been pleased to honour them.
One advantage

78-79 69 shall have, which no

89 69 and 78S done, and how little has been done, I must

87 Reynolds appears to have gathered information on some of the continental academies. He instructed James Barry in a letter of 1769 to "make memorandums of the regulations of the academies that you may visit in your travels, to be engrafted on our own, if they should be found useful." *Letters of Sir Joshua Reynolds*, ed. F. W. Hilles (Cambridge, [Eng.], 1929), p. 19.

91 The Visitors were nine academicians, elected annually, who attended the various schools of design within the academy in order to supervise and instruct the students.

I WOULD chiefly recommend, that an implicit obedience to the *Rules of Art*, as established by the practice of the great MASTERS, should be exacted from the *young* Students. That those models, which have passed through the approbation of ages, should be considered by them as perfect and infallible guides; as subjects for their imitation, not their criticism.

I AM confident, that this is the only efficacious method of making a progress in the Arts; and that he who sets out with doubting, will find life finished before he becomes master of the rudiments. For it may be laid down as a maxim, that he who begins by presuming on his own sense, has ended his studies as soon as he has commenced them. Every opportunity, therefore, should be taken to discountenance that false and vulgar opinion, that rules are the fetters of genius. They are fetters only to men of no genius; as that armour, which upon the strong is an ornament and a defence, upon the weak and mis-shapen becomes a load, and cripples the body which it was made to protect.

How much liberty may be taken to break through those rules, and, as the Poet expresses it,

To snatch a grace beyond the reach of art,

may be a subsequent consideration, when the pupils become masters themselves. It is then, when their genius has received its utmost improvement, that rules may possibly be dispensed with. But let us not destroy the scaffold, until we have raised the building.

THE Directors ought more particularly to watch over the genius of those Students, who, being more advanced, are arrived at that critical period of study, on the nice management of which their future turn of taste depends. At that age it is natural for them to be more captivated with what is brilliant than with what is solid, and to prefer splendid negligence to painful and humiliating exactness.

A FACILITY in composing,—a lively, and what is called a masterly, handling of the chalk or pencil, are, it must be confessed, captivating

105-106 69 and 78S strong becomes an ornament

106-107 69 and 78S misshapen turns into a load

111 69 and 78S be an after consideration

113 69 rules may be

122 78S handling the chalk

92-114 For an analysis of the literary style of this passage see F. W. Hilles, "Sir Joshua's Prose," in *The Age of Johnson* (New Haven, 1949), pp. 52 ff.

110 Alexander Pope, *Essay on Criticism*, l. 155: "And snatch a grace beyond the reach of Art."

qualities to young minds, and become of course the objects of their ambition. They endeavour to imitate those dazzling excellencies, which they will find no great labour in attaining. After much time spent in these frivolous pursuits, the difficulty will be to retreat; but it will be then too late; and there is scarce an instance of return to scrupulous labour, after the mind has been debauched and deceived by this fallacious mastery.

By this useless industry they are excluded from all power of advancing in real excellence. Whilst boys, they are arrived at their utmost perfection; they have taken the shadow for the substance; and make the mechanical felicity, the chief excellence of the art, which is only an ornament, and of the merit of which few but painters themselves are judges.

THIS seems to me to be one of the most dangerous sources of corruption; and I speak of it from experience, not as an error which may possibly happen, but which has actually infected all foreign Academies. The directors were probably pleased with this premature dexterity in their pupils, and praised their dispatch at the expence of their correctness.

BUT young men have not only this frivolous ambition of being thought masters of execution, inciting them on one hand, but also their natural sloth tempting them on the other. They are terrified at the prospect before them, of the toil required to attain exactness. The impetuosity of youth is disgusted at the slow approaches of a regular siege, and desires, from mere impatience of labour, to take the citadel by storm. They wish to find some shorter path to excellence, and hope to obtain the reward of eminence by other means, than those which the indispensible rules of art have prescribed. They must therefore be told again and again, that labour is the only price of solid fame, and that whatever their force of genius may be, there is no easy method of becoming a good Painter.

WHEN we read the lives of the most eminent Painters, every page informs us, that no part of their time was spent in dissipation. Even an increase of fame served only to augment their industry. To be con-

124-125 69 and 78S dazzling excellences, which

128-130 69 mind has been relaxed and debauched by these delightful trifles. By this

132-133 69 and 78S make that mechanical facility, the chief

143 69 and 78S thought masterly inciting

vinced with what persevering assiduity they pursued their studies, we need only reflect on their method of proceeding in their most celebrated works. When they conceived a subject, they first made a variety of sketches; then a finished drawing of the whole; after that a more correct drawing of every separate part,—heads, hands, feet, and pieces of drapery; they then painted the picture, and after all re-touched it from the life. The pictures, thus wrought with such pains, now appear like the effect of enchantment, and as if some mighty Genius had struck them off at a blow.

But, whilst diligence is thus recommended to the Students, the Visitors will take care that their diligence be effectual; that it be well directed, and employed on the proper object. A Student is not always advancing because he is employed; he must apply his strength to that part of the art where the real difficulties lie; to that part which distinguishes it as a liberal art; and not by mistaken industry lose his time in that which is merely ornamental. The Students, instead of vying with each other which shall have the readiest hand, should be taught to contend who shall have the purest and most correct out line; instead of striving which shall produce the brightest tint, or, curiously trifling, shall give the gloss of stuffs, so as to appear real, let their ambition be directed to contend, which shall dispose his drapery in the most graceful folds, which shall give the most grace and dignity to the human figure.

I must beg leave to submit one thing more to the consideration of the Visitors, which appears to me a matter of very great consequence, and the omission of which I think a principal defect in the method of education pursued in all the Academies I have ever visited. The error I mean is, that the Students never draw exactly from the living models which they have before them. It is not indeed their intention; nor are they directed to do it. Their drawings resemble the model only in the attitude. They change the form according to their vague and uncertain ideas of beauty, and make a drawing rather of what they think the figure ought to be, than of what it appears. I have thought this the obstacle, that has stopped the progress of many young men of real genius; and I very much doubt, whether a habit of drawing correctly what we see, will not give a proportionable power of drawing correctly what we imagine. He who endeavours to copy nicely the figure before

163 69 and 78S such pain, now 175-176 69 and 78S trifling, endeavour to
 give

him, not only acquires a habit of exactness and precision, but is con-
195 tinually advancing in his knowledge of the human figure; and though
he seems to superficial observers to make a slower progress, he will be
found at last capable of adding (without running into capricious wild-
ness) that grace and beauty, which is necessary to be given to his more
finished works, and which cannot be got by the moderns, as it was not
200 acquired by the ancients, but by an attentive and well compared study
of the human form.

WHAT I think ought to enforce this method is, that it has been the
practice (as may be seen by their drawings) of the great Masters in
the Art. I will mention a drawing of RAFFAELLE, *The Dispute of the*
205 *Sacrament*, the print of which, by Count CAILUS, is in every hand. It
appears, that he made his sketch from one model; and the habit he had
of drawing exactly from the form before him appears by his making
all the figures with the same cap, such as his model then happened to
wear; so servile a copyist was this great man, even at a time when he was
210 allowed to be at his highest pitch of excellence.

Plate I I HAVE seen also Academy figures by ANNIBALE CARACCI, though
he was often sufficiently licentious in his finished works, drawn with
all the peculiarities of an individual model.

THIS scrupulous exactness is so contrary to the practice of the Acad-
215 emies, that it is not without great deference, that I beg leave to recom-
mend it to the consideration of the Visitors; and submit to them,
whether the neglect of this method is not one of the reasons why Stu-
dents so often disappoint expectation, and, being more than boys at
sixteen, become less than men at thirty.

220 IN short, the method I recommend can only be detrimental when
there are but few living forms to copy; for then Students, by always

216 69 and 78S submit it to 220-221 98 detrimental where there
220 69 short, this method can

204 The drawing, which is now at Chantilly, is not considered to be by Raphael. Reynolds
returns to the problem of Raphael's copies, particularly after other painters, in Discourse XII.

205 Anne Claude Comte de Caylus (1692-1765) was a patron of the arts, an archaeologist,
and a man of letters. As a print maker De Caylus is remembered primarily for his etchings and
engravings after drawings. Arthur M. Hind (*A History of Engraving & Etching* [London,
1923], p. 248) says there are some three thousand such reproductions of drawings from his
hand.

211 Annibale Carracci (1560-1609) does appear to have worked directly from life in many
of his preparatory drawings, though there are rather few with all the peculiarities of an indi-
vidual model. See Rudolf Wittkower, *The Drawings of the Carracci in the Collection of Her
Majesty the Queen at Windsor Castle* (London, [1952]).

drawing from one alone, will by habit be taught to overlook defects, and mistake deformity for beauty. But of this there is no danger; since the Council has determined to supply the Academy with a variety of subjects; and indeed those laws which they have drawn up, and which the Secretary will presently read for your confirmation, have in some measure precluded me from saying more upon this occasion. Instead, therefore, of offering my advice, permit me to indulge my wishes, and express my hope, that this institution may answer the expectations of its Royal Founder; that the present age may vie in Arts with that of Leo the Tenth; and that *the dignity of the dying Art* (to make use of an expression of Pliny) may be revived under the Reign of GEORGE THE THIRD.

225

230

223 69 this objection there 229 98 expectation

224 The governing body of the Royal Academy was established as a council consisting of the president and eight other academicians elected in rotation from the whole body.

225 The "Instrument," which defines the constitution and government of the Royal Academy, is given in full by Sandby (I, 49 ff.).

226 The first secretary of the Royal Academy was a minor portraitist, Francis Milner Newton (1720-1794).

231 By the age of Leo the Tenth Reynolds means the period that historians of art call the High Renaissance, the time in particular of the work of Raphael and early Michelangelo (ca. 1500-1520). But it was Julius II (pope, 1503-1513) who was the great Maecenas of the period, rather than his successor Leo X (pope, 1513-1521).

231-232 Pliny *Historia naturalis* XXXV. x: "hactenus dictum sit de dignitate artis morientis." Reynolds may have found the phrase in Franciscus Junius: "We did speak hitherto, sayth Plinie, of the dignitie of the dying Art" (*The Painting of the Ancients* [London, 1638], p. 332); or in Conte Francesco Algarotti, *An Essay on Painting Written in Italian* (London, 1764), p. 21.

DISCOURSE II

Delivered to the Students of The Royal Academy,

on the Distribution of the Prizes,

December 11, 1769

DISCOURSE II

GENTLEMEN,

I CONGRATULATE you on the honour which you have just received. I have the highest opinion of your merits, and could wish to show my sense of them in something which possibly may be more useful to you than barren praise. I could wish to lead you into such a course of study as may render your future progress answerable to your 5 past improvement; and, whilst I applaud you for what has been done, remind you how much yet remains to attain perfection.

I flatter myself, that from the long experience I have had, and the unceasing assiduity with which I have pursued those studies, in which, like you, I have been engaged, I shall be acquitted of vanity in offer- 10 ing some hints to your consideration. They are indeed in a great degree founded upon my own mistakes in the same pursuit. But the history of errors, properly managed, often shortens the road to truth. And although no method of study that I can offer, will of itself conduct to excellence, yet it may preserve industry from being misapplied. 15

In speaking to you of the Theory of the Art, I shall only consider it as it has a relation to the *method* of your studies.

DIVIDING the study of painting into three distinct periods, I shall address you as having passed through the first of them, which is confined to the rudiments; including a facility of drawing any object that 20 presents itself, a tolerable readiness in the management of colours, and an acquaintance with the most simple and obvious rules of composition.

4 69 than empty praise 7 69 and 78S remind you of how

18-72 The next five paragraphs are of critical importance in reading the *Discourses*. Reynolds here explains the various "levels" of instruction with which he is concerned in the early discourses. Many apparent inconsistencies or even contradictions can be resolved if one keeps clearly in mind the "level" of student to which he is addressing his remarks. Reynolds emphasizes again at the beginning of Discourse III the progressive, graded character of the early discourses. See Introduction, p. xvii.

THIS first degree of proficiency is, in painting, what grammar is in literature, a general preparation for whatever species of the art the student may afterwards choose for his more particular application. The power of drawing, modelling, and using colours, is very properly called the Language of the art; and in this language, the honours you have just received, prove you to have made no inconsiderable progress.

WHEN the Artist is once enabled to express himself with some degree of correctness, he must then endeavour to collect subjects for expression; to amass a stock of ideas, to be combined and varied as occasion may require. He is now in the second period of study, in which his business is to learn all that has been known and done before his own time. Having hitherto received instructions from a particular master, he is now to consider the Art itself as his master. He must extend his capacity to more sublime and general instructions. Those perfections which lie scattered among various masters, are now united in one general idea, which is henceforth to regulate his taste, and enlarge his imagination. With a variety of models thus before him, he will avoid that narrowness and poverty of conception which attends a bigotted admiration of a single master, and will cease to follow any favourite where he ceases to excel. This period is, however, still a time of subjection and discipline. Though the Student will not resign himself blindly to any single authority, when he may have the advantage of consulting many, he must still be afraid of trusting his own judgment, and of deviating into any track where he cannot find the footsteps of some former master.

THE third and last period emancipates the Student from subjection to any authority, but what he shall himself judge to be supported by reason. Confiding now in his own judgment, he will consider and separate those different principles to which different modes of beauty owe their original. In the former period he sought only to know and combine excellence, wherever it was to be found, into one idea of perfection: in this, he learns, what requires the most attentive survey and the most subtle disquisition, to discriminate perfections that are incompatible with each other.

25 69 and 78S preparation to whatever

34-35 69 and 78S been hitherto known and done. Having hitherto

37-38 69 instructions; he must lift up his eyes to the Art itself, as it may be said to live and to teach, in the works of the great Artists of past ages. Those perfections

56 97 diquisition

He is from this time to regard himself as holding the same rank with those masters whom he before obeyed as teachers; and as exercising a sort of sovereignty over those rules which have hitherto restrained him. Comparing now no longer the performances of Art with each other, but examining the Art itself by the standard of Nature, he corrects what is erroneous, supplies what is scanty, and adds by his own observation what the industry of his predecessors may have yet left wanting to perfection. Having well established his judgment, and stored his memory, he may now without fear try the power of his imagination. The mind that has been thus disciplined, may be indulged in the warmest enthusiasm, and venture to play on the borders of the wildest extravagance. The habitual dignity which long converse with the greatest minds has imparted to him, will display itself in all his attempts; and he will stand among his instructors, not as an imitator, but a rival.

These are the different stages of the Art. But as I now address myself particularly to those Students who have been this day rewarded for their happy passage through the first period, I can with no propriety suppose they want any help in the initiatory studies. My present design is to direct your view to distant excellence, and to show you the readiest path that leads to it. Of this I shall speak with such latitude, as may leave the province of the professor uninvaded; and shall not anticipate those precepts, which it is his business to give, and your duty to understand.

It is indisputably evident that a great part of every man's life must be employed in collecting materials for the exercise of genius. Invention, strictly speaking, is little more than a new combination of those images which have been previously gathered and deposited in the memory: nothing can come of nothing: he who has laid up no materials, can produce no combinations.

A Student unacquainted with the attempts of former adventurers, is always apt to over-rate his own abilities; to mistake the most trifling excursions for discoveries of moment, and every coast new to him, for a new-found country. If by chance he passes beyond his usual limits, he congratulates his own arrival at those regions which they who have steered a better course have long left behind them.

59-60 69 exercising sovereignty
64 69 predecessors has yet
72 69 but as a rival

88 97 attemps
90-91 69 every well-known coast for

THE productions of such minds are seldom distinguished by an air
of originality: they are anticipated in their happiest efforts; and if they
are found to differ in any thing from their predecessors, it is only in
irregular sallies, and trifling conceits. The more extensive therefore
your acquaintance is with the works of those who have excelled, the
more extensive will be your powers of invention; and what may appear
still more like a paradox, the more original will be your conceptions.
But the difficulty on this occasion is to determine who ought to be pro-
posed as models of excellence, and who ought to be considered as the
properest guides.

To a young man just arrived in *Italy*, many of the present painters
of that country are ready enough to obtrude their precepts, and to
offer their own performances as examples of that perfection which
they affect to recommend. The Modern, however, who recommends
himself as a standard, may justly be suspected as ignorant of the true
end, and unacquainted with the proper object, of the art which he
professes. To follow such a guide, will not only retard the Student,
but mislead him.

ON whom then can he rely, or who shall show him the path that
leads to excellence? the answer is obvious: those great masters who have
travelled the same road with success, are the most likely to conduct
others. The works of those who have stood the test of ages, have a
claim to that respect and veneration to which no modern can pretend.
The duration and stability of their fame, is sufficient to evince that
it has not been suspended upon the slender thread of fashion and
caprice, but bound to the human heart by every tie of sympathetick
approbation.

THERE is no danger of studying too much the works of those great
men; but how they may be studied to advantage is an enquiry of great
importance.

101 98 determine what ought 107 69 they pretend to recommend

104-107 Roger Fry comments on this passage, "Such an artist might in this year (1769) have
met the following:—Canaletto, Belotti, Marieschi, Guardi, Zuccharelli, Raphael Mengs, Pom-
peo Batoni, Ant. Cavalucci; Tiepolo, even, he might just have seen. Longhi and Pannini were
recently dead" (*Discourses . . . Sir Joshua Reynolds* [London, 1905], p. 430). In other words
the Italian painters of the mid-18th century were mostly rococo landscapists, decorators, and
portraitists. Reynolds would have dismissed them as belonging to his "ornamental" class of
artists who "seem more willing to dazzle than to affect" (IV, 206). Mengs, who was a leader in
the reaction against some of the more frivolous aspects of the rococo, might have gained Reyn-
olds' approval, but the two men appear to have disliked one another (Hilles, *Literary Career*,
pp. 61 ff.).

Some who have never raised their minds to the consideration of the real dignity of the Art, and who rate the works of an Artist in proportion as they excel or are defective in the mechanical parts, look on theory as something that may enable them to talk but not to paint better; and confining themselves entirely to mechanical practice, very assiduously toil on in the drudgery of copying; and think they make a rapid progress while they faithfully exhibit the minutest part of a favourite picture. This appears to me a very tedious, and I think a very erroneous method of proceeding. Of every large composition, even of those which are most admired, a great part may be truly said to be *common-place*. This, though it takes up much time in copying, conduces little to improvement. I consider general copying as a delusive kind of industry; the Student satisfies himself with the appearance of doing something; he falls into the dangerous habit of imitating without selecting, and of labouring without any determinate object; as it requires no effort of the mind, he sleeps over his work; and those powers of invention and composition which ought particularly to be called out, and put in action, lie torpid, and lose their energy for want of exercise.

How incapable those are of producing any thing of their own, who have spent much of their time in making finished copies, is well known to all who are conversant with our art.

To suppose that the complication of powers, and variety of ideas necessary to that mind which aspires to the first honours in the art of Painting, can be obtained by the frigid contemplation of a few single models, is no less absurd, than it would be in him who wishes to be a Poet, to imagine that by translating a tragedy he can acquire to himself sufficient knowledge of the appearances of nature, the operations of the passions, and the incidents of life.

The great use in copying, if it be at all useful, should seem to be in learning to colour; yet even colouring will never be perfectly attained by servilely copying the model before you. An eye critically nice can

125

130

135

140

145

150

155

127 69 Theory as an Art that

142-146 69 and 78S of exercise.
It is an observation that all must have made,

how incapable those are of producing any thing of their own, who have spent much of their time in making finished copies.
To suppose

154 Fry (p. 430) comments, "colouring with Reynolds implies the whole technique of painting." Surely this is a moot point. The sense of the paragraph would suggest that Reynolds means by "colour" and "colouring" little more than the words imply today. He seems to use the words "style" and "handling" to refer to the executive side of painting (II, 241 ff.).

only be formed by observing well-coloured pictures with attention: and by close inspection, and minute examination, you will discover, at last, the manner of handling, the artifices of contrast, glazing, and other expedients, by which good colourists have raised the value of their tints, and by which nature has been so happily imitated.

I MUST inform you, however, that old pictures deservedly celebrated for their colouring, are often so changed by dirt and varnish, that we ought not to wonder if they do not appear equal to their reputation in the eyes of unexperienced painters, or young students. An artist whose judgment is matured by long observation, considers rather what the picture once was, than what it is at present. He has by habit acquired a power of seeing the brilliancy of tints through the cloud by which it is obscured. An exact imitation, therefore, of those pictures, is likely to fill the student's mind with false opinions; and to send him back a colourist of his own formation, with ideas equally remote from nature and from art, from the genuine practice of the masters, and the real appearances of things.

FOLLOWING these rules, and using these precautions, when you have clearly and distinctly learned in what good colouring consists, you cannot do better than have recourse to nature herself, who is always at hand, and in comparison of whose true splendour the best coloured pictures are but faint and feeble.

HOWEVER, as the practice of copying is not entirely to be excluded, since the mechanical practice of painting is learned in some measure by it, let those choice parts only be selected which have recommended the work to notice. If its excellence consists in its general effect, it would be proper to make slight sketches of the machinery and general management of the picture. Those sketches should be kept always by you for the regulation of your stile. Instead of copying the touches of those great masters, copy only their conceptions. Instead of treading in their footsteps, endeavour only to keep the same road. Labour to invent on their general principles and way of thinking. Possess yourself with their spirit. Consider with yourself how a MICHAEL ANGELO

166-167	69 and 78S	has acquired a power	176	69	whose rules the best
by habit of			178	69	as this method is
171	69	genuine rules of	186	97	foosteps

188-191 Hilles (*Literary Career*, p. 127) points out a similarity in thought to that expressed in Junius, pp. 250-251: "Yet shall that Artificer bring greater spirits to his worke, who beside the most profitable endeavours of an emulating vertue, associateth himselfe with Apelles, Protog-

or a RAFFAELLE would have treated this subject: and work yourself into a belief that your picture is to be seen and criticised by them when completed. Even an attempt of this kind will rouse your powers.

But as mere enthusiasm will carry you but a little way, let me recommend a practice that may be equivalent to and will perhaps more efficaciously contribute to your advancement, than even the verbal corrections of those masters themselves, could they be obtained. What I would propose is, that you should enter into a kind of competition, by painting a similar subject, and making a companion to any picture that you consider as a model. After you have finished your work, place it near the model, and compare them carefully together. You will then not only see, but feel your own deficiencies more sensibly than by precepts, or any other means of instruction. The true principles of painting will mingle with your thoughts. Ideas thus fixed by sensible objects, will be certain and definitive; and sinking deep into the mind, will not only be more just, but more lasting than those presented to you by precepts only; which will always be fleeting, variable, and undetermined.

THIS method of comparing your own efforts with those of some great master, is indeed a severe and mortifying task, to which none will submit, but such as have great views, with fortitude sufficient to forego the gratifications of present vanity for future honour. When the Student has succeeded in some measure to his own satisfaction, and has felicitated himself on his success, to go voluntarily to a tribunal where he knows his vanity must be humbled, and all self-approbation must vanish, requires not only great resolution, but great humility. To him, however, who has the ambition to be a real master, the solid satisfaction which proceeds from a consciousness of his advancement, (of which seeing his own faults is the first step,) will very abundantly compensate for the mortification of present disappointment. There is, besides, this alleviating circumstance. Every discovery he

193 69 and 78S equivalent, and

202 69 thoughts; and the example before you will shew you how much Art is to be employed in attaining the seemingly obvious simplicity of Nature.
Ideas thus

210 69 for a distant good. When
219 69 is, beside, this

enes, Polycletus, Phidias; not only considering with himselfe, what these noble soules if they were present, should do or else advise him to doe in the workes he taketh in hand; but propounding also unto himselfe, how they should censure his worke brought to an end." There is a similar thought, phrased in terms of literary figures rather than artists, in Cassius Longinus, *On the Sublime*, trans. William Smith (London, 1739), pp. 38-39. Sir Joshua's copy of this book is in the possession of F. W. Hilles.

220 makes, every acquisition of knowledge he attains, seems to proceed from his own sagacity; and thus he acquires a confidence in himself sufficient to keep up the resolution of perseverance.

WE all must have experienced how lazily, and consequently how ineffectually, instruction is received when forced upon the mind by 225 others. Few have been taught to any purpose who have not been their own teachers. We prefer those instructions which we have given ourselves, from our affection to the instructor; and they are more effectual, from being received into the mind at the very time when it is most open and eager to receive them.

230 WITH respect to the pictures that you are to choose for your models, I could wish that you would take the world's opinion rather than your own. In other words, I would have you choose those of established reputation, rather than follow your own fancy. If you should not admire them at first, you will, by endeavouring to imitate them, find 235 that the world has not been mistaken.

IT is not an easy task to point out those various excellencies for your imitation which lie distributed amongst the various schools. An endeavour to do this may perhaps be the subject of some future discourse. I will, therefore, at present only recommend a model for Stile in 240 Painting, which is a branch of the art more immediately necessary to the young student. Stile in painting is the same as in writing, a power over materials, whether words or colours, by which conceptions or sentiments are conveyed. And in this LODOVICO CARRACHE (I mean in his best works) appears to me to approach the nearest to perfection. 245 His unaffected breadth of light and shadow, the simplicity of colouring, which holding its proper rank, does not draw aside the least part

222 69 the ardour of 243-244 69 Carrache appears

233-235 See Reynolds' letter to James Barry (1769): "If you should not relish them at first [Raphael and Michelangelo], which may probably be the case, as they have none of those qualities which are captivating at first sight, never cease looking till you feel something like inspiration come over you, till you think every other painter insipid in comparison, and to be admired only for petty excellencies" (Hilles, *Letters*, p. 19). See also Reynolds, *Works*, 2nd ed. (London, 1798), I, xiv, xvi: "I remember very well my own disappointment, when I first visited the Vatican. . . . Notwithstanding my disappointment, I proceeded to copy some of those excellent works. . . . In a short time a new taste and new perceptions began to dawn upon me; and I was convinced that I had originally formed a false opinion of the perfection of art. . . ."

243-244 Lodovico Carracci (1555-1619) was the uncle of Annibale Carracci. Reynolds' high praise of this painter is a little puzzling. He occupies a transitional position between late 16th-century mannerism and early 17th-century baroque and is certainly not of the stature of the other artists to whom Reynolds refers the student. But it must be remembered that Lodovico is held up as a model of "style" only. For Reynolds' use of that term see above, II, 241-243.

of the attention from the subject, and the solemn effect of that twilight which seems diffused over his pictures, appear to me to correspond with grave and dignified subjects, better than the more artificial brilliancy of sunshine which enlightens the pictures of TITIAN: though TINTORET thought that TITIAN's colouring was the model of perfection, and would correspond even with the sublime of MICHAEL ANGELO; and that if ANGELO had coloured like TITIAN, or TITIAN designed like ANGELO, the world would once have had a perfect painter.

IT is our misfortune, however, that those works of CARRACHE which I would recommend to the Student, are not often found out of *Bologna*. The *St. Francis in the midst of his Friars, The Transfiguration, The Birth of St. John the Baptist, The Calling of St. Matthew, The St. Jerome, The Fresco Paintings* in the Zampieri palace, are all worthy the attention of the student. And I think those who travel would do well to allot a much greater portion of their time to that city than it has been hitherto the custom to bestow.

IN this art, as in others, there are many teachers who profess to shew the nearest way to excellence; and many expedients have been invented by which the toil of study might be saved. But let no man be seduced to idleness by specious promises. Excellence is never granted to man, but as the reward of labour. It argues indeed no small strength of mind to persevere in habits of industry, without the pleasure of perceiving those advances; which, like the hand of a clock, whilst they make hourly approaches to their point, yet proceed so slowly as to escape observation. A facility of drawing, like that of playing upon a musical instrument, cannot be acquired but by an infinite number of acts. I need not, therefore, enforce by many words the necessity of continual application; nor tell you that the porte-crayon ought to be for ever in your hands. Various methods will occur to you by which this

250

255

Plate II

260

265

270

275

248 69 seems to enlighten his Pictures	266 69 by empty promises	
250 69 which is diffused over the Pictures	270 69 approaches to perfection, yet	

257-259 On the works of Lodovico see Heinrich Bodmer, *Lodovico Carracci* (Burg bei Magdeburg, [1939]). The paintings Reynolds refers to are probably to be identified as follows:
"St. Francis in the Middle of His Friars," Bodmer, Fig. 82 (now in the Pinakothek, Bologna)
"The Transfiguration," Bodmer, Fig. 42 (Pinakothek, Bologna)
"Birth of St. John," Bodmer, Fig. 50 (Pinakothek, Bologna)
"Calling of St. Matthew," Bodmer, Fig. 55 (Pinakothek, Bologna)
"St. Jerome," Bodmer, Fig. 47 (S. Martino Maggiore, Bologna)
On the Zampieri frescoes see Bodmer, p. 119.

274 The porte-crayon is an instrument for holding a drawing crayon and is usually a tube split at one end.

33

power may be acquired. I would particularly recommend, that after your return from the Academy (where I suppose your attendance to be constant) you would endeavour to draw the figure by memory. I will even venture to add, that by perseverance in this custom, you will become able to draw the human figure tolerably correct, with as little effort of the mind as is required to trace with a pen the letters of the alphabet.

THAT this facility is not unattainable, some members in this Academy give a sufficient proof. And be assured, that if this power is not acquired whilst you are young, there will be no time for it afterwards: at least the attempt will be attended with as much difficulty as those experience who learn to read or write after they have arrived to the age of maturity.

But while I mention the porte-crayon as the student's constant companion, he must still remember, that the pencil is the instrument by which he must hope to obtain eminence. What, therefore, I wish to impress upon you is, that whenever an opportunity offers, you paint your studies instead of drawing them. This will give you such a facility in using colours, that in time they will arrange themselves under the pencil, even without the attention of the hand that conducts it. If one act excluded the other, this advice could not with any propriety be given. But if Painting comprises both drawing and colouring, and if by a short struggle of resolute industry, the same expedition is attainable in painting as in drawing on paper, I cannot see what objection can justly be made to the practice; or why that should be done by parts, which may be done all together.

IF we turn our eyes to the several Schools of Painting, and consider their respective excellencies, we shall find that those who excel most in colouring, pursued this method. The *Venetian* and *Flemish* schools, which owe much of their fame to colouring, have enriched the cabinets of the collectors of drawings, with very few examples. Those of

281 69 and 78S as to trace 291 69 eminence. The advice, therefore, that I

290 "Pencil" means paintbrush.

304-312 Reynolds' point, that the great colorists did not execute many drawings, is generally true, although he tends to disparage unjustly what they did do. All of the artists he mentions produced drawings of great power and distinction, and Rubens in particular was a prolific draftsman. Reynolds himself, although his own drawings tend to be "slight and undetermined," was more inclined to draw rather than paint his studies.

TITIAN, PAUL VERONESE, TINTORET, and the BASSANS, are in general slight and undetermined. Their sketches on paper are as rude as their pictures are excellent in regard to harmony of colouring. CORREGGIO and BAROCCI have left few, if any finished drawings behind them. And in the *Flemish* school, RUBENS and VANDYCK made their designs for the most part either in colours, or in chiaro oscuro. It is as common to find studies of the *Venetian* and *Flemish* Painters on canvass, as of the schools of *Rome* and *Florence* on paper. Not but that many finished drawings are sold under the names of those masters. Those, however, are undoubtedly the productions either of engravers or of their scholars, who copied their works.

THESE instructions I have ventured to offer from my own experience; but as they deviate widely from received opinions, I offer them with diffidence; and when better are suggested, shall retract them without regret.

THERE is one precept, however, in which I shall only be opposed by the vain, the ignorant, and the idle. I am not afraid that I shall repeat it too often. You must have no dependence on your own genius. If you have great talents, industry will improve them; if you have but moderate abilities, industry will supply their deficiency. Nothing is denied to well directed labour: nothing is to be obtained without it. Not to enter into metaphysical discussions on the nature or essence of genius, I will venture to assert, that assiduity unabated by difficulty, and a disposition eagerly directed to the object of its pursuit, will produce effects similar to those which some call the result of *natural powers*.

THOUGH a man cannot at all times, and in all places, paint or draw, yet the mind can prepare itself by laying in proper materials, at all times, and in all places. Both LIVY and PLUTARCH, in describing PHILO-POEMEN, one of the ablest generals of antiquity, have given us a striking picture of a mind always intent on its profession, and by assiduity obtaining those excellencies which some all their lives vainly expect

310

315

320

325

330

335

314 97 shools

307 "Bassani" is the name given to a group of painters of the Da Ponte family active in northern Italy during the 16th and early 17th centuries.

310 Federico Barocci (1526-1612) was a late mannerist, particularly addicted to pinks and pastel colors.

333-335 See Junius, p. 26: "and although we cannot at all times and in all places draw and paint, our mind for all that can prepare it selfe alwayes and every where."

from Nature. I shall quote the passage in LIVY at length, as it runs
340 parallel with the practice I would recommend to the Painter, Sculptor,
and Architect.

"PHILOPOEMEN was a man eminent for his sagacity and experience
in choosing ground, and in leading armies; to which he formed his
mind by perpetual meditation, in times of peace as well as war. When,
345 in any occasional journey, he came to a strait difficult passage, if he
was alone, he considered with himself, and if he was in company he
asked his friends, what it would be best to do if in this place they had
found an enemy, either in the front, or in the rear, on the one side,
or on the other. 'It might happen,' says he, 'that the enemy to be
350 opposed might come on drawn up in regular lines, or in a tumultuous
body, formed only by the nature of the place.' He then considered a
little what ground he should take; what number of soldiers he should
use, and what arms he should give them; where he should lodge his
carriages, his baggage, and the defenceless followers of his camp; how
355 many guards, and of what kind, he should send to defend them; and
whether it would be better to press forward along the pass, or recover
by retreat his former station: he would consider likewise where his
camp could most commodiously be formed; how much ground he
should inclose within his trenches; where he should have the conven-
360 ience of water, and where he might find plenty of wood and forage;
and when he should break up his camp on the following day, through
what road he could most safely pass, and in what form he should dis-
pose his troops. With such thoughts and disquisitions he had from his
early years so exercised his mind, that on these occasions nothing could
365 happen which he had not been already accustomed to consider."

I CANNOT help imagining that I see a promising young painter,
equally vigilant, whether at home, or abroad, in the streets, or in the
fields. Every object that presents itself, is to him a lesson. He regards
all Nature with a view to his profession; and combines her beauties,
370 or corrects her defects. He examines the countenance of men under
the influence of passion; and often catches the most pleasing hints from

340-341 69 and 78S Sculptor, or Archi-
tect

342-365 Livy *Historiarum libri* XXXV. xxviii. Hilles (*Literary Career*, p. 126) suggests that
Reynolds knew the passage from Junius, p. 25. Reynolds owned Junius' book both in its origi-
nal Latin version and in English translation. He appears here to be making his own translation
from the Latin.

subjects of turbulence or deformity. Even bad pictures themselves supply him with useful documents; and, as LEONARDO DA VINCI has observed, he improves upon the fanciful images that are sometimes seen in the fire, or are accidentally sketched upon a discoloured wall. 375

THE artist who has his mind thus filled with ideas, and his hand made expert by practice, works with ease and readiness; whilst he who would have you believe that he is waiting for the inspirations of Genius, is in reality at a loss how to begin; and is at last delivered of his monsters, with difficulty and pain. 380

THE well-grounded painter, on the contrary, has only maturely to consider his subject, and all the mechanical parts of his art follow without his exertion. Conscious of the difficulty of obtaining what he possesses, he makes no pretensions to secrets, except those of closer application. Without conceiving the smallest jealousy against others, 385 he is contented that all shall be as great as himself, who have undergone the same fatigue; and as his pre-eminence depends not upon a trick, he is free from the painful suspicions of a juggler, who lives in perpetual fear lest his trick should be discovered.

374 69 observed, improves

386-387 69 and 78S who are willing to undergo the same

373-375 Leonardo da Vinci speaks of images suggested by spotted walls in the *Treatise on Painting*, Ch. xvi (trans. A. Philip McMahon [Princeton, 1956], I, 109). I have not found any passage in which he speaks of flames in the same way. The passage on spotted walls is referred to by many authors, including Roger de Piles (*The Art of Painting and the Lives of the Painters* [London, 1706], p. 13).

376-380 Blake considered this "A Stroke at Mortimer!" See "Annotations to Reynolds's 'Discourses,'" in *The Writings of William Blake*, ed. Geoffrey Keynes (London, 1925), III, 21. John Hamilton Mortimer (1741?-1779) was a painter and draftsman of considerable historical importance, belonging, along with Fuseli and Barry, with the pioneers of English romantic figure painting. Blake knew and admired his work.

DISCOURSE III

Delivered to the Students of The Royal Academy,

on the Distribution of the Prizes,

December 14, 1770

DISCOURSE III

GENTLEMEN,

IT is not easy to speak with propriety to so many Students of different ages and different degrees of advancement. The mind requires nourishment adapted to its growth; and what may have promoted our earlier efforts, might retard us in our nearer approaches to perfection.

THE first endeavours of a young Painter, as I have remarked in a [5] former discourse, must be employed in the attainment of mechanical dexterity, and confined to the mere imitation of the object before him. Those who have advanced beyond the rudiments, may, perhaps, find advantage in reflecting on the advice which I have likewise given them, when I recommended the diligent study of the works of our [10] great predecessors; but I at the same time endeavoured to guard them against an implicit submission to the authority of any one master however excellent; or by a strict imitation of his manner, precluding themselves from the abundance and variety of Nature. I will now add that Nature herself is not to be too closely copied. There are excellencies [15] in the art of painting beyond what is commonly called the imitation of nature: and these excellencies I wish to point out. The students who, having passed through the initiatory exercises, are more advanced in the art, and who, sure of their hand, have leisure to exert their understanding, must now be told, that a mere copier of nature can never [20] produce any thing great; can never raise and enlarge the conceptions, or warm the heart of the spectator.

13-14 78S manner, to preclude ourselves 13-14 70 manner. I will now from

5-7 See I, 183-185 and II, 18 ff.

14 For an analysis of Reynolds' use of the word "Nature" and a discussion of previous comment on the subject see Walter J. Hipple, Jr., "General and Particular in the *Discourses* of Sir Joshua Reynolds," *The Journal of Aesthetics and Art Criticism*, XI (1953), 231-247.

THE wish of the genuine painter must be more extensive: instead of endeavouring to amuse mankind with the minute neatness of his imitations, he must endeavour to improve them by the grandeur of his ideas; instead of seeking praise, by deceiving the superficial sense of the spectator, he must strive for fame, by captivating the imagination.

THE principle now laid down, that the perfection of this art does not consist in mere imitation, is far from being new or singular. It is, indeed, supported by the general opinion of the enlightened part of mankind. The poets, orators, and rhetoricians of antiquity, are continually enforcing this position; that all the arts receive their perfection from an ideal beauty, superior to what is to be found in individual nature. They are ever referring to the practice of the painters and sculptors of their times, particularly Phidias, (the favourite artist of antiquity,) to illustrate their assertions. As if they could not sufficiently express their admiration of his genius by what they knew, they have recourse to poetical enthusiasm. They call it inspiration; a gift from heaven. The artist is supposed to have ascended the celestial regions, to furnish his mind with this perfect idea of beauty. "He," says Proclus*, "who takes for his model such forms as nature pro-"duces, and confines himself to an exact imitation of them, will never "attain to what is perfectly beautiful. For the works of nature are full "of disproportion, and fall very short of the true standard of beauty. "So that Phidias, when he formed his Jupiter, did not copy any object "ever presented to his sight; but contemplated only that image which "he had conceived in his mind from Homer's description." And thus Cicero, speaking of the same Phidias: "Neither did this artist," says he, "when he carved the image of Jupiter or Minerva, set before him any

*Lib. 2, in Timæum Platonis, as cited by Junius de Pictura Veterum.

40-47 Junius, p. 19: "Likewise he that maketh any thing after the example of things generated, shall never, as long namely as he doth fix his eyes upon them, attaine to what is perfectly beautifull; seeing the things generated are full of deformed disproportions, and far remoted from the principall true beautie. Hence it is that Phidias, when he made Jupiter, did not cast his eyes upon any thing generated, but he fetched the patterne of his worke out of a Jupiter conceived after Homers description."

48-53 Junius, p. 20: "Neither did that same Artificer, when he made the images of Jupiter and Minerva, fixe his eyes upon one after whom he should draw such a similitude; but there did abide in his minde an exquisite forme of beautie, upon the which he staring, directed both his Art and his hand to the similitude of the same."

49 Phidias created a large seated image of Zeus (Jupiter) for the Temple of Zeus at Olympia and a large standing Athena (Minerva) for the Parthenon. The two statues are known only through small copies.

"one human figure, as a pattern, which he was to copy; but having a ⁵⁰
"more perfect idea of beauty fixed in his mind, this he steadily con-
"templated, and to the imitation of this all his skill and labour were
"directed."

The Moderns are not less convinced than the Ancients of this supe-
rior power existing in the art; nor less sensible of its effects. Every lan- ⁵⁵
guage has adopted terms expressive of this excellence. The *gusto grande*
of the Italians, the *beau ideal* of the French, and the *great style, genius,*
and *taste* among the English, are but different appellations of the same
thing. It is this intellectual dignity, they say, that ennobles the painter's
art; that lays the line between him and the mere mechanick; and pro- ⁶⁰
duces those great effects in an instant, which eloquence and poetry,
by slow and repeated efforts, are scarcely able to attain.

Such is the warmth with which both the Ancients and Moderns
speak of this divine principle of the art; but, as I have formerly
observed, enthusiastick admiration seldom promotes knowledge. ⁶⁵
Though a student by such praise may have his attention roused, and
a desire excited, of running in this great career; yet it is possible that
what has been said to excite, may only serve to deter him. He exam-
ines his own mind, and perceives there nothing of that divine inspira-
tion, with which, he is told, so many others have been favoured. He ⁷⁰
never travelled to heaven to gather new ideas; and he finds himself
possessed of no other qualifications than what mere common observa-
tion and a plain understanding can confer. Thus he becomes gloomy
amidst the splendour of figurative declamation, and thinks it hopeless,
to pursue an object which he supposes out of the reach of human ⁷⁵
industry.

But on this, as upon many other occasions, we ought to distinguish
how much is to be given to enthusiasm, and how much to reason. We
ought to allow for, and we ought to commend, that strength of vivid
expression, which is necessary to convey, in its full force, the highest ⁸⁰
sense of the most complete effect of art; taking care at the same time,
not to lose in terms of vague admiration, that solidity and truth of
principle, upon which alone we can reason, and may be enabled to
practise.

It is not easy to define in what this great style consists; nor to ⁸⁵

55 70 and 78S less conscious of 72-73 70 common sense and
64 70 this divine art

43

describe, by words, the proper means of acquiring it, if the mind of the student should be at all capable of such an acquisition. Could we teach taste or genius by rules, they would be no longer taste and genius. But though there neither are, nor can be, any precise invariable rules for the exercise, or the acquisition, of these great qualities, yet we may truly say that they always operate in proportion to our attention in observing the works of nature, to our skill in selecting, and to our care in digesting, methodizing, and comparing our observations. There are many beauties in our art, that seem, at first, to lie without the reach of precept, and yet may easily be reduced to practical principles. Experience is all in all; but it is not every one who profits by experience; and most people err, not so much from want of capacity to find their object, as from not knowing what object to pursue. This great ideal perfection and beauty are not to be sought in the heavens, but upon the earth. They are about us, and upon every side of us. But the power of discovering what is deformed in nature, or in other words, what is particular and uncommon, can be acquired only by experience; and the whole beauty and grandeur of the art consists, in my opinion, in being able to get above all singular forms, local customs, particularities, and details of every kind.

ALL the objects which are exhibited to our view by nature, upon close examination will be found to have their blemishes and defects. The most beautiful forms have something about them like weakness, minuteness, or imperfection. But it is not every eye that perceives these blemishes. It must be an eye long used to the contemplation and comparison of these forms; and which, by a long habit of observing what any set of objects of the same kind have in common, has acquired the power of discerning what each wants in particular. This long laborious comparison should be the first study of the painter, who aims at the greatest style. By this means, he acquires a just idea of beautiful forms; he corrects nature by herself, her imperfect state by her more perfect. His eye being enabled to distinguish the accidental deficiencies, excrescences, and deformities of things, from their general figures, he makes out an abstract idea of their forms more perfect than any one original; and what may seem a paradox, he learns to design naturally by drawing his figures unlike to any one object. This idea of the perfect state of

nature, which the Artist calls the Ideal Beauty, is the great leading principle, by which works of genius are conducted. By this Phidias acquired his fame. He wrought upon a sober principle, what has so much excited the enthusiasm of the world; and by this method you, who have courage to tread the same path, may acquire equal reputation.

THIS is the idea which has acquired, and which seems to have a right to the epithet of *divine*; as it may be said to preside, like a supreme judge, over all the productions of nature; appearing to be possessed of the will and intention of the Creator, as far as they regard the external form of living beings. When a man once possesses this idea in its perfection, there is no danger, but that he will be sufficiently warmed by it himself, and be able to warm and ravish every one else.

THUS it is from a reiterated experience, and a close comparison of the objects in nature, that an artist becomes possessed of the idea of that central form, if I may so express it, from which every deviation is deformity. But the investigation of this form, I grant, is painful, and I know but of one method of shortening the road; this is, by a careful study of the works of the ancient sculptors; who, being indefatigable in the school of nature, have left models of that perfect form behind them, which an artist would prefer as supremely beautiful, who had spent his whole life in that single contemplation. But if industry carried them thus far, may not you also hope for the same reward from the same labour? We have the same school opened to us, that was opened to them; for nature denies her instructions to none, who desire to become her pupils.

THIS laborious investigation, I am aware, must appear superfluous to those who think every thing is to be done by felicity, and the powers

146-171 70 and 78S her pupils.
To the principle
[two paragraphs not present in 70 and 78S]

136 The ideal as the average or "central" form was set forth by Reynolds in the "Idler," No. 82 (Nov. 10, 1759), in *Works*, II, 235-243. For a closely related concept see Adam Smith, *The Theory of Moral Sentiments* (London, 1759), p. 380 (Pt. V, Sec. 1).

136-137 Dixon Wecter in an unpublished dissertation for Yale has pointed out a relation to Edmund Burke, *A Philosophical Enquiry . . . of the Sublime and Beautiful* (London, 1757), Pt. III, Sec. v: "For *deformity* is opposed, not to beauty, but to the *compleat, common form*."

147-170 It is important that Reynolds should late in life introduce these two paragraphs, which reiterate and emphasize his conviction that beauty and hence the creation of pleasure through painting depend on rule and reason. Some critics contend that the emphasis in the later discourses shifts away from "reason" toward "feeling." See Walter J. Bate, *From Classic to Romantic* (Cambridge, [Mass.], 1946), p. 81.

of native genius. Even the great Bacon treats with ridicule the idea of
150 confining proportion to rules, or of producing beauty by selection.
"A man cannot tell," says he, "whether Apelles or Albert Durer were
"the more trifler: whereof the one would make a personage by geo-
"metrical proportions; the other, by taking the best parts out of divers
"faces, to make one excellent. The painter, (he adds,) must do it
155 "by a kind of felicity, . . . and not by rule*."

IT is not safe to question any opinion of so great a writer, and so
profound a thinker, as undoubtedly Bacon was. But he studies brevity
to excess; and therefore his meaning is sometimes doubtful. If he
means that beauty has nothing to do with rule, he is mistaken. There
160 is a rule, obtained out of general nature, to contradict which is to fall
into deformity. Whenever any thing is done beyond this rule, it is
in virtue of some other rule which is followed along with it, but which
does not contradict it. Every thing which is wrought with certainty,
is wrought upon some principle. If it is not, it cannot be repeated. If
165 by felicity is meant any thing of chance or hazard, or something born
with a man, and not earned, I cannot agree with this great philoso-
pher. Every object which pleases must give us pleasure upon some cer-
tain principles; but as the objects of pleasure are almost infinite, so
their principles vary without end, and every man finds them out, not
170 by felicity or successful hazard, but by care and sagacity.

To the principle I have laid down, that the idea of beauty in each
species of beings is an invariable one, it may be objected, that in every
particular species there are various central forms, which are separate
and distinct from each other, and yet are undeniably beautiful; that
175 in the human figure, for instance, the beauty of Hercules is one, of the

*ESSAYS, p. 252, edit. 1625.

172 70 and 78S is invariably one 175 70 and 78S of the Hercules
172-173 70 in every species there

155n Francis Bacon, "Of Beauty," The Essays, ed. Samuel H. Reynolds (Oxford, 1890),
p. 304.

157-158 Reynolds alludes to Horace Ars poetica, ll. 25-26:
 brevis esse laboro,
 obscurus fio;

175-176 The "Hercules" to which Reynolds refers is probably the so-called "Farnese Her-
cules" now in Naples. The "Apollo" is, of course, the "Apollo Belvedere" in the Vatican. The
"Gladiator," because of the later reference to his "activity" (III, 193), is probably the "Borghese
Warrior" now in the Louvre (see also XII, 189). The "Dying Gaul" in the Capitoline Museum,
Rome, was also called the "Gladiator" in the 18th century (see Settimo Bocconi, The Capitoline
Collections [Rome, 1950], p. 181).

Gladiator another, of the Apollo another; which makes so many *Plate III* different ideas of beauty.

It is true, indeed, that these figures are each perfect in their kind, though of different characters and proportions; but still none of them is the representation of an individual, but of a class. And as there is 180 one general form, which, as I have said, belongs to the human kind at large, so in each of these classes there is one common idea and central form, which is the abstract of the various individual forms belonging to that class. Thus, though the forms of childhood and age differ exceedingly, there is a common form in childhood, and a common 185 form in age, which is the more perfect, as it is more remote from all peculiarities. But I must add further, that though the most perfect forms of each of the general divisions of the human figure are ideal, and superior to any individual form of that class; yet the highest perfection of the human figure is not to be found in any one of them. It 190 is not in the Hercules, nor in the Gladiator, nor in the Apollo; but in that form which is taken from them all, and which partakes equally of the activity of the Gladiator, of the delicacy of the Apollo, and of the muscular strength of the Hercules. For perfect beauty in any species must combine all the characters which are beautiful in that 195 species. It cannot consist in any one to the exclusion of the rest: no one, therefore, must be predominant, that no one may be deficient.

The knowledge of these different characters, and the power of separating and distinguishing them, is undoubtedly necessary to the painter, who is to vary his compositions with figures of various forms and pro- 200 portions, though he is never to lose sight of the general idea of perfection in each kind.

There is, likewise, a kind of symmetry, or proportion, which may properly be said to belong to deformity. A figure lean or corpulent, tall or short, though deviating from beauty, may still have a certain 205 union of the various parts, which may contribute to make them on the whole not unpleasing.

When the Artist has by diligent attention acquired a clear and distinct idea of beauty and symmetry; when he has reduced the variety of nature to the abstract idea; his next task will be to become acquainted 210 with the genuine habits of nature, as distinguished from those of fashion. For in the same manner, and on the same principles, as he has

179 70 still neither of them 192 70 is compounded of them

47

acquired the knowledge of the real forms of nature, distinct from accidental deformity, he must endeavour to separate simple chaste
215 nature, from those adventitious, those affected and forced airs or actions, with which she is loaded by modern education.

PERHAPS I cannot better explain what I mean, than by reminding you of what was taught us by the Professor of Anatomy, in respect to the natural position and movement of the feet. He observed that the
220 fashion of turning them outwards was contrary to the intent of nature, as might be seen from the structure of the bones, and from the weakness that proceeded from that manner of standing. To this we may add the erect position of the head, the projection of the chest, the walking with straight knees, and many such actions, which we know to be
225 merely the result of fashion, and what nature never warranted, as we are sure that we have been taught them when children.

I HAVE mentioned but a few of those instances, in which vanity or caprice have contrived to distort and disfigure the human form; your own recollection will add to these a thousand more of ill-understood
230 methods, which have been practised to disguise nature, among our dancing-masters, hair-dressers, and tailors, in their various schools of deformity*.

HOWEVER the mechanick and ornamental arts may sacrifice to fashion, she must be entirely excluded from the Art of Painting; the painter
235 must never mistake this capricious changeling for the genuine offspring of nature; he must divest himself of all prejudices in favour of his age

"*Those," says Quintilian, "who are taken with the outward shew of things, "think that there is more beauty in persons, who are trimmed, curled, and "painted, than uncorrupt nature can give; as if beauty were merely the effect of "the corruption of manners."

217 97 cannnot 230 70 and 78S methods, that have
224-225 70 and 78S which are merely

218 The professor of anatomy in 1770 was Dr. William Hunter.

232n See Junius, p. 287: "Those who are taken with an outward shew of things, saith Quintilian, judge sometimes that there is more beautie in them which are polled, shaved, smoothed, curled, and painted, than incorrupt Nature can give unto them: even as if pulchritude did proceed out of the corruption of manners."

236-239 E. M. S. Thompson draws attention to the verbal similarity between this passage and one in Samuel Johnson's *Rasselas* (London, 1759), Ch. x: "He [the poet] must divest himself of the prejudices of his age and country; he must consider right and wrong in their abstracted and invariable state; he must disregard present laws and opinions, and rise to general and transcendental truths, which will always be the same" ("The *Discourses* of Sir Joshua Reynolds," *PMLA*, XXXII [1917], 352).

or country; he must disregard all local and temporary ornaments, and look only on those general habits which are every where and always the same. He addresses his works to the people of every country and every age; he calls upon posterity to be his spectators, and says with Zeuxis, *in æternitatem pingo*. 240

THE neglect of separating modern fashions from the habits of nature, leads to that ridiculous style which has been practised by some painters, who have given to Grecian Heroes the airs and graces practised in the court of Lewis the Fourteenth; an absurdity almost as great as it would 245 have been to have dressed them after the fashion of that court.

To avoid this error, however, and to retain the true simplicity of nature, is a task more difficult than at first sight it may appear. The prejudices in favour of the fashions and customs that we have been used to, and which are justly called a second nature, make it too often diffi- 250 cult to distinguish that which is natural, from that which is the result of education; they frequently even give a predilection in favour of the artificial mode; and almost every one is apt to be guided by those local prejudices, who has not chastised his mind, and regulated the instability of his affections by the eternal invariable idea of nature. 255

HERE then, as before, we must have recourse to the Ancients as instructors. It is from a careful study of their works that you will be enabled to attain to the real simplicity of nature; they will suggest many observations, which would probably escape you, if your study were confined to nature alone. And, indeed, I cannot help suspecting, that in 260 this instance the ancients had an easier task than the moderns. They had, probably, little or nothing to unlearn, as their manners were nearly approaching to this desirable simplicity; while the modern artist, before he can see the truth of things, is obliged to remove a veil, with which the fashion of the times has thought proper to cover her. 265

HAVING gone thus far in our investigation of the great stile in painting; if we now should suppose that the artist has formed the true idea of beauty, which enables him to give his works a correct and perfect design; if we should suppose also, that he has acquired a knowledge of the unadulterated habits of nature, which gives him simplicity; the rest 270 of his task is, perhaps, less than is generally imagined. Beauty and sim-

238 70 and 78S habits that are

241 Hilles (*Literary Career*, p. 108) traces the Latin phrase to Steele in the *Spectator*, No. 52.

plicity have so great a share in the composition of a great stile, that he who has acquired them has little else to learn. It must not, indeed, be forgotten, that there is a nobleness of conception, which goes beyond any thing in the mere exhibition even of perfect form; there is an art of animating and dignifying the figures with intellectual grandeur, of impressing the appearance of philosophick wisdom, or heroick virtue. This can only be acquired by him that enlarges the sphere of his understanding by a variety of knowledge, and warms his imagination with the best productions of antient and modern poetry.

A HAND thus exercised, and a mind thus instructed, will bring the art to an higher degree of excellence than, perhaps, it has hitherto attained in this country. Such a student will disdain the humbler walks of painting, which, however profitable, can never assure him a permanent reputation. He will leave the meaner artist servilely to suppose that those are the best pictures, which are most likely to deceive the spectator. He will permit the lower painter, like the florist or collector of shells, to exhibit the minute discriminations, which distinguish one object of the same species from another; while he, like the philosopher, will consider nature in the abstract, and represent in every one of his figures the character of its species.

IF deceiving the eye were the only business of the art, there is no doubt, indeed, but the minute painter would be more apt to succeed: but it is not the eye, it is the mind, which the painter of genius desires to address; nor will he waste a moment upon those smaller objects, which only serve to catch the sense, to divide the attention, and to counteract his great design of speaking to the heart.

THIS is the ambition which I wish to excite in your minds; and the object I have had in my view, throughout this discourse, is that one great idea, which gives to painting its true dignity, which entitles it to the name of a Liberal Art, and ranks it as a sister of poetry.

273-274　70 and 78S　be forgot, that

295　70 and 78S　upon these smaller

298　70 and 78S　ambition I could wish to

300　70　idea of the Art, which gives it its true dignity, that entitles

300　78S　dignity, that entitles

287-291　Thompson (p. 352) notes a verbal similarity to Johnson's *Rasselas*, Ch. x: "'The business of a poet', said Imlac, 'is to examine, not the individual, but the species; to remark general properties and large appearances. He does not number the streaks of the tulip, or describe the different shades in the verdure of the forest; he is to exhibit in his portraits of nature such prominent and striking features, as recall the original to every mind; and must neglect the minuter discriminations. . .'"

It may possibly have happened to many young students, whose application was sufficient to overcome all difficulties, and whose minds were capable of embracing the most extensive views, that they have, by a wrong direction originally given, spent their lives in the meaner walks of painting, without ever knowing there was a nobler to pursue. Albert Durer, as Vasari has justly remarked, would, probably, have been one of the first painters of his age, (and he lived in an era of great artists,) had he been initiated into those great principles of the art, which were so well understood and practised by his contemporaries in Italy. But unluckily having never seen or heard of any other manner, he, without doubt, considered his own as perfect.

As for the various departments of painting, which do not presume to make such high pretensions, they are many. None of them are without their merit, though none enter into competition with this universal presiding idea of the art. The painters who have applied themselves more particularly to low and vulgar characters, and who express with precision the various shades of passion, as they are exhibited by vulgar minds, (such as we see in the works of Hogarth,) deserve great praise; but as their genius has been employed on low and confined subjects, the praise which we give must be as limited as its object. The merry-making, or quarrelling, of the Boors of Teniers; the same sort of productions of Brouwer, or Ostade, are excellent in their kind; and the excellence and its praise will be in proportion, as, in those limited subjects, and peculiar forms, they introduce more or less of the expression of those passions, as they appear in general and more enlarged nature. This principle may be applied to the Battle-pieces of Bourgognone, the French Gallantries of Watteau, and even beyond the exhibition of animal life, to the Land-

311-312 70 and 78S he considered his own, without doubt, as

313 70 of the Art, which

315 70 and 78S this great universal

321 70 and 78S praise that we

323-330 70 kind. So likewise are the French gallantries of Watteau; the landscapes of Claude Lorraine; the sea-pieces of Vandervelde; the battles of Burgognone; and the views of Cannaletti. All these

307-312 For Vasari on Dürer see the life of Marcantonio: "It is indeed certain that if this man, so highly endowed, so assiduous and so varied in his powers, had been a native of Tuscany instead of Flanders, had he been in a position which permitted him to study the treasures of Rome, as we are able to do, he would have been the best painter of our country, as he was the best and most renowned that has ever appeared among the Flemings" (III, 490). Actually, Dürer did visit Italy twice, but he did not go as far south as Rome. He certainly knew and admired the work of many of his Italian contemporaries through prints after their paintings.

327 Jacques Courtois, le Bourguignon, ca. 1628-ca. 1679.

scapes of Claude Lorraine, and the Sea-Views of Vandervelde. All these painters have, in general, the same right, in different degrees, to the name of a painter, which a satirist, an epigrammatist, a sonneteer, a writer of pastorals, or descriptive poetry, has to that of a poet.

IN the same rank, and perhaps of not so great merit, is the cold painter of portraits. But his correct and just imitation of his object has its merit. Even the painter of still life, whose highest ambition is to give a minute representation of every part of those low objects which he sets before him, deserves praise in proportion to his attainment; because no part of this excellent art, so much the ornament of polished life, is destitute of value and use. These, however, are by no means the views to which the mind of the student ought to be *primarily* directed. Having begun by aiming at better things, if from particular inclination, or from the taste of the time and place he lives in, or from necessity, or from failure in the highest attempts, he is obliged to descend lower, he will bring into the lower sphere of art a grandeur of composition and character, that will raise and ennoble his works far above their natural rank.

A MAN is not weak, though he may not be able to wield the club of Hercules; nor does a man always practise that which he esteems the best; but does that which he can best do. In moderate attempts, there are many walks open to the artist. But as the idea of beauty is of necessity but one, so there can be but one great mode of painting; the leading principle of which I have endeavoured to explain.

I SHOULD be sorry, if what is here recommended, should be at all understood to countenance a careless or indetermined manner of painting. For though the painter is to overlook the accidental discriminations of nature, he is to exhibit distinctly, and with precision, the general forms of things. A firm and determined outline is one of the characteristics of the great style in painting; and let me add, that he who possesses the knowledge of the exact form which every part of nature ought to have, will be fond of expressing that knowledge with correctness and precision in all his works.

340-341 70 and 78S directed. By aiming 359 70 and 78S form, that every
356 70 and 78S to pronounce distinctly

329 Of the many painters bearing the name Vandervelde, Reynolds probably means the seascapist Willem van der Velde II (1633-1707), who accompanied his father to England in the 1670's.

To conclude; I have endeavoured to reduce the idea of beauty to general principles: and I had the pleasure to observe that the Professor of painting proceeded in the same method, when he shewed you that the artifice of contrast was founded but on one principle. I am convinced that this is the only means of advancing science, of clearing the mind from a confused heap of contradictory observations, that do but perplex and puzzle the student, when he compares them, or misguide him if he gives himself up to their authority: bringing them under one general head, can alone give rest and satisfaction to an inquisitive mind.

365

370

365 70 and 78S principle. And I 369 70 and 78S authority; but bringing

363-364 The professor of painting in 1770 was Edward Penny, who held the office until 1783. His lectures do not survive in published form.

DISCOURSE IV

Delivered to the Students of The Royal Academy,

on the Distribution of the Prizes,

December 10, 1771

DISCOURSE IV

GENTLEMEN,

THE value and rank of every art is in proportion to the mental labour employed in it, or the mental pleasure produced by it. As this principle is observed or neglected, our profession becomes either a liberal art, or a mechanical trade. In the hands of one man it makes the highest pretensions, as it is addressed to the noblest faculties: in those of another it is reduced to a mere matter of ornament; and the painter has but the humble province of furnishing our apartments with elegance.

THIS exertion of mind, which is the only circumstance that truly ennobles our Art, makes the great distinction between the Roman and Venetian schools. I have formerly observed, that perfect form is produced by leaving out particularities, and retaining only general ideas: I shall now endeavour to shew that this principle, which I have proved to be metaphysically just, extends itself to every part of the Art; that it gives what is called the *grand style*, to Invention, to Composition, to Expression, and even to Colouring and Drapery.

INVENTION in Painting does not imply the invention of the subject; for that is commonly supplied by the Poet or Historian. With respect to the choice, no subject can be proper that is not generally interesting. It ought to be either some eminent instance of heroick action, or heroick suffering. There must be something either in the action, or in the object, in which men are universally concerned, and which powerfully strikes upon the publick sympathy.

STRICTLY speaking, indeed, no subject can be of universal, hardly can it be of general, concern; but there are events and characters so popularly known in those countries where our Art is in request, that

11 71 schools, and gives the superiority to the Painter of History over all others of our profession. No part of his work is produced but by an effort of the mind; there is no object which he can set before him as a perfect model; there is none which he can venture minutely to imitate, and to transfer with all its beauties and blemishes into his great design.
 I have

20 71 heroic virtue, or

they may be considered as sufficiently general for all our purposes. Such are the great events of Greek and Roman fable and history, which early education, and the usual course of reading, have made familiar and interesting to all Europe, without being degraded by the vulgarism of ordinary life in any country. Such too are the capital subjects of scripture history, which, besides their general notoriety, become venerable by their connection with our religion.

As it is required that the subject selected should be a general one, it is no less necessary that it should be kept unembarrassed with whatever may any way serve to divide the attention of the spectator. Whenever a story is related, every man forms a picture in his mind of the action and expression of the persons employed. The power of representing this mental picture on canvass is what we call Invention in a Painter. And as in the conception of this ideal picture, the mind does not enter into the minute peculiarities of the dress, furniture, or scene of action; so when the Painter comes to represent it, he contrives those little necessary concomitant circumstances in such a manner, that they shall strike the spectator no more than they did himself in his first conception of the story.

I AM very ready to allow that some circumstances of minuteness and particularity frequently tend to give an air of truth to a piece, and to interest the spectator in an extraordinary manner. Such circumsances therefore cannot wholly be rejected: but if there be any thing in the Art which requires peculiar nicety of discernment, it is the disposition of these minute circumstantial parts; which, according to the judgement employed in the choice, become so useful to truth, or so injurious to grandeur.

HOWEVER, the usual and most dangerous error is on the side of minuteness; and therefore I think caution most necessary where most have failed. The general idea constitutes real excellence. All smaller things, however perfect in their way, are to be sacrificed without mercy to the greater. The Painter will not enquire what things may be admitted without much censure: he will not think it enough to shew that they may be there; he will shew that they must be there; that their absence would render his picture maimed and defective.

THUS, though to the principal group a second or third be added, and a second and third mass of light, care must be yet taken that these

32	98	which, beside their	
38	71 and 78S	and the expression	
39	71 and 78S	picture in canvass	
44	71	did him in	

subordinate actions and lights, neither each in particular, nor all to- 65
gether, come into any degree of competition with the principal; they
should merely make a part of that whole which would be imperfect
without them. To every kind of painting this rule may be applied.
Even in portraits, the grace, and, we may add, the likeness, consists
more in taking the general air, than in observing the exact similitude
of every feature. 70

THUS figures must have a ground whereon to stand; they must be
cloathed; there must be a back-ground; there must be light and shadow:
but none of these ought to appear to have taken up any part of the
artist's attention. They should be so managed as not even to catch that
of the spectator. We know well enough, when we analyze a piece, 75
the difficulty and the subtilty with which an artist adjusts the back-
ground, drapery, and masses of light; we know that a considerable part
of the grace and effect of his picture depends upon them; but this art
is so much concealed, even to a judicious eye, that no remains of any
of these subordinate parts occur to the memory when the picture is 80
not present.

THE great end of the art is to strike the imagination. The Painter is
therefore to make no ostentation of the means by which this is done;
the spectator is only to feel the result in his bosom. An inferior artist
is unwilling that any part of his industry should be lost upon the spec- 85
tator. He takes as much pains to discover, as the greater artist does to
conceal, the marks of his subordinate assiduity. In works of the lower
kind, every thing appears studied, and encumbered; it is all boastful
art, and open affectation. The ignorant often part from such pictures
with wonder in their mouths, and indifference in their hearts. 90

BUT it is not enough in Invention that the Artist should restrain and
keep under all the inferior parts of his subject; he must sometimes
deviate from vulgar and strict historical truth, in pursuing the grandeur
of his design.

How much the great stile exacts from its professors to conceive and 95
represent their subjects in a poetical manner, not confined to mere
matter of fact, may be seen in the Cartoons of RAFFAELLE. In all the *Plate IV*

66 71 and 78S should make 82-83 98 Painter therefore is to make
67 71 and 78S every part of

97 The cartoons of Raphael, to which Reynolds refers so often, were full-scale designs for
tapestries. The cartoons themselves were executed by Raphael's pupils after designs by the
master. Seven of the original set of ten are now in the Victoria and Albert Museum. The other

pictures in which the painter has represented the apostles, he has drawn
them with great nobleness; he has given them as much dignity as the
human figure is capable of receiving; yet we are expressly told in scrip-
ture they had no such respectable appearance; and of St. Paul in par-
ticular, we are told by himself, that his *bodily* presence was *mean*.
Alexander is said to have been of a low stature: a Painter ought not so
to represent him. Agesilaus was low, lame, and of a mean appearance:
none of these defects ought to appear in a piece of which he is the
hero. In conformity to custom, I call this part of the art History Paint-
ing; it ought to be called Poetical, as in reality it is.

ALL this is not falsifying any fact; it is taking an allowed poetical
licence. A painter of portraits retains the individual likeness; a painter
of history shews the man by shewing his actions. A Painter must com-
pensate the natural deficiencies of his art. He has but one sentence to
utter, but one moment to exhibit. He cannot, like the poet or histo-
rian, expatiate, and impress the mind with great veneration for the
character of the hero or saint he represents, though he lets us know at
the same time, that the saint was deformed, or the hero lame. The
Painter has no other means of giving an idea of the dignity of the
mind, but by that external appearance which grandeur of thought
does generally, though not always, impress on the countenance; and
by that correspondence of figure to sentiment and situation, which all
men wish, but cannot command. The Painter, who may in this one
particular attain with ease what others desire in vain, ought to give all
that he possibly can, since there are so many circumstances of true
greatness that he cannot give at all. He cannot make his hero talk like
a great man; he must make him look like one. For which reason, he
ought to be well studied in the analysis of those circumstances, which
constitute dignity of appearance in real life.

As in Invention, so likewise in Expression, care must be taken not
to run into particularities. Those expressions alone should be given to

three cartoons have been lost, and the designs are known only through the tapestries woven
from them. The surviving ones were acquired by Charles I, and they have remained in Eng-
land ever since. During the 18th century they were at Hampton Court until 1763. From 1763 to
1787 they were in the "great saloon" at Buckingham House. During the last years of the 18th
century they were at Windsor. See John Pope-Hennessy, *The Raphael Cartoons* (London,
1950).

102 II Cor. x. 9-10: "That I may not seem as if I would terrify you by letters. For his let-
ters, say they, are weighty and powerful; but his bodily presence is weak, and his speech
contemptible."

the figures which their respective situations generally produce. Nor
is this enough; each person should also have that expression which men 130
of his rank generally exhibit. The joy, or the grief of a character of
dignity, is not to be expressed in the same manner as a similar passion
in a vulgar face. Upon this principle, Bernini, perhaps, may be subject
to censure. This sculptor, in many respects admirable, has given a very
mean expression to his statue of David, who is represented as just go- *Plate VI*
ing to throw the stone from the sling; and in order to give it the expres-
sion of energy, he has made him biting his under-lip. This expression
is far from being general, and still farther from being dignified. He
might have seen it in an instance or two; and he mistook accident for
generality. 140

WITH respect to Colouring, though it may appear at first a part of
painting merely mechanical, yet it still has its rules, and those grounded
upon that presiding principle which regulates both the great and the
little in the study of a Painter. By this, the first effect of the picture is
produced; and as this is performed, the spectator as he walks the gal- 145
lery, will stop, or pass along. To give a general air of grandeur at first
view, all trifling or artful play of little lights, or an attention to a vari-
ety of tints is to be avoided; a quietness and simplicity must reign over
the whole work; to which a breadth of uniform, and simple colour,
will very much contribute. Grandeur of effect is produced by two dif- 150
ferent ways, which seem entirely opposed to each other. One is, by
reducing the colours to little more than chiaro oscuro, which was often
the practice of the Bolognian schools; and the other, by making the
colours very distinct and forcible, such as we see in those of Rome and
Florence; but still, the presiding principle of both those manners is 155
simplicity. Certainly, nothing can be more simple than monotony; and
the distinct blue, red, and yellow colours which are seen in the dra-
peries of the Roman and Florentine schools, though they have not that
kind of harmony which is produced by a variety of broken and trans-
parent colours, have that effect of grandeur which was intended. Per- 160

139-141 71 and 78S accident for univer- 160 71 and 78S grandeur that was
sality.
With respect

133-135 G. L. Bernini (1598-1680) was the greatest sculptor of the 17th century. "David" is
an early work (1623) and is now in the Borghese Gallery, Rome. See Rudolf Wittkower, *Gian
Lorenzo Bernini* (London, 1955), Pls. 13, 23, 25, 27. Reynolds himself acquired on speculation
in the mid-1780's a major example of Bernini's sculpture, "Neptune and Triton," which is close
in date and conception to "David." It is now in the Victoria and Albert Museum. See X, 258.

haps these distinct colours strike the mind more forcibly, from there not being any great union between them; as martial musick, which is intended to rouse the nobler passions, has its effect from the sudden and strongly marked transitions from one note to another, which that style of musick requires; whilst in that which is intended to move the softer passions, the notes imperceptibly melt into one another.

In the same manner as the historical Painter never enters into the detail of colours, so neither does he debase his conceptions with minute attention to the discriminations of Drapery. It is the inferior stile that marks the variety of stuffs. With him, the cloathing is neither woollen, nor linen, nor silk, sattin, or velvet: it is drapery; it is nothing more. The art of disposing the foldings of the drapery make a very considerable part of the painter's study. To make it merely natural is a mechanical operation, to which neither genius or taste are required; whereas, it requires the nicest judgement to dispose the drapery, so that the folds shall have an easy communication, and gracefully follow each other, with such natural negligence as to look like the effect of chance, and at the same time shew the figure under it to the utmost advantage.

Carlo Maratti was of opinion, that the disposition of drapery was a more difficult art than even that of drawing the human figure; that a Student might be more easily taught the latter than the former; as the rules of drapery, he said, could not be so well ascertained as those for delineating a correct form. This, perhaps, is a proof how willingly we favour our own peculiar excellence. Carlo Maratti is said to have valued himself particularly upon his skill in this part of his art; yet in him, the disposition appears so ostentatiously artificial, that he is inferior to Raffaelle, even in that which gave him his best claim to reputation.

Such is the great principle by which we must be directed in the nobler branches of our art. Upon this principle, the Roman, the Florentine, the Bolognese schools, have formed their practice; and by this they have deservedly obtained the highest praise. These are the three great schools of the world in the epick stile. The best of the French

165	71 and 78S	whilst that
172	98	drapery makes a very

176	71 and 78S	folds have
186	71 and 78S	so artificial

179 Carlo Maratti (1625-1713) is referred to frequently by Reynolds, usually as an example of the successful, but pedestrian, academic artist. The modern judgment is much the same. See V, 276-285; VI, 406-418; VIII, 423-427.

school, Poussin, Le Sueur, and Le Brun, have formed themselves upon
these models, and consequently may be said, though Frenchmen, to
be a colony from the Roman school. Next to these, but in a very dif-
ferent stile of excellence, we may rank the Venetian, together with the
Flemish and the Dutch schools; all professing to depart from the great
purposes of painting, and catching at applause by inferior qualities.

I AM not ignorant that some will censure me for placing the Vene-
tians in this inferior class, and many of the warmest admirers of paint-
ing will think them unjustly degraded; but I wish not to be misunder-
stood. Though I can by no means allow them to hold any rank with
the nobler schools of painting, they accomplished perfectly the thing
they attempted. But as mere elegance is their principal object, as they
seem more willing to dazzle than to affect, it can be no injury to them
to suppose that their practice is useful only to its proper end. But what
may heighten the elegant may degrade the sublime. There is a sim-
plicity, and I may add, severity, in the great manner, which is, I am
afraid, almost incompatible with this comparatively sensual style.

TINTORET, Paul Veronese, and others of the Venetian school, seem
to have painted with no other purpose than to be admired for their
skill and expertness in the mechanism of painting, and to make a parade
of that art, which as I before observed, the higher stile requires its
followers to conceal.

IN a conference of the French Academy, at which were present Le
Brun, Sebastian Bourdon, and all the eminent Artists of that age, one
of the academicians desired to have their opinion on the conduct of
Paul Veronese, who, though a Painter of great consideration, had, con-
trary to the strict rules of art, in his picture of Perseus and Andromeda,
represented the principal figure in shade. To this question no satisfac-
tory answer was then given. But I will venture to say, that if they had
considered the class of the Artist, and ranked him as an ornamental

Plate XIV
195

200

205
Plate XVI

210

215

220

207 71 end; that what 211 71 and 78S Venetian schools, seem

194-196 Poussin in particular passed nearly the whole of his active career in Rome.

216-228 Reynolds' source for this incident is not known. Louis Dimier, who tracked down
most of Reynolds' references to French literature on art, is silent about this passage (*Reynolds
Discours* [Paris, 1909]). André Félibien, in "Conférences de l'Académie Royale" (in *Entretiens
sur les vies et sur les ouvrages des plus excellens peintres* [Trévoux, 1725], V, 393 ff.), includes a
long discussion on the use of light in Veronese's "Supper at Emmaus," but this bears no relation
to Reynolds' remarks.

220 Veronese's "Perseus and Andromeda" is now in the museum at Rennes. It is reproduced
in Louis Gonse, *Les chefs-d'œuvre des musées de France* (Paris, 1900), p. 274.

Painter, there would have been no difficulty in answering—"It was
"unreasonable to expect what was never intended. His intention was
"solely to produce an effect of light and shadow; every thing was to
"be sacrificed to that intent, and the capricious composition of that
"picture suited very well with the stile which he professed."

YOUNG minds are indeed too apt to be captivated by this splendour
of stile; and that of the Venetians is particularly pleasing; for by them,
all those parts of the Art that gave pleasure to the eye or sense, have
been cultivated with care, and carried to the degree nearest to perfec-
tion. The powers exerted in the mechanical part of the Art have been
called *the language of Painters*; but we may say, that it is but poor elo-
quence which only shews that the orator can talk. Words should be
employed as the means, not as the end: language is the instrument,
conviction is the work.

THE language of Painting must indeed be allowed these masters; but
even in that, they have shewn more copiousness than choice, and more
luxuriancy than judgment. If we consider the uninteresting subjects
of their invention, or at least the uninteresting manner in which they
are treated; if we attend to their capricious composition, their violent
and affected contrasts, whether of figures or of light and shadow, the
richness of their drapery, and at the same time, the mean effect which
the discrimination of stuffs gives to their pictures; if to these we add
their total inattention to expression; and then reflect on the conceptions
and the learning of Michael Angelo, or the simplicity of Raffaelle,
we can no longer dwell on the comparison. Even in colouring, if we
compare the quietness and chastity of the Bolognese pencil to the bustle
and tumult that fills every part of a Venetian picture, without the least
attempt to interest the passions, their boasted art will appear a mere
struggle without effect; *a tale told by an ideot, full of sound and fury,
signifying nothing*.

SUCH as suppose that the great stile might happily be blended with
the ornamental, that the simple, grave and majestick dignity of Raf-
faelle could unite with the glow and bustle of a Paulo, or Tintoret, are

228 71 and 78S the stile he

229 71 minds indeed are too

230 71 and 78S Venetians will be particu-
larly

231 71 and 78S that give pleasure

252 71 and 78S effect; an empty *tale*

252-253 *Macbeth* V.v.26.

totally mistaken. The principles by which each are attained are so contrary to each other, that they seem, in my opinion, incompatible, and as impossible to exist together, as that in the mind the most sublime ideas and the lowest sensuality should at the same time be united. 260

THE subjects of the Venetian Painters are mostly such as give them an opportunity of introducing a great number of figures; such as feasts, *Plate XVI* marriages, and processions, publick martyrdoms, or miracles. I can easily conceive that Paul Veronese, if he were asked, would say, that no subject was proper for an historical picture, but such as admitted 265 at least forty figures; for in a less number, he would assert, there could be no opportunity of the Painter's shewing his art in composition, his dexterity of managing and disposing the masses of light and groups of figures, and of introducing a variety of Eastern dresses and characters in their rich stuffs. 270

BUT the thing is very different with a pupil of the greater schools. Annibal Carrache thought twelve figures sufficient for any story: he conceived that more would contribute to no end but to fill space; that they would be but cold spectators of the general action, or, to use his own expression, that they would be *figures to be let*. Besides, it is im- 275 possible for a picture composed of so many parts to have that effect so indispensably necessary to grandeur, that of one complete whole. However contradictory it may be in geometry, it is true in taste, that many little things will not make a great one. The Sublime impresses the mind at once with one great idea; it is a single blow: the Elegant 280 indeed may be produced by repetition; by an accumulation of many minute circumstances.

HOWEVER great the difference is between the composition of the Venetian, and the rest of the Italian schools, there is full as great a dis-

257 98 each is attained

259-261 71 and 78S together, as to unite in the mind at the same time the most sublime ideas, and the lowest sensuality.
 The subjects

277 71 and 78S grandeur, of

281 71 and 78S produced by a repetition

272-275 Richardson (*Works*, p. 31) speaks of Carracci using only twelve figures. De Piles also mentions the fact in "Observations on the Art of Painting," in Du Fresnoy, *The Art of Painting* (London, 1695), p. 132. The phrase "figures to be let" is also used by De Piles, p. 115. The problem of the number of figures suitable for a composition was touched on frequently by Renaissance writers on art. See Leone Battista Alberti, *On Painting*, trans. John R. Spencer (London, 1956), p. 76; also Hans Posse, *Der römische Maler Andrea Sacchi* (Leipzig, 1925), pp. 35-36.

285 parity in the effect of their pictures as produced by colours. And though in this respect the Venetians must be allowed extraordinary skill, yet even that skill, as they have employed it, will but ill correspond with the great style. Their colouring is not only too brilliant, but, I will venture to say, too harmonious, to produce that solidity,

290 steadiness, and simplicity of effect, which heroick subjects require, and which simple or grave colours only can give to a work. That they are to be cautiously studied by those who are ambitious of treading the great walk of history, is confirmed, if it wants confirmation, by the greatest of all authorities, Michael Angelo. This wonderful man, after

Plate XVII having seen a picture by Titian, told Vasari, who accompanied him*, "that he liked much his colouring and manner;" but then he added, that "it was a pity the Venetian painters did not learn to draw correctly "in their early youth, and adopt a better *manner of study*."

BY this it appears, that the principal attention of the Venetian

300 painters, in the opinion of Michael Angelo, seemed to be engrossed by the study of colours, to the neglect of the *ideal beauty of form*, or propriety of expression. But if general censure was given to that school from the sight of a picture of Titian, how much more heavily, and more justly, would the censure fall on Paulo Veronese, and more

305 especially on Tintoret? And here I cannot avoid citing Vasari's opinion of the style and manner of Tintoret. "Of all the extraordinary gen-"iusest," says he, "that have ever practised the art of painting, for wild,

*Dicendo, che molto gli piaceva il colorito suo, e la maniera; mà che era un peccato, che a Venezia non s'imparasse da principio a disegnare bene, e che non havessano que' pittori miglior modo nello studio. Vas. tom. iii. p. 226. Vita di Tiziano.

†Nelle cose della pittura, stravagante, capriccioso, presto, e resoluto, et il più terribile cervello, che habbia havuto mai la pittura, come si può vedere in tutte le sue opere; e ne' componimenti delle storie, fantastiche, e fatte da lui diversamente, e fuori dell' uso degli altri pittori: anzi hà superato la stravaganza, con le nuove,

304 71 and 78S Veronese, or more 307 98 that have practised

295-298 Reynolds makes Michelangelo appear rather less appreciative of Titian than he is in the Vasari text: "Buonarroti declared that the manner and colouring of that artist [Titian] pleased him greatly, but that it was a pity the Venetians did not study drawing more, 'for if this artist', said he, 'had been aided by Art and knowledge of design, as he is by nature, he would have produced works which none can surpass, more especially in imitating life, seeing that he has a fine genius, and a graceful animated manner'" (V, 394).

306-313 The passage comes from the life of Battista Franco (Vasari, V, 50).

"capricious, extravagant and fantastical inventions, for furious impet-
"uosity and boldness in the execution of his work, there is none like
"Tintoret; his strange whimsies are even beyond extravagance, and his 310
"works seem to be produced rather by chance, than in consequence
"of any previous design, as if he wanted to convince the world that
"the art was a trifle, and of the most easy attainment."

FOR my own part, when I speak of the Venetian painters, I wish
to be understood to mean Paulo Veronese and Tintoret, to the exclusion 315
of Titian; for though his style is not so pure as that of many other of the
Italian schools, yet there is a sort of senatorial dignity about him,
which, however aukward in his imitators, seems to become him ex-
ceedingly. His portraits alone, from the nobleness and simplicity of
character which he always gave them, will intitle him to the greatest 320
respect, as he undoubtedly stands in the first rank in this branch of
the art.

IT is not with Titian, but with the seducing qualities of the two
former, that I could wish to caution you against being too much
captivated. These are the persons who may be said to have exhausted 325
all the powers of florid eloquence, to debauch the young and unex-
perienced, and have, without doubt, been the cause of turning off
the attention of the connoisseur and of the patron of art, as well as that
of the painter, from those higher excellencies of which the art is capable,
and which ought to be required in every considerable production. By 330
them, and their imitators, a style merely ornamental has been dis-
seminated throughout all Europe. Rubens carried it to Flanders; Voet,
to France; and Luca Giordano, to Spain and Naples.

THE Venetian is indeed the most splendid of the schools of elegance;
and it is not without reason, that the best performances in this lower 335
school are valued higher than the second rate performances of those

e capricciose inventioni, e strani ghiribizzi del suo intelleto, che ha lavorato a
caso, e senza disegno, quasi monstrando che quest' arte è una baia.

332-333 Simon Vouet (1590-1649) was the teacher of Le Sueur, LeBrun, and Mignard.
Reynolds' comment is a little aside from the mark. Vouet *did* work in Venice, but mostly in
Rome before settling in Paris in 1627. He established in France and disseminated through his
students a highly eclectic form of painting based on a study of many early 17th-century Ital-
ian painters such as Caravaggio, Annibale Carracci, Guercino, and Guido Reni. Two of Vouet's
pupils, Le Sueur and LeBrun, were among the French painters Reynolds most admired (see
IV, 193-196, but also VI, 404-406).

333 Luca Giordano (1632-1705) was born in Naples, where he was active much of his life.
In 1692 he accompanied Charles II to Spain, where he remained about a decade. See XII,
264-265.

above them: for every picture has value when it has a decided character, and is excellent in its kind. But the Student must take care not to be so much dazzled with this splendour, as to be tempted to imitate what must
340 ultimately lead from perfection. Poussin, whose eye was always steadily fixed on the Sublime, has been often heard to say, "That a particular "attention to colouring was an obstacle to the Student, in his progress "to the great end and design of the art; and that he who attaches him- "self to this principal end, will acquire by practice a reasonable good
345 "method of colouring.*"

Though it be allowed that elaborate harmony of colouring, a brilliancy of tints, a soft and gradual transition from one to another, present to the eye, what an harmonious concert of musick does to the ear, it must be remembered, that painting is not merely a gratifica-
350 tion of the sight. Such excellence, though properly cultivated, where nothing higher than elegance is intended, is weak and unworthy of regard, when the work aspires to grandeur and sublimity.

The same reasons that have been urged to shew that a mixture of the Venetian style cannot improve the great style, will hold good in
355 regard to the Flemish and Dutch schools. Indeed, the Flemish school, of which Rubens is the head, was formed upon that of the Venetian; like them, he took his figures too much from the people before him. But it must be allowed in favour of the Venetians, that he was more gross than they, and carried all their mistaken methods to a far greater excess.
360 In the Venetian school itself, where they all err from the same cause, there is a difference in the effect. The difference between Paulo and Bassano seems to be only, that one introduced Venetian gentlemen into his pictures, and the other the boors of the district of Bassano, and called them patriarchs and prophets.

*Que cette application singuliere n'etoit qu'un obstacle pour empêcher de parvenir au veritable but de la peinture, & celui qui s'attache au principal, acquiert par la pratique une assez belle maniere de peindre. Conference de l'Acad. Franc.

341 71 and 78S to say, "*That

345-346 71 and 78S of colouring."
Though

353 71 and 78S urged why a mixture

357-361 71 before him; and his works have as much of Fleming in them as the works of Paul Veronese have of Venetian. The difference between

345n The particular "Conférence de l'Académie" from which this passage is taken (June 12, 1672) does not appear to be reported on by Félibien. But the conference is recorded in Henri Testelin, Sentimens des plus habiles peintres sur la practique de la peinture et sculpture (Paris, 1696), p. 35.

THE painters of the Dutch school have still more locality. With them, a history-piece is properly a portrait of themselves; whether they describe the inside or outside of their houses, we have their own people engaged in their own peculiar occupations; working, or drinking, playing, or fighting. The circumstances that enter into a picture of this kind, are so far from giving a general view of human life, that they exhibit all the minute particularities of a nation differing in several respects from the rest of mankind. Yet, let them have their share of more humble praise. The painters of this school are excellent in their own way; they are only ridiculous when they attempt general history on their own narrow principles, and debase great events by the meanness of their characters.

SOME inferior dexterity, some extraordinary mechanical power is apparently that from which they seek distinction. Thus, we see, that school alone has the custom of representing candle-light, not as it really appears to us by night, but red, as it would illuminate objects to a spectator by day. Such tricks, however pardonable in the little style, where petty effects are the sole end, are inexcusable in the greater, where the attention should never be drawn aside by trifles, but should be entirely occupied by the subject itself.

THE same local principles which characterize the Dutch school extend even to their landscape painters; and Rubens himself, who has painted many landscapes, has sometimes transgressed in this particular. Their pieces in this way are, I think, always a representation of an individual spot, and each in its kind a very faithful but very confined portrait.

CLAUDE LORRAIN, on the contrary, was convinced, that taking

365
Plate VIII

370

375

380

385

Plate IX

390

369　71　that enters into　　　　　389　98　but a very confined

365-369 The passage is interesting in relation to the well-known comment of Eugène Fromentin, *Les maîtres d'autrefois* (first published in 1876): "Un écrivain de notre temps, très éclaire en ces matières, a fort spirituellement répondu qu'un pareil peuple n'avait plus qu'à se proposer une chose très simple et très hardie, la seule qui depuis cinquante ans lui eût constamment réussi: exiger qu'on fit son portrait.

"Le mot dit tout. La peinture hollandaise, on s'en aperçut bien vite, ne fut et ne pouvait être que le portrait de la Hollande, son image extérieure, fidèle, exacte, complète, ressemblante, sans nul embéllissement . . ." (cited from the edition by Maurice Allemand, Paris, n.d., p. 135).

Allemand suggests that the passage was inspired by Taine, *Philosophie de l'art*, t. 11, p. 71: "Il n'y a qu'un emploi pour le style héroïque: ce sont les grands portraits qui décorent les hôtels-de-ville et les établissements publics en commemoration des services rendus. . . . Ce qu'il [l'instinct national] exige et ce qu'il provoque, c'est la représentation de l'homme réel et de la vie réele, tels que les yeux les voient."

Reynolds is closer.

Plate X nature as he found it seldom produced beauty. His pictures are a composition of the various draughts which he had previously made from various beautiful scenes and prospects. However, Rubens in
395 some measure has made amends for the deficiency with which he is charged; he has contrived to raise and animate his otherwise uninteresting views, by introducing a rainbow, storm, or some particular accidental effect of light. That the practice of Claude Lorrain, in respect to his choice, is to be adopted by Landschape Painters, in opposition
400 to that of the Flemish and Dutch schools, there can be no doubt, as its truth is founded upon the same principle as that by which the Historical Painter acquires perfect form. But whether landschape painting has a right to aspire so far as to reject what the painters call Accidents of Nature, is not easy to determine. It is certain Claude Lorrain seldom,
405 if ever, availed himself of those accidents; either he thought that such peculiarities were contrary to that style of general nature which he professed, or that it would catch the attention too strongly, and destroy that quietness and repose which he thought necessary to that kind of painting.
410 A PORTRAIT-Painter likewise, when he attempts history, unless he is upon his guard, is likely to enter too much into the detail. He too frequently makes his historical heads look like portraits; and this was once the custom amongst those old painters, who revived the art before general ideas were practised or understood. An History-
415 painter paints man in general; a Portrait-Painter, a particular man, and consequently a defective model.

THUS an habitual practice in the lower exercises of the art will prevent many from attaining the greater. But such of us who move in these humbler walks of the profession, are not ignorant that, as the
420 natural dignity of the subject is less, the more all the little ornamental helps are necessary to its embellishment. It would be ridiculous for a painter of domestick scenes, of portraits, landschapes, animals, or of still life, to say that he despised those qualities which has made the

393 71 and 78S he has previously 423 71 and 78S which have made
422-423 98 or still life

411-414 Reynolds probably had in mind the historical and religious paintings of the Florentine Quattrocento, in which portraits of contemporaries were frequently introduced (e.g., Botticelli's "Adoration of the Magi" [Uffizi], which contains portraits of the Medici family). Reynolds has apparently forgotten that Raphael also introduced portraits into the religious and historical scenes in the Stanze.

subordinate schools so famous. The art of colouring, and the skilful management of light and shadow, are essential requisites in his confined labours. If we descend still lower, what is the painter of fruit and flowers without the utmost art in colouring, and what the painters call handling; that is, a lightness of pencil that implies great practice, and gives the appearance of being done with ease? Some here, I believe, must remember a flower-painter whose boast it was, that he scorned to paint for the *million:* no, he professed to paint in the true Italian taste; and despising the crowd, called strenuously upon the *few* to admire him. His idea of the Italian taste was to paint as black and dirty as he could, and to leave all clearness and brilliancy of colouring to those who were fonder of money than of immortality. The consequence was such as might be expected. For these petty excellencies are here essential beauties; and without this merit the artist's work will be more short-lived than the objects of his imitation.

FROM what has been advanced, we must now be convinced that there are two distinct styles in history-painting: the grand, and the splendid or ornamental.

THE great style stands alone, and does not require, perhaps does not so well admit, any addition from inferior beauties. The ornamental style also possesses its own peculiar merit. However, though the union of the two may make a sort of composite style, yet that style is likely to be more imperfect than either of those which go to its composition. Both kinds have merit, and may be excellent though in different ranks, if uniformity be preserved, and the general and particular ideas of nature be not mixed. Even the meanest of them is difficult enough to attain; and the first place being already occupied by the great artists in each department, some of those who followed thought there was less room for them, and feeling the impulse of ambition and the desire of novelty, and being at the same time perhaps willing to take the shortest way, endeavoured to make for themselves a place between both.

435 98 than immortality 454 71 and 78S way, they endeavoured
451 71 and 78S in either department

430 Fry (p. 433) thought Reynolds meant Joseph Cooper (1682-1743), who is mentioned by Horace Walpole in *Anecdotes of Painting in England* as an imitator of Caravaggio in painting fruit and flowers.

444-458 Reynolds' thought here departs from the normal eclectic attitude of the 16th and 17th centuries, which advocated a combination of all that was most esteemed in the various schools (see Introduction, pp. xxviii-xxix).

455 This they have effected by forming an union of the different orders. But as the grave and majestick style would suffer by an union with the florid and gay, so also has the Venetian ornament in some respect been injured by attempting an alliance with simplicity.

460 IT may be asserted, that the great style is always more or less contaminated by any meaner mixture. But it happens in a few instances, that the lower may be improved by borrowing from the grand. Thus if a portrait-painter is desirous to raise and improve his subject, he has *Plate XXIII* no other means than by approaching it to a general idea. He leaves out all the minute breaks and peculiarities in the face, and changes the dress 465 from a temporary fashion to one more permanent, which has annexed to it no ideas of meanness from its being familiar to us. But if an exact resemblance of an individual be considered as the sole object to be aimed at, the portrait-painter will be apt to lose more than he gains by the acquired dignity taken from general nature. It is very difficult 470 to ennoble the character of a countenance but at the expense of the likeness, which is what is most generally required by such as sit to the painter.

OF those who have practised the composite style, and have succeeded in this perilous attempt, perhaps the foremost is Coregio. His style 475 is founded upon modern grace and elegance, to which is superadded something of the simplicity of the grand style. A breadth of light and colour, the general ideas of the drapery, an uninterrupted flow of outline, all conspire to this effect. Next to him (perhaps equal to him) *Plate XII* Parmegiano has dignified the genteelness of modern effeminacy, by 480 uniting it with the simplicity of the ancients and the grandeur and severity of Michael Angelo. It must be confessed however that these two extraordinary men, by endeavouring to give the utmost degree of grace, have sometimes perhaps exceeded its boundaries, and have fallen into the most hateful of all hateful qualities, affectation. Indeed, it 485 is the peculiar characteristick of men of genius to be afraid of coldness

478 71 and 78S Next him

459-472 This paragraph is of great interest in studying Reynolds' own practice as a portraitist. It provides a theoretical justification for much of the stylistic variety in his work (see Introduction, pp. xxxii ff.).

479 Francesco Mazzola, called Il Parmigianino (1503-1540), enjoyed great popularity during the 18th century. See in particular the numerous references to Parmigianino in the writings of James Barry, who was professor of painting at the Royal Academy from 1783 to 1799 (*The Works of James Barry* [London, 1809], II, Index).

and insipidity, from which they think they never can be too far removed. It particularly happens to these great masters of grace and elegance. They often boldly drive on to the very verge of ridicule; the spectator is alarmed, but at the same time admires their vigour and intrepidity:

> *Strange graces still, and stranger flights they had,*
>
> *.*
>
> *Yet ne'er so sure our passion to create,*
> *As when they touch'd the brink of all we hate.*

THE errors of genius, however, are pardonable, and none even of the more exalted painters are wholly free from them; but they have taught us, by the rectitude of their general practice, to correct their own affected or accidental deviation. The very first have not been always upon their guard, and perhaps there is not a fault, but what may take shelter under the most venerable authorities; yet that style only is perfect, in which the noblest principles are uniformly pursued; and those masters only are entitled to the first rank in our estimation, who have enlarged the boundaries of their art, and have raised it to its highest dignity, by exhibiting the general ideas of nature.

ON the whole, it seems to me that there is but one presiding principle which regulates, and gives stability to every art. The works, whether of poets, painters, moralists, or historians, which are built upon general nature, live for ever; while those which depend for their existence on particular customs and habits, a partial view of nature, or the fluctuation of fashion, can only be coeval with that which first raised them from obscurity. Present time and future may be considered as rivals, and he who solicits the one must expect to be discountenanced by the other.

491-494 Alexander Pope, *Epistles to Several Persons (Moral Essays)*, ed. F. W. Bateson London, [1951]), Ep. II ("To a Lady"), ll. 49-52:

> Strange graces still, and stranger flights she had,
> Was just not ugly, and was just not mad;
> Yet ne'er so sure our passion to create,
> As when she touch'd the brink of all we hate.

DISCOURSE V

Delivered to the Students of The Royal Academy,

on the Distribution of the Prizes,

December 10, 1772

DISCOURSE V

Gentlemen,

I Purpose to carry on in this discourse the subject which I began in my last. It was my wish upon that occasion to incite you to pursue the higher excellencies of the art. But I fear that in this particular I have been misunderstood. Some are ready to imagine, when any of their favourite acquirements in the art are properly classed, that they are utterly disgraced. This is a very great mistake: nothing has its proper lustre but in its proper place. That which is most worthy of esteem in its allotted sphere, becomes an object, not of respect, but of derision, when it is forced into a higher, to which it is not suited; and there it becomes doubly a source of disorder, by occupying a situation which is not natural to it, and by putting down from the first place what is in reality of too much magnitude to become with grace and proportion that subordinate station, to which something of less value would be much better suited.

My advice in a word is this: keep your principal attention fixed upon the higher excellencies. If you compass them and compass nothing more, you are still in the first class. We may regret the innumerable beauties which you may want; you may be very imperfect; but still, you are an imperfect artist of the highest order.

If, when you have got thus far, you can add any, or all, of the sub-ordinate qualifications, it is my wish and advice that you should not neglect them. But this is as much a matter of circumspection and caution at least, as of eagerness and pursuit.

The mind is apt to be distracted by a multiplicity of objects; and that scale of perfection, which I wish always to be preserved, is in the greatest danger of being totally disordered, and even inverted.

1-2 72 and 78S I begun in

19 72 and 78S imperfect person of

24 72 by multiplicity of pursuits; and

24 78S by a multiplicity of pursuits; and

77

SOME excellencies bear to be united, and are improved by union; others are of a discordant nature; and the attempt to join them, only produces a harsh jarring of incongruent principles. The attempt to unite contrary excellencies (of form, for instance,) in a single figure, can never escape degenerating into the monstrous, but by sinking into the insipid; by taking away its marked character, and weakening its expression.

THIS remark is true to a certain degree with regard to the passions. If you mean to preserve the most perfect beauty *in its most perfect state*, you cannot express the passions, all of which produce distortion and deformity, more or less, in the most beautiful faces.

GUIDO, from want of choice in adapting his subject to his ideas and his powers, or from attempting to preserve beauty where it could not be preserved, has in this respect succeeded very ill. His figures are often engaged in subjects that required great expression: yet his Judith and Holofernes, the daughter of Herodias with the Baptist's head, the Andromeda, and some even of the Mothers of the Innocents, have little more expression than his Venus attired by the Graces.

OBVIOUS as these remarks appear, there are many writers on our art, who, not being of the profession, and consequently not knowing what can or cannot be done, have been very liberal of absurd praises in their descriptions of favourite works. They always find in them what they are resolved to find. They praise excellencies that can hardly exist together; and above all things are fond of describing with great exactness the expression of a mixed passion, which more particularly appears to me out of the reach of our art.

SUCH are many disquisitions which I have read on some of the Cartoons and other pictures of Raffaelle, where the Criticks have described their own imaginations; or indeed where the excellent master himself may have attempted this expression of passions above the powers of the art; and has therefore, by an indistinct and imperfect marking, left

Plate IV

29	72 and 78S	a harsher jarring			
30	72, 78S and 98	contrary excellencies (of	39	72 and 78S	or in attempting
32	72 and 78S	insipid; taking	43	72 and 78S	and even the Mothers
36	72 and 78S	passions, which produce (all of them) distortion	47	72 and 78S	what can or what cannot
			55	72 and 78S	own imagination; or

41-44 One cannot be sure which paintings by Guido Reni (1575-1642) Reynolds had in mind. Probably the "Judith" is the one now in the Galleria Spada, Rome; "Salome," Galleria Corsini, Rome; "Massacre of the Innocents," Pinakothek, Bologna.

room for every imagination, with equal probability to find a passion of his own. What has been, and what can be done in the art, is sufficiently difficult; we need not be mortified or discouraged at not being able to execute the conceptions of a romantick imagination. Art has its boundaries, though Imagination has none. We can easily, like the Antients, suppose a Jupiter to be possessed of all those powers and perfections which the subordinate Deities were endowed with separately. Yet, when they employed their art to represent him, they confined his character to majesty alone. Pliny, therefore, though we are under great obligations to him for the information he has given us in relation to the works of the antient artists, is very frequently wrong when he speaks of them, which he does very often in the style of many of our modern Connoisseurs. He observes, that in a statue of Paris, by Euphranor, you might discover at the same time three different characters; the dignity of a Judge of the Goddesses, the Lover of Helen, and the conqueror of Achilles. A statue in which you endeavour to unite stately dignity, youthful elegance, and stern valour, must surely possess none of these to any eminent degree.

From hence it appears, that there is much difficulty as well as danger, in an endeavour to concentrate in a single subject those various powers, which, rising from different points, naturally move in different directions.

The summit of excellence seems to be an assemblage of contrary qualities, but mixed, in such proportions, that no one part is found to counteract the other. How hard this is to be attained in every art, those only know, who have made the greatest progress in their respective professions.

To conclude what I have to say on this part of the subject, which I think of great importance, I wish you to understand, that I do not discourage the younger Students from the noble attempt of uniting all the excellencies of art; but suggest to them, that, beside the difficulties

60 72 and 78S discouraged for not

67 72 information which he

77 72 and 78S concentrate upon a single

88 72 but to make them aware, that besides the difficulties

88 78S but to make them aware, that, besides the difficulties

66-73 Félibien (*The Tent of Darius Explain'd*, trans. William Parsons [London, 1703], p. 11) praises LeBrun for achieving, as Euphranor did, the expression of many different passions on a single face.

70-73 Pliny *Historia naturalis* XXXIV.xix.77. Reynolds might also have found the passage in *Œuvres d'Etienne Falconet, statuaire* (Lausanne, 1781), III, 131.

which attend every arduous attempt, there is a peculiar difficulty in
90 the choice of the excellencies which ought to be united. I wish you to
attend to this, that you may try yourselves, whenever you are capable
of that trial, what you can, and what you cannot do; and that, instead
of dissipating your natural faculties over the immense field of possible
excellence, you may choose some particular walk in which you may
95 exercise all your powers; in order that each of you may become the
first in his way. If any man shall be master of such a transcendent, com-
manding, and ductile genius, as to enable him to rise to the highest, and
to stoop to the lowest, flights of art, and to sweep over all of them
unobstructed and secure, he is fitter to give example than to receive
100 instruction.

HAVING said thus much on the *union* of excellencies, I will next say
something of the subordination in which various excellencies ought to
be kept.

I AM of opinion, that the ornamental style, which in my discourse of
105 last year I cautioned you against, considering it as *principal*, may not
be wholly unworthy the attention even of those who aim at the grand
style, when it is properly placed and properly reduced.

BUT this study will be used with far better effect, if its principles are
employed in softening the harshness and mitigating the rigour of the
110 great style, than if it attempt to stand forward with any pretensions of
its own to positive and original excellence. It was thus Lodovico Car-
Plate II racci, whose example I formerly recommended to you, employed it.
He was acquainted with the works both of Coreggio and the Vene-
tian painters, and knew the principles by which they produced those
115 pleasing effects which at the first glance prepossess us so much in their
favour; but he took only as much from each as would embellish, but
not over-power, that manly strength and energy of style, which is his
peculiar character.

SINCE I have already expatiated so largely in my former discourse,
120 and in my present, upon the *styles* and *characters* of Painting, it will
not be at all unsuitable to my subject if I mention to you some particu-
lars relative to the leading principles, and capital works of those who
excelled in the *great style*; that I may bring you from abstraction nearer

95-96 72 and 78S order each of you to be 106 72 and 78S attention of those, who
the first aim even at

105 72 and 78S considering as 110 72 and 78S if in attempt

to practice, and by exemplifying the positions which I have laid down, enable you to understand more clearly what I would enforce.

THE principal works of modern art are in *Fresco*; a mode of Painting which excludes attention to minute elegancies: yet these works in Fresco, are the productions on which the fame of the greatest masters depend: such are the pictures of Michael Angelo and Raffaelle in the Vatican; to which we may add the Cartoons; which, though not strictly to be called Fresco, yet may be put under that denomination; and such are the works of Giulio Romano at Mantua. If these performances were destroyed, with them would be lost the best part of the reputation of those illustrious painters; for these are justly considered as the greatest efforts of our art which the world can boast. To these, therefore, we should principally direct our attention for higher excellencies. As for the lower arts, as they have been once discovered, they may be easily attained by those possessed of the former.

RAFFAELLE, who stands in general foremost of the first painters, owes his reputation, as I have observed, to his excellence in the higher parts of the art: his works in *Fresco*, therefore, ought to be the first object of our study and attention. His *easel*-works stand in a lower degree of estimation; for though he continually, to the day of his death, embellished his performances more and more with the addition of those lower ornaments, which entirely make the merit of some painters, yet he never arrived at such perfection as to make him an object of imitation. He never was able to conquer perfectly that dryness, or even littleness of manner, which he inherited from his master. He never acquired that nicety of taste in colours, that breadth of light and shadow, that art and management of uniting light to light, and shadow to shadow, so as to make the object rise out of the ground with that plenitude of effect so much admired in the works of Coreggio. When he painted in oil, his hand seemed to be so cramped and confined, that he not only

Plates XIII and IV

125

135

140

145

150

124 72 and 78S the propositions which

128-129 98 masters depends: such

141 72 art. Therefore, his works in Fresco, ought

141 78S art. Therefore, his works in *Fresco*, ought

144-145 72 and 78S embellished his works more and more with the addition of these lower ornaments, which entirely make the merit of some; yet

130-131 The Raphael cartoons are executed in sized color on paper. In technique they are more closely akin to water color than to fresco painting. See *The Raphael Cartoons*, p. 9.

132 Giulio Romano or Giulio Pippi (1499-1546) was a pupil and follower of Raphael. He built the Palazzo del Te at Mantua and executed a series of paintings in the interior.

lost that facility and spirit, but I think even that correctness of form,
155 which is so perfect and admirable in his *Fresco*-works. I do not recol-
lect any pictures of his of this kind, except perhaps the Transfiguration,
in which there are not some parts that appear to be even feebly drawn.
That this is not a necessary attendant on Oil-painting, we have abun-
dant instances in more modern painters. Lodovico Carracci, for instance,
160 preserved in his works in oil the same spirit, vigour, and correctness,
which he had in *Fresco*. I have no desire to degrade Raffaelle from the
high rank which he deservedly holds; but by comparing him with him-
self, he does not appear to me to be the same man in Oil as in Fresco.

FROM those who have ambition to tread in this great walk of the art,
165 Michael Angelo claims the next attention. He did not possess so many
excellencies as Raffaelle, but those which he had were of the highest
kind. He considered the art as consisting of little more than what may
Plate XIII be attained by Sculpture; correctness of form, and energy of character.
We ought not to expect more than an artist intends in his work. He
170 never attempted those lesser elegancies and graces in the art. Vasari
says, he never painted but one picture in oil, and resolved never to paint
another, saying, it was an employment only fit for women and children.

IF any man had a right to look down upon the lower accomplish-
ments as beneath his attention, it was certainly Michael Angelo; nor can
175 it be thought strange, that such a mind should have slighted or have been
withheld from paying due attention to all those graces and embellish-
ments of art, which have diffused such lustre over the works of other
painters.

IT must be acknowledged, however, that together with these, which
180 we wish he had more attended to, he has rejected all the false, though
specious ornaments, which disgrace the works even of the most
esteemed artists; and I will venture to say, that when those higher excel-
lencies are more known and cultivated by the artists and the patrons of
arts, his fame and credit will encrease with our encreasing knowledge.
185 His name will then be held in the same veneration as it was in the

166 72 and 78S those he 179 72 and 78S acknowledged likewise,
 that

156 Reynolds lights on a picture that modern scholarship does not accept as entirely from
Raphael's own hand. The design is taken to be his, but a good deal of the actual execution is by
Giulio Romano and Giovanni Francesco Penni. See Oskar Fischel, *Raphael* (London, [1948]),
I, 367; see II, 268, for an illustration.

170-172 I have not found this passage in Vasari.

enlightened age of Leo the tenth: and it is remarkable that the reputation of this truly great man has been continually declining as the art itself has declined. For I must remark to you, that it has long been much on the decline, and that our only hope of its revival will consist in your being thoroughly sensible of its depravation and decay. It is to Michael Angelo, that we owe even the existence of Raffaelle: it is to him Raffaelle owes the grandeur of his style. He was taught by him to elevate his thoughts, and to conceive his subjects with dignity. His genius, however formed to blaze and to shine, might, like fire in combustible matter, for ever have lain dormant, if it had not caught a spark by its contact with Michael Angelo: and though it never burst out with *his* extraordinary heat and vehemence, yet it must be acknowledged to be a more pure, regular, and chaste flame. Though our judgement must upon the whole decide in favour of Raffaelle, yet he never takes such a firm hold and entire possession of the mind as to make us desire nothing else, and to feel nothing wanting. The effect of the capital works of Michael Angelo perfectly corresponds to what Bouchardon said he felt from reading Homer; his whole frame appeared to himself to be enlarged, and all nature which surrounded him, diminished to atoms.

IF we put these great artists in a light of comparison with each other, Raffaelle had more Taste and Fancy, Michael Angelo more Genius and Imagination. The one excelled in beauty, the other in energy. Michael Angelo has more of the Poetical Inspiration; his ideas are vast and sublime; his people are a superior order of beings; there is nothing about them, nothing in the air of their actions or their attitudes, or the style and cast of their limbs or features, that reminds us of their belonging to our own species. Raffaelle's imagination is not so elevated; his figures are not so much disjoined from our own diminutive race of beings, though his ideas are chaste, noble, and of great conformity to their subjects. Michael Angelo's works have a strong, peculiar, and marked char-

196 72 and 78S with that extraordinary

198 72 and 78S our judgment will upon

199 72 and 78S takes that firm

200-201 72 and 78S mind in such a manner as to desire nothing else, and feel

202 72 and 78S perfectly correspond to

205 72 and 78S put those great

211 72 and 78S their very limbs or features, that puts one in mind of

190-192 See I, n. 61-67.

201-204 Reynolds probably took the anecdote from Algarotti (p. 130): "Bouchardon, after reading Homer, conceited, to use his own words, that men were three times taller than before, and that the world was enlarged in every respect." Dimier thought the ultimate source was Voltaire.

acter: they seem to proceed from his own mind entirely, and that mind so rich and abundant, that he never needed, or seemed to disdain, to look abroad for foreign help. Raffaelle's materials are generally borrowed, though the noble structure is his own. The excellency of this extraordinary man lay in the propriety, beauty, and majesty of his characters, the judicious contrivance of his Composition, his correctness of Drawing, purity of Taste, and skilful accommodation of other men's conceptions to his own purpose. Nobody excelled him in that judgment, with which he united to his own observations on Nature, the Energy of Michael Angelo, and the Beauty and Simplicity of the Antique. To the question therefore, which ought to hold the first rank, Raffaelle or Michael Angelo, it must be answered, that if it is to be given to him who possessed a greater combination of the higher qualities of the art than any other man, there is no doubt but Raffaelle is the first. But if, as Longinus thinks, the sublime, being the highest excellence that human composition can attain to, abundantly compensates the absence of every other beauty, and atones for all other deficiencies, then Michael Angelo demands the preference.

These two extraordinary men carried some of the higher excellencies of the art to a greater degree of perfection than probably they ever arrived at before. They certainly have not been excelled, nor equalled since. Many of their successors were induced to leave this great road as a beaten path, endeavouring to surprise and please by something uncommon or new. When this desire of novelty has proceeded from mere idleness or caprice, it is not worth the trouble of criticism; but when it has been the result of a busy mind of a peculiar complexion, it is always striking and interesting, never insipid.

Such is the great style, as it appears in those who possessed it at its height: in this, search after novelty, in conception or in treating the subject, has no place.

But there is another style, which, though inferior to the former, has still great merit, because it shews that those who cultivated it were men of lively and vigorous imagination. This, which may be called the origi-

221 72 and 78S characters, his judicious

221 72 and 78S Composition, correctness

222 72 and 78S and the skilful

230 72 and 78S But if, according to Longinus, the sublime

239 72 and 78S desire after novelty

241 72 and 78S been in consequence of a busy

248-249 72 and 78S This I call the original, or characteristical Style; this, being

230-233 Longinus, *On the Sublime*, pp. 78-88.

nal or characteristical style, being less referred to any true architype existing either in general or particular nature, must be supported by the 250 painter's consistency in the principles which he has assumed, and in the union and harmony of his whole design. The excellency of every style, but of the subordinate styles more especially, will very much depend on preserving that union and harmony between all the component parts, that they may appear to hang well together, as if the whole 255 proceeded from one mind. It is in the works of art, as in the characters of men. The faults or defects of some men seem to become them, when they appear to be the natural growth, and of a piece with the rest of their character. A faithful picture of a mind, though it be not of the most elevated kind, though it be irregular, wild, and incorrect, yet if 260 it be marked with that spirit and firmness which characterises works of genius, will claim attention, and be more striking than a combination of excellencies that do not seem to unite well together; or we may say, than a work that possesses even all excellencies, but those in a moderate degree. 265

ONE of the strongest-marked characters of this kind, which must be allowed to be subordinate to the great style, is that of Salvator Rosa. He gives us a peculiar cast of nature, which, though void of all grace, *Plate XI* elegance, and simplicity, though it has nothing of that elevation and dignity which belongs to the grand style, yet, has that sort of dignity 270 which belongs to savage and uncultivated nature: but what is most to be admired in him, is, the perfect correspondence which he observed between the subjects which he chose and his manner of treating them. Every thing is of a piece: his Rocks, Trees, Sky, even to his handling, have the same rude and wild character which animates his figures. 275

WITH him we may contrast the character of Carlo Maratti, who, in my opinion, had no great vigour of mind or strength of original genius. He rarely seizes the imagination by exhibiting the higher excellencies, nor does he captivate us by that originality which attends the painter who thinks for himself. He knew and practised all the rules of 280

251 72 and 78S principles he

253 72 and 78S but I think of the subordinate ones more

255 72 and 78S they appear

263 72 and 78S to hang well

275-276 72 and 78S his figures. To him

277 72 and 78S my own opinion

267 Salvator Rosa (1615-1673), painter, engraver, poet, and musician, enjoyed a much higher reputation in the 18th century than he does today. See Hilles, *Letters*, p. 165 and note.

276 See IV, 179*n*.

art, and from a composition of Raffaelle, Carracci, and Guido, made up a style, of which the only fault was, that it had no manifest defects and no striking beauties; and that the principles of his composition are never blended together, so as to form one uniform body, original in its kind, or excellent in any view.

I WILL mention two other painters, who, though entirely dissimilar, yet by being each consistent with himself and possessing a manner entirely his own, have both gained reputation, though for very opposite accomplishments. The painters I mean, are Rubens and Poussin. Rubens I mention in this place, as I think him a remarkable instance of the same mind being seen in all the various parts of the art. The whole is so much of a piece, that one can scarce be brought to believe but that if any one of the qualities he possessed had been more correct and perfect, his works would not have been so complete as they now appear. If we should allow him a greater purity and correctness of Drawing, his want of Simplicity in Composition, Colouring, and Drapery, would appear more gross.

IN his Composition his art is too apparent. His figures have expression, and act with energy, but without simplicity or dignity. His Colouring, in which he is eminently skilled, is notwithstanding too much of what we call tinted. Throughout the whole of his works, there is a proportionable want of that nicety of distinction and elegance of mind, which is required in the higher walks of painting; and to this want it may be in some degree ascribed, that those qualities which make the excellency of this subordinate style, appear in him with their greatest lustre. Indeed the facility with which he invented, the richness of his composition, the luxuriant harmony and brilliancy of his colouring, so dazzle the eye, that whilst his works continue before us, we cannot help thinking that all his deficiences are fully supplied.

OPPOSED to this florid, careless, loose, and inaccurate style, that of the simple, careful, pure, and correct style of Poussin seems to be a complete contrast. Yet however opposite their characters, in one thing they agreed; both of them always preserving a perfect correspondence

Plates XIX and XIV

285

295

300

305

310

282 72 and 78S which its only

293-294 72 and 78S of them had been more correct and perfect, his works would not be so

295 72 and 78S allow a greater

309 98 fully supplied*. [the note added by Malone]
*A more detailed character of Rubens may

be found in the "Journey to Flanders and Holland" near the conclusion. M.

313-316 72 and 78S them having a perfect correspondence between all the parts of their respective manners.
One is not sure but every alteration of what is considered as defective in either, would destroy

between all the parts of their respective manners: insomuch that it may be doubted whether any alteration of what is considered as defective in either, would not destroy the effect of the whole. 315

Poussin lived and conversed with the ancient statues so long, that he may be said to have been better acquainted with them, than with the people who were about him. I have often thought that he carried his veneration for them so far as to wish to give his works the air of Ancient 320 Paintings. It is certain he copied some of the Antique Paintings, particularly the Marriage in the Aldobrandini-Palace at Rome, which I believe to be the best relique of those remote ages that has yet been found.

No works of any modern has so much of the air of Antique Painting 325 as those of Poussin. His best performances have a remarkable dryness of manner, which though by no means to be recommended for imitation, yet seems perfectly correspondent to that ancient simplicity which distinguishes his style. Like Polidoro he studied the ancients so much, that he acquired a habit of thinking in their way, and seemed to 330 know perfectly the actions and gestures they would use on every occasion.

Poussin in the latter part of his life changed from his dry manner to one much softer and richer, where there is a greater union between the figures and the ground; as in the Seven Sacraments in the Duke of *Plate XIV* Orleans's collection; but neither these, nor any of his other pictures in this manner, are at all comparable to many in his dry manner which we have in England.

The favourite subjects of Poussin were Ancient Fables; and no painter was ever better qualified to paint such subjects, not only from 340 his being eminently skilled in the knowledge of the ceremonies, cus-

318 72 and 78S to be better

329 72 and 78S studied them so

335-336 72 and 78S ground, such as the Seven Sacraments in the Duke of Orleans' collection

336 72 and 78S any in

341 72 and 78S knowledge of Ceremonies

322 The "Aldobrandini Marriage" is a fresco about eight feet long found on the Esquiline near the arch of Gallianus early in the 17th century. It is now in the Vatican. Richardson mentions a copy by Poussin, which belonged to Cav. del Pozzo (*An Account of Some Statues* [London, 1722], p. 189). Otto Grautoff (*Nicolas Poussin* [Munich, 1914], I, 70) mentions a copy by Poussin in the Doria Gallery.

329 Polidoro Caldara of Caravaggio (1495-1543), pupil and follower of Raphael.

335-336 The Orleans Collection came to England in 1798. The "Sacraments" to which Reynolds refers are now in the collection of Lord Ellesmere, on loan to the National Gallery of Scotland. See Pl. XIV.

toms and habits of the Ancients, but from his being so well acquainted with the different characters which those who invented them gave to their allegorical figures. Though Rubens has shewn great fancy in his Satyrs, Silenuses, and Fauns, yet they are not that distinct separate class of beings, which is carefully exhibited by the Ancients, and by Poussin. Certainly when such subjects of antiquity are represented, nothing in the picture ought to remind us of modern times. The mind is thrown back into antiquity, and nothing ought to be introduced that may tend to awaken it from the illusion.

POUSSIN seemed to think that the style and the language in which such stories are told, is not the worse for preserving some relish of the old way of painting, which seemed to give a general uniformity to the whole, so that the mind was thrown back into antiquity not only by the subject, but the execution.

IF Poussin in imitation of the Ancients represents Apollo driving his chariot out of the sea by way of representing the Sun rising, if he personifies Lakes and Rivers, it is nowise offensive in him; but seems perfectly of a piece with the general air of the picture. On the contrary, if the Figures which people his pictures had a modern air or countenance, if they appeared like our countrymen, if the draperies were like cloth or silk of our manufacture, if the landskip had the appearance of a modern view, how ridiculous would Apollo appear instead of the Sun; an old Man, or a Nymph with an urn, to represent a River or a Lake?

I CANNOT avoid mentioning here a circumstance in portrait-painting, which may help to confirm what has been said. When a portrait is painted in the Historical Style, as it is neither an exact minute representation of an individual, nor completely ideal, every circumstance ought to correspond to this mixture. The simplicity of the antique air and attitude, however much to be admired, is ridiculous when joined to a figure in a modern dress. It is not to my purpose to enter into the question at present, whether this mixed style ought to be adopted or not; yet if it is chosen, 'tis necessary it should be complete and all of a piece: the difference of stuffs, for instance, which make the cloathing, should be distinguished in the same degree as the head deviates from a general idea. Without this union, which I have so often recommended, a work can have no marked and determined character, which is the

343-344 72 and 78S gave their
358 72 and 78S is no ways offensive
364-365 72 and 78S Urn instead of a River or Lake

peculiar and constant evidence of genius. But when this is accomplished to a high degree, it becomes in some sort a rival to that style which we have fixed as the highest. 380

THUS I have given a sketch of the characters of Rubens and Salvator Rosa, as they appear to me to have the greatest uniformity of mind throughout their whole work. But we may add to these, all those Artists who are at the head of a class, and have had a school of imitators from Michael Angelo down to Vatteau. Upon the whole it appears, that setting aside the Ornamental Style, there are two different modes, either of which a Student may adopt without degrading the dignity of his art. The object of the first is, to combine the higher excellencies and embellish them to the greatest advantage; of the other, to carry one of these excellencies to the highest degree. But those who possess neither must be classed with them, who, as Shakspeare says, are *men of no mark or likelihood*. 385

390

I INCULCATE as frequently as I can your forming yourselves upon great principles and great models. Your time will be much misspent in every other pursuit. Small excellencies should be viewed, not studied; they ought to be viewed, because nothing ought to escape a Painter's observation; but for no other reason. 395

THERE is another caution which I wish to give you. Be as select in those whom you endeavour to please, as in those whom you endeavour to imitate. Without the love of fame you can never do any thing excellent; but by an excessive and undistinguishing thirst after it, you will come to have vulgar views; you will degrade your style; and your taste will be entirely corrupted. It is certain that the lowest style will be the most popular, as it falls within the compass of ignorance itself; and the Vulgar will always be pleased with what is natural, in the confined and misunderstood sense of the word. 400

405

ONE would wish that such depravation of taste should be counteracted with that manly pride which actuated Euripides when he said to the Athenians who criticised his works, "I do not compose my 410

387-391 72 and 78S different paths, either of which a Student may take without degrading the dignity of his Art. The first is to combine the higher excellencies and embellish them to the greatest advantage. The other is to carry

409-410 72 and 78S with such manly pride as Euripides expressed to

410 72 and 78S compose, says he, my

386 Antoine Watteau.
393 *1 Henry IV* III.ii.45: "A fellow of no mark nor likelihood."
410-411 Valerius Maximus III.vii (De fiducia sui quae in externis). 1.

"works in order to be corrected by you, but to instruct you." It is true, to have a right to speak thus, a man must be an Euripides. However, thus much may be allowed, that when an Artist is sure that he is upon firm ground, supported by the authority and practice of his predecessors of the greatest reputation, he may then assume the boldness and intrepidity of genius; at any rate he must not be tempted out of the right path by any allurement of popularity, which always accompanies the lower styles of painting.

I MENTION this, because our Exhibitions, while they produce such admirable effects by nourishing emulation and calling out genius, have also a mischievous tendency, by seducing the Painter to an ambition of pleasing indiscriminately the mixed multitude of people who resort to them.

412 72 be a Euripides 419 72 and 78S exhibitions, that produce

417 72 and 78S any tide of popularity
that always

DISCOURSE VI

Delivered to the Students of The Royal Academy,

on the Distribution of the Prizes,

December 10, 1774

DISCOURSE VI

GENTLEMEN,

WHEN I have taken the liberty of addressing you on the course and order of your studies, I never proposed to enter into a minute detail of the art. This I have always left to the several Professors, who pursue the end of our institution with the highest honour to themselves, and with the greatest advantage to the Students.

MY purpose in the discourses I have held in the Academy has been, to lay down certain general positions, which seem to me proper for the formation of a sound taste: principles, necessary to guard the pupils against those errors, into which the sanguine temper common to their time of life has a tendency to lead them; and which have rendered abortive the hopes of so many successions of promising young men in all parts of Europe. I wished also, to intercept and suppress those prejudices which particularly prevail when the mechanism of painting is come to its perfection; and which, when they do prevail, are certain utterly to destroy the higher and more valuable parts of this literate and liberal profession.

THESE two have been my principal purposes; they are still as much my concern, as ever; and if I repeat my own notions on the subject, you who know how fast mistake and prejudice, when neglected, gain ground upon truth and reason, will easily excuse me. I only attempt to set the same thing in the greatest variety of lights.

6-7 74 and 78S Academy is, to lay down certain general Ideas, which

9-10 74 and 78S common at their

12 74 and 78S I wish also

14-15 74 and 78S certain to prevail to the utter destruction of the higher

18 74 and 78S own Ideas on

3 The "Instrument" establishing the Royal Academy provided four professorships: anatomy, architecture, painting, and perspective. The first incumbents were Dr. W. Hunter (anatomy), E. Penny (painting), T. Sandby (architecture), and S. Wale (perspective). There were two honorary professors: Samuel Johnson (ancient literature) and Oliver Goldsmith (ancient history). A professorship of sculpture was added in 1810 and of chemistry in 1871.

E

THE subject of this discourse will be *Imitation*, as far as a painter is concerned in it. By imitation I do not mean imitation in its largest sense, but simply the following of other masters, and the advantage to be drawn from the study of their works.

THOSE who have undertaken to write on our art, and have represented it as a kind of *inspiration*, as a *gift* bestowed upon peculiar favourites at their birth, seem to insure a much more favourable disposition from their readers, and have a much more captivating and liberal air, than he who attempts to examine, coldly, whether there are any means by which this art may be acquired; how the mind may be strengthened and expanded, and what guides will shew the way to eminence.

IT is very natural for those who are unacquainted with the *cause* of any thing extraordinary, to be astonished at the *effect*, and to consider it as a kind of magick. They, who have never observed the gradation by which art is acquired; who see only what is the full result of long labour and application of an infinite number and infinite variety of acts, are apt to conclude from their entire inability to do the same at once, that it is not only inaccessible to themselves, but can be done by those only, who have some gift of the nature of inspiration bestowed upon them.

THE travellers into the East tell us, that when the ignorant inhabitants of those countries are asked concerning the ruins of stately edifices yet remaining amongst them, the melancholy monuments of their former grandeur and long-lost science, they always answer, that they were built by magicians. The untaught mind finds a vast gulph between its own powers, and those works of complicated art, which it is utterly unable to fathom; and it supposes that such a void can be passed only by supernatural powers.

AND, as for artists themselves, it is by no means their interest to undeceive such judges, however conscious they may be of the very

30 74 and 78S who goes about to examine 44 74 and 78S of these countries
31 74 and 78S how our mind 48 74 and 78S and these works

43-47 See [Robert Wood], *The Ruins of Balbec* (London, 1757), p. 7: "whether he [Solomon] effected this work in a natural way, as the Jews affirm, or was assisted by spirits in the execution of what the Arabs think beyond human power, with many other opinions equally ridiculous, hath already been too seriously taken notice of by travellers and missionaries." Sir Joshua's copy of the book is now in the possession of F. W. Hilles, to whom I am indebted for drawing this passage to my attention.

natural means by which their extraordinary powers were acquired; though our art, being intrinsically imitative, rejects this idea of inspiration, more perhaps than any other. 55

IT is to avoid this plain confession of truth, as it should seem, that this imitation of masters, indeed almost all imitation, which implies a more regular and progressive method of attaining the ends of painting, has ever been particularly inveighed against with great keenness, both by ancient and modern writers. 60

To derive all from native power, to owe nothing to another, is the praise which men, who do not much think on what they are saying, bestow sometimes upon others, and sometimes on themselves; and their imaginary dignity is naturally heightened by a supercilious censure of the low, the barren, the groveling, the servile imitator. It would be 65
no wonder if a student, frightened by these terrifick and disgraceful epithets, with which the poor imitators are so often loaded, should let fall his pencil in mere despair; (conscious as he must be, how much he has been indebted to the labours of others, how little, how very little of his art was born with him;) and, consider it as hopeless, to 70
set about acquiring by the imitation of any human master, what he is taught to suppose is matter of inspiration from heaven.

SOME allowance must be made for what is said in the gaiety or ambition of rhetorick. We cannot suppose that any one can really mean to exclude all imitation of others. A position so wild would 75
scarce deserve a serious answer; for it is apparent, if we were forbid to make use of the advantages which our predecessors afford us, the art would be always to begin, and consequently remain always in its infant state; and it is a common observation, that no art was ever invented and carried to perfection at the same time. 80

BUT to bring us entirely to reason and sobriety, let it be observed, that a painter must not only be of necessity an imitator of the works of nature, which alone is sufficient to dispel this phantom of inspiration, but he must be as necessarily an imitator of the works of other painters:

53-54 74 and 78S which the extraordinary powers were acquired; our art

62 74 and 78S think what

66 74 and 78S these terrors and disgraceful

68 74 and 78S conscious how

70 74 and 78S and, considering it

73-74 98 gaiety of rhetorick

65 Reynolds alludes to Horace *Epistles* I.xix (to Maecenas).19: "imitatores, servum pecus." Reynolds uses the phrase again in "The Ironical Discourse." See Hilles, *Portraits by Sir Joshua Reynolds* (London, 1952), p. 134.

85 this appears more humiliating, but is equally true; and no man can be an artist, whatever he may suppose, upon any other terms.

HOWEVER, those who appear more moderate and reasonable, allow, that our study is to begin by imitation; but maintain that we should no longer use the thoughts of our predecessors, when we are become 90 able to think for ourselves. They hold that imitation is as hurtful to the more advanced student, as it was advantageous to the beginner.

FOR my own part, I confess, I am not only very much disposed to maintain the absolute necessity of imitation in the first stages of the art; but am of opinion, that the study of other masters, which I here call 95 imitation, may be extended throughout our whole lives, without any danger of the inconveniencies with which it is charged, of enfeebling the mind, or preventing us from giving that original air which every work undoubtedly ought always to have.

I AM on the contrary persuaded, that by imitation only, variety, 100 and even originality of invention, is produced. I will go further; even genius, at least what generally is so called, is the child of imitation. But as this appears to be contrary to the general opinion, I must explain my position before I enforce it.

GENIUS is supposed to be a power of producing excellencies, which 105 are out of the reach of the rules of art; a power which no precepts can teach, and which no industry can acquire.

THIS opinion of the impossibility of acquiring those beauties, which stamp the work with the character of genius, supposes, that it is something more fixed than in reality it is; and that we always do, and ever 110 did agree in opinion, with respect to what should be considered as the characteristick of genius. But the truth is, that the *degree* of excellence which proclaims *Genius* is different, in different times and different places; and what shews it to be so is, that mankind have often changed their opinion upon this matter.

115 WHEN the arts were in their infancy, the power of merely drawing the likeness of any object, was considered as one of its greatest efforts. The common people, ignorant of the principles of art, talk the same language, even to this day. But when it was found that every man could be taught to do this, and a great deal more, merely by the observ-

88 74 and 78S that study is to begin by imitation, but that

92-93 74 and 78S disposed, to lay down the absolute

95 74 and 78S whole life, without

110 74 and 78S agree, about what

110-111 74 and 78S as a characteristic of

ance of certain precepts; the name of Genius then shifted its application, and was given only to him who added the peculiar character of the object he represented; to him who had invention, expression, grace, or dignity; in short, those qualities, or excellencies, the power of producing which, could not *then* be taught by any known and promulgated rules.

WE are very sure that the beauty of form, the expression of the passions, the art of composition, even the power of giving a general air of grandeur to a work, is at present very much under the dominion of rules. These excellencies were, heretofore, considered merely as the effects of genius; and justly, if genius is not taken for inspiration, but as the effect of close observation and experience.

HE who first made any of these observations, and digested them, so as to form an invariable principle for himself to work by, had that merit, but probably no one went very far at once; and generally, the first who gave the hint, did not know how to pursue it steadily, and methodically; at least not in the beginning. He himself worked on it, and improved it; others worked more, and improved further; until the secret was discovered, and the practice made as general, as refined practice can be made. How many more principles may be fixed and ascertained, we cannot tell; but as criticism is likely to go hand in hand with the art which is its subject, we may venture to say, that as that art shall advance, its powers will be still more and more fixed by rules.

BUT by whatever strides criticism may gain ground, we need be under no apprehension, that invention will ever be annihilated, or subdued; or intellectual energy be brought entirely within the restraint of written law. Genius will still have room enough to expatiate, and keep always at the same distance from narrow comprehension and mechanical performance.

WHAT we now call Genius, begins, not where rules, abstractedly taken, end; but where known vulgar and trite rules have no longer any place. It must of necessity be, that even works of Genius, like every other effect, as they must have their cause, must likewise have their rules; it cannot be by chance, that excellencies are produced with any

121-124 74 and 78S to those who added the peculiar character of the object they represented; to those who had invention, expression, grace, or dignity; or in short, such qualities, or excellencies, the producing of which

128 74 and 78S to your work

137 74 and 78S improved farther, until

147 74 and 78S always the same

151-153 74 and 78S Genius as well as every other effect, as it must have its cause, must likewise have its rules

constancy or any certainty, for this is not the nature of chance; but the rules by which men of extraordinary parts, and such as are called men of Genius work, are either such as they discover by their own peculiar observations, or of such a nice texture as not easily to admit being expressed in words; especially as artists are not very frequently skilful in that mode of communicating ideas. Unsubstantial, however, as these rules may seem, and difficult as it may be to convey them in writing, they are still seen and felt in the mind of the artist; and he works from them with as much certainty, as if they were embodied, as I may say, upon paper. It is true, these refined principles cannot be always made palpable, like the more gross rules of art; yet it does not follow, but that the mind may be put in such a train, that it shall perceive, by a kind of scientifick sense, that propriety, which words, particularly words of unpractised writers, such as we are, can but very feebly suggest.

INVENTION is one of the great marks of genius; but if we consult experience, we shall find, that it is by being conversant with the inventions of others, that we learn to invent; as by reading the thoughts of others we learn to think.

WHOEVER has so far formed his taste, as to be able to relish and feel the beauties of the great masters, has gone a great way in his study; for, merely from a consciousness of this relish of the right, the mind swells with an inward pride, and is almost as powerfully affected, as if it had itself produced what it admires. Our hearts frequently warmed in this manner by the contact of those whom we wish to resemble, will undoubtedly catch something of their way of thinking; and we shall receive in our own bosoms some radiation at least of their fire and splendour. That disposition, which is so strong in children, still continues with us, of catching involuntarily the general air and manner of those with whom we are most conversant; with this difference only, that a young mind is naturally pliable and imitative; but in a more advanced state it grows rigid, and must be warmed and softened, before it will receive a deep impression.

FROM these considerations, which a little of your own reflection will carry a great way further, it appears, of what great consequence it is, that our minds should be habituated to the contemplation of excellence; and that, far from being contented to make such habits the dis-

156-157 74 and 78S peculiar observation, 157-158 74 and 78S admit handling, or
or expressing in words

 186 74 and 78S your reflection

cipline of our youth only, we should, to the last moment of our lives, 190
continue a settled intercourse with all the true examples of grandeur.
Their inventions are not only the food of our infancy, but the sub-
stance which supplies the fullest maturity of our vigour.

The mind is but a barren soil; a soil which is soon exhausted, and will
produce no crop, or only one, unless it be continually fertilized and 195
enriched with foreign matter.

When we have had continually before us the great works of Art
to impregnate our minds with kindred ideas, we are then, and not till
then, fit to produce something of the same species. We behold all about
us with the eyes of those penetrating observers whose works we con- 200
template; and our minds accustomed to think the thoughts of the
noblest and brightest intellects, are prepared for the discovery and selec-
tion of all that is great and noble in nature. The greatest natural genius
cannot subsist on its own stock: he who resolves never to ransack any
mind but his own, will be soon reduced, from mere barrenness, to the 205
poorest of all imitations; he will be obliged to imitate himself, and to
repeat what he has before often repeated. When we know the subject
designed by such men, it will never be difficult to guess what kind of
work is to be produced.

It is vain for painters or poets to endeavour to invent without mate- 210
rials on which the mind may work, and from which invention must
originate. Nothing can come of nothing.

Homer is supposed to be possessed of all the learning of his time: and
we are certain that Michael Angelo, and Raffaelle, were equally pos-
sessed of all the knowledge in the art which had been discovered in the 215
works of their predecessors.

A mind enriched by an assemblage of all the treasures of ancient and
modern art, will be more elevated and fruitful in resources in propor-
tion to the number of ideas which have been carefully collected and
thoroughly digested. There can be no doubt but that he who has the 220
most materials has the greatest means of invention; and if he has not
the power of using them, it must proceed from a feebleness of intellect;
or from the confused manner in which those collections have been
laid up in his mind.

The addition of other men's judgment is so far from weakening our 225

194 74 and 78S barren soil; is a soil soon 215 74 and 78S which was discoverable in

200-201 74 and 78S of these penetrating 225-226 74 and 78S weakening, as is the
observers; and our minds opinion of many, our own, that

own, as is the opinion of many, that it will fashion and consolidate those ideas of excellence which lay in embryo, feeble, ill-shaped, and confused, but which are finished and put in order by the authority and practice of those, whose works may be said to have been consecrated by having stood the test of ages.

THE mind, or genius, has been compared to a spark of fire, which is smothered by a heap of fuel, and prevented from blazing into a flame: This simile, which is made use of by the younger Pliny, may be easily mistaken for argument or proof. But there is no danger of the mind's being over-burthened with knowledge, or the genius extinguished by any addition of images; on the contrary, these acquisitions may as well, perhaps better, be compared, if comparisons signified any thing in reasoning, to the supply of living embers, which will contribute to strengthen the spark, that without the association of more fuel would have died away. The truth is, he whose feebleness is such, as to make other men's thoughts an incumbrance to him, can have no very great strength of mind or genius of his own to be destroyed; so that not much harm will be done at worst.

WE may oppose to Pliny the greater authority of Cicero, who is continually enforcing the necessity of this method of study. In his dialogue on Oratory, he makes Crassus say, that one of the first and most important precepts is, to choose a proper model for our imitation. *Hoc sit primum in præceptis meis ut demonstremus quem imitemur.*

WHEN I speak of the habitual imitation and continued study of masters, it is not to be understood, that I advise any endeavour to copy the exact peculiar colour and complexion of another man's mind; the success of such an attempt must always be like his, who imitates exactly the air, manner, and gestures, of him whom he admires. His model may be excellent, but the copy will be ridiculous; this ridicule does not arise from his having imitated, but from his not having chosen the right mode of imitation.

IT is a necessary and warrantable pride to disdain to walk servilely

227 74 and 78S in their birth feeble

234 74 and 78S or proof.
There is

236 74 and 78S may be as

239-240 74 and 78S more, would have

231-233 Reynolds' source for this image has never been discovered. It is not in Pliny. In his notes for this passage Reynolds attributes the image merely to "somebody." See Hilles, *Literary Career*, p. 226.

244 Cicero *De oratore* II.xxii.90: "... *quem imitetur.*"

behind any individual, however elevated his rank. The true and liberal ground of imitation is an open field; where, though he who precedes has had the advantage of starting before you, you may always propose to overtake him: it is enough however to pursue his course; you need not tread in his footsteps; and you certainly have a right to outstrip him if you can. 260

Nor whilst I recommend studying the art from artists, can I be supposed to mean, that nature is to be neglected: I take this study in aid, and not in exclusion, of the other. Nature is, and must be the fountain which alone is inexhaustible; and from which all excellencies must originally flow. 265

The great use of studying our predecessors is, to open the mind, to shorten our labour, and to give us the result of the selection made by those great minds of what is grand or beautiful in nature: her rich stores are all spread out before us; but it is an art, and no easy art, to know how or what to choose, and how to attain and secure the object of our choice. Thus the highest beauty of form must be taken from nature; but it is an art of long deduction, and great experience, to know how to find it. We must not content ourselves with merely admiring and relishing; we must enter into the principles on which the work is wrought: these do not swim on the superficies, and consequently are not open to superficial observers. 270 275

Art in its perfection is not ostentatious; it lies hid, and works its effect, itself unseen. It is the proper study and labour of an artist to uncover and find out the latent cause of conspicuous beauties, and from thence form principles for his own conduct: such an examination is a continual exertion of the mind; as great, perhaps, as that of the artist whose works he is thus studying. 280 285

The sagacious imitator does not content himself with merely remarking what distinguishes the different manner or genius of each master; he enters into the contrivance in the composition, how the masses of lights are disposed, the means by which the effect is produced, how artfully some parts are lost in the ground, others boldly relieved, and how all these are mutually altered and interchanged according to the reason and scheme of the work. He admires not the harmony of colouring alone, but examines by what artifice one colour is a foil to its 290

260-261 74 and 78S before you; yet it is enough to pursue

283 98 principles of his

286-287 74 and 78S imitator, not only remarks what

293 74 and 78S but he examines

neighbour. He looks close into the tints, examines of what colours they are composed, till he has formed clear and distinct ideas, and has learnt to see in what harmony and good colouring consists. What is learned in this manner from the works of others becomes really our own, sinks deep, and is never forgotten, nay, it is by seizing on this clue that we proceed forward, and, get further and further in enlarging the principles and improving the practice of our art.

THERE can be no doubt, but the art is better learnt from the works themselves than from the precepts which are formed upon those works; but if it is difficult to choose proper models for imitation, it requires no less circumspection to separate and distinguish what in those models we ought to imitate.

I CANNOT avoid mentioning here, though it is not my intention at present to enter into the art and method of study, an error which students are too apt to fall into. He that is forming himself, must look with great caution and wariness on those peculiarities, or prominent parts, which at first force themselves upon view; and are the marks, or what is commonly called the manner, by which that individual artist is distinguished.

PECULIAR marks, I hold to be, generally, if not always, defects; however difficult it may be wholly to escape them.

PECULIARITIES in the works of art, are like those in the human figure; it is by them that we are cognizable and distinguished one from another, but they are always so many blemishes; which, however, both in real life and in painting, cease to appear deformities, to those who have them continually before their eyes. In the works of art, even the most enlightened mind, when warmed by beauties of the highest kind, will by degrees find a repugnance within him to acknowledge any defects; nay, his enthusiasm will carry him so far, as to transform them into beauties, and objects of imitation.

IT must be acknowledged, that a peculiarity of style, either from its novelty, or by seeming to proceed from a peculiar turn of mind, often escapes blame; on the contrary, it is sometimes striking and pleasing; but this it is a vain labour to endeavour to imitate; because novelty and peculiarity being its only merit, when it ceases to be new, it ceases to have value.

294 74 and 78S tints, of what

299-301 74 and 78S the principle, and improving the practice.
There can

302 74 and 78S upon these works

317-318 74 and 78S both in the one case, and in the other, cease

327 74 and 78S is vain

A MANNER therefore being a defect, and every painter, however
excellent, having a manner, it seems to follow, that all kinds of faults,
as well as beauties, may be learned under the sanction of the greatest
authorities. Even the great name of Michael Angelo may be used, to
keep in countenance a deficiency or rather neglect of colouring, and
every other ornamental part of the art. If the young student is dry and
hard, Poussin is the same. If his work has a careless and unfinished air,
he has most of the Venetian school to support him. If he makes no selec-
tion of objects, but takes individual nature just as he finds it, he is like
Rembrant. If he is incorrect in the proportions of his figures, Correggio
was likewise incorrect. If his colours are not blended and united, Rubens
was equally crude. In short, there is no defect that may not be excused,
if it is a sufficient excuse that it can be imputed to considerable artists;
but it must be remembered, that it was not by these defects they ac-
quired their reputation; they have a right to our pardon, but not to
our admiration.

HOWEVER, to imitate peculiarities or mistake defects for beauties,
that man will be most liable, who confines his imitation to one favourite
master; and even though he chooses the best, and is capable of distin-
guishing the real excellencies of his model, it is not by such narrow prac-
tice, that a genius or mastery in the art is acquired. A man is as little
likely to form a true idea of the perfection of the art, by studying a
single artist, as he would be to produce a perfectly beautiful figure, by
an exact imitation of any individual living model. And as the painter,
by bringing together in one piece, those beauties which are dispersed
among a great variety of individuals, produces a figure more beautiful
than can be found in nature, so that artist who can unite in himself
the excellencies of the various great painters, will approach nearer to
perfection than any one of his masters. He, who confines himself to the
imitation of an individual, as he never proposes to surpass, so he is not
likely to equal, the object of his imitation. He professes only to follow;
and he that follows must necessarily be behind.

WE should imitate the conduct of the great artists in the course of
their studies, as well as the works which they produced, when they
were perfectly formed. Raffaelle began by imitating implicitly the man-

341 74 and 78S defect, but may be
352 74 and 78S be of producing a per-
fectly
354-355 74 and 78S dispersed amongst a
great

357 74 and 78S various Painters
360 74 and 78S object of imitation
364 74 and 78S Raffaelle begun by

365 ner of Pietro Perugino, under whom he studied; hence his first works are scarce to be distinguished from his master's; but soon forming higher and more extensive views, he imitated the grand outline of Michael Angelo; he learned the manner of using colours from the works of Leonardo da Vinci, and Fratre Bartolomeo: to all this he added the

370 contemplation of all the remains of antiquity that were within his reach; and employed others to draw for him what was in Greece and distant places. And it is from his having taken so many models, that he became himself a model for all succeeding painters; always imitating, and always original.

375 IF your ambition, therefore, be to equal Raffaelle, you must do as Raffaelle did; take many models, and not even *him* for your guide alone to the exclusion of others*. And yet the number is infinite of those who seem, if one may judge by their style, to have seen no other works but those of their master, or of some favourite, whose *manner* is their first

380 wish, and their last.

I WILL mention a few that occur to me of this narrow, confined, illiberal, unscientifick, and servile kind of imitators. Guido was thus meanly copied by Elizabetta Sirani, and Simone Cantarini; Poussin, by Verdier, and Cheron; Parmeggiano, by Jeronimo Mazzuoli. Paolo Vero-

385 nese, and Iacomo Bassan, had for their imitators their brothers and

*Sed non qui maxime imitandus, etiam solus imitandus est. Quintilian.

365	74	studied, so his	376	74 and 78S	not take even
365	78S	studied; so his	383	74, 78S, 97 and 98	Elizabetta, Sirani
			384	74	Parmeggiano, by Francesco Maz-
375	74	therefore to be equal	zuoli		

377*n* Quintilian *Institutio oratoria* X.ii.24.

381-392 Reynolds' judgment has generally been borne out. Most of the "servile imitators" are now remembered only by specialists, whereas those who "adopted a more liberal style of imitation" have retained the interest of students. Biographical notes on the various artists are readily available in *Allgemeines Lexikon der Bildenden Künstler*, ed. Ulrich Thieme and Felix Becker (Leipzig, 1908-50). Notes are included here only on those names about which there might be some confusion or uncertainty.

383 The 1797 text, like the earlier ones, reads "Elizabetta, Sirani," but there is no doubt that only one artist is intended, Elisabetta Sirani (1638-1665).

384 Probably François Verdier (1651-1730), pupil, assistant, and follower of LeBrun. Dimier thought Reynolds meant Elisabeth Sophie Chéron (1648-1711). Her brother Louis (1660-1713) may also be intended.

384 Girolamo Mazzola-Bedoli (1500-1569), cousin, pupil, and follower of Parmigianino.

385 Brothers and sons of Veronese: Benedetto Caliari (1538-1598), brother; Carlo Caliari (1570-1596), son; Gabriele Caliari (1568-1631), son. Sons of Giacomo Bassano (ca. 1510-1592): Gerolamo, Francesco, Giambattista, Leandro.

sons. Pietro de Cortona was followed by Ciro Ferri, and Romanelli; Rubens, by Jacques Jordans, and Diepenbeck; Guercino, by his own family, the Gennari. Carlo Maratti was imitated by Giuseppe Chiari, and Pietro da Pietri; and Rembrant, by Bramer, Eckhout, and Flink. All these, to whom may be added a much longer list of painters, whose works among the ignorant pass for those of their masters, are justly to be censured for barrenness and servility. 390

To oppose to this list a few that have adopted a more liberal style of imitation;—Pelegrino Tibaldi, Rosso, and Primaticcio, did not coldly imitate, but caught something of the fire that animates the works 395 of Michael Angelo. The Caraccis formed their style from Pelegrino Tibaldi, Correggio, and the Venetian School. Domenichino, Guido, Lanfranco, Albano, Guercino, Cavidone, Schidone, Tiarini, though it is sufficiently apparent that they came from the school of the Caraccis, have yet the appearance of men who extended their views beyond the 400 model that lay before them, and have shewn that they had opinions of their own, and thought for themselves, after they had made themselves masters of the general principles of their schools.

LE SUEUR's first manner resembles very much that of his master Voüet: but as he soon excelled him, so he differed from him in every 405 part of the art. Carlo Maratti succeeded better than those I have first named, and I think owes his superiority to the extension of his views; beside his master Andrea Sacchi, he imitated Raffaelle, Guido, and the Caraccis. It is true, there is nothing very captivating in Carlo Maratti; but this proceeded from a want which cannot be completely supplied; 410 that is, want of strength of parts. In this certainly men are not equal; and a man can bring home wares only in proportion to the capital with which he goes to market. Carlo, by diligence, made the most of what he had; but there was undoubtedly a heaviness about him, which extended itself, uniformly, to his invention, expression, his drawing, col- 415 ouring, and the general effect of his pictures. The truth is, he never

407-408 74 and 78S views; besides his 410 74 and 78S from wants which

387 Jacob Jordaens (1593-1678). Reynolds is unfair to Jordaens who, although in close contact with Rubens, had a distinct, easily recognizable personality of his own.

398 The last three, Giacomo Cavedone (1577-1660), Schidone (1570-1615), and Alexander Tiarini (1577-1668), hardly rank by modern standards alongside the other artists with whom they are grouped.

404-405 See IV, n. 332-333.

406 See IV, 179n.

equalled any of his patterns in any one thing, and he added little of his own.

But we must not rest contented even in this general study of the
420 moderns; we must trace back the art to its fountain-head; to that source from whence they drew their principal excellencies, the monuments of pure antiquity. All the inventions and thoughts of the Antients, whether conveyed to us in statues, bas-reliefs, intaglios, cameos, or coins, are to be sought after and carefully studied: the genius that hovers
425 over these venerable reliques, may be called the father of modern art.

From the remains of the works of the antients the modern arts were revived, and it is by their means that they must be restored a second time. However it may mortify our vanity, we must be forced to allow them our masters; and we may venture to prophecy, that when they
430 shall cease to be studied, arts will no longer flourish, and we shall again relapse into barbarism.

The fire of the artist's own genius operating upon these materials which have been thus diligently collected, will enable him to make new combinations, perhaps, superior to what had ever before been in the
435 possession of the art: as in the mixture of the variety of metals, which are said to have been melted and run together at the burning of Corinth, a new and till then unknown metal was produced, equal in value to any of those that had contributed to its composition. And though a curious refiner should come with his crucibles, analyse and separate its various
440 component parts, yet Corinthian brass would still hold its rank amongst the most beautiful and valuable of metals.

We have hitherto considered the advantages of imitation as it tends to form the taste, and as a practice by which a spark of that genius may be caught, which illumines those noble works that ought always to
445 be present to our thoughts.

We come now to speak of another kind of imitation; the borrow-ing a particular thought, an action, attitude, or figure, and transplanting it into your own work: this will either come under the charge of plagiarism, or be warrantable, and deserve commendation, according
450 to the address with which it is performed. There is some difference likewise, whether it is upon the antients or the moderns that these

439 74 and 78S refiner may come 451 98 antients or moderns
444 74 and 78S illumines these noble

435-441 Pliny, whom Reynolds acknowledges as a source on many occasions, discusses Corinthian brass in *Historia naturalis* XXXIV.iii.

depredations are made. It is generally allowed, that no man need be ashamed of copying the antients: their works are considered as a magazine of common property, always open to the publick, whence every man has a right to take what materials he pleases; and if he has the art of using them, they are supposed to become to all intents and purposes his own property. The collection of the thoughts of the antients, which Raffaelle made with so much trouble, is a proof of his opinion on this subject. Such collections may be made with much more ease, by means of an art scarce known in his time; I mean that of engraving; by which, at an easy rate, every man may now avail himself of the inventions of antiquity.

IT must be acknowledged that the works of the moderns are more the property of their authors; he, who borrows an idea from an antient, or even from a modern artist not his contemporary, and so accommodates it to his own work, that it makes a part of it, with no seam or joining appearing, can hardly be charged with plagiarism: poets practise this kind of borrowing, without reserve. But an artist should not be contented with this only; he should enter into a competition with his original, and endeavour to improve what he is appropriating to his own work. Such imitation is so far from having any thing in it of the servility of plagiarism, that it is a perpetual exercise of the mind, a continual invention. Borrowing or stealing with such art and caution, will have a right to the same lenity as was used by the Lacedemonians; who did not punish theft, but the want of artifice to conceal it.

IN order to encourage you to imitation, to the utmost extent, let me add, that very finished artists in the inferior branches of the art, will contribute to furnish the mind and give hints, of which a skilful painter, who is sensible of what he wants, and is in no danger of being infected by the contact of vicious models, will know how to avail himself. He will pick up from dunghills what by a nice chymistry, passing through his own mind, shall be converted into pure gold; and, under the rudeness of Gothick essays, he will find original, rational, and even sublime inventions.

455 74 and 78S right to what

457-458 74 and 78S collection which Raffaelle made of the thoughts of the antients with

464-465 74 and 78S from an artist, or perhaps from a modern, not

483-490 74 and 78S sublime inventions. In the luxuriant

[one paragraph omitted in 74 and 78S]

473-475 "Life of Lycurgus," in *Plutarch's Lives*, trans. John Langhorne (London, 1770), I, 125.

485 THE works of Albert Durer, Lucas Van Leyden, the numerous inventions of Tobias Stimer, and Jost Ammon, afford a rich mass of genuine materials, which wrought up and polished to elegance, will add copiousness to what, perhaps, without such aid, could have aspired only to justness and propriety.

Plate XVI IN the luxuriant style of Paul Veronese, in the capricious compositions of Tintoret, he will find something, that will assist his invention, and give points, from which his own imagination shall rise and take flight, when the subject which he treats will with propriety admit of splendid effects.

495 IN every school, whether Venetian, French, or Dutch, he will find, either ingenious compositions, extraordinary effects, some peculiar expressions, or some mechanical excellence, well worthy of his attention, and, in some measure, of his imitation. Even in the lower class of the French painters great beauties are often found united with great defects.

500 Though Coypel wanted a simplicity of taste, and mistook a presumptuous and assuming air for what is grand and majestick; yet he frequently has good sense and judgment in his manner of telling his stories, great skill in his compositions, and is not without a considerable power of expressing the passions. The modern affectation of grace in his works,

505 as well as in those of Bouche and Vatteau, may be said to be separated, by a very thin partition, from the more simple and pure grace of Correggio and Parmeggiano.

 AMONG the Dutch painters, the correct, firm, and determined pencil,

494 97 splended	507-508 74 and 78S and Parmeggiano.	
497 74 and 78S worthy his	Amongst the	

485-489 In a section of Reynolds' reading notes now in the possession of F. W. Hilles the following passage has been copied out from Johnson's "Life of Cowley" (*Lives of the English Poets*, ed. George B. Hill [Oxford, 1905], I, 22): "in the mass of materials, which ingenious absurdity has thrown together, genuine wit and useful knowledge may be sometimes found, buried perhaps in grossness of expression, but useful to those who know their value, and such as, when they are expanded to perspicuity and polished to elegance, may give lustre to works which have more propriety though less copiousness of sentiment."

486 Tobias Stimmer (1539-1584); Jost Amman (1539-1591).

500 There were several painters with the surname Coypel in late 17th- and early 18th-century France. Reynolds probably means Antoine (1661-1722), who painted the vault of the chapel at Versailles. See VIII, 175.

505 Reynolds means Boucher and Watteau. Malone's arbitrary alteration of "Bouche" to "Bosch" in the 1798 edition caused trouble for later editors, especially Fry, who depended on that edition. In Discourse XII (529), where Reynolds is unmistakably referring to Boucher, he also spells the name "Bouche" in the 1784 edition. Hendrik Jansen in his 18th-century French translation understood the name correctly.

which was employed by Bamboccio and Jean Miel, on vulgar and mean subjects, might, without any change, be employed on the highest; to 510 which, indeed, it seems more properly to belong. The greatest style, if that style is confined to small figures, such as Poussin generally *Plate XIV* painted, would receive an additional grace by the elegance and precision of pencil so admirable in the works of Teniers; and though the school to which he belonged more particularly excelled in the mechanism 515 of painting, yet it produced many, who have shewn great abilities in expressing what must be ranked above mechanical excellencies. In the works of Frank Halls, the portrait-painter may observe the composition of a face, the features well put together, as the painters express it; from whence proceeds that strong-marked character of individual 520 nature, which is so remarkable in his portraits, and is not found in an equal degree in any other painter. If he had joined to this most difficult part of the art, a patience in finishing what he had so correctly planned, he might justly have claimed the place which Vandyck, all things considered, so justly holds as the first of portrait-painters. 525

OTHERS of the same school have shewn great power in expressing the character and passions of those vulgar people, which were the subjects of their study and attention. Among those Jean Stein seems *Plate VIII* to be one of the most diligent and accurate observers of what passed in those scenes which he frequented, and which were to him an academy. 530 I can easily imagine, that if this extraordinary man had had the good fortune to have been born in Italy, instead of Holland, had he lived in Rome instead of Leyden, and been blessed with Michael Angelo and Raffaelle for his masters, instead of Brower and Van Gowen; the same sagacity and penetration which distinguished so accurately the dif- 535 ferent characters and expression in his vulgar figures, would, when exerted in the selection and imitation of what was great and elevated

514-516 74 and 78S of Teniers.
Though this school more particularly excelled in the mechanism of painting, yet there are many

521 74 and 78S not to be found

527-528 74 and 78S which are the subjects

528 74 and attention.
Amongst those

528 78S attention. Amongst those

533 74 and 78S and had been

534 74 and 78S Van Gowen; that the same

509 Bamboccio was Pieter van Laer, nicknamed Bamboccio or Bamboots (1592 or 1595-1642). He was active in Haarlem and studied in France and Italy. Jan Miel (1599-1663) was born in Antwerp; he spent much of his life in Italy.

518 Frans Hals.

in nature, have been equally successful; and he now would have ranged with the great pillars and supporters of our Art.

540 MEN who although thus bound down by the almost invincible powers of early habits, have still exerted extraordinary abilities within their narrow and confined circle; and have, from the natural vigour of their mind, given a very interesting expression, and great force and energy to their works; though they cannot be recommended to be exactly

545 imitated, may yet invite an artist to endeavour to transfer, by a kind of parody, their excellencies to his own performances. Whoever has acquired the power of making this use of the Flemish, Venetian, and French schools, is a real genius, and has sources of knowledge open to him which were wanting to the great artists who lived in the great age

550 of painting.

To find excellencies, however dispersed, to discover beauties, however concealed by the multitude of defects with which they are sur-rounded, can be the work only of him, who having a mind always alive to his art, has extended his views to all ages and to all schools; and has

555 acquired from that comprehensive mass which he has thus gathered to himself, a well-digested and perfect idea of his art, to which every thing is referred. Like a sovereign judge and arbiter of art, he is possessed of that presiding power which separates and attracts every excellence from every school; selects both from what is great, and what is little;

560 brings home knowledge from the East and from the West; making the universe tributary towards furnishing his mind and enriching his works with originality, and variety of inventions.

THUS I have ventured to give my opinion of what appears to me the true and only method by which an artist makes himself master of his

565 profession; which I hold ought to be one continued course of imitation that is not to cease but with his life.

538 74 and 78S successful, and his name would have been now ranged

543 74 and 78S given such an interesting expression, such force

546 74 and 78S parody, those excellen-cies to his own works. Whoever

566-567 74 and 78S with our lives. Those, who

557-562 James Northcote, a young painter who was living with Reynolds when this dis-course was written, wrote: "I remember one day in particular, after Sir Joshua had been study-ing the preceding night, Burke paid him a morning visit, and at that time I was at work in the adjoining room, and could easily overhear their conversation, which, as Sir Joshua was deaf, was very distinct; and he read aloud to Burke the following paragraph of his discourse for December the 10th, 1774. 'Like a sovereign judge . . . invention'. Burke commended it in the highest terms saying, 'This is, indeed, excellent, nobody can mend it, no man could say it better'." *The Life of Sir Joshua Reynolds* (London, 1818), II, 315 f.

THOSE, who either from their own engagements and hurry of business, or from indolence, or from conceit and vanity, have neglected looking out of themselves, as far as my experience and observation reaches, have from that time, not only ceased to advance, and improve in their performances, but have gone backward. They may be compared to men who have lived upon their principal till they are reduced to beggary, and left without resources.

I CAN recommend nothing better, therefore, than that you endeavour to infuse into your works what you learn from the contemplation of the works of others. To recommend this has the appearance of needless and superfluous advice; but it has fallen within my own knowledge, that artists, though they were not wanting in a sincere love for their art, though they had great pleasure in seeing good pictures, and were well skilled to distinguish what was excellent or defective in them, yet have gone on in their own manner, without any endeavour to give a little of those beauties, which they admired in others, to their own works. It is difficult to conceive how the present Italian painters, who live in the midst of the treasures of art, should be contented with their own style. They proceed in their common-place inventions, and never think it worth while to visit the works of those great artists with which they are surrounded.

I REMEMBER, several years ago, to have conversed at Rome with an artist of great fame throughout Europe; he was not without a considerable degree of abilities, but those abilities were by no means equal to his own opinion of them. From the reputation he had acquired, he too fondly concluded that he stood in the same rank, when compared with his predecessors, as he held with regard to his miserable contemporary rivals. In conversation about some particulars of the works of Raffaelle, he seemed to have, or to affect to have, a very obscure memory of them. He told me that he had not set his foot in the Vatican for fifteen years together; that indeed he had been in treaty to copy a capital picture

570

575

580

585

590

595

571 74 their performance but
571 78S their performance, but
578 74 and 78S they are not
579-581 74 and 78S they have great pleasure in seeing good pictures, and are well

skilled to distinguish what is excellent or defective in them, yet go on
582 74 and 78S they admire in
592-593 74 and 78S compared to his
597 98 that he

588-589 Fry, taking a note that Edmund Gosse had received from F. G. Stephens, suggests that Raphael Mengs may be the painter to whom reference is made. Mengs's known admiration for and dependence on the work of Raphael make this unlikely. Pompeo Batoni is a more probable candidate.

of Raffaelle, but that the business had gone off; however, if the agreement had held, his copy would have greatly exceeded the original. The merit of this artist, however great we may suppose it, I am sure would have been far greater, and his presumption would have been far less, if he had visited the Vatican, as in reason he ought to have done, at least once every month of his life.

I address myself, Gentlemen, to you who have made some progress in the art, and are to be, for the future, under the guidance of your own judgment and discretion. I consider you as arrived to that period, when you have a right to think for yourselves, and to presume that every man is fallible; to study the masters with a suspicion, that great men are not always exempt from great faults; to criticise, compare, and rank their works in your own estimation, as they approach to, or recede from, that standard of perfection which you have formed in your own minds, but which those masters themselves, it must be remembered, have taught you to make; and which you will cease to make with correctness, when you cease to study them. It is their excellencies which have taught you their defects.

I would wish you to forget where you are, and who it is that speaks to you. I only direct you to higher models and better advisers. We can teach you here but very little; you are henceforth to be your own teachers. Do this justice, however, to the English Academy; to bear in mind, that in this place you contracted no narrow habits, no false ideas, nothing that could lead you to the imitation of any living master, who may be the fashionable darling of the day. As you have not been taught to flatter us, do not learn to flatter yourselves. We have endeavoured to lead you to the admiration of nothing but what is truly admirable. If you choose inferior patterns, or if you make your own *former* works your patterns for your *latter*, it is your own fault.

The purport of this discourse, and, indeed, of most of my other discourses, is, to caution you against that false opinion, but too prevalent

602-603 74 and 78S done, once at least every

612 74 and 78S own mind, but

626-627 74 and 78S own fault. The purpose of

627-628 74 and 78S my others, is

628-629 74 and 78S prevalent amongst Artists

622-623 Algarotti censured continental academies because pupils attempted to please the masters. Great painters, he said, "painted, not to flatter a master, but to please mankind" (p. 149).

among artists, of the imaginary power of native genius, and its suf-
ficiency in great works. This opinion, according to the temper of mind 630
it meets with, almost always produces, either a vain confidence, or a
sluggish despair, both equally fatal to all proficiency.

STUDY therefore the great works of the great masters, for ever. Study
as nearly as you can, in the order, in the manner, and on the principles,
on which they studied. Study nature attentively, but always with those 635
masters in your company; consider them as models which you are to
imitate, and at the same time as rivals with whom you are to contend.

629 98 imaginary powers of 637 74 and 78S rivals, which you are to
634 74 manner, on the the principles combat
634 78S manner, on the principles

DISCOURSE VII

Delivered to the Students of The Royal Academy,

on the Distribution of the Prizes,

December 10, 1776

DISCOURSE VII

GENTLEMEN,

IT has been my uniform endeavour, since I first addressed you from
this place, to impress you strongly with one ruling idea. I wished
you to be persuaded, that success in your art depends almost entirely
on your own industry; but the industry which I principally recom-
mended, is not the industry of the *hands*, but of the *mind*. 5

As our art is not a divine *gift*, so neither is it a mechanical *trade*. Its
foundations are laid in solid science: and practice, though essential to
perfection, can never attain that to which it aims, unless it works under
the direction of principle.

SOME writers upon art carry this point too far, and suppose that 10
such a body of universal and profound learning is requisite, that the
very enumeration of its kinds is enough to frighten a beginner. Vitru-
vius, after going through the many accomplishments of nature, and the
many acquirements of learning, necessary to an architect, proceeds
with great gravity to assert, that he ought to be well skilled in the civil 15
law; that he may not be cheated in the title of the ground he builds
on. But without such exaggeration, we may go so far as to assert, that
a painter stands in need of more knowledge than is to be picked off his
pallet, or collected by looking on his model, whether it be in life or in
picture. He can never be a great artist, who is grossly illiterate. 20

EVERY man whose business is description, ought to be tolerably con-
versant with the poets, in some language or other; that he may imbibe a
poetical spirit, and enlarge his stock of ideas. He ought to acquire an
habit of comparing and digesting his notions. He ought not to be
wholly unacquainted with that part of philosophy which gives an insight 25

8 98 can ever attain 20 76 He never can be
10 76 art overdo this point, and 25 76 and 78S gives him an

12-17 Vitruvius *De architectura* I.i.10.

117

into human nature, and relates to the manners, characters, passions, and affections. He ought to know *something* concerning the mind, as well as *a great deal* concerning the body of man. For this purpose, it is not necessary that he should go into such a compass of reading, as must, by distracting his attention, disqualify him for the practical part of his profession, and make him sink the performer in the critick. Reading, if it can be made the favourite recreation of his leisure hours, will improve and enlarge his mind, without retarding his actual industry. What such partial and desultory reading cannot afford, may be supplied by the conversation of learned and ingenious men, which is the best of all substitutes for those who have not the means or opportunities of deep study. There are many such men in this age; and they will be pleased with communicating their ideas to artists, when they see them curious and docile, if they are treated with that respect and deference which is so justly their due. Into such society, young artists, if they make it the point of their ambition, will by degrees be admitted. There, without formal teaching, they will insensibly come to feel and reason like those they live with, and find a rational and systematick taste imperceptibly formed in their minds, which they will know how to reduce to a standard, by applying general truth to their own purposes, better perhaps than those to whom they owed the original sentiment.

OF these studies, and this conversation, the desired and legitimate offspring is a power of distinguishing right from wrong; which power applied to works of art, is denominated *Taste*. Let me then, without further introduction, enter upon an examination, whether taste be so far beyond our reach, as to be unattainable by care; or be so very vague and capricious, that no care ought to be employed about it.

IT has been the fate of arts to be enveloped in mysterious and incomprehensible language, as if it was thought necessary that even the terms should correspond to the idea entertained of the instability and uncertainty of the rules which they expressed.

To speak of genius and taste, as in any way connected with reason

57 76 and 78S as any

35 Reynolds' own associations with "learned and ingenious men" immediately come to mind. He numbered among his intimate friends Dr. Johnson, Edmund Burke, and Oliver Goldsmith, and he spent most of his leisure time in their company (see Hilles, *Literary Career*, Ch. ii).

Ascanio Condivi: "And as he [Michelangelo] has delighted much in the conversation of learned men, so has he taken pleasure in reading the writers both of prose and verse .." (*The Life of Michelagnolo Buonarroti*, trans. Herbert P. Horne [(Boston, 1904)], p. 80).

or common sense, would be, in the opinion of some towering talkers, to speak like a man who possessed neither; who had never felt that enthusiasm, or, to use their own inflated language, was never warmed by that Promethean fire, which animates the canvas and vivifies the marble.

If, in order to be intelligible, I appear to degrade art by bringing her down from her visionary situation in the clouds, it is only to give her a more solid mansion upon the earth. It is necessary that at some time or other we should see things as they really are, and not impose on ourselves by that false magnitude with which objects appear when viewed indistinctly as through a mist.

We will allow a poet to express his meaning, when his meaning is not well known to himself, with a certain degree of obscurity, as it is one source of the sublime. But when, in plain prose, we gravely talk of courting the muse in shady bowers; waiting the call and inspiration of Genius, finding out where he inhabits, and where he is to be invoked with the greatest success; of attending to times and seasons when the imagination shoots with the greatest vigour, whether at the summer solstice or the vernal equinox; sagaciously observing how much the wild freedom and liberty of imagination is cramped by attention to established rules; and how this same imagination begins to grow dim in advanced age, smothered and deadened by too much judgment; when we talk such language, or entertain such sentiments as these, we generally rest contented with mere words, or at best entertain notions not only groundless, but pernicious.

If all this means, what it is very possible was originally intended only to be meant, that in order to cultivate an art, a man secludes himself from the commerce of the world, and retires into the country at particular seasons; or that at one time of the year his body is in better health, and consequently his mind fitter for the business of hard thinking than at another time; or that the mind may be fatigued and grow confused by long and unremitted application; this I can understand. I can like-

60 76 was ever warmed 76 78S or the equinox

76 76 or the equinox; when it is saga- 78 76 rules; or how
ciously observed how

69-71 See Burke's *The Sublime and Beautiful*, passim. This is one of the few instances in which Reynolds seems to think of the sublime in the same terms as Burke.

71-82 Thompson (p. 341) points out that Johnson held similar thoughts about the creative process (*Rasselas*, Chs. xvi, xx).

90 wise believe, that a man eminent when young for possessing poetical imagination, may, from having taken another road, so neglect its cultivation, as to shew less of its powers in his latter life. But I am persuaded, that scarce a poet is to be found, from Homer down to Dryden, who preserved a sound mind in a sound body, and continued practising his

95 profession to the very last, whose latter works are not as replete with the fire of imagination, as those which were produced in his more youthful days.

To understand literally these metaphors or ideas expressed in poetical language, seems to be equally absurd as to conclude, that because

100 painters sometimes represent poets writing from the dictates of a little winged boy or genius, that this same genius did really inform him in a whisper what he was to write; and that he is himself but a mere machine, unconscious of the operations of his own mind.

Opinions generally received and floating in the world, whether

105 true or false, we naturally adopt and make our own; they may be considered as a kind of inheritance to which we succeed and are tenants for life, and which we leave to our posterity very nearly in the condition in which we received it; it not being much in any one man's power either to impair or improve it. The greatest part of these opinions, like

110 current coin in its circulation, we are used to take without weighing or examining; but by this inevitable inattention many adulterated pieces are received, which, when we seriously estimate our wealth, we must throw away. So the collector of popular opinions, when he embodies his knowledge, and forms a system, must separate those which are true

115 from those which are only plausible. But it becomes more peculiarly a duty to the professors of art not to let any opinions relating to *that* art pass unexamined. The caution and circumspection required in such examination we shall presently have an opportunity of explaining.

Genius and taste, in their common acceptation, appear to be very

120 nearly related; the difference lies only in this, that genius has superadded to it a habit or power of execution: or we may say, that taste, when this power is added, changes its name, and is called genius. They both, in the popular opinion, pretend to an entire exemption from the restraint of rules. It is supposed that their powers are intuitive; that

95 76 and 78S whose later works 110 76 and 78S are obliged to

107-108 76 and 78S very near in the condition in which we received it; not much being in

under the name of genius great works are produced, and under the name 125
of taste an exact judgment is given, without our knowing why, and
without our being under the least obligation to reason, precept, or
experience.

ONE can scarce state these opinions without exposing their absurdity;
yet they are constantly in the mouths of men, and particularly of artists. 130
They who have thought seriously on this subject, do not carry the
point so far; yet I am persuaded, that even among those few who may
be called thinkers, the prevalent opinion allows less than it ought to
the powers of reason; and considers the principles of taste, which give
all their authority to the rules of art, as more fluctuating, and as having 135
less solid foundations, than we shall find, upon examination, they really
have.

THE common saying, that *tastes are not to be disputed*, owes its in-
fluence, and its general reception, to the same error which leads us
to imagine this faculty of too high an original to submit to the authority 140
of an earthly tribunal. It likewise corresponds with the notions of those
who consider it as a mere phantom of the imagination, so devoid of
substance as to elude all criticism.

WE often appear to differ in sentiments from each other, merely
from the inaccuracy of terms, as we are not obliged to speak always 145
with critical exactness. Something of this too may arise from want of
words in the language in which we speak, to express the more nice
discriminations which a deep investigation discovers. A great deal how-
ever of this difference vanishes, when each opinion is tolerably explained
and understood by constancy and precision in the use of terms. 150

WE apply the term *Taste* to that act of the mind by which we like
or dislike, whatever be the subject. Our judgment upon an airy nothing,
a fancy which has no foundation, is called by the same name which we
give to our determination concerning those truths which refer to the

127 76 and 78S without being

133 76 and 78S opinion gives less

140 76 and 78S imagine it of too high
original to submit

141 76 and 78S It will likewise corre-
spond with

147 76 and 78S language to express

138 ff. See Alexander Gerard, *An Essay on Taste* (Edinburgh, 1780 [first pub., 1759]), p. 207.

151-152 Thompson (pp. 355-356) quotes Addison on taste: "that faculty of the soul, which
discerns the beauties of an author with pleasure, and the imperfections with dislike" (*Spectator*,
No. 409); and Thomas Reid, "that power of the mind by which we are capable of discerning
and relishing the beauties of nature, and whatever is excellent in the fine arts" ("Of Taste," in
Essays on the Intellectual Powers of Man [Edinburgh, 1785]).

155 most general and most unalterable principles of human nature; to the
works which are only to be produced by the greatest efforts of the
human understanding. However inconvenient this may be, we are
obliged to take words as we find them; all we can do is to distinguish
the *things* to which they are applied.

160 WE may let pass those things which are at once subjects of taste and
sense, and which having as much certainty as the senses themselves,
give no occasion to enquiry or dispute. The natural appetite or taste
of the human mind is for *Truth;* whether that truth results from the
real agreement or equality of original ideas among themselves; from the
165 agreement of the representation of any object with the thing repre-
sented; or from the correspondence of the several parts of any arrange-
ment with each other. It is the very same taste which relishes a demon-
stration in geometry, that is pleased with the resemblance of a picture
to an original, and touched with the harmony of musick.

170 ALL these have unalterable and fixed foundations in nature, and are
therefore equally investigated by reason, and known by study; some
with more, some with less clearness, but all exactly in the same way.
A picture that is unlike, is false. Disproportionate ordonnance of parts
is not right; because it cannot be true, until it ceases to be a contradic-
175 tion to assert, that the parts have no relation to the whole. Colouring is
true when it is naturally adapted to the eye, from brightness, from
softness, from harmony, from resemblance; because these agree with
their object, *nature,* and therefore are true; as true as mathematical
demonstration; but known to be true only to those who study these
180 things.

BUT beside *real,* there is also *apparent* truth, or opinion, or prejudice.
With regard to real truth, when it is known, the taste which conforms
to it, is, and must be, uniform. With regard to the second sort of truth,
which may be called truth upon sufferance, or truth by courtesy, it
185 is not fixed, but variable. However, whilst these opinions and prejudices,
on which it is founded, continue, they operate as truth; and the art,
whose office it is to please the mind, as well as instruct it, must direct
itself according to *opinion,* or it will not attain its end.

IN proportion as these prejudices are known to be generally diffused,
190 or long received, the taste which conforms to them approaches nearer

155-156	76	nature, and those works	176	76 and 78S	true where it
155-156	78S	nature, to works	181	76 and 78S	But besides *real*
174	76	true; it			

to certainty, and to a sort of resemblance to real science, even where opinions are found to be no better than prejudices. And since they deserve, on account of their duration and extent, to be considered as really true, they become capable of no small degree of stability and determination by their permanent and uniform nature. 195

As these prejudices become more narrow, more local, more transitory, this secondary taste becomes more and more fantastical; recedes from real science; is less to be approved by reason, and less followed in practice; though in no case perhaps to be wholly neglected, where it does not stand, as it sometimes does, in direct defiance of the most respectable opinions received amongst mankind. 200

HAVING laid down these positions, I shall proceed with less method, because less will serve, to explain and apply them.

WE will take it for granted, that reason is something invariable and fixed in the nature of things; and without endeavouring to go back to 205 an account of first principles, which for ever will elude our search, we will conclude, that whatever goes under the name of taste, which we can fairly bring under the dominion of reason, must be considered as equally exempt from change. If therefore, in the course of this enquiry, we can shew that there are rules for the conduct of the artist 210 which are fixed and invariable, it follows of course, that the art of the connoisseur, or, in other words, taste, has likewise invariable principles.

OF the judgment which we make on the works of art, and the preference that we give to one class of art over another, if a reason be demanded, the question is perhaps evaded by answering, I judge from 215 my taste; but it does not follow that a better answer cannot be given, though, for common gazers, this may be sufficient. Every man is not obliged to investigate the causes of his approbation or dislike.

THE arts would lie open for ever to caprice and casualty, if those who are to judge of their excellencies had no settled principles by which 220 they are to regulate their decisions, and the merit or defect of performances were to be determined by unguided fancy. And indeed we may venture to assert, that whatever speculative knowledge is necessary to the artist, is equally and indispensably necessary to the connoisseur.

THE first idea that occurs in the consideration of what is fixed in 225 art, or in taste, is that presiding principle of which I have so frequently spoken in former discourses,—the general idea of nature. The beginning,

192-193 76 since, for the greater part, 211 76 and 78S it implies of course
they deserve in that case, on account

the middle, and the end of every thing that is valuable in taste, is comprised in the knowledge of what is truly nature; for whatever notions
230 are not conformable to those of nature, or universal opinion, must be considered as more or less capricious.

MY notion of nature comprehends not only the forms which nature produces, but also the nature and internal fabrick and organization, as I may call it, of the human mind and imagination. The terms beauty,
235 or nature, which are general ideas, are but different modes of expressing the same thing, whether we apply these terms to statues, poetry, or picture. Deformity is not nature, but an accidental deviation from her accustomed practice. This general idea therefore ought to be called Nature, and nothing else, correctly speaking, has a right to that name.
240 But we are so far from speaking, in common conversation, with any such accuracy, that, on the contrary, when we criticise Rembrandt and other Dutch painters, who introduced into their historical pictures
Plate VIII exact representations of individual objects with all their imperfections, we say, —though it is not in a good taste, yet it is nature.

245 THIS misapplication of terms must be very often perplexing to the young student. Is not art, he may say, an imitation of nature? Must he not therefore who imitates her with the greatest fidelity, be the best artist? By this mode of reasoning Rembrandt has a higher place than Raffaelle. But a very little reflection will serve to shew us that these
250 particularities cannot be nature: for how can that be the nature of man, in which no two individuals are the same?

IT plainly appears, that as a work is conducted under the influence of general ideas, or partial, it is principally to be considered as the effect of a good or a bad taste.

255 As beauty therefore does not consist in taking what lies immediately before you, so neither, in our pursuit of taste, are those opinions which we first received and adopted, the best choice, or the most natural to the mind and imagination. In the infancy of our knowledge we seize with greediness the good that is within our reach; it is by after-
260 consideration, and in consequence of discipline, that we refuse the

229-230 76 and 78S whatever ideas are

231-232 76 less capricious.
Within this idea of nature let it be always understood, that I comprehend not only

231-232 78S less capricious.
The idea of nature comprehending not only

233 76 but the nature

234-235 76 and 78S imagination. General ideas, beauty, or nature, are but different ways of

238-239 76 called beauty, and

246 76 and 78S Is not, he may say, art an imitation

present for a greater good at a distance. The nobility or elevation of all arts, like the excellency of virtue itself, consists in adopting this enlarged and comprehensive idea; and all criticism built upon the more confined view of what is natural, may properly be called *shallow* criticism, rather than false: its defect is, that the truth is not sufficiently extensive.

It has sometimes happened, that some of the greatest men in our art have been betrayed into errors by this confined mode of reasoning. Poussin, who, upon the whole, may be produced as an artist strictly attentive to the most enlarged and extensive ideas of nature, from not having settled principles on this point, has in one instance at least, I think, deserted truth for prejudice. He is said to have vindicated the conduct of Julio Romano for his inattention to the masses of light and shade, or grouping the figures in THE BATTLE OF CONSTANTINE, as if designedly neglected, the better to correspond with the hurry and confusion of a battle. Poussin's own conduct in many of his pictures, makes us more easily give credit to this report. That it was too much his own practice, THE SACRIFICE TO SILENUS, and THE TRIUMPH OF BACCHUS AND ARIADNE,* may be produced as instances; but this principle is still more apparent, and may be said to be even more ostentatiously displayed in his PERSEUS and MEDUSA'S HEAD.†

*In the Cabinet of the Earl of Ashburnham.

†In the Cabinet of Sir Peter Burrel.

269-270 76 and 78S as an instance of attention to

272 76 think, defeated truth

276-298 76 and 78S conduct in his representations of Bacchanalian triumphs and sacrifices, makes us more easily give credit to this report, since in such subjects, as well indeed as in many others, it was too much his own practice. The best apology we can make for this conduct is what proceeds from the association of our ideas, the prejudice we have in favour of antiquity. Poussin's works, as I have formerly observed, have very much the air of the antient manner of painting; in which there is not the least traces to make us think that what we call the *keeping*, the composition of light and shade, or distribution of the work into masses, claimed any part of their attention. But surely whatever apology we may find out for this neglect, it ought to be ranked among the defects of Poussin, as well as of the antique paintings; and the moderns have a right to that praise which is their due, for having given so pleasing an addition to the splendor of the art.

Perhaps no

274 The fresco is in the Sala detta di Costantino in the Vatican.

278 By "The Sacrifice to Silenus" Reynolds may be referring to the "Bacchanalian Festival" in the National Gallery, London. It was formerly attributed to Poussin, but is now given to Pierre Dulin. See Martin Davies, *French School* (London: National Gallery, 1946), p. 40.

278 "The Triumph of Bacchus" is now in the Nelson Gallery, Kansas City.

281 Dimier refers to a painting that was in the National Gallery, Dublin. The picture is now in the National Gallery, London, but is not on exhibit. It is not considered to be by Poussin.

THIS is undoubtedly a subject of great bustle and tumult, and that the first effect of the picture may correspond to the subject, every principle of composition is violated; there is no principal figure, no principal light, no groups; every thing is dispersed, and in such a state of confusion that the eye finds no repose any where. In consequence of the forbidding appearance, I remember turning from it with disgust, and should not have looked a second time, if I had not been called back to a closer inspection. I then indeed found, what we may expect always to find in the works of Poussin, correct drawing, forcible expression, and just character; in short all the excellencies which so much distinguish the works of this learned painter.

THIS conduct of Poussin I hold to be entirely improper to imitate. A picture should please at first sight, and appear to invite the spectator's attention: if on the contrary the general effect offends the eye, a second view is not always sought, whatever more substantial and intrinsick merit it may possess.

PERHAPS no apology ought to be received for offences committed against the vehicle (whether it be the organ of seeing, or of hearing,) by which our pleasures are conveyed to the mind. We must take care that the eye be not perplexed and distracted by a confusion of equal parts, or equal lights, or offended by an unharmonious mixture of colours, as we should guard against offending the ear by unharmonious sounds. We may venture to be more confident of the truth of this observation, since we find that Shakspeare, on a parallel occasion, has made Hamlet recommend to the players a precept of the same kind,— never to offend the ear by harsh sounds: *In the very torrent, tempest, and whirlwind of your passion*, says he, *you must acquire and beget a temperance that may give it smoothness.* And yet, at the same time, he very justly observes, *The end of playing, both at the first, and now, was and is, to hold, as 'twere, the mirrour up to nature.* No one can deny, that violent passions will naturally emit harsh and disagreeable tones: yet this great poet and critick thought that this imitation of nature would cost too much, if purchased at the expence of disagree-

300 76 and 78S take the same care

302-304 76 and 78S lights, as of offending it by an unharmonious mixture of colours. We may

308 76 and 78S *your passions*, says he, *you must beget*

310-311 76 and 78S *now, is, to hold, as it were, the mirror*

312 76 and 78S deny, but that

307-311 *Hamlet* III.ii.

able sensations, or, as he expresses it, of *splitting the ear*. The poet and actor, as well as the painter of genius who is well acquainted with all the variety and sources of pleasure in the mind and imagination, has little regard or attention to common nature, or creeping after common sense. By overleaping those narrow bounds, he more effectually seizes the whole mind, and more powerfully accomplishes his purpose. This success is ignorantly imagined to proceed from inattention to all rules, and a defiance of reason and judgment; whereas it is in truth acting according to the best rules and the justest reason.

HE who thinks nature, in the narrow sense of the word, is alone to be followed, will produce but a scanty entertainment for the imagination: every thing is to be done with which it is natural for the mind to be pleased, whether it proceeds from simplicity or variety, uniformity or irregularity; whether the scenes are familiar or exotick; rude and wild, or enriched and cultivated; for it is natural for the mind to be pleased with all these in their turn. In short, whatever pleases has in it what is analogous to the mind, and is therefore, in the highest and best sense of the word, natural.

IT is the sense of nature or truth which ought more particularly to be cultivated by the professors of art; and it may be observed, that many wise and learned men, who have accustomed their minds to admit nothing for truth but what can be proved by mathematical demonstration, have seldom any relish for those arts which address themselves to the fancy, the rectitude and truth of which is known by another kind of proof: and we may add, that the acquisition of this knowledge requires as much circumspection and sagacity, as is necessary to attain those truths which are more capable of demonstration. Reason must ultimately determine our choice on every occasion; but this reason may still be exerted ineffectually by applying to taste principles which, though right as far as they go, yet do not reach the object. No man, for instance, can deny, that it seems at first view very reasonable, that a statue which is to carry down to posterity the resemblance of an individual, should be dressed in the fashion of the times, in the dress which

317 97 scources

322 76 and 78S and in defiance

333 76 and 78S is this sense

340-341 76 and 78S as to attain those truths which are more open to demonstration

326-330 It is doubtful whether critics prior to the mid-18th century would find it "natural for the mind to be pleased" with so many different things. See Introduction, p. xxix.

he himself wore: this would certainly be true, if the dress were part of the man; but after a time, the dress is only an amusement for an anti-
350 quarian; and if it obstructs the general design of the piece, it is to be disregarded by the artist. Common sense must here give way to a higher sense. In the naked form, and in the disposition of the drapery, the difference between one artist and another is principally seen. But if he is compelled to exhibit the modern dress, the naked form is entirely hid,
355 and the drapery is already disposed by the skill of the tailor. Were a Phidias to obey such absurd commands, he would please no more than an ordinary sculptor; since, in the inferior parts of every art, the learned and the ignorant are nearly upon a level.

THESE were probably among the reasons that induced the sculptor
360 of that wonderful figure of Laocoon to exhibit him naked, notwithstanding he was surprised in the act of sacrificing to Apollo, and consequently ought to have been shewn in his sacerdotal habits, if those greater reasons had not preponderated. Art is not yet in so high estimation with us, as to obtain so great a sacrifice as the antients made, espe-
365 cially the Grecians; who suffered themselves to be represented naked, whether they were generals, lawgivers, or kings.

UNDER this head of balancing and choosing the greater reason, or of two evils taking the least, we may consider the conduct of Rubens in in the Luxembourg gallery, where he has mixed allegorical figures with
370 representations of real personages, which must be acknowledged to be a fault; yet, if the Artist considered himself as engaged to furnish this gallery with a rich, various, and splendid ornament, this could not be done, at least in an equal degree, without peopling the air and water with these allegorical figures: he therefore accomplished all that he

354 76 and 78S to the modern

362 76 and 78S ought to be shewn

369 76 and 78S gallery, of mixing allegorical

370-371 76 personages, which, though acknowledged to be a fault, yet, if he considered

370 78S personages, which, though acknowledged

372 76 and 78S rich and splendid

359-363 This circumstance in connection with the "Laokoon" interested many critics. It is mentioned by Richardson (*Works*, pp. 133-134) and Algarotti (p. 78), who refers in turn to a comment on the same topic by De Piles. Lessing also mentions it (*Laokoon*, Ch. v).

369 Reynolds refers to the Marie de Medici series, painted for the Luxembourg Palace, now in the Louvre.

369-371 Algarotti (p. 100) also comments on Rubens' mixing portraiture and allegorical figures in the Luxembourg gallery.

purposed. In this case all lesser considerations, which tend to obstruct 375
the great end of the work, must yield and give way.

THE variety which portraits and modern dresses, mixed with allegorical figures, produce, is not to be slightly given up upon a punctilio of reason, when that reason deprives the art in a manner of its very existence. It must always be remembered that the business of a great Painter, 380 is to produce a great picture, he must therefore take especial care not to be cajoled by specious arguments out of his materials.

WHAT has been so often said to the disadvantage of allegorical poetry, —that it is tedious, and uninteresting,—cannot with the same propriety be applied to painting, where the interest is of a different kind. If alle- 385 gorical painting produces a greater variety of ideal beauty, a richer, a more various and delightful composition, and gives to the artist a greater opportunity of exhibiting his skill, all the interest he wishes for is accomplished: such a picture not only attracts, but fixes the attention.

IF it be objected that Rubens judged ill at first in thinking it neces- 390 sary to make his work so very ornamental, this puts the question upon new ground. It was his peculiar style; he could paint in no other; and he was selected for that work, probably, because it was his style. Nobody will dispute but some of the best of the Roman or Bolognian schools would have produced a more learned and more noble work. 395

THIS leads us to another important province of taste, that of weighing the value of the different classes of the art, and of estimating them accordingly.

ALL arts have means within them of applying themselves with success both to the intellectual and sensitive part of our natures. It cannot 400 be disputed, supposing both these means put in practice with equal abilities, to which we ought to give the preference; to him who represents the heroick arts and more dignified passions of man, or to him who, by the help of meretricious ornaments, however elegant and graceful, captivates the sensuality, as it may be called, of our taste. 405 Thus the Roman and Bolognian schools are reasonably preferred to

376-390 76 and 78S give way.
 If it is objected
[two paragraphs not present in 76 and 78S]

391 76 and 78S this brings the question

396 76 and 78S taste, of weighing

400-401 76 and 78S It can be no dispute, supposing

384 "Of the ancient poets every reader feels the mythology tedious and oppressive." Johnson, "Life of Butler," *Lives of the English Poets*, ed. G. B. Hill, I, 213. "The machinery of the Pagans is uninteresting to us: when a Goddess appears in Homer or Virgil, we grow weary...." Boswell, *Life of Johnson*, ed. George B. Hill, rev. L. F. Powell (Oxford, 1934-50), IV, 16.

the Venetian, Flemish, or Dutch schools, as they address themselves to our best and noblest faculties.

WELL-TURNED periods in eloquence, or harmony of numbers in poetry, which are in those arts what colouring is in painting, however highly we may esteem them, can never be considered as of equal importance with the art of unfolding truths that are useful to mankind, and which make us better or wiser. Nor can those works which remind us of the poverty and meanness of our nature, be considered as of equal rank with what excites ideas of grandeur, or raises and dignifies humanity; or, in the words of a late poet, which makes the beholder *learn to venerate himself as man**.

IT is reason and good sense therefore which ranks and estimates every art, and every part of that art, according to its importance, from the painter of animated, down to inanimated nature. We will not allow a man, who shall prefer the inferior style, to say it is his taste; taste here has nothing, or at least ought to have nothing to do with the question. He wants not taste, but sense, and soundness of judgment.

INDEED perfection in an inferior style may be reasonably preferred to mediocrity in the highest walks of art. A landskip of Claude Lorrain may be preferred to a history by Luca Giordano; but hence appears the necessity of the connoisseur's knowing in what consists the excellency of each class, in order to judge how near it approaches to perfection.

EVEN in works of the same kind, as in history-painting, which is composed of various parts, excellence of an inferior species, carried to a very high degree, will make a work very valuable, and in some measure compensate for the absence of the higher kinds of merit. It is the duty of the connoisseur to know and esteem, as much as it may deserve, every part of painting: he will not then think even Bassano unworthy of his notice; who, though totally devoid of expression, sense, grace, or elegance, may be esteemed on account of his admirable taste of colours, which, in his best works, are little inferior to those of Titian.

SINCE I have mentioned Bassano, we must do him likewise the justice to acknowledge, that though he did not aspire to the dignity of

*Dr. Goldsmith.

417 76 *as man.* [no note] 433 76 and 78S higher kind of merits. It
426 76 and 78S history of Luca Jordano;
but

416-417 Goldsmith, "The Traveller," l. 334.

130

expressing the characters and passions of men, yet, with respect to facility and truth in his manner of touching animals of all kinds, and giving them what painters call *their character*, few have ever excelled him.

To Bassano we may add Paul Veronese and Tintoret, for their entire inattention to what is justly thought the most essential part of our art, the expression of the passions. Notwithstanding these glaring deficiencies, we justly esteem their works; but it must be remembered, that they do not please from those defects, but from their great excellencies of another kind, and in spite of such transgressions. These excellencies too, as far as they go, are founded in the truth of *general* nature: they tell the *truth*, though not *the whole truth*.

By these considerations, which can never be too frequently impressed, may be obviated two errors which I observed to have been, formerly at least, the most prevalent, and to be most injurious to artists; that of thinking taste and genius to have nothing to do with reason, and that of taking particular living objects for nature.

I SHALL now say something on that part of *taste*, which, as I have hinted to you before, does not belong so much to the external form of things, but is addressed to the mind, and depends on its original frame, or, to use the expression, the organization of the soul; I mean the imagination and the passions. The principles of these are as invariable as the former, and are to be known and reasoned upon in the same manner, by an appeal to common sense deciding upon the common feelings of mankind. This sense, and these feelings, appear to me of equal authority, and equally conclusive. Now this appeal implies a general uniformity and agreement in the minds of men. It would be else an idle and vain endeavour to establish rules of art; it would be pursuing a phantom to attempt to move affections with which we were entirely unacquainted. We have no reason to suspect there is a greater difference between our minds than between our forms; of which, though there are no two alike, yet there is a general similitude that goes through the whole race of mankind; and those who have cultivated their taste can distinguish what is beautiful or deformed, or, in other words, what agrees with or deviates from the general idea of nature, in one case, as well as in the other.

445

450

455

460

465

470

475

441-442 76 and 78S to the facility
446 76 and 78S justly esteemed the most
475 76 and 78S agrees or what deviates

476-477 76 other.
We are as sure as of any thing, that the internal fabric of our mind, as

THE internal fabrick of our minds, as well as the external form of our bodies, being nearly uniform; it seems then to follow of course, that as the imagination is incapable of producing any thing originally of itself, and can only vary and combine those ideas with which it is furnished by means of the senses, there will be necessarily an agreement in the imaginations as in the senses of men. There being this agreement, it follows, that in all cases, in our lightest amusements, as well as in our most serious actions and engagements of life, we must regulate our affections of every kind by that of others. The well-disciplined mind acknowledges this authority, and submits its own opinion to the publick voice. It is from knowing what are the general feelings and passions of mankind, that we acquire a true idea of what imagination is; though it appears as if we had nothing to do but to consult our own particular sensations, and these were sufficient to ensure us from all error and mistake.

A KNOWLEDGE of the disposition and character of the human mind can be acquired only by experience: a great deal will be learned, I admit, by a habit of examining what passes in our bosoms, what are our own motives of action, and of what kind of sentiments we are conscious on any occasion. We may suppose an uniformity, and conclude that the same effect will be produced by the same cause in the minds of others. This examination will contribute to suggest to us matters of enquiry; but we can never be sure that our own sensations are true and right, till they are confirmed by more extensive observation. One man opposing another determines nothing; but a general union of minds, like a general combination of the forces of all mankind, makes a strength that is irresistible. In fact, as he who does not know himself does not know others, so it may be said with equal truth, that he who does not know others, knows himself but very imperfectly.

A MAN who thinks he is guarding himself against prejudices by resisting the authority of others, leaves open every avenue to singularity,

477 78S of our mind, as 480 76 and 78S combine these ideas

478 76 bodies, is nearly 481 76 and 78S be of course an agreement

477–482 Greenway draws attention to the relation between this passage and the one in Burke's "Introduction on Taste" added to the second edition of *The Sublime and Beautiful* (London, 1759), p. 16: "the power of the imagination is incapable of producing any thing absolutely new; it can only vary the disposition of those ideas which it has received from the senses." "Some Predecessors of Sir Joshua Reynolds in the Criticism of the Fine Arts," by George L. Greenway, unpub. diss. (Yale, 1930), p. 213.

vanity, self-conceit, obstinacy, and many other vices, all tending to warp the judgment, and prevent the natural operation of his faculties. This submission to others is a deference which we owe, and indeed are 510
forced involuntarily to pay. In fact, we never are satisfied with our opinions, whatever we may pretend, till they are ratified and confirmed by the suffrages of the rest of mankind. We dispute and wrangle for ever; we endeavour to get men to come to us, when we do not go to them. 515

He therefore who is acquainted with the works which have pleased different ages and different countries, and has formed his opinion on them, has more materials, and more means of knowing what is analogous to the mind of man, than he who is conversant only with the works of his own age or country. What has pleased, and continues to 520
please, is likely to please again: hence are derived the rules of art, and on this immoveable foundation they must ever stand.

This search and study of the history of the mind ought not to be confined to one art only. It is by the analogy that one art bears to another, that many things are ascertained, which either were but 525
faintly seen, or, perhaps, would not have been discovered at all, if the inventor had not received the first hints from the practices of a sister art on a similar occasion*. The frequent allusions which every man who treats of any art is obliged to make to others in order to illustrate and confirm his principles, sufficiently shew their near connection and 530
inseparable relation.

All arts having the same general end, which is to please; and addressing themselves to the same faculties through the medium of the senses; it follows that their rules and principles must have as great affinity as the different materials and the different organs or vehicles by which they 535
pass to the mind, will permit them to retain†.

*Nulla ars, non alterius artis, aut mater, aut propinqua est. Tertull. as cited by Junius.

†Omnes artes quæ ad humanitatem pertinent, habent quoddam commune vinculum, et quasi cognatione inter se continentur. Cicero.

511-512 76 and 78S we are never satisfied 529 76 and 78S obliged to draw from
with our opinions till others

528n Hilles, *Literary Career* (p. 125), points out that the references to Tertullian and Cicero (536n) also occur side by side in Junius, p. 44. They are also in De Piles, "Observations on the Art of Painting," in Du Fresnoy, *Art of Painting*, trans. Dryden (London, 1695), p. 79.

We may therefore conclude, that the real substance, as it may be called, of what goes under the name of taste, is fixed and established in the nature of things; that there are certain and regular causes by which the imagination and passions of men are affected; and that the knowledge of these causes is acquired by a laborious and diligent investigation of nature, and by the same slow progress as wisdom or knowledge of every kind, however instantaneous its operations may appear when thus acquired.

IT has been often observed, that the good and virtuous man alone can acquire this true or just relish even of works of art. This opinion will not appear entirely without foundation, when we consider that the same habit of mind which is acquired by our search after truth in the more serious duties of life, is only transferred to the pursuit of lighter amusements. The same disposition, the same desire to find something steady, substantial, and durable, on which the mind can lean as it were, and rest with safety, actuates us in both cases. The subject only is changed. We pursue the same method in our search after the idea of beauty and perfection in each; of virtue, by looking forwards beyond ourselves to society, and to the whole; of arts, by extending our views in the same manner to all ages and all times.

EVERY art, like our own, has in its composition fluctuating as well as fixed principles. It is an attentive enquiry into their difference that will enable us to determine how far we are influenced by custom and habit, and what is fixed in the nature of things.

To distinguish how much has solid foundation, we may have recourse to the same proof by which some hold that wit ought to be tried; whether it preserves itself when translated. That wit is false, which can subsist only in one language; and that picture which pleases only one age or one nation, owes its reception to some local or accidental association of ideas.

WE may apply this to every custom and habit of life. Thus the general principles of urbanity, politeness, or civility, have been ever the same in all nations; but the mode in which they are dressed, is contin-

552 76 and 78S safety. The subject 568-569 98 have been the same
562 76 and 78S hold wit

537-544 Thompson (p. 357) mentions Hume's *Of the Standard of Taste*, in which an attempt is made to show that the principles of taste are universal and nearly, if not entirely, the same in all men. The idea that judgment is an important factor in determining taste is also in Gerard, Reid, and Burke.

ually varying. The general idea of shewing respect is by making your-
self less; but the manner, whether by bowing the body, kneeling, pros-
tration, pulling off the upper part of our dress, or taking away the
lower*, is a matter of custom.

THUS in regard to ornaments, it would be unjust to conclude that
because they were at first arbitrarily contrived, they are therefore unde-
serving of our attention; on the contrary, he who neglects the cultiva-
tion of those ornaments, acts contrary to nature and reason. As life
would be imperfect without its highest ornaments, the Arts, so these
arts themselves would be imperfect without *their* ornaments. Though
we by no means ought to rank these with positive and substantial beau-
ties, yet it must be allowed that a knowledge of both is essentially requi-
site towards forming a complete, whole, and perfect taste. It is in real-
ity from the ornaments that arts receive their peculiar character and
complexion; we may add, that in them we find the characteristical mark
of a national taste; as by throwing up a feather in the air, we know
which way the wind blows, better than by a more heavy matter.

THE striking distinction between the works of the Roman, Bolog-
nian, and Venetian schools, consists more in that general effect which
is produced by colours, than in the more profound excellencies of the
art; at least it is from thence that each is distinguished and known at
first sight. Thus it is the ornaments, rather than the proportions of
architecture, which at the first glance distinguish the different orders
from each other; the Dorick is known by its triglyphs, the Ionick by
its volutes, and the Corinthian by its acanthus.

WHAT distinguishes oratory from a cold narration, is a more liberal,
though chaste, use of those ornaments which go under the name of
figurative and metaphorical expressions; and poetry distinguishes itself
from oratory by words and expressions still more ardent and glowing.
What separates and distinguishes poetry, is more particularly the orna-
ment of *verse:* it is this which gives it its character, and is an essential
without which it cannot exist. Custom has appropriated different metre

*Put off thy shoes from off thy feet; for the place whereon thou standest is
holy ground. Exodus, iii. 5.

573n 78S Exodus, chap. iii. 5.

573-575 76 lower, is a matter of habit. It
would be unjust to conclude that all orna-
ments, because they were at first arbitrarily
contrived, are therefore

573-575 78S lower* . . . therefore [same
as 76, but note added]

577 76 and 78S acts contrarily to

585 97 trhowing

591 76 and 78S sight. As it

to different kinds of composition, in which the world is not perfectly agreed. In England the dispute is not yet settled, which is to be preferred, rhyme or blank verse. But however we disagree about what these metrical ornaments shall be, that some metre is essentially necessary, is universally acknowledged.

IN poetry or eloquence, to determine how far figurative or metaphorical language may proceed, and when it begins to be affectation or beside the truth, must be determined by taste; though this taste, we must never forget, is regulated and formed by the presiding feelings of mankind, by those works which have approved themselves to all times and all persons. Thus, though eloquence has undoubtedly an essential and intrinsick excellence, and immoveable principles common to all languages, founded in the nature of our passions and affections; yet it has its ornaments and modes of address, which are merely arbitrary. What is approved in the eastern nations as grand and majestick, would be considered by the Greeks and Romans as turgid and inflated; and they, in return, would be thought by the Orientals to express themselves in a cold and insipid manner.

WE may add likewise to the credit of ornaments, that it is by their means that art itself accomplishes its purpose. Fresnoy calls colouring, which is one of the chief ornaments of painting, *lena sororis*, that which procures lovers and admirers to the more valuable excellencies of the art.

IT appears to be the same right turn of mind which enables a man to acquire the *truth*, or the just idea of what is right, in the ornaments, as in the more stable principles of art. It has still the same centre of perfection, though it is the centre of a smaller circle.

To illustrate this by the fashion of dress, in which there is allowed to be a good or bad taste. The component parts of dress are continually changing from great to little, from short to long; but the general form still remains: it is still the same general dress which is comparatively fixed, though on a very slender foundation; but it is on this which fashion must rest. He who invents with the most success, or dresses in the best taste, would probably, from the same sagacity employed to greater

616-619 Gerard (*Essay on Taste*, p. 233) records these comments of an easterner on western eloquence: "tameness of imagination, a coldness of spirit, a preciseness of thinking, or a dullness of feeling."

622 Du Fresnoy, *De Arte Graphica* (London, 1695), l. 263.

purposes, have discovered equal skill, or have formed the same correct taste, in the highest labours of art.

I HAVE mentioned taste in dress, which is certainly one of the lowest subjects to which this word is applied; yet, as I have before observed, there is a right even here, however narrow its foundation respecting the fashion of any particular nation. But we have still more slender means of determining, to which of the different customs of different ages or countries we ought to give the preference, since they seem to be all equally removed from nature. If an European, when he has cut off his beard, and put false hair on his head, or bound up his own natural hair in regular hard knots, as unlike nature as he can possibly make it; and after having rendered them immoveable by the help of the fat of hogs, has covered the whole with flour, laid on by a machine with the utmost regularity; if, when thus attired he issues forth, and meets a Cherokee Indian, who has bestowed as much time at his toilet, and laid on with equal care and attention his yellow and red oker on particular parts of his forehead or cheeks, as he judges most becoming; whoever of these two despises the other for this attention to the fashion of his country, which ever first feels himself provoked to laugh, is the barbarian.

ALL these fashions are very innocent; neither worth disquisition, nor any endeavour to alter them; as the change would, in all probability, be equally distant from nature. The only circumstances against which indignation may reasonably be moved, is where the operation is painful or destructive of health, such as some of the practices at Otaheite, and the straight lacing of the English ladies; of the last of which practices, how destructive it must be to health and long life, the professor of anatomy took an opportunity of proving a few days since in this Academy.

IT is in dress as in things of greater consequence. Fashions originate from those only who have the high and powerful advantages of rank,

<table>
<tr><td>642-643 76 and 78S determining, in regard to the different customs of different ages or countries, to which to give</td><td>654 76 and 78S which ever of these two first</td></tr>
<tr><td></td><td>657 98 circumstance</td></tr>
<tr><td>646-647 76 and 78S and having</td><td>659 76 and 78S such as is practised at Otahaiti</td></tr>
<tr><td>649 76 and 78S forth, he meets</td><td></td></tr>
<tr><td>652-653 76 and 78S whoever despises</td><td>660-661 76 and 78S which, how</td></tr>
</table>

644-654 There are similar comments comparing arbitrary customs in Europe and elsewhere in Sir Harry Beaumont [Joseph Spence], *Crito* (London, 1752), pp. 48 ff. See also John Locke, "An Essay concerning Human Understanding," in *Works* (London, 1722), I, 15.

birth, and fortune. Many of the ornaments of art, those at least for which no reason can be given, are transmitted to us, are adopted, and acquire their consequence from the company in which we have been used to see them. As Greece and Rome are the fountains from whence

670 have flowed all kinds of excellence, to that veneration which they have a right to claim for the pleasure and knowledge which they have afforded us, we voluntarily add our approbation of every ornament and every custom that belonged to them, even to the fashion of their dress. For it may be observed that, not satisfied with them in their own

675 place, we make no difficulty of dressing statues of modern heroes or senators in the fashion of the Roman armour or peaceful robe; we go so far as hardly to bear a statue in any other drapery.

THE figures of the great men of those nations have come down to us in sculpture. In sculpture remain almost all the excellent specimens

680 of ancient art. We have so far associated personal dignity to the persons thus represented, and the truth of art to their manner of representation, that it is not in our power any longer to separate them. This is not so in painting; because having no excellent ancient portraits, that connexion was never formed. Indeed we could no more venture to paint

685 a general officer in a Roman military habit, than we could make a statue in the present uniform. But since we have no ancient portraits,—to shew how ready we are to adopt those kind of prejudices, we make the best authority among the moderns serve the same purpose. The great variety of excellent portraits with which Vandyck has enriched this nation, we

690 are not content to admire for their real excellence, but extend our approbation even to the dress which happened to be the fashion of that age. We all very well remember how common it was a few years ago for portraits to be drawn in this fantastick dress; and this custom is not yet entirely laid aside. By this means it must be acknowledged

666 76 and 78S fortune. As many 693 76 and 78S this Gothic dress

684-686 On the use of "modern" dress in painting of historical subjects in the 1770's see Edgar Wind, "The Revolution of History Painting," *Journal of the Warburg and Courtauld Institutes*, II (1938), 116-127; also Charles Mitchell, "Benjamin West's 'Death of General Wolfe' and the Popular History Piece," *Warburg Journal*, VII (1944), 20-33.

688-701 The "Van Dyck habit" was a frequent feature of English fashionable portraiture during the third quarter of the 18th century. Reynolds himself employs the costume more often than any other major portraitist. It occurs in his work as early as the mid-1750's and is still found, at least in portraits of children, as late as 1780, four years after the delivery of Discourse VII. For illustrations see Ellis K. Waterhouse, *Reynolds* (London, 1941), Pls. 35, 48, 53, 57, 88, 93, 95, 96, 106, 129, 132, 162, 173, 179, 185, 194, 220. Gainsborough objected to "fancy dress" portraits (William T. Whitley, *Thomas Gainsborough* [London, 1915], pp. 74 ff.); nevertheless, what is probably his best-known painting, "The Blue Boy," employs the Van Dyck habit.

very ordinary pictures acquired something of the air and effect of the 695
works of Vandyck, and appeared therefore at first sight to be better
pictures than they really were; they appeared so, however, to those
only who had the means of making this association; and when made, it
was irresistible. But this association is nature, and refers to that sec-
ondary truth that comes from conformity to general prejudice and 700
opinion; it is therefore not merely fantastical. Besides the prejudice
which we have in favour of ancient dresses, there may be likewise other
reasons for the effect which they produce; among which we may justly
rank the simplicity of them, consisting of little more than one single
piece of drapery, without those whimsical capricious forms by which 705
all other dresses are embarrassed.

Thus, though it is from the prejudice we have in favour of the
ancients, who have taught us architecture, that we have adopted like-
wise their ornaments; and though we are satisfied that neither nature
nor reason are the foundation of those beauties which we imagine we 710
see in that art, yet if any one, persuaded of this truth, should therefore
invent new orders of equal beauty, which we will suppose to be pos-
sible, they would not please; nor ought he to complain, since the old
has that great advantage of having custom and prejudice on its side.
In this case we leave what has every prejudice in its favour, to take 715
that which will have no advantage over what we have left, but novelty;
which soon destroys itself, and at any rate is but a weak antagonist
against custom.

Ancient ornaments, having the right of possession, ought not to
be removed, unless to make room for that which not only has higher 720
pretensions, but such pretensions as will balance the evil and confusion
which innovation always brings with it.

To this we may add, that even the durability of the materials will
often contribute to give a superiority to one object over another.
Ornaments in buildings, with which taste is principally concerned, are 725

698 76 and 78S association, for when	718-719 76 and 78S against custom.	
703 76 and 78S reasons, amongst which we	These ornaments	
712-713 76 and 78S possible, yet they	720 76 and 78S removed, but to make room for not only what has	
717 97 week	723 76 and 78S add, even	

699 On association and aesthetic perception see Locke, "An Essay concerning Human Un-
derstanding," Bk. II, Ch. xxxiii, in *Works*, I; Mark Akenside, *The Pleasures of Imagination*
(London, 1744), p. 7; Gerard, *Essay on Taste*, p. 21; Adam Smith, *The Theory of Moral Senti-
ments* (London, 1759), V, Sec. 1.

composed of materials which last longer than those of which dress is composed; the former therefore make higher pretensions to our favour and prejudice.

SOME attention is surely due to what we can no more get rid of than
730 we can go out of ourselves. We are creatures of prejudice; we neither can nor ought to eradicate it; we must only regulate it by reason; which kind of regulation is indeed little more than obliging the lesser, the local and temporary prejudices, to give way to those which are more durable and lasting.

735 HE therefore who in his practice of portrait-painting wishes to dignify his subject, which we will suppose to be a lady, will not paint her in the modern dress, the familiarity of which alone is sufficient to destroy all dignity. He takes care that his work shall correspond to those ideas and that imagination which he knows will regulate the
740 judgment of others; and therefore dresses his figure something with the general air of the antique for the sake of dignity, and preserves something of the modern for the sake of likeness. By this conduct his works correspond with those prejudices which we have in favour of what we continually see; and the relish of the antique simplicity
745 corresponds with what we may call the more learned and scientifick prejudice.

THERE was a statue made not long since of Voltaire, which the sculptor, not having that respect for the prejudices of mankind which he ought to have had, made entirely naked, and as meagre and emaci-
750 ated as the original is said to be. The consequence was what might have been expected; it remained in the sculptor's shop, though it was intended as a publick ornament and a publick honour to Voltaire, for it was procured at the expence of his contemporary wits and admirers.

WHOEVER would reform a nation, supposing a bad taste to prevail
755 in it, will not accomplish his purpose by going directly against the

727 76 and 78S composed; it therefore makes higher

729 76 and 78S surely required to

731-732 76 and 78S which regulation by reason is

749 76 and 78S have, has made

750-751 76 and 78S consequence is what might be expected; it has remained

752-753 76 and 78S Voltaire, as it

735-746 Reynolds here accurately describes the theory of dress that he employed in most of his "public face" academy portraits. See Pl. XXIII.

747 Reynolds refers to the statue by Jean-Baptiste Pigalle (1714-1785) now in the Biblio-thèque de l'Institut, Paris. It was executed during the 1770's. See Louis Réau, *J.-B. Pigalle* (Paris, 1950), pp. 60 ff., Pls. 20-21.

stream of their prejudices. Men's minds must be prepared to receive what is new to them. Reformation is a work of time. A national taste, however wrong it may be, cannot be totally changed at once; we must yield a little to the prepossession which has taken hold on the mind, and we may then bring people to adopt what would offend them, if endeavoured to be introduced by violence. When Battista Franco was employed, in conjunction with Titian, Paul Veronese and Tintoret, to adorn the library of St. Mark, his work, Vasari says, gave less satisfaction than any of the others: the dry manner of the Roman school was very ill calculated to please eyes that had been accustomed to the luxuriancy, splendour, and richness of Venetian colouring. Had the Romans been the judges of this work, probably the determination would have been just contrary; for in the more noble parts of the art, Battista Franco was perhaps not inferior to any of his rivals.

GENTLEMEN,

It has been the main scope and principal end of this discourse to demonstrate the reality of a standard in taste, as well as in corporeal beauty; that a false or depraved taste is a thing as well known, as easily discovered, as any thing that is deformed, mis-shapen, or wrong, in our form or outward make; and that this knowledge is derived from the uniformity of sentiments among mankind, from whence proceeds the knowledge of what are the general habits of nature; the result of which is an idea of perfect beauty.

If what has been advanced be true, that beside this beauty or truth, which is formed on the uniform, eternal and immutable laws of nature, and which of necessity can be but *one*; that beside this one immutable verity there are likewise what we have called apparent or secondary truths, proceeding from local and temporary prejudices, fancies, fashions, or accidental connexion of ideas; if it appears that these last have still their foundation, however slender, in the original fabrick of our minds; it follows that all these truths or beauties deserve and require the attention of the artist, in proportion to their stability or duration, or as their influence is more or less extensive. And let me add,

761 76 and 78S by storm. When 781 76 and 78S that besides this
779 76 and 78S that besides this

761 Battista Franco, Venetian by birth, Roman by training (Vasari, V, 48).

that as they ought not to pass their just bounds, so neither do they, in a well-regulated taste, at all prevent or weaken the influence of those general principles, which alone can give to art its true and permanent dignity.

To form this just taste is undoubtedly in your own power, but it is to reason and philosophy that you must have recourse; from them you must borrow the balance by which is to be weighed and estimated the value of every pretension that intrudes itself on your notice.

THE general objection which is made to the introduction of Philosophy into the regions of taste, is, that it checks and restrains the flights of the imagination, and gives that timidity which an over-carefulness not to err or act contrary to reason is likely to produce. It is not so. Fear is neither reason nor philosophy. The true spirit of philosophy, by giving knowledge, gives a manly confidence, and substitutes rational firmness in the place of vain presumption. A man of real taste is always a man of judgment in other respects; and those inventions which either disdain or shrink from reason, are generally, I fear, more like the dreams of a distempered brain than the exalted enthusiasm of a sound and true genius. In the midst of the highest flights of fancy or imagination, reason ought to preside from first to last, though I admit her more powerful operation is upon reflection.

LET me add, that some of the greatest names of antiquity, and those who have most distinguished themselves in works of genius and imagination, were equally eminent for their critical skill. Plato, Aristotle, Cicero, and Horace; and among the moderns, Boileau, Corneille, Pope, and Dryden, are at least instances of genius not being destroyed by attention or subjection to rules and science. I should hope therefore, that the natural consequence of what has been said, would be, to excite in you a desire of knowing the principles and conduct of the great masters of our art, and respect and veneration for them when known.

790-791 76 and 78S of these general
794-795 76 and 78S them we must
797-798 76 made to philosophy's intro-
duction into

809-810 76 and 78S upon reflexion.
I cannot help adding, that some
816 76 and 78S consequence likewise of

142

DISCOURSE VIII

Delivered to the Students of The Royal Academy,

on the Distribution of the Prizes,

December 10, 1778

DISCOURSE VIII

Gentlemen,

I HAVE recommended, in former discourses,* that Artists should learn their profession by endeavouring to form an idea of perfection from the different excellencies which lie dispersed in the various schools of painting. Some difficulty will still occur, to know what is beauty, and where it may be found: one would wish not to be obliged to take it entirely on the credit of fame; though to this, I acknowledge, the younger Students must unavoidably submit. Any suspicion in them of the chance of their being deceived, will have more tendency to obstruct their advancement, than even an enthusiastick confidence in the perfection of their models. But to the more advanced in the art, who wish to stand on more stable and firmer ground, and to establish principles on a stronger foundation than authority, however venerable or powerful, it may be safely told, that there is still a higher tribunal, to which those great masters themselves must submit, and to which indeed every excellence in art must be ultimately referred. He who is ambitious to enlarge the boundaries of his art, must extend his views, beyond the precepts which are found in books or may be drawn from the practice of his predecessors, to a knowledge of those precepts in the mind, those operations of intellectual nature,—to which every thing that aspires to please, must be proportioned and accommodated.

Poetry having a more extensive power than our art, exerts its influence over almost all the passions; among those may be reckoned one of our most prevalent dispositions, anxiety for the future. Poetry

*Discourse II. and VI.

1 78 in a former Discourse [no note] 19 78 mind, to those
3 78 excellencies, as they lye 22 78 passions; amongst those
17 78 books, or to be

operates by raising our curiosity, engaging the mind by degrees to take an interest in the event, keeping that event suspended, and surprising at last with an unexpected catastrophe.

THE Painter's art is more confined, and has nothing that corresponds with, or perhaps is equivalent to, this power and advantage of leading the mind on, till attention is totally engaged. What is done by Painting, must be done at one blow; curiosity has received at once all the satisfaction it can ever have. There are, however, other intellectual qualities and dispositions which the Painter can satisfy and affect as powerfully as the Poet; among those we may reckon our love of novelty, variety, and contrast; these qualities, on examination, will be found to refer to a certain activity and restlessness, which has a pleasure and delight in being exercised and put in motion: Art therefore only administers to those wants and desires of the mind.

IT requires no long disquisition to shew, that the dispositions which I have stated actually subsist in the human mind. Variety reanimates the attention, which is apt to languish under a continual sameness. Novelty makes a more forcible impression on the mind, than can be made by the representation of what we have often seen before; and contrasts rouse the power of comparison by opposition. All this is obvious; but, on the other hand, it must be remembered, that the mind, though an active principle, has likewise a disposition to indolence; and though it loves exercise, loves it only to a certain degree, beyond which it is very unwilling to be led, or driven; the pursuit therefore of novelty and variety may be carried to excess. When variety entirely destroys the pleasure proceeding from uniformity and repetition, and when novelty counteracts and shuts out the pleasure arising from old habits and customs, they oppose too much the indolence of our disposition: the mind therefore can bear with pleasure but a small portion of novelty at a time. The main part of the work must be in the mode to which we have been used. An affection to old habits and customs I take to be the predominant disposition of the mind, and novelty comes as an exception: where all is novelty, the attention, the exercise of the mind is too violent. Contrast, in the same manner, when it exceeds certain limits, is as disagreeable as a violent and perpetual opposition; it gives

27-28 78 corresponds, or

33 78 Poet; amongst those

41-42 78 can be done by representation

47-48 78 driven; these qualities therefore may

51 78 customs, opposes too

55 78 and that novelty

to the senses, in their progress, a more sudden change than they can bear with pleasure. 60

It is then apparent, that those qualities, however they contribute to the perfection of Art, when kept within certain bounds, if they are carried to excess, become defects, and require correction: a work consequently will not proceed better and better as it is more varied; variety can never be the ground-work and principle of the performance, it 65 must be only employed to recreate and relieve.

To apply these general observations which belong equally to all arts, to ours in particular. In a composition, when the objects are scattered and divided into many equal parts, the eye is perplexed and fatigued, from not knowing where to rest, where to find the principal action, or 70 which is the principal figure; for where all are making equal pretensions to notice, all are in equal danger of neglect.

The expression which is used very often on these occasions is, the piece wants *repose*; a word which perfectly expresses a relief of the mind from that state of hurry and anxiety which it suffers, when looking 75 at a work of this character.

On the other hand, absolute unity, that is, a large work, consisting of one group or mass of light only, would be as defective as an heroick poem without episode, or any collateral incidents to recreate the mind with that variety which it always requires. 80

An instance occurs to me of two painters, (Rembrandt and Poussin,) of characters totally opposite to each other in every respect, but in nothing more than in their mode of composition, and management of light and shadow. Rembrandt's manner is absolute unity; he often has but *Plate XV* one group, and exhibits little more than one spot of light in the midst 85 of a large quantity of shadow; if he has a second mass, that second bears no proportion to the principal. Poussin, on the contrary, has scarce any *Plate XIV* principal mass of light at all, and his figures are often too much dispersed, without sufficient attention to place them in groups.

The conduct of these two painters is entirely the reverse of what 90 might be expected from their general style and character; the works of Poussin being as much distinguished for simplicity, as those of Rembrandt for combination. Even this conduct of Poussin might proceed

63-64 78 work then will 90 78 of those two

80-81 78 always requires.
Two instances occur to

from too great an affection to simplicity of *another kind*; too great a
desire to avoid that ostentation of art, with regard to light and shadow,
on which Rembrandt so much wished to draw the attention: however,
each of them ran into contrary extremes, and it is difficult to determine
which is the most reprehensible, both being equally distant from the
demands of nature, and the purposes of art.

THE same just moderation must be observed in regard to ornaments;
nothing will contribute more to destroy repose than profusion, of what-
ever kind, whether it consists in the multiplicity of objects, or the vari-
ety and brightness of colours. On the other hand, a work without
ornament, instead of simplicity, to which it makes pretensions, has
rather the appearance of poverty. The degree to which ornaments are
admissible, must be regulated by the professed style of the work; but
we may be sure of this truth,—that the most ornamental style requires
repose to set off even its ornaments to advantage. I cannot avoid men-
tioning here an instance of repose in that faithful and accurate painter
of nature, Shakspeare; the short dialogue between Duncan and Banquo,
whilst they are approaching the gates of Macbeth's castle. Their con-
versation very naturally turns upon the beauty of its situation, and the
pleasantness of the air; and Banquo observing the martlets' nests in every
recess of the cornice, remarks, that where those birds most breed and
haunt, the air is delicate. The subject of this quiet and easy conversa-
tion gives that repose so necessary to the mind, after the tumultuous
bustle of the preceding scenes, and perfectly contrasts the scene of hor-
rour that immediately succeeds. It seems as if Shakspeare asked him-
self, What is a Prince likely to say to his attendants on such an occasion?
The modern writers seem, on the contrary, to be always searching for
new thoughts, such as never could occur to men in the situation repre-
sented. This is also frequently the practice of Homer, who, from the
midst of battles and horrours, relieves and refreshes the mind of the
reader, by introducing some quiet rural image, or picture of familiar
domestick life. The writers of every age and country, where taste has
begun to decline, paint and adorn every object they touch; are always
on the stretch; never deviate or sink a moment from the pompous and

105-106 78 are admitted, must

116 78 the more tumultuous

119-120 78 occasion? Whereas the mod-
ern

121-122 78 in that situation. This

110 *Macbeth* I.vi.

the brilliant. Lucan, Statius, and Claudian, (as a learned critick has observed,) are examples of this bad taste and want of judgment; they never soften their tones, or condescend to be natural: all is exaggeration and perpetual splendour, without affording repose of any kind.

As we are speaking of excesses, it will not be remote from our purpose to say a few words upon simplicity; which, in one of the senses in which it is used, is considered as the general corrector of excess. We shall at present forbear to consider it as implying that exact conduct which proceeds from an intimate knowledge of simple unadulterated nature, as it is then only another word for perfection, which neither stops short of, nor oversteps, reality and truth.

In our enquiry after simplicity, as in many other enquiries of this nature, we can best explain what is right, by shewing what is wrong; and, indeed, in this case it seems to be absolutely necessary: simplicity, being only a negative virtue, cannot be described or defined. We must therefore explain its nature, and shew the advantage and beauty which is derived from it, by shewing the deformity which proceeds from its neglect.

Though instances of this neglect might be expected to be found in practice, we should not expect to find in the works of criticks, precepts that bid defiance to simplicity and every thing that relates to it. Du Piles recommends to us portrait-painters, to add Grace and Dignity to the characters of those, whose pictures we draw: so far he is undoubtedly right; but, unluckily, he descends to particulars, and gives his own idea of Grace and Dignity. *If*, says he, *you draw persons of high character and dignity, they ought to be drawn in such an attitude, that the Portrait must seem to speak to us of themselves, and, as it were, to say to us,* 'stop, take notice of me, I am that invincible King, surrounded by Majesty.' 'I am that valiant commander, who struck terrour every where.' 'I am that great minister who knew all the springs of politicks.' 'I am that magistrate of consummate wisdom and probity.' He goes on in this manner, with all the characters he can think on. We may contrast the tumour of this presumptuous loftiness with the natural unaffected air

130

135

140

145

150

155

160

128-129 78 critic observed

135-136 78 conduct proceeding from

146-147 78 in the practice

155 78 *surrounded with majesty*

128 In Section viii (p. 22) of Joseph Warton's *Essay on Pope* (a section not published until 1782 but in print for about two decades before) Statius, Lucan, and Claudian are named as examples of "this bad taste".

152-158 Roger de Piles, *The Principles of Painting* (London, 1743), p. 169.

of the portraits of Titian, where dignity seeming to be natural and inherent, draws spontaneous reverence, and instead of being thus vainly assumed, has the appearance of an unalienable adjunct; whereas such pompous and laboured insolence of grandeur is so far from creating respect, that it betrays vulgarity and meanness, and new-acquired consequence.

THE painters, many of them at least, have not been backward in adopting the notions contained in these precepts. The portraits of Rigaud are perfect examples of an implicit observance of these rules of Du Piles; so that though he was a painter of great merit in many respects, yet, that merit is entirely overpowered by a total absence of simplicity in every sense.

NOT to multiply instances, which might be produced for this purpose, from the works of History-painters, I shall mention only one,— a picture which I have seen, of the SUPREME BEING, by Coypell.

THIS subject the Roman Catholick painters have taken the liberty to represent, however indecent the attempt, and however obvious the impossibility of any approach to an adequate representation: but here the air and character, which the Painter has given, and he has doubtless given the highest he could conceive, are so degraded by an attempt at such dignity as Du Piles has recommended, that we are enraged at the folly and presumption of the artist, and consider it as little less than profanation.

As we have passed to a neighbouring nation for instances of want of this quality, we must acknowledge, at the same time, that they have *Plate XIV* produced great examples of simplicity in Poussin and Le Sueur. But as we are speaking of the most refined and subtle notion of perfection, may we not enquire, whether a curious eye cannot discern some faults, even in those great men? I can fancy, that even Poussin, by abhorring that affectation and that want of simplicity, which he observed in his countrymen, has, in certain particulars, fallen into the contrary

168 78 the ideas contained in those precepts

169 78 of those rules

180-182 78 by the idea of dignity, such as Du Piles has recommended, that one is enraged at the folly and presumption of the Painter, and considers it

184-185 78 want of Simplicity; we
185 78 time, they
186 78 of it in
187 78 subtle idea of

175 Reynolds may have in mind the vault of the chapel at Versailles, painted by Antoine Coypel. For an illustration see Louis Dimier, *Les peintres Français du XVIIIe siècle* (Paris, 1928), I, Pl. XX (see VI, 500).

extreme, so far as to approach to a kind of affectation,—to what, in writing, would be called pedantry.

WHEN Simplicity, instead of being a corrector, seems to set up for herself; that is, when an artist seems to value himself solely upon this quality; such an ostentatious display of simplicity becomes then as disagreeable and nauseous as any other kind of affectation. He is, however, in this case, likely enough to sit down contented with his own work; for though he finds the world look at it with indifference or dislike, as being destitute of every quality that can recreate or give pleasure to the mind, yet he consoles himself, that it has simplicity, a beauty of too pure and chaste a nature to be relished by vulgar minds.

IT is in art as in morals: no character would inspire us with an enthusiastick admiration of his virtue, if that virtue consisted only in an absence of vice; something more is required; a man must do more than merely his duty, to be a hero.

THOSE works of the ancients, which are in the highest esteem, have something beside mere simplicity to recommend them. The Apollo, the Venus, the Laocoon, the Gladiator, have a certain Composition of Action, have contrasts sufficient to give grace and energy in a high degree; but it must be confessed of the many thousand antique statues which we have, that their general characteristick is bordering at least on inanimate insipidity.

SIMPLICITY, when so very inartificial as to seem to evade the difficulties of art, is a very suspicious virtue.

I DO not, however, wish to degrade simplicity from the high estimation in which it has been ever justly held. It is our barrier against that great enemy to truth and nature, Affectation, which is ever clinging to the pencil, and ready to drop in and poison every thing it touches.

OUR love and affection to simplicity proceeds in a great measure from our aversion to every kind of affectation. There is likewise another reason why so much stress is laid upon this virtue; the propensity which artists have to fall into the contrary extreme: we therefore set a guard on that side which is most assailable. When a young artist is first told that his composition and his attitudes must be contrasted, that he must turn the head contrary to the position of the body, in order to produce grace and animation; that his outline must be undulating, and swelling,

Plate III

197-198	78	affectation; yet he is, in	224	78	side that is
208	78	something besides mere	227	78	be unadulating, and
216	78	not want to degrade			

to give grandeur; and that the eye must be gratified with a variety of colours;—when he is told this, with certain animating words, of Spirit, Dignity, Energy, Grace, greatness of Style, and brilliancy of Tints, he becomes suddenly vain of his newly acquired knowledge, and never thinks he can carry those rules too far. It is then that the aid of simplicity ought to be called in, to correct the exuberance of youthful ardour.

THE same may be said in regard to Colouring, which in its pre-eminence is particularly applied to flesh. An artist in his first essay of imitating nature, would make the whole mass of one colour, as the oldest painters did; till he is taught to observe not only the variety of tints, which are in the object itself, but the differences produced by the gradual decline of light to shadow: he then immediately puts his instruction in practice, and introduces a variety of distinct colours. He must then be again corrected, and told, that though there is this variety, yet the effect of the whole upon the eye must have the union and simplicity of the colouring of nature.

AND here we may observe, that the progress of an individual Student bears a great resemblance to the progress and advancement of the Art itself. Want of simplicity would probably be not one of the defects of an artist who had studied nature only, as it was not of the old masters, who lived in the time preceding the great Art of Painting; on the contrary, their works are too simple and too inartificial.

THE Art in its infancy, like the first work of a Student, was dry, hard, and simple. But this kind of barbarous simplicity, would be better named Penury, as it proceeds from mere want; from want of knowledge, want of resources, want of abilities to be otherwise: their simplicity was the offspring not of choice, but necessity.

IN the second stage they were sensible of this poverty, and those who were the most sensible of the want, were the best judges of the measure of the supply. There were painters who emerged from poverty without falling into luxury. Their success induced others, who probably never would of themselves have had strength of mind to discover the original defect, to endeavour at the remedy by an abuse; and they ran into the contrary extreme. But however they may have strayed, we cannot recommend to them to return to that simplicity which they have justly quitted; but to deal out their abundance with a more sparing hand,

231 78 his new acquired
232-233 78 Simplicity is called
253-254 78 Simplicity is the offspring
260 78 and ran

with that dignity which makes no parade, either of its riches, or of its
art. It is not easy to give a rule which may serve to fix this just and cor-
rect medium; because, when we may have fixed, or nearly fixed, the
middle point, taken as a general principle, circumstances may oblige us
to depart from it, either on the side of Simplicity, or on that of Variety
and Decoration.

I THOUGHT it necessary in a former discourse, speaking of the differ-
ence of the sublime and ornamental style of painting,—in order to excite
your attention to the more manly, noble, and dignified manner, to leave
perhaps an impression too contemptuous of those ornamental parts of
our Art, for which many have valued themselves, and many works are
much valued and esteemed.

I SAID then, what I thought it was right at that time to say; I supposed
the disposition of young men more inclinable to splendid negligence,
than perseverance in laborious application to acquire correctness; and
therefore did as we do in making what is crooked straight, by bending
it the contrary way, in order that it may remain straight at last.

FOR this purpose then, and to correct excess or neglect of any kind,
we may here add, that it is not enough that a work be learned; it must be
pleasing: the painter must add grace to strength, if he desires to secure
the first impression in his favour. Our taste has a kind of sensuality
about it, as well as a love of the sublime; both these qualities of the mind



264　78　dignity that makes

269-270　78　and Decoration.
It is the knowledge of those powers and
faculties of our nature, to which Art addresses
itself, that will enable the Artist to distinguish
between those rules that require implicit
obedience, and those which are of less conse-
quence, and may be more easily dispensed
with.
To distinguish in what the spirit of each
rule consists; and amongst the difficulties of
the Art from which this knowledge must ex-
tricate him, may be reckoned the nice judg-
ment required to choose the least evil, when
an Artist finds himself in that situation, that
whatever he does must be in a certain degree
wrong.
I need not here recommend to the Artist
the exclusion of beauties which belong to an-
other stile, as I have already enlarged on this
subject in a former discourse, speaking of the
difference between the Roman and Venetian
schools: I will only observe now, in order to
refer it to the present purpose, that we expect

to find in Art, what we find in life and man-
ners, a uniformity of character.
Before I speak of the different importance
of rules, I cannot avoid mentioning one rule,
which indeed may be said to comprehend all
the rest, the importance of pleasing at first
sight; a Painter produces his work in vain if
it does not invite attention.
I thought

279-280　78　straight when it is bent the
contrary

282　78　enough a work

284　78　his favour.
The Cartoons of Raffaelle have powers that
strike so forcibly, that the absence of the
lesser elegancies of the Art are not perceived;
we even sometimes go greater lengths, and
carry our enthusiastic admiration so far, as to
despise those ornamental qualities, without
considering perhaps sufficiently our own im-
becillity, or recollecting how few can have
any title or pretension to such neglect.
Our taste

285　78　both those qualities



are to have their proper consequence, as far as they do not counteract each other; for that is the grand error which much care ought to be taken to avoid.

THERE are some rules, whose absolute authority, like that of our nurses, continues no longer than while we are in a state of childhood. One of the first rules, for instance, that I believe every master would give to a young pupil, respecting his conduct and management of light and shadow, would be what Lionardo da Vinci has actually given; that you must oppose a light ground to the shadowed side of your figure, and a dark ground to the light side. If Lionardo had lived to see the superior splendour and effect which has been since produced by the exactly contrary conduct,—by joining light to light, and shadow to shadow,—though without doubt he would have admired it, yet, as it ought not, so probably it would not be the first rule with which he would have begun his instructions.

AGAIN; in the artificial management of the figures, it is directed that they shall contrast each other according to the rules generally given; that if one figure opposes his front to the spectator, the next figure is to have his back turned, and that the limbs of each individual figure be contrasted; that is, if the right leg be put forward, the right arm is to be drawn back.

IT is very proper that those rules should be given in the Academy; it is proper the young students should be informed that some research is to be made, and that they should be habituated to consider every excellence as reduceable to principles. Besides; it is the natural progress of instruction to teach first what is obvious and perceptible to the senses, and from thence proceed gradually to notions large, liberal, and complete, such as comprise the more refined and higher excellencies in Art. But when students are more advanced, they will find that the greatest beauties of character and expression are produced without contrast; nay more, that this contrast would ruin and destroy that natural energy of men engaged in real action, unsolicitous of grace. St Paul preaching

291	78	rules that	307	78	proper those
293	78	shadow, for instance, would	309	78	made, and be habituated
297	78	conduct, joining	313-314	78	in Art. When students
300-301	78	his instructions. Thus, in the	316-317	78	destroy them. St. Paul

291-295 Leonardo da Vinci, *Treatise on Painting*, I, 73 (par. 145).

at Athens in one of the Cartoons, far from any affected academical con- *Plate IV*
trast of limbs, stands equally on both legs, and both hands are in the
same attitude: add contrast, and the whole energy and unaffected grace 320
of the figure is destroyed. Elymas the Sorcerer stretches both hands for-
ward in the same direction, which gives perfectly the expression in-
tended. Indeed you never will find in the works of Raffaelle any of
those school-boy affected contrasts. Whatever contrast there is, appears
without any seeming agency of art, by the natural chance of things. 325

WHAT has been said of the evil of excesses of all kinds, whether of
simplicity, variety, or contrast, naturally suggests to the painter the
necessity of a general enquiry into the true meaning and cause of rules,
and how they operate on those faculties to which they are addressed: by
knowing their general purpose and meaning, he will often find that he 330
need not confine himself to the literal sense, it will be sufficient if he
preserve the spirit, of the law.

CRITICAL remarks are not always understood without examples: it
may not be improper therefore to give instances where the rule itself,
though generally received, is false, or where a narrow conception of it 335
may lead the artist into great errors.

IT is given as a rule by Fresnoy, That *the principal figure of a subject
must appear in the midst of the picture, under the principal light, to dis-
tinguish it from the rest.* A painter who should think himself obliged
strictly to follow this rule, would encumber himself with needless diffi- 340
culties; he would be confined to great uniformity of composition, and
be deprived of many beauties which are incompatible with its observ-
ance. The meaning of this rule extends, or ought to extend, no further

323 78 will meet in

325-337 78 of things.
The contrasts, such as I just mentioned,
will scarce ever succeed except in Statues or
Pictures of single figures only; to them it may
in a considerable degree be applicable; in a
composition it will be apt to destroy that
natural energy of men engaged in real action,
unsolicitous of grace.
It would be useful to a Painter to enquire

into the true meaning and cause of rules, and
how they operate on those faculties to which
they are addressed; by knowing their general
purpose and meaning, he will often find that
he need not confine himself to the literal
sense, it will be sufficient if he preserves the
spirit of the Law.
It is given as a rule, for instance, by Fresnoy

337 98 *the principle figure*

333-336 This paragraph begins with a phrase borrowed from Johnson's "Life of Cowley":
"Critical remarks are not easily understood without examples" (I, 22). This was one of the
phrases that Reynolds copied out when rereading the *Lives of the English Poets*. The notes he
made at that time are now in the possession of F. W. Hilles.

337-339 Du Fresnoy, *De Arte Graphica*, ll. 129 ff. "Let the principal Figure of the Subject
appear in the middle of the Piece, under the strongest Light, that it may have somewhat to
make it more remarkable than the rest" (trans. Dryden [London, 1695], p. 19).

than this;—That the principal figure should be immediately distinguished at the first glance of the eye; but there is no necessity that the principal light should fall on the principal figure, or that the principal figure should be in the middle of the picture. It is sufficient that it be distinguished by its place, or by the attention of other figures pointing it out to the spectator. So far is this rule from being indispensable, that it is very seldom practised, other considerations of greater consequence often standing in the way. Examples in opposition to this rule, are found in the Cartoons, in Christ's Charge to Peter, the Preaching of St. Paul, and Elymas the Sorcerer, who is undoubtedly the principal object in that picture. In none of those compositions is the principal figure in the midst of the picture. In the very admirable composition of the Tent of Darius, by Le Brun, Alexander is not in the middle of the picture, nor does the principal light fall on him; but the attention of all the other figures immediately distinguishes him, and distinguishes him more properly; the greatest light falls on the daughter of Darius, who is in the middle of the picture, where it is more necessary the principal light should be placed.

IT is very extraordinary that Felibien, who has given a very minute description of this picture, but indeed such a description as may be rather called panegyrick than criticism, thinking it necessary (according to the precept of Fresnoy) that Alexander should possess the principal light, has accordingly given it to him; he might with equal truth have said that he was placed in the middle of the picture, as he seemed resolved to give this piece every kind of excellence which he conceived to be necessary to perfection. His generosity is here unluckily misapplied, as it would have destroyed in a great measure the beauty of the composition.

ANOTHER instance occurs to me where equal liberty may be taken in regard to the management of light. Though the general practice is to make a large mass about the middle of the picture surrounded by shadow, the reverse may be practised, and the spirit of the rule may still be preserved. Examples of this principle reversed may be found

Plate IV (margin, opposite lines 351–352)

345 / 350 / 355 / 360 / 365 / 370 / 375 (marginal line numbers)

350-351 78 consequence standing 367 78 said he
357-358 78 all the rest immediately 374-375 78 rule still exist. Examples

355-356 The painting is now in the Louvre, Cat. No. 72. For an illustration see the frontispiece to Félibien, *Tent of Darius*.

362-366 Félibien, ibid., pp. 32-33. Reynolds again makes substantially the same comment on the passage as a marginal note in his copy of the book. See Hilles, *Literary Career*, p. 232.

very frequently in the works of the Venetian school. In the great composition of Paul Veronese, the Marriage at Cana, the figures are for the most part in half shadow; the great light is in the sky; and indeed the general effect of this picture which is so striking, is no more than what we often see in landscapes, in small pictures of fairs and country feasts; but those principles of light and shadow being transferred to a large scale, to a space containing near a hundred figures as large as life, and conducted to all appearance with as much facility, and with an attention as steadily fixed upon *the whole together,* as if it were a small picture immediately under the eye, the work justly excites our admiration; the difficulty being encreased as the extent is enlarged.

Plate XVI

380

385

THE various modes of composition are infinite: sometimes it shall consist of one large group in the middle of the picture, and the smaller groups on each side; or a plain space in the middle, and the groups of figures ranged round this vacuity.

390

WHETHER this principal broad light be in the middle space of ground, as in the School of Athens; or in the sky, as in the Marriage at Cana, in the Andromeda, and in most of the pictures of Paul Veronese; or whether the light be on the groups; whatever mode of composition is adopted, every variety and licence is allowable: this only is indisputably necessary, that to prevent the eye from being distracted and confused by a multiplicity of objects of equal magnitude, those objects, whether they consist of lights, shadows, or figures, must be disposed in large masses and groups properly varied and contrasted; that to a certain quantity of action a proportioned space of plain ground is required; that

395

400

384 78 it was a small 396-397 78 confused with a multiplicity

387 78 sometimes they shall

377 The painting is now in the Louvre. When Reynolds actually saw the picture in 1752 in S. Giorgio Maggiore, Venice, he made the following comment in his notebook: "The principal light in the middle Paolo himself, dressed in white, and light yellow stockings, and playing on a violino; the next is his brother going to taste the liquor: he is dressed in white, but flowered in various colours. The table-cloth, the end on the other side, with the lady, makes a large mass of light. Almost all the other figures seem to be in mezzotint; here and there a little brightness to hinder it from looking heavy, all the banisters are mezzotint; between some of them, on the right side, is seen the light building to hinder the line of shadow, so as to make the picture look half shadow and half light. The sky blue, with white clouds. The tower in the middle, white as the clouds; and so all the distant architecture, which grows darker and darker as it approaches the fore figures; between the dark architecture in the foreground and the light behind, are placed figures to join them, as it were, together." Charles Robert Leslie and Tom Taylor, *Life and Times of Sir Joshua Reynolds* (London, 1865), I, 68-69.

392 Reynolds refers, of course, to the fresco by Raphael in the Stanza della Segnatura.

393 For the "Andromeda" see IV, 220.

light is to be supported by sufficient shadow; and, we may add, that a certain quantity of cold colours is necessary to give value and lustre to the warm colours: what those proportions are cannot be so well learnt by precept as by observation on pictures, and in this knowledge bad
405 pictures will instruct as well as good. Our enquiry why pictures have a bad effect, may be as advantageous as the enquiry why they have a good effect; each will corroborate the principles that are suggested by the other.

THOUGH it is not my *business* to enter into the detail of our Art, yet
410 I must take this opportunity of mentioning one of the means of producing that great effect which we observe in the works of the Venetian painters, as I think it is not generally known or observed. It ought, in my opinion, to be indispensably observed, that the masses of light in a picture be always of a warm mellow colour, yellow, red, or a yellow-
415 ish-white; and that the blue, the grey, or the green colours be kept almost entirely out of these masses, and be used only to support and set off these warm colours; and for this purpose, a small proportion of cold colours will be sufficient.

LET this conduct be reversed; let the light be cold, and the surround-
420 ing colours warm, as we often see in the works of the Roman and Florentine painters, and it will be out of the power of art, even in the hands of Rubens or Titian, to make a picture splendid and harmonious.

LE Brun and Carlo Maratti were two painters of great merit, and particularly what may be called Academical Merit, but were both
425 deficient in this management of Colours; the want of observing this rule is one of the causes of that heaviness of effect which is so observable in their works. The principal light in the Picture of Le Brun, which I just now mentioned, falls on Statira, who is dressed very injudiciously in a pale blue drapery; it is true, he has heightened this blue with gold,
430 but that is not enough; the whole picture has a heavy air, and by no means answers the expectation raised by the Print. Poussin often made a spot of blue drapery, when the general hue of the picture was inclinable to brown or yellow; which shews sufficiently, that harmony of

419 98 be reserved; let 424 78 particularly in what

409-418 This passage was probably the foundation of the anecdote about Gainsborough's "The Blue Boy" being painted to prove Reynolds wrong. The story seems to appear first in John Young, *A Catalogue of the Pictures at Grosvenor House* (London, [1821]), p. 6. It is very unlikely that the story is true. The date of "The Blue Boy" is not definitely established, but it was probably painted about 1770 (i.e., some eight years prior to the delivery of Discourse VIII).

colouring was not a part of the art that had much engaged the attention of that great painter.

435

THE conduct of Titian in the picture of Bacchus and Ariadne, has *Plate XVII* been much celebrated, and justly, for the harmony of colouring. To Ariadne is given (say the criticks) a red scarf, to relieve the figure from the sea which is behind her. It is not for that reason, alone, but for another of much greater consequence; for the sake of the general har- 440 mony and effect of the picture. The figure of Ariadne is separated from the great group, and is dressed in blue, which added to the colour of the sea, makes that quantity of cold colour which Titian thought necessary for the support and brilliancy of the great group; which group is com- posed, with very little exception, entirely of mellow colours. But as the 445 picture in this case would be divided into two distinct parts, one half cold, and the other warm, it was necessary to carry some of the mellow colours of the great group into the cold part of the picture, and a part of the cold into the great group; accordingly Titian gave Ariadne a red scarf, and to one of the Bacchante a little blue drapery. 450

THE light of the picture, as I observed, ought to be of a warm col- our; for though white may be used for the principal light, as was the practice of many of the Dutch and Flemish painters, yet it is better to suppose *that white* illumined by the yellow rays of the setting sun, as was the manner of Titian. The superiority of which manner is never 455 more striking, than when in a collection of pictures we chance to see a portrait of Titian's hanging by the side of a Flemish picture, (even though that should be of the hand of Vandyck,) which, however admirable in other respects, becomes cold and grey in the comparison.

THE illuminated parts of objects are in nature of a warmer tint than 460 those that are in the shade: what I have recommended therefore is no more, than that the same conduct be observed in the whole, which is acknowledged to be necessary in every individual part. It is presenting to the eye the same effect as that which it has been *accustomed* to feel, which in this case, as in every other, will always produce beauty; no 465

| 435 | 78 | of this great | 443 | 78 | sea, make that |
| 439 | 78 | reason, but | 460 | 78 | The illumined parts |

436 Titian's "Bacchus and Ariadne" is now in the National Gallery, London. Reynolds would have seen it in the Villa Aldobrandini, Rome.

438 Félibien ("L'idée du peintre parfait," in *Entretiens sur les vies et sur les ouvrages des plus excellens peintres* [Paris, 1725], VI, 50) also mentions and dismisses the notion that Ariadne is given a red scarf to detach her from the background. He feels that the red scarf is used simply to draw attention to the figure.

principle therefore in our art can be more certain, or is derived from a higher source.

WHAT I just now mentioned of the supposed reason why Ariadne has part of her drapery red, gives me occasion here to observe, that
470 this favourite quality of giving objects relief, and which De Piles and all the Criticks have considered as a requisite of the utmost importance, was not one of those objects which much engaged the attention of Titian: painters of an inferior rank have far exceeded him in producing this effect. This was a great object of attention when art was in its
475 infant state, as it is at present with the vulgar and ignorant, who feel the highest satisfaction in seeing a figure, which, as they say, looks as if they could walk round it. But however low I may rate this pleasure of deception, I should not oppose it, did it not oppose itself to a quality of a much higher kind, by counteracting entirely that fulness of
480 manner which is so difficult to express in words, but which is found in perfection in the best works of Correggio, and we may add, of Rem-
Plate XV brandt. This effect is produced by melting and losing the shadows in a ground still darker than those shadows; whereas that relief is produced by opposing and separating the ground from the figure either by light,
485 or shadow, or colour. This conduct of in-laying, as it may be called, figures on their ground, in order to produce relief, was the practice of the old Painters, such as Andrea Mantegna, Pietro Perugino, and Albert Durer; and to these we may add, the first manner of Lionardo da Vinci, Giorgione, and even Correggio; but these three were among
490 the first who began to correct themselves in this dryness of style, by no longer considering relief as a principal object. As those two qualities, relief, and fulness of effect, can hardly exist together, it is not very difficult to determine to which we ought to give the preference. An Artist is obliged for ever to hold a balance in his hand, by which he
495 must determine the value of different qualities; that, when *some* fault must be committed, he may choose the least. Those painters who have best understood the art of producing a good effect, have adopted one principle that seems perfectly conformable to reason; that a part may

466 78 or be derived

480-481 78 found in such perfection

482 78 This manner is

482-483 78 shadows into a ground

489-490 78 were amongst the first who begun to correct

490 98 in dryness

493-494 78 the preference. As I have observed, an Artist

498 97 comformable

470 De Piles, "Observations on the Art of Painting," p. 176.

be sacrificed for the good of the whole. Thus, whether the masses consist of light or shadow, it is necessary that they should be compact and of a pleasing shape; to this end, some parts may be made darker and some lighter, and reflexions stronger than nature would warrant. Paul Veronese took great liberties of this kind. It is said, that being once asked, why certain figures were painted in shade, as no cause was seen in the picture itself; he turned off the enquiry by answering, "*una nuevola che passa*," a cloud is passing which has overshadowed them.

BUT I cannot give a better instance of this practice than a picture which I have of Rubens: it is a representation of a Moon-light. Rubens has not only diffused more light over the picture than is in nature, but has bestowed on it those warm glowing colours by which his works are so much distinguished. It is so unlike what any other painters have given us of Moon-light, that it might be easily mistaken, if he had not likewise added stars, for a fainter setting sun.—Rubens thought the eye ought to be satisfied in this case, above all other considerations: he might indeed have made it more natural, but it would have been at the expence of what he thought of much greater consequence,—the harmony proceeding from the contrast and variety of colours.

THIS same picture will furnish us with another instance, where we must depart from nature for a greater advantage. The Moon in this picture does not preserve so great a superiority in regard to its lightness over the object which it illumines, as it does in nature; this is likewise an intended deviation, and for the same reason. If Rubens had preserved the same scale of gradation of light between the Moon and the objects, which is found in nature, the picture must have consisted of one small spot of light only, and at a little distance from the picture nothing but this spot would have been seen. It may be said indeed, that this being the case, it is a subject that ought not to be painted: but then, for the same reason, neither armour, nor any thing shining, ought ever to be painted; for though pure white is used in order to represent the greatest light of shining objects, it will not in the picture preserve

Plate IX

500
505
510
515
520
525
530

505 78 off their enquiry	523-524 78 objects as in nature	
506-507 78 overshadowed it. But I	525 78 a small distance	
	526 78 would be seen	
507 78 than in a Picture	528 78 reason, armour, nor	

508 The picture is in the collection of Count Seilern, London. It was sold with the rest of Reynolds' collection March 14, 1795 (No. 85 of the catalogue).

the same superiority over flesh, as it has in nature, without keeping that flesh-colour of a very low tint. Rembrandt, who thought it of more consequence to paint light, than the objects that are seen by it, has *Plate XV* done this in a picture of Achilles which I have. The head is kept down
535 to a very low tint, in order to preserve this due gradation and distinction between the armour and the face; the consequence of which is, that upon the whole the picture is too black. Surely too much is sacrificed here to this narrow conception of nature: allowing the contrary conduct a fault, yet it must be acknowledged a less fault than
540 making a picture so dark that it cannot be seen without a peculiar light, and then with difficulty. The merit or demerit of the different conduct of Rubens and Rembrandt in those instances which I have given, is not to be determined by the narrow principles of nature, separated from its effect on the human mind. Reason and common sense tell
545 us, that before, and above all other considerations, it is necessary that the work should be seen, not only without difficulty or inconvenience, but with pleasure and satisfaction; and every obstacle which stands in the way of this pleasure and convenience must be removed.

THE tendency of this Discourse, with the instances which have
550 been given, is not so much to place the Artist above rules, as to teach him their reason; to prevent him from entertaining a narrow confined conception of Art; to clear his mind from a perplexed variety of rules and their exceptions, by directing his attention to an intimate acquaintance with the passions and affections of the mind, from which all rules
555 arise, and to which they are all referable. Art effects its purpose by their means; an accurate knowledge therefore of those passions and dispositions of the mind is necessary to him who desires to affect them upon sure and solid principles.

A COMPLETE essay or enquiry into the connection between the rules
560 of Art, and the eternal and immutable dispositions of our passions, would be indeed going at once to the foundation of criticism;* but

*This was inadvertently said. I did not recollect the admirable treatise *On the Sublime and Beautiful.*

534 78 picture which I have of Achilles. The head	553 78	exceptions, by recommending the attention of the Artist to an acquaintance
	556 78	an intimate knowledge
540 78 dark as cannot	556-557 78	passions and affections is
542-543 78 given, are not	561 78	Criticism; but [no note]

534 Now in the Glasgow Art Gallery, known as "A Man in Armour."
561n Reynolds refers to Edmund Burke's youthful treatise, *The Sublime and Beautiful.*

I am too well convinced what extensive knowledge, what subtle and penetrating judgment would be required, to engage in such an undertaking: it is enough for me, if, in the language of painters, I have produced a slight sketch of a part of this vast composition, but that sufficiently distinct to shew the usefulness of such a theory, and its practicability.

BEFORE I conclude, I cannot avoid making one observation on the pictures now before us. I have observed, that every candidate has copied the celebrated invention of Timanthes in hiding the face of Agamemnon in his mantle; indeed such lavish encomiums have been bestowed on this thought, and that too by men of the highest character in critical knowledge,—Cicero, Quintilian, Valerius Maximus, and Pliny,—and have been since re-echoed by almost every modern that has written on the Arts, that your adopting it can neither be wondered at nor blamed. It appears now to be so much connected with the subject, that the spectator would perhaps be disappointed in not finding united in the picture what he always united in his mind, and considered as indispensably belonging to the subject. But it may be observed, that those who praise this circumstance were not painters. They use it as an illustration only of their own art; it served their purpose, and it was certainly not their business to enter into the objections that lie against it in another Art. I fear *we* have but very scanty means of exciting those powers over the imagination which make so very considerable and refined a part of poetry. It is a doubt with me, whether we should even make the attempt. The chief, if not the only occasion which the painter has for this artifice, is, when the subject is improper to be more fully represented, either for the sake of decency, or to avoid what would be disagreeable to be seen; and this is not to raise or increase the passions, which is the reason that is given for this practice, but on the contrary to diminish their effect.

IT is true, sketches, or such drawings as painters generally make for their works, give this pleasure of imagination to a high degree. From a

565

570

575

580

585

590

574 78 and since re-echoed

574-575 78 has wrote on

576 78 blamed. Indeed it

577 78 would be

585-586 78 whether they should be even attempted. The chief

573 Cicero *Orator* xxii.74; Quintilian *Institutio oratoria* II.xiii.14; Valerius Maximus VIII.xi (De effectibus artium raris apud externos).6; Pliny XXXV.xxxvi.73. Quintilian and Pliny are cited by Junius, p. 242.

slight undetermined drawing, where the ideas of the composition and
character are, as I may say, only just touched upon, the imagination
supplies more than the painter himself, probably, could produce; and
we accordingly often find that the finished work disappoints the expec-
tation that was raised from the sketch; and this power of the imagina-
tion is one of the causes of the great pleasure we have in viewing a
collection of drawings by great painters. These general ideas, which
are expressed in sketches, correspond very well to the art often used in
Poetry. A great part of the beauty of the celebrated description of Eve
in Milton's Paradise Lost, consists in using only general indistinct
expressions, every reader making out the detail according to his own
particular imagination,—his own idea of beauty, grace, expression, dig-
nity, or loveliness: but a painter, when he represents Eve on a canvas,
is obliged to give a determined form, and his own idea of beauty
distinctly expressed.

WE cannot on this occasion, nor indeed on any other, recommend
an undeterminate manner, or vague ideas of any kind, in a complete
and finished picture. This notion, therefore, of leaving any thing to the
imagination, opposes a very fixed and indispensable rule in our art,—
that every thing shall be carefully and distinctly expressed, as if the
painter knew, with correctness and precision, the exact form and char-
acter of whatever is introduced into the picture. This is what with us
is called Science, and Learning; which must not be sacrificed and given
up for an uncertain and doubtful beauty, which, not naturally belong-
ing to our Art, will probably be sought for without success.

MR. Falconet has observed, in a note on this passage in his transla-
tion of Pliny, that the circumstance of covering the face of Agamem-
non was probably not in consequence of any fine imagination of the
painter; which he considers as a discovery of the criticks; but merely

594	78	the idea of
598-599	78	power is
600	78	drawings of great
601	78	Art in
604	78	every man making
609-610	78	indeed in any other, recommend an undetermined manner

611 78 This idea, therefore,

617 78 for a beauty so uncertain and doubtful, which

622-623 78 Painter; this he considers as a discovery of the critics; but that he merely copied the description of the sacrifice, as he found it in Euripides.

602-603 Reynolds probably has in mind Bk. IV, ll. 304 ff. For annotations on this passage by an artist whose writings Reynolds knew and admired see Jonathan Richardson (father and son), *Explanatory Notes ... on ... Paradise Lost* (London, 1734), pp. 154-159.

619 ff. See *Œuvres d'Etienne Falconet*, V, 62 ff.

copied from the description of the sacrifice, as it is found in Euripides.

THE words from which the picture is supposed to be taken, are these: *Agamemnon saw Iphigenia advance towards the fatal altar; he groaned, he turned aside his head, he shed tears, and covered his face with his robe.* 625

FALCONET does not at all acquiesce in the praise that is bestowed on Timanthes; not only because it is not his invention, but because he thinks meanly of this trick of concealing, except in instances of blood, 630 where the objects would be too horrible to be seen; but, says he, "in an afflicted Father, in a King, in Agamemnon, you, who are a painter, conceal from me the most interesting circumstance, and then put me off with sophistry and a veil. You are (he adds) a feeble Painter, without resources; you do not know even those of your Art: I care not 635 what veil it is, whether closed hands, arms raised, or any other action that conceals from me the countenance of the Hero. You think of veiling Agamemnon; you have unveiled your own ignorance. A Painter who represents Agamemnon veiled, is as ridiculous as a Poet would be, who in a pathetick situation, in order to satisfy my expectations, and 640 rid himself of the business, should say, that the sentiments of his Hero are so far above whatever can be said on the occasion, that he shall say nothing."

To what Falconet has said, we may add, that supposing this method of leaving the expression of grief to the imagination, to be, as it was 645 thought to be, the invention of the painter, and that it deserves all the praise that has been given it, still it is a trick that will serve but once; whoever does it a second time, will not only want novelty, but be justly suspected of using artifice to evade difficulties. If difficulties overcome make a great part of the merit of Art, difficulties evaded can deserve 650 but little commendation.

634-635 78 You, says he, are a feeble Painter, without resources; you don't know

636 78 or whatever action

638-639 78 Painter, says he, who represents

625-627 Euripides *Iphigeneia at Aulis*, ll. 1547-50.
Messenger: "But when King Agamemnon saw
The maid for slaughter entering the grove,
He heaved a groan, he turned his head away
Weeping, and drew his robe before his eyes."

DISCOURSE IX

Delivered at the Opening of The Royal Academy,

in Somerset-Place,

October 16, 1780

DISCOURSE IX

GENTLEMEN,

THE honour which the Arts acquire by being permitted to take possession of this noble habitation, is one of the most considerable of the many instances we have received of his MAJESTY's protection; and the strongest proof of his desire to make the Academy respectable.

NOTHING has been left undone that might contribute to excite our pursuit, or to reward our attainments. We have already the happiness of seeing the Arts in a state to which they never before arrived in this nation. This Building, in which we are now assembled, will remain to many future ages an illustrious specimen of the Architect's abilities. It is our duty to endeavour that those who gaze with wonder at the structure, may not be disappointed when they visit the apartments. It will be no small addition to the glory which this nation has already acquired from having given birth to eminent men in every part of science, if it should be enabled to produce, in consequence of this institution, a School of English Artists. The estimation in which we stand in respect to our neighbours, will be in proportion to the degree in which we excel or are inferior to them in the acquisition of intellectual excellence, of which Trade and its consequential riches must be acknowledged to give the means; but a people whose whole attention is absorbed in those means, and who forget the end, can aspire but little above the rank of a barbarous nation. Every establishment that tends to the cultivation of the pleasures of the mind, as distinct from those of sense, may be considered as an inferior school of morality, where the mind is polished and prepared for higher attainments.

LET us for a moment take a short survey of the progress of the mind towards what is, or ought to be, its true object of attention. Man, in

9 98 the Architect's* abilities
*Sir William Chambers.

8 The major portion of Somerset House was designed by Sir William Chambers. It was begun in 1776, and the Strand block was completed in 1780. It was in this section that the Royal Academy was installed for fifty-seven years.

169

his lowest state, has no pleasures but those of sense, and no wants but those of appetite; afterwards, when society is divided into different ranks, and some are appointed to labour for the support of others, those whom their superiority sets free from labour, begin to look for intellectual entertainments. Thus, whilst the shepherds were attending their flocks, their masters made the first astronomical observations; so musick is said to have had its origin from a man at leisure listening to the strokes of a hammer.

As the senses, in the lowest state of nature, are necessary to direct us to our support, when that support is once secure there is danger in following them further; to him who has no rule of action but the gratification of the senses, plenty is always dangerous: it is therefore necessary to the happiness of individuals, and still more necessary to the security of society, that the mind should be elevated to the idea of general beauty, and the contemplation of general truth; by this pursuit the mind is always carried forward in search of something more excellent than it finds, and obtains its proper superiority over the common senses of life, by learning to feel itself capable of higher aims and nobler enjoyments. In this gradual exaltation of human nature, every art contributes its contingent towards the general supply of mental pleasure. Whatever abstracts the thoughts from sensual gratifications, whatever teaches us to look for happiness within ourselves, must advance in some measure the dignity of our nature.

PERHAPS there is no higher proof of the excellency of man than this, —that to a mind properly cultivated whatever is bounded is little. The mind is continually labouring to advance, step by step, through successive gradations of excellence, towards perfection, which is dimly seen, at a great though not hopeless distance, and which we must always follow because we never can attain; but the pursuit rewards itself: one truth teaches another, and our store is always increasing, though nature can never be exhausted. Our art, like all arts which address the imagination, is applied to somewhat a lower faculty of the mind, which approaches nearer to sensuality; but through sense and fancy it must make its way to reason; for such is the progress of thought, that we perceive by sense, we combine by fancy, and distinguish by reason: and without carrying our art out of its natural and true character, the more we purify it from every thing that is gross in sense, in that pro-

32 80 first observations on astronomy; so 44 80 and of nobler music

portion we advance its use and dignity; and in proportion as we lower it to mere sensuality, we pervert its nature, and degrade it from the 65 rank of a liberal art; and this is what every artist ought well to remember. Let him remember also, that he deserves just so much encouragement in the state as he makes himself a member of it virtuously useful, and contributes in his sphere to the general purpose and perfection of society. 70

THE Art which we profess has beauty for its object; this it is our business to discover and to express; but the beauty of which we are in quest is general and intellectual; it is an idea that subsists only in the mind; the sight never beheld it, nor has the hand expressed it: it is an idea residing in the breast of the artist, which he is always labouring to 75 impart, and which he dies at last without imparting; but which he is yet so far able to communicate, as to raise the thoughts, and extend the views of the spectator; and which, by a succession of art, may be so far diffused, that its effects may extend themselves imperceptibly into publick benefits, and be among the means of bestowing on whole 80 nations refinement of taste: which, if it does not lead directly to purity of manners, obviates at least their greatest depravation, by disentangling the mind from appetite, and conducting the thoughts through successive stages of excellence, till that contemplation of universal rectitude and harmony which began by Taste, may, as it is exalted and 85 refined, conclude in Virtue.

DISCOURSE X

Delivered to the Students of The Royal Academy,

on the Distribution of the Prizes,

December 11, 1780

DISCOURSE X

I SHALL now, as it has been customary on this day, and on this occasion, communicate to you such observations as have occurred to me on the Theory of Art.

IF these observations have hitherto referred principally to Painting, let it be remembered that this Art is much more extensive and complicated than Sculpture, and affords therefore a more ample field for criticism; and as the greater includes the less, the leading principles of Sculpture are comprised in those of Painting.

HOWEVER, I wish now to make some remarks with particular relation to Sculpture; to consider wherein, or in what manner, its principles and those of Painting agree or differ; what is within its power of performing, and what it is vain or improper to attempt; that it may be clearly and distinctly known what ought to be the great purpose of the Sculptor's labours.

SCULPTURE is an art of much more simplicity and uniformity than Painting; it cannot with propriety, and the best effect, be applied to many subjects. The object of its pursuit may be comprised in two words, Form and Character; and those qualities are presented to us but in one manner, or in one style only; whereas the powers of Painting, as they are more various and extensive, so they are exhibited in as great a variety of manners. The Roman, Lombard, Florentine, Venetian, and Flemish Schools, all pursue the same end by different means. But Sculpture having but one style, can only to one style of painting have any relation; and to this (which is indeed the highest and most dignified that Painting can boast,) it has a relation so close, that it may be said to be almost the same art operating upon different materials. The Sculptors of the last age, from not attending sufficiently to this discrimination of the different styles of Painting, have been led into many errors.

12 80 and what is in vain

28-29 80 many errors.
Though Sculptors may justly be allowed

Though they well knew that they were allowed to imitate, or take ideas for the improvement of their own Art from the grand style of Painting, they were not aware that it was not permitted to borrow in the same manner from the ornamental. When they endeavour to copy the picturesque effects, contrasts, or petty excellencies of whatever kind, which not improperly find a place in the inferior branches of Painting, they doubtless imagine themselves improving and extending the boundaries of their art by this imitation; but they are in reality violating its essential character, by giving a different direction to its operations, and proposing to themselves either what is unattainable, or at best a meaner object of pursuit. The grave and austere character of Sculpture requires the utmost degree of formality in composition; picturesque contrasts have here no place; every thing is carefully weighed and measured, one side making almost an exact equipoise to the other: a child is not a proper balance to a full-grown figure, nor is a figure sitting or stooping a companion to an upright figure.

THE excellence of every art must consist in the complete accomplishment of its purpose; and if by a false imitation of nature, or mean ambition of producing a picturesque effect or illusion of any kind, all the grandeur of ideas which this art endeavours to excite, be degraded or destroyed, we may boldly oppose ourselves to any such innovation. If the producing of a deception is the summit of this art, let us at once give to statues the addition of colour; which will contribute more towards accomplishing this end, than all those artifices which have been introduced and professedly defended, on no other principle but that of rendering the work more natural. But as colour is universally rejected, every practice liable to the same objection must fall with it. If the business of Sculpture were to administer pleasure to ignorance, or a mere entertainment to the senses, the Venus of Medicis might certainly receive much improvement by colour; but the character of Sculpture makes it her duty to afford delight of a different, and, perhaps, of a

30-31　80　Painting, yet it is not

38-45　80　themselves not only an unattainable but a meaner object of pursuit. The excellence [omits a sentence]

46　80　by this false

48　80　art is taught to excite is degraded

51　97　contribut emore

53-54　80　that of being more

55　80　must certainly fall

58　80　colour; but the grave and austere character

55-58　Most ancient sculpture was in fact painted, but this was not generally known in the 18th century.

176

higher kind; the delight resulting from the contemplation of perfect 60
beauty: and this, which is in truth an intellectual pleasure, is in many
respects incompatible with what is merely addressed to the senses, such
as that with which ignorance and levity contemplate elegance of form.

THE Sculptor may be safely allowed to practise every means within
the power of his art to produce a deception, provided this practice does 65
not interfere with or destroy higher excellencies; on these conditions
he will be forced, however loth, to acknowledge that the boundaries of
his art have long been fixed, and that all endeavours will be vain that
hope to pass beyond the best works which remain of ancient Sculpture.

IMITATION is the means, and not the end, of art; it is employed by 70
the sculptor as the language by which his ideas are presented to the
mind of the spectator. Poetry and elocution of every sort make use of
signs, but those signs are arbitrary and conventional. The sculptor
employs the representation of the thing itself; but still as a means to a
higher end,—as a gradual ascent always advancing towards faultless 75
form and perfect beauty. It may be thought at the first view, that even
this form, however perfectly represented, is to be valued and take its
rank only for the sake of still a higher object, that of conveying senti-
ment and character, as they are exhibited by attitude, and expression
of the passions. But we are sure from experience, that the beauty of 80
form alone, without the assistance of any other quality, makes of itself
a great work, and justly claims our esteem and admiration. As a proof
of the high value we set on the mere excellence of form, we may pro-
duce the greatest part of the works of Michael Angelo, both in painting
and sculpture; as well as most of the antique statues, which are justly 85
esteemed in a very high degree, though no very marked or striking
character or expression of any kind is represented.

BUT, as a stronger instance that this excellence alone inspires senti-
ment, what artist ever looked at the Torso without feeling a warmth
of enthusiasm, as from the highest efforts of poetry? From whence 90
does this proceed? What is there in this fragment that produces this
effect, but the perfection of this science of abstract form?

A MIND elevated to the contemplation of excellence perceives in this

89 The Torso Belvedere is in the Vatican. Date and place of discovery are unknown. It was
formerly in the Colonna family collection and was added to the Belvedere Gardens by Clement
VII (pope, 1523-1534).

defaced and shattered fragment, *disjecti membra poetæ*, the traces of
95 superlative genius, the reliques of a work on which succeeding ages
can only gaze with inadequate admiration.

IT may be said that this pleasure is reserved only to those who have
spent their whole life in the study and contemplation of this art; but
the truth is, that all would feel its effects, if they could divest themselves
100 of the expectation of *deception*, and look only for what it really is, a
partial representation of nature. The only impediment of their judg-
ment must then proceed from their being uncertain to what rank, or
rather kind of excellence, it aspires; and to what sort of approbation it
has a right. This state of darkness is, without doubt, irksome to every
105 mind; but by attention to works of this kind, the knowledge of what
is aimed at comes of itself, without being taught, and almost without
being perceived.

THE Sculptor's art is limited in comparison of others, but it has its
variety and intricacy within its proper bounds. Its essence is correct-
110 ness: and when to correct and perfect form is added the ornament of
grace, dignity of character, and appropriated expression, as in the
Plate III Apollo, the Venus, the Laocoon, the Moses of Michael Angelo, and
many others, this art may be said to have accomplished its purpose.

WHAT Grace is, how it is to be acquired or conceived, are in specu-
115 lation difficult questions; but *causa latet, res est notissima:* without
any perplexing enquiry, the effect is hourly perceived. I shall only
observe, that its natural foundation is correctness of design; and though
grace may be sometimes united with incorrectness, it cannot proceed
from it.

94 80 shattered *disjecti*
95-96 80 ages could only
107-108 80 being perceived.
The effect of elaborate pieces of music is
not always understood or felt (whatever may
be pretended) according to the expectation of
those who have been taught what those arbi-
trary sounds denote, and are meant to sig-
nify. It requires long habit to perceive the
effect of the various combinations of sound,
and the particular ends they are designed to
attain, though the ground and foundation of
the whole is in nature.
The Sculptor's
109-110 80 proper bounds.
The essence of the Sculptor's art is correct-
ness: when

113 80 have fully accomplished

119-120 80 from it.
I know that Correggio and Parmegiano are
often produced as authorities to support this
opinion; but very little attention will con-
vince us, that the incorrectness of some parts
which we find in their works, does not con-
tribute, but rather tends to destroy grace.
The Madona, with the sleeping Infant,
and beautiful group of Angels, in the Palazzo
Piti of Parmigiano, would not have lost any
of its excellence, if the neck, fingers, and other
parts, instead of being so long and incorrect,
had preserved their true proportion.
But to come

94 Horace *Satires* I.iv.62.
115 Ovid *Metamorphoses* IV.287: "causa latet, vis est notissima fontis."

BUT to come nearer to our present subject. It has been said that the 120
grace of the Apollo depends on a certain degree of incorrectness; that
the head is not anatomically placed between the shoulders; and that the
lower half of the figure is longer than just proportion allows.

I KNOW that Correggio and Parmegiano are often produced as author-
ities to support this opinion; but very little attention will convince us, 125
that the incorrectness of some parts which we find in their works, does
not contribute to grace, but rather tends to destroy it. The Madonna,
with the sleeping Infant, and beautiful group of Angels, by Parme-
giano, in the Palazzo Piti, would not have lost any of its excellence, if
the neck, fingers, and indeed the whole figure of the Virgin, instead of 130
being so very long and incorrect, had preserved their due proportion.

IN opposition to the first of these remarks I have the authority of a
very able sculptor of this Academy, who has copied that figure, con-
sequently measured and carefully examined it, to declare, that the criti-
cism is not true. In regard to the last, it must be remembered, that 135
Apollo is here in the exertion of one of his peculiar powers, which is
swiftness; he has therefore that proportion which is best adapted to that
character. This is no more incorrectness, than when there is given to
an Hercules an extraordinary swelling and strength of muscles.

THE art of discovering and expressing grace is difficult enough of 140
itself, without perplexing ourselves with what is incomprehensible. A
supposition of such a monster as Grace, begot by Deformity, is poison
to the mind of a young Artist, and may make him neglect what is essen-
tial to his art, correctness of Design, in order to pursue a phantom
which has no existence but in the imagination of affected and refined 145
speculators.

I CANNOT quit the Apollo, without making one observation on the
character of this figure. He is supposed to have just discharged his
arrow at the Python; and, by the head retreating a little towards the

123-132 80 proportion allows. 130 97 idneed
To the first of these remarks
[omits a paragraph] 145-147 80 refined speculation.
 I cannot

120-123 Algarotti, p. 42: "The legs and thighs of the Apollo Belvidere, by being made some-
what longer, than the common proportion of these limbs to the rest of the body seems to admit,
contribute not a little to give him that ease and freedom, which correspond so well with the
activity attributed to that deity. . . ."

127-128 Reynolds is referring to "The Madonna of the Long Neck," one of the best-known
works by Parmigianino, painted about 1535. It now hangs in the Uffizi, Florence. For a full
set of detail plates of the painting see Sydney Joseph Freedberg, *Parmigianino* (Cambridge,
[Mass.], 1950).

150 right shoulder, he appears attentive to its effect. What I would remark, is the difference of this attention from that of the Discobolus, who is engaged in the same purpose, watching the effect of his Discus. The graceful, negligent, though animated air of the one, and the vulgar eagerness of the other, furnish a signal instance of the judgment of the 155 ancient Sculptors in their nice discrimination of character. They are both equally true to nature, and equally admirable.

IT may be remarked, that Grace, Character, and Expression, though words of different sense and meaning, and so understood when applied to the works of Painters, are indiscriminately used when we speak of 160 Sculpture. This indecision we may suspect to proceed from the undetermined effects of the Art itself: those qualities are exhibited in Sculpture rather by form and attitude than by the features, and can therefore be expressed but in a very general manner.

THOUGH the Laocoon and his two sons have more expression in the 165 countenance than perhaps any other antique statues, yet it is only the general expression of pain; and this passion is still more strongly expressed by the writing and contortion of the body than by the features.

IT has been observed in a late publication, that if the attention of the 170 Father in this group had been occupied more by the distress of his children, than by his own sufferings, it would have raised a much greater interest in the spectator. Though this observation comes from a person whose opinion, in every thing relating to the Arts, carries with it the highest authority, yet I cannot but suspect that such refined expres-175 sion is scarce within the province of this Art; and in attempting it, the Artist will run great risk of enfeebling expression, and making it less intelligible to the spectator.

150	80	effect. But what I would
154	80	other, is a signal
158	80	meaning, and are so
166-167	80	more expressed

167 98 the writing and

170-171 80 Children, than appearing to feel only for himself, it would

176 80 run a great risque of enfeebling the expression

151-155 The only known copy of the "Discobolus" with an original head is the one in the Lancelotti Palace, Rome (see Gisela M. A. Richter, *The Sculpture and Sculptors of the Greeks* [New Haven, 1929], Fig. 582). The face, like that of most mid-5th-century heads, is generalized and without specific momentary expression. Reynolds here, as elsewhere, is the victim of the archaeological methods and knowledge of his period (see X, 188 ff.).

169-172 The author of Reynolds' "late publication" has not been ascertained. Winckelmann in 1764 says just the opposite: his own suffering seems to distress him less than that of his children (*The History of Ancient Art*, Bk. X, Ch. i, Sec. 16). Lessing in 1766 does not deal directly with the point in *Laokoon*. Hazlitt, in his marginalia to the Discourses, says "Locke", presumably William Locke Sr. of Norbury Park, but this cannot be verified.

As the general figure presents itself in a more conspicuous manner than the features, it is there we must principally look for expression or character; *patuit in corpore vultus*; and, in this respect, the Sculptor's art is not unlike that of Dancing, where the attention of the spectator is principally engaged by the attitude and action of the performer; and it is there he must look for whatever expression that art is capable of exhibiting. The Dancers themselves acknowledge this, by often wearing masks, with little diminution in the expression. The face bears so very inconsiderable a proportion to the effect of the whole figure, that the ancient Sculptors neglected to animate the features, even with the general expression of the passions. Of this the group of the Boxers is a remarkable instance; they are engaged in the most animated action with the greatest serenity of countenance. This is not recommended for imitation, (for there can be no reason why the countenance should not correspond with the attitude and expression of the figure,) but is mentioned in order to infer from hence, that this frequent deficiency in ancient Sculpture could proceed from nothing but a habit of inattention to what was considered as comparatively immaterial.

THOSE who think Sculpture can express more than we have allowed, may ask, by what means we discover, at the first glance, the character that is represented in a Bust, Cameo, or Intaglio? I suspect it will be found, on close examination, by him who is resolved not to see more than he really does see, that the figures are distinguished by their *insignia* more than by any variety of form or beauty. Take from Apollo his Lyre, from Bacchus his Thirsus and Vine-leaves, and from Meleager the Boar's Head, and there will remain little or no difference in their characters. In a Juno, Minerva, or Flora, the idea of the artist seems to have gone no further than representing perfect beauty, and afterwards

187-188 80 with general

192-193 80 but in order

195 80 what they considered as immaterial

200 80 that they are

202-203 98 and Meleager the Boar's

204 80 the artists seems

180 Statius, *Thebaid*, VI, 573.

188-190 Reynolds probably means one of two groups of wrestlers, marble in the Uffizi, bronze in Naples. The Naples figures are separate and were not found until 1754 in Herculaneum. As Reynolds returned to London from Italy in 1752, it is unlikely that he means this pair. The marble in the Uffizi is a close-knit group, found in 1583 near the Lateran. The heads, although antique, did not originally belong to the statues concerned, so the point of Reynolds' observation is rather lost. But his contention is generally valid for Greek sculpture prior to the late 5th century B.C. See in particular the sculpture from the pediments and metopes of the Temple of Zeus at Olympia.

adding the proper attributes, with a total indifference to which they gave them. Thus John De Bologna, after he had finished a group of a young man holding up a young woman in his arms, with an old man at his feet, called his friends together, to tell him what name he should
210 give it, and it was agreed to call it The Rape of the Sabines*; and this is the celebrated group which now stands before the old Palace at Florence. The figures have the same general expression which is to be found in most of the antique Sculpture; and yet it would be no wonder if future criticks should find out delicacy of expression which was never
215 intended; and go so far as to see, in the old man's countenance, the exact relation which he bore to the woman, who appears to be taken from him.

THOUGH Painting and Sculpture are, like many other arts, governed by the same general principles, yet in the detail, or what may be called
220 the by-laws of each art, there seems to be no longer any connection between them. The different materials upon which those two arts exert their powers, must infallibly create a proportional difference in their practice. There are many petty excellencies which the Painter attains with ease but which are impracticable in Sculpture; and which, even
225 if it could accomplish them, would add nothing to the true value and dignity of the work.

OF the ineffectual attempts which the modern Sculptors have made by way of improvement, these seem to be the principal: The practice of detatching drapery from the figure, in order to give the appearance
230 of flying in the air;—

OF making different plans in the same bas-relievos;—

OF attempting to represent the effects of perspective:—

To these we may add the ill effect of figures cloathed in a modern dress.

235 THE folly of attempting to make stone sport and flutter in the air, is

*See *Il reposo di Raffaelle Borghini.*

206 80 adding their attributes	213 80 Sculpture, though it would	
206-207 80 which he gave them.* As John *See Raffaell's Borghini nel suo Riposo.	217-218 80 from him. Painting and Sculpture, though they are	
	220-221 80 connection. But the different	
210 80 was at last agreed to call it The Rape of the Sabines; and [no note]	222 80 a proportionable difference	
	225 80 accomplish, would	
212 80 expression as is	226 80 of his work	

210*n* *Il Riposo di Raffaello Borghini* (Milan, 1807), I, 82.

so apparent, that it carries with it its own reprehension; and yet to accomplish this, seemed to be the great ambition of many modern Sculptors, particularly Bernini: his heart was so much set on overcoming this difficulty, that he was for ever attempting it, though by that attempt he risked every thing that was valuable in the art. 240

BERNINI stands in the first class of modern Sculptors, and therefore it is the business of criticism to prevent the ill effects of so powerful an example.

FROM his very early work of Apollo and Daphne, the world justly *Plate VII* expected he would rival the best productions of ancient Greece; but he 245 soon strayed from the right path. And though there is in his works something which always distinguishes him from the common herd, yet he appears in his latter performances to have lost his way. Instead of pursuing the study of that ideal beauty with which he had so successfully begun, he turned his mind to an injudicious quest of novelty; 250 attempted what was not within the province of the Art, and endeavoured to overcome the hardness and obstinacy of his materials; which even supposing he had accomplished, so far as to make this species of drapery appear natural, the ill effect and confusion occasioned by its being detached from the figure to which it belongs, ought to have been 255 alone a sufficient reason to have deterred him from that practice.

WE have not, I think, in our Academy, any of Bernini's works, except a cast of the head of his Neptune; this will be sufficient to serve *Plate VI* us for an example of the mischief produced by this attempt of representing the effects of the wind. The locks of the hair are flying abroad 260 in all directions, insomuch that it is not a superficial view that can discover what the object is which is represented, or distinguish those flying locks from the features, as they are all of the same colour, of equal solidity, and consequently project with equal force.

THE same entangled confusion which is here occasioned by the 265 hair, is produced by drapery flying off; which the eye must, for the

248 80 latter works to have

257-258 80 works but a cast

258 98 his Neptune*; this
*Some years after this Discourse was writ-

ten, Bernini's NEPTUNE was purchased for our author at Rome, and brought to England. After his death it was sold by his Executors for 500l. to Charles Anderson Pelham, Esq. now Lord Yarborough. M.

244 Bernini's "Apollo and Daphne," executed ca. 1622, is now in the Galleria Borghese, Rome. For additional reproductions see Wittkower, *Gian Lorenzo Bernini*, Pls. 14, 19, 24, 26.

258 Reynolds is probably referring to the group that he himself acquired in the mid-1780's, "Neptune and Triton." The group is now in the Victoria and Albert Museum. For additional illustrations see Wittkower, ibid., Pls. 11, 18, 21. See also IV, n. 133-135.

same reason, inevitably mingle and confound with the principal parts of the figure.

270 IT is a general rule, equally true in both Arts, that the form and attitude of the figure should be seen clearly, and without any ambiguity, at the first glance of the eye. This the Painter can easily do by colour, by losing parts in the ground, or keeping them so obscure as to prevent them from interfering with the more principal objects. The Sculptor has no other means of preventing this confusion than by 275 attaching the drapery for the greater part close to the figure; the folds of which following the order of the limbs, whenever the drapery is seen, the eye is led to trace the form and attitude of the figure at the same time.

Plate III THE drapery of the Apollo, though it makes a large mass, and is sepa-
280 rated from the figure, does not affect the present question, from the very circumstance of its being so completely separated; and from the regularity and simplicity of its form, it does not in the least interfere with a distinct view of the figure. In reality, it is no more a part of it than a pedestal, a trunk of a tree, or an animal, which we often see 285 joined to statues.

THE principal use of those appendages is to strengthen and preserve the statue from accidents; and many are of opinion, that the mantle which falls from the Apollo's arm is for the same end; but surely it answers a much greater purpose, by preventing that dryness of effect 290 which would inevitably attend a naked arm, extended almost at full length; to which we may add, the disagreeable effect which would proceed from the body and arm making a right angle.

THE Apostles, in the church of St. John Lateran, appear to me to fall under the censure of an injudicious imitation of the manner of the 295 Painters. The drapery of those figures, from being disposed in large masses, gives undoubtedly that air of grandeur which magnitude or quantity is sure to produce. But though it should be acknowledged, that it is managed with great skill and intelligence, and contrived to appear as light as the materials will allow, yet the weight and solidity 300 of stone was not to be overcome.

291 80 the disagreeableness which

286-292 Cf. William Hogarth, *The Analysis of Beauty*, ed. Joseph Burke (Oxford, 1955), p. 104.

293 The Apostles in St. John Lateran were added in the early 18th century to Borromini's 17th-century decoration of the nave. The best-known figures are by Camillo Rusconi (1658-1728), Pierre Legros II (1666-1719), and Pierre Etienne Monot (1657-1733).

THOSE figures are much in the style of Carlo Maratti, and such as we may imagine he would have made if he had attempted Sculpture; and when we know he had the superintendance of that work, and was an intimate friend of one of the principal Sculptors, we may suspect that his taste had some influence, if he did not even give the designs. 305 No man can look at those figures without recognizing the manner of Carlo Maratti. They have the same defect which his works so often have, of being overloaded with drapery, and that too artificially disposed. I cannot but believe, that if Ruscono, Le Gros, Monot, and the rest of the Sculptors employed in that work, had taken for their guide 310 the simple dress, such as we see in the antique statues of the philosophers, it would have given more real grandeur to their figures, and would certainly have been more suitable to the characters of the Apostles.

THOUGH there is no remedy for the ill effect of those solid projec- 315 tions which flying drapery in stone must always produce in statues, yet in bas-relievos it is totally different; those detached parts of drapery the Sculptor has here as much power over as the Painter, by uniting and losing it in the ground, so that it shall not in the least entangle and confuse the figure. 320

BUT here again the Sculptor, not content with this successful imitation, if it may be so called, proceeds to represent figures, or groups of figures, on different plans; that is, some on the fore-ground, and some at a greater distance, in the manner of Painters in historical compositions. To do this he has no other means than by making the distant fig- 325 ures of less dimensions, and relieving them in a less degree from the surface; but this is not adequate to the end; they will still appear only as figures on a less scale, but equally near the eye with those in the front of the piece.

NOR does the mischief of this attempt, which never accomplishes its 330 intention, rest here: by this division of the work into many minute parts, the grandeur of its general effect is inevitably destroyed.

PERHAPS the only circumstance in which the Modern have excelled the Ancient Sculptors, is the management of a single group in basso-relievo; the art of gradually raising the group from the flat surface, till 335

329-331 80 the piece.
This attempt is not only unsuccessful, by not accomplishing its intention; but by this division

333-334 80 the Moderns have excelled the Antients, is in the management

334-335 80 basso-relievo; in the art

185

Plate XVIII

340

it imperceptibly emerges into alto-relievo. Of this there is no ancient example remaining that discovers any approach to the skill which Le Gros has shewn in an Altar in the Jesuits Church at Rome. Different plans or degrees of relief in the same group have, as we see in this instance, a good effect, though the contrary happens when the groups are separated, and are at some distance behind each other.

345

350

THIS improvement in the art of composing a group in Basso-relievo was probably first suggested by the practice of the modern Painters, who relieve their figures, or groups of figures, from their ground, by the same gentle gradation; and it is accomplished in every respect by the same general principles; but as the marble has no colour, it is the composition itself that must give it its light and shadow. The ancient Sculptors could not borrow this advantage from their Painters, for this was an art with which they appear to have been entirely unacquainted; and in the bas-relievos of Lorenzo Ghiberti, the casts of which we have in the Academy, this art is no more attempted than it was by the Painters of his age.

355

360

THE next imaginary improvement of the moderns, is the representing the effects of Perspective in Bas-relief. Of this little need be said; all must recollect how ineffectual has been the attempt of modern Sculptors to turn the buildings which they have introduced as seen from their angle, with a view to make them appear to recede from the eye in perspective. This, though it may shew indeed their eager desire to encounter difficulties, shews at the same time how inadequate their materials are even to this their humble ambition.

365

THE Ancients, with great judgment, represented only the elevation of whatever architecture they introduced into their bas-reliefs, which is composed of little more than horizontal or perpendicular lines; whereas the interruption of crossed lines or whatever causes a multiplicity of subordinate parts, destroys that regularity and firmness of effect on which grandeur of style so much depends.

WE come now to the last consideration; in what manner Statues

353	80	improvement is the representing	358	80	eye as in
356	80	Sculptors of turning the buildings	359-360	80	inadequate the materials
357	80	angle, to make			

336-338 There is sculpture by Legros on the altars of two Jesuit churches in Rome, the Gesù and S. Ignazio. It seems probable from his remarks about relief that Reynolds is referring to the Altar of S. Luigi Gonzaga in S. Ignazio by Pierre Legros the Younger.

are to be dressed, which are made in honour of men, either now living, or lately departed.

This is a question which might employ a long discourse of itself: I shall at present only observe, that he who wishes not to obstruct the Artist, and prevent his exhibiting his abilities to their greatest advantage, will certainly not desire a modern dress.

The desire of transmitting to posterity the shape of modern dress must be acknowledged to be purchased at a prodigious price, even the price of every thing that is valuable in art.

Working in stone is a very serious business; and it seems to be scarce worth while to employ such durable materials in conveying to posterity a fashion of which the longest existence scarce exceeds a year.

However agreeable it may be to the Antiquary's principles of equity and gratitude, that as he has received great pleasure from the contemplation of the fashions of Dress of former ages, he wishes to give the same satisfaction to future Antiquaries; yet, methinks pictures of an inferior style, or prints, may be considered as quite sufficient, without prostituting this great art to such mean purposes.

In this town may be seen an Equestrian Statue in a modern dress, which may be sufficient to deter future artists from any such attempt: even supposing no other objection, the familiarity of the modern dress by no means agrees with the dignity and gravity of Sculpture.

Sculpture is formal, regular, and austere; disdains all familiar objects, as incompatible with its dignity; and is an enemy to every species of affectation, or appearance of academical art. All contrast, therefore, of one figure to another, or of the limbs of a single figure, or even in the folds of the drapery, must be sparingly employed. In short, whatever partakes of fancy or caprice, or goes under the denomination of Picturesque, (however to be admired in its proper place,) is incompatible with that sobriety and gravity which is peculiarly the characteristick of this art.

There is no circumstance which more distinguishes a well regulated and sound taste, than a settled uniformity of design, where all the

372 80 Artist from exhibiting

374 80 of a modern

380 80 the Antiquarian's principles

383-384 80 future Antiquarians; yet, methinks, the inferior stiles of Painting, or Prints

386 Reynolds probably refers to the statue of the duke of Cumberland in Cavendish Square, executed by Sir Henry Cheere (not Chew, as given in most editions) in 1770. In 1868 the statue was removed to be recast and has not been replaced.

parts are compact, and fitted to each other, every thing being of a piece. This principle extends itself to all habits of life, as well as to all works of art. Upon this general ground therefore we may safely venture to pronounce, that the uniformity and simplicity of the materials on which the Sculptor labours, (which are only white marble,) prescribes bounds to his art, and teaches him to confine himself to a proportionable simplicity of design.

DISCOURSE XI

Delivered to the Students of The Royal Academy,

on the Distribution of the Prizes,

December 10, 1782

DISCOURSE XI

GENTLEMEN,

THE highest ambition of every Artist is to be thought a man of
Genius. As long as this flattering quality is joined to his name,
he can bear with patience the imputation of carelessness, incorrectness,
or defects of whatever kind.

So far indeed is the presence of Genius from implying an absence
of faults, that they are considered by many as its inseparable com-
panions. Some go such lengths as to take indications from them, and
not only excuse faults on account of Genius, but presume Genius
from the existence of certain faults.

IT is certainly true, that a work may justly claim the character of
Genius, though full of errors; and it is equally true, that it may be
faultless, and yet not exhibit the least spark of Genius. This naturally
suggests an enquiry, a desire at least of enquiring, what qualities of a
work and of a workman may justly entitle a Painter to that character.

I HAVE in a former discourse* endeavoured to impress you with a
fixed opinion, that a comprehensive and critical knowledge of the
works of nature is the only source of beauty and grandeur. But when
we speak to Painters we must always consider this rule, and all rules,
with a reference to the mechanical practice of their own particular
Art. It is not properly in the learning, the taste, and the dignity of the
ideas, that Genius appears as belonging to a painter. There is a Genius
particular and appropriated to his own trade, (as I may call it,) dis-
tinguished from all others. For that power, which enables the Artist
to conceive his subject with dignity, may be said to belong to general
education; and is as much the Genius of a Poet, or the professor of any
other liberal Art, or even a good Critick in any of those arts, as of

*Discourse III.

6 82 as inseparable
7 98 indication from
8 82 but they presume

22 82 appropriated in his
26 82 even of a good

a Painter. Whatever sublime ideas may fill his mind, he is a Painter only as he can put in practice what he knows, and communicate those ideas by visible representation.

30 IF my expression can convey my idea, I wish to distinguish excellence of this kind by calling it the Genius of mechanical performance. This Genius consists, I conceive, in the power of expressing that which employs your pencil, whatever it may be, *as a whole;* so that the general effect and power of the whole may take possession of the mind, and

35 for a while suspend the consideration of the subordinate and particular beauties or defects.

THE advantage of this method of considering objects, is what I wish now more particularly to enforce. At the same time I do not forget, that a Painter must have the power of contracting as well as

40 dilating his sight; because, he that does not at all express particulars, expresses nothing; yet it is certain, that a nice discrimination of minute circumstances, and a punctilious delineation of them, whatever excellence it may have, (and I do not mean to detract from it,) never did confer on the Artist the character of Genius.

45 BESIDE those minute differences in things which are frequently not observed at all, and, when they are, make little impression, there are in all considerable objects great characteristick distinctions, which press strongly on the senses, and therefore fix the imagination. These are by no means, as some persons think, an aggregate of all the small discrimi-

50 nating particulars; nor will such an accumulation of particulars ever express them. These answer to what I have heard great lawyers call the leading points in a case, or the leading cases relative to those points.

THE detail of particulars, which does not assist the expression of the main characteristick, is worse than useless, it is mischievous, as it

55 dissipates the attention, and draws it from the principal point. It may be remarked, that the impression which is left on our mind, even of things which are familiar to us, is seldom more than their general effect; beyond which we do not look in recognising such objects. To express this in Painting, is to express what is congenial and natural to the mind

60 of man, and what gives him by reflection his own mode of conceiving. The other presupposes *nicety* and *research*, which are only the business of the curious and attentive, and therefore does not speak to the general sense of the whole species; in which common, and, as I may

33 82 so as that 49 82 some people think
45 82 Besides those 52 82 to these points

so call it, mother tongue, every thing grand and comprehensive must
be uttered. 65

I DO not mean to prescribe what degree of attention ought to be paid
to the minute parts; this it is hard to settle. We are sure that it is express-
ing the general effect of the whole which alone can give to objects their
true and touching character; and wherever this is observed, whatever
else may be neglected, we acknowledge the hand of a Master. We 70
may even go further, and observe, that when the general effect only
is presented to us by a skilful hand, it appears to express the object
represented in a more lively manner than the minutest resemblance
would do.

THESE observations may lead to very deep questions, which I do 75
not mean here to discuss; among others, it may lead to an enquiry,
Why we are not always pleased with the most absolute possible re-
semblance of an imitation to its original object. Cases may exist in
which such a resemblance may be even disagreeable. I shall only
observe that the effect of figures in Wax-work, though certainly a more 80
exact representation than can be given by Painting or Sculpture, is a
sufficient proof that the pleasure we receive from imitation is not in-
creased merely in proportion as it approaches to minute and detailed
reality; we are pleased, on the contrary, by seeing ends accomplished
by seemingly inadequate means. 85

To express protuberance by actual relief, to express the softness of
flesh by the softness of wax, seems rude and inartificial, and creates
no grateful surprise. But to express distances on a plain surface, softness
by hard bodies, and particular colouring by materials which are not
singly of that colour, produces that magick which is the prize and 90
triumph of art.

CARRY this principle a step further. Suppose the effect of imitation
to be fully compassed by means still more inadequate; let the power of
a few well-chosen strokes, which supersede labour by judgment and
direction, produce a complete impression of all that the mind demands 95
in an object; we are charmed with such an unexpected happiness of

68　82　which can
69-70　82　whatever is neglected
71　82　go farther and
71　97　observe, than
72-73　82　express that object in a

84-85　82　ends answered by seeming in-
adequate
90　82　the pride and
96-97　82　happiness, and

193

execution, and begin to be tired with the superfluous diligence, which in vain solicits an appetite already satiated.

100 THE properties of all objects, as far as a Painter is concerned with them, are, the outline or drawing, the colour, and the light and shade. The drawing gives the form, the colour its visible quality, and the light and shade its solidity.

 EXCELLENCE in any one of these parts of art will never be acquired by an artist, unless he has the habit of looking upon objects at large, 105 and observing the effect which they have on the eye when it is dilated, and employed upon the whole, without seeing any one of the parts distinctly. It is by this that we obtain the ruling characteristick, and that we learn to imitate it by short and dexterous methods. I do not mean by dexterity a trick or mechanical habit, formed by guess, and estab- 110 lished by custom; but that science, which, by a profound knowledge of ends and means, discovers the shortest and surest way to its own purpose.

 IF we examine with a critical view the manner of those painters whom we consider as patterns, we shall find that their great fame does 115 not proceed from their works being more highly finished than those of other artists, or from a more minute attention to details, but from that enlarged comprehension which sees the whole object at once, and that energy of art which gives its characteristick effect by adequate expression.

120 RAFFAELLE and TITIAN are two names which stand the highest in our art; one for Drawing, the other for Painting. The most consider-

Plate IV able and the most esteemed works of Raffaelle are the Cartoons, and his Fresco works in the Vatican; those, as we all know, are far from being minutely finished: his principal care and attention seems to have 125 been fixed upon the adjustment of the whole, whether it was the general composition, or the composition of each individual figure; for every figure may be said to be a lesser whole, though in regard to the general work to which it belongs, it is but a part; the same may be said of the head, of the hands, and feet. Though he possessed this art of seeing and 130 comprehending the whole, as far as form is concerned, he did not exert the same faculty in regard to the general effect, which is presented to the eye by colour, and light and shade. Of this the deficiency of his oil

113-114	82	those Artists whom	124-125	82	seems to be fixed
115-116	82	finished, or from	129	82	hands, or feet

pictures, where this excellence is more expected than in Fresco, is a sufficient proof.

IT is to Titian we must turn our eyes to find excellence with regard 135
to colour, and light and shade, in the highest degree. He was both the *Plate XVII*
first and the greatest master of this art. By a few strokes he knew how
to mark the general image and character of whatever object he at-
tempted; and produced, by this alone, a truer representation than his
master Giovanni Bellino, or any of his predecessors, who finished every 140
hair. His great care was to express the general colour, to preserve the
masses of light and shade, and to give by opposition the idea of that
solidity which is inseparable from natural objects. When those are pre-
served, though the work should possess no other merit, it will have in
a proper place its complete effect; but where any of these are wanting, 145
however minutely laboured the picture may be in the detail, the whole
will have a false and even an unfinished appearance, at whatever distance,
or in whatever light, it can be shewn.

IT is vain to attend to the variation of tints, if, in that attention, the
general hue of flesh is lost; or to finish ever so minutely the parts, if the 150
masses are not observed, or the whole not well put together.

VASARI seems to have had no great disposition to favour the Vene-
tian Painters, yet he every where justly commends *il modo di fare, la
maniera, la bella pratica*; that is, the admirable manner and practice
of that school. On Titian, in particular, he bestows the epithets of 155
giudicioso, bello, e stupendo.

THIS manner was then new to the world, but that unshaken truth
on which it is founded, has fixed it as a model to all succeeding Painters;
and those who will examine into the artifice, will find it to consist in
the power of generalising, and in the shortness and simplicity of the 160
means employed.

MANY Artists, as Vasari likewise observes, have ignorantly imagined
they are imitating the manner of Titian, when they leave their colours
rough, and neglect the detail; but, not possessing the principles on which

140 82 master Giam: Bellino

143-144 82 preserved, though with noth-
ing more, the work will have

152 82 have no

160-162 82 simplicity of the means.
Many Artists

148 Hilles, *Literary Career* (p. 135), notes a change made in Johnson's hand on Reynolds'
original draft, from "it is placed" to "it can be shewn."

152 Hilles (ibid.) notes that Johnson changed "Vasari who seems to have no great partiality
to" to "Vasari seems to have no great disposition to favour."

165 he wrought, they have produced what he calls *goffe pitture*, absurd foolish pictures; for such will always be the consequence of affecting dexterity without science, without selection, and without fixed principles.

RAFFAELLE and Titian seem to have looked at nature for different 170 purposes; they both had the power of extending their view to the whole; but one looked only for the general effect as produced by form the other as produced by colour.

WE cannot entirely refuse to Titian the merit of attending to the general *form* of his object, as well as colour; but his deficiency lay, a 175 deficiency at least when he is compared with Raffaelle, in not possessing the power, like him, of correcting the form of his model by any general idea of beauty in his own mind. Of this his St. Sebastian is a particular instance. This figure appears to be a most exact representation both of the form and the colour of the model, which he then happened to have 180 before him; it has all the force of nature, and the colouring is flesh itself; but, unluckily, the model was of a bad form, especially the legs. Titian has with as much care preserved these defects, as he has imitated the beauty and brilliancy of the colouring. In his colouring he was large and general, as in his design he was minute and partial; in the one he was a 185 Genius, in the other not much above a copier. I do not, however, speak now of all his pictures; instances enough may be produced in his works, where those observations on his defects could not with any propriety be applied: but it is in the manner, or language, as it may be called, in which Titian and others of that school express themselves, that their 190 chief excellence lies. This manner is in reality, in painting, what language is in poetry; we are all sensible how differently the imagination is affected by the same sentiment expressed in different words, and how mean or how grand the same object appears when presented to us by different Painters. Whether it is the human figure, an animal, or even 195 inanimate objects, there is nothing, however unpromising in appear-

169 82 Titian seemed to look at 179 82 and of the colour
172 82 other as by

165 Vasari, V, 398.

177 It is not clear what picture Reynolds has in mind. Fry thought it was the St. Sebastian section of the altar in S.S. Nazaro e Celso, Brescia, painted about 1522. Dimier thought it was the "Madonna with Six Saints," now in the Vatican, formerly in S. Niccolo dei Frari, Venice. Reynolds refers to the latter picture in his notes on Venetian paintings (Leslie and Taylor, I, 75-76), but it is not possible to deduce definitely from his remarks that this is the painting he has in mind in Discourse XI.

ance, but may be raised into dignity, convey sentiment, and produce emotion, in the hands of a Painter of genius. What was said of Virgil, that he threw even the dung about the ground with an air of dignity, may be applied to Titian: whatever he touched, however naturally mean, and habitually familiar, by a kind of magick he invested with grandeur and importance.

I MUST here observe, that I am not recommending a neglect of the detail; indeed it would be difficult, if not impossible, to prescribe *certain* bounds, and tell how far, or when it is to be observed or neglected; much must, at last, be left to the taste and judgment of the Artist. I am well aware that a judicious detail will sometimes give the force of truth to the work, and consequently interest the spectator. I only wish to impress on your minds the true distinction between essential and subordinate powers; and to shew what qualities in the art claim your *chief* attention, and what may, with the least injury to your reputation, be neglected. Something, perhaps, always must be neglected; the lesser ought then to give way to the greater; and since every work can have but a limited time allotted to it, (for even supposing a whole life to be employed about one picture, it is still limited,) it appears more reasonable to employ that time to the best advantage, in contriving various methods of composing the work,—in trying different effect of light and shadow,—and employing the labour of correction in heightening by a judicious adjustment of the parts the effects of the whole,—than that the time should be taken up in minutely finishing those parts.

BUT there is another kind of high finishing which may safely be condemned, as it seems to counteract its own purpose; that is, when the artist, to avoid that hardness which proceeds from the outline cutting against the ground, softens and blends the colours to excess: this is what the ignorant call high finishing, but which tends to destroy the brilliancy of colour, and the true effect of representation; which consists very much in preserving the same proportion of sharpness and bluntness that is found in natural objects. This extreme softning, instead of

200

205

210

215

220

225

196 82 but what may

206 82 aware how a judicious

207 82 the spectator.* I
*See Discourse III, page 105.

209 82 powers, and shew

216-217 82 work; of trying different effects of light and shade; and

226-227 82 bluntness which is in

198 He "tosses the dung about with an air of gracefulness." Joseph Addison, "An Essay on Virgil's *Georgics*," in *The Works of . . . Joseph Addison, Esq.* (Birmingham, 1761), I, 244.

producing the effect of softness, gives the appearance of ivory, or some other hard substance, highly polished.

230 THE portraits of Cornelius Jansen appear to have this defect, and consequently want that suppleness which is the characteristick of flesh; whereas, in the works of Vandyck we find that true mixture of softness and hardness perfectly observed. The same defect may be found in the manner of Vanderwerf, in opposition to that of Teniers; and such also, 235 we may add, is the manner of Raffaelle in his oil pictures, in comparison with that of Titian.

THE name which Raffaelle has so justly maintained as the first of Painters, we may venture to say was not acquired by this laborious attention. His apology may be made by saying that it was the manner 240 of his country; but if he had expressed his ideas with the facility and eloquence, as it may be called, of Titian, his works would certainly not have been less excellent; and that praise, which ages and nations have poured out upon him, for possessing Genius in the higher attainments of art, would have been extended to them all.

245 THOSE who are not conversant in works of art, are often surprised at the high value set by connoisseurs on drawings which appear careless, and in every respect unfinished; but they are truly valuable; and their value arises from this, that they give the idea of an whole; and this whole is often expressed by a dexterous facility which indicates the true 250 power of a Painter, even though roughly exerted: whether it consists in the general composition, or the general form of each figure, or the turn of the attitude which bestows grace and elegance. All this we may see fully exemplified in the very skilful drawings of Parmegiano and Correggio. On whatever account we value these drawings, it is certainly 255 not for high finishing, or a minute attention to particulars.

EXCELLENCE in every part, and in every province of our art, from the highest style of history down to the resemblances of still-life, will depend

232	82	we may observe that	243	82	upon his works, for
233-234	82	defect is in the manner	248	82	of a whole
234-235	82	such we	251-252	82	or in the turn

230 Cornelius Jansen (Johnson, Jonson), 1593-1661. Active in England 1619-1643, retired to Holland during the Civil War.

234 There are two brothers Van der Werff, Adrian (1659-1722) and Pieter (1665-1722). They worked together and their hands are not readily distinguishable.

234 Reynolds probably means David Teniers the Younger (1610-1690).

on this power of extending the attention at once to the whole, without which the greatest diligence is vain.

I WISH you to bear in mind, that when I speak of an whole, I do not mean simply an *whole* as belonging to composition, but an *whole* with respect to the general style of colouring; an *whole* with regard to the light and shade; an *whole* of every thing which may separately become the main object of a Painter.

I REMEMBER a Landscape-Painter in Rome, who was known by the name of STUDIO, from his patience in high finishing, in which he thought the whole excellence of art consisted; so that he once endeavoured, as he said, to represent every individual leaf on a tree. This picture I never saw; but I am very sure that an artist, who looked only at the general character of the species, the order of the branches, and the masses of the foliage, would in a few minutes produce a more true resemblance of trees, than this Painter in as many months.

A Landscape-Painter certainly ought to study anatomically (if I may use the expression) all the objects which he paints; but when he is to turn his studies to use, his skill, as a man of Genius, will be displayed in shewing the general effect, preserving the same degree of hardness and softness which the objects have in nature; for he applies himself to the imagination, not to the curiosity, and works not for the Virtuoso or the Naturalist, but for the common observer of life and nature. When he knows his subject, he will know not only what to describe, but what to omit; and this skill in leaving out, is, in all things, a great part of knowledge and wisdom.

THE same excellence of manner which Titian displayed in History or Portrait-painting, is equally conspicuous in his Landscapes, whether they are professedly such, or serve only as backgrounds. One of the most eminent of this latter kind is to be found in the picture of St. Pietro Martire. The large trees, which are here introduced, are plainly distinguished from each other by the different manner with which the

260

265

270

275

280

285

260 82 of a *whole*, I 277 82 softness as the objects
264 82 main purpose of 281 82 out, in all things, is a great

266 Hendrik Frans van Lint (1684-1763), called "Studio." He was Regent of the Virtuosi in 1752, when Reynolds was in Rome.

286-287 Titian's "S. Pietro Martire" was destroyed by fire on Aug. 16, 1867. It is known through copies, one of which is now in the place of the original in S.S. Giovanni e Paolo, Venice. Reynolds refers to the picture in his notes on Venetian painting (Leslie and Taylor, I, 67-68).

branches shoot from their trunks, as well as by their different foliage;
and the weeds in the fore-ground are varied in the same manner, just as
much as variety requires, and no more. When Algarotti, speaking of
this picture, praises it for the minute discriminations of the leaves and
plants, even, as he says, to excite the admiration of a Botanist, his inten-
tion was undoubtedly to give praise even at the expence of truth; for he
must have known, that this is not the character of the picture; but con-
noisseurs will always find in pictures what they think they ought to
find: he was not aware that he was giving a description injurious to the
reputation of Titian.

SUCH accounts may be very hurtful to young artists, who never have
had an opportunity of seeing the work described; and they may pos-
sibly conclude, that this great Artist acquired the name of the Divine
Titian from his eminent attention to such trifling circumstances, which,
in reality, would not raise him above the level of the most ordinary
painter.

WE may extend these observations even to what seems to have but
a single, and that an individual, object. The excellence of Portrait-
Painting, and we may add even the likeness, the character, and counte-
nance, as I have observed in another place, depend more upon the gen-
eral effect produced by the painter, than on the exact expression of the
peculiarities, or minute discrimination of the parts. The chief attention
of the artist is therefore employed in planting the features in their
proper places, which so much contributes to giving the effect and true
impression of the whole. The very peculiarities may be reduced to
classes and general descriptions; and there are therefore large ideas to
be found even in this contracted subject. He may afterwards labour
single features to what degree he thinks proper, but let him not forget
continually to examine, whether in finishing the parts he is not
destroying the general effect.

IT is certainly a thing to be wished, that all excellence were applied
to illustrate subjects that are interesting and worthy of being com-
memorated; whereas, of half the pictures that are in the world, the sub-
ject can be valued only as an occasion which set the artist to work; and

290

295

300

305

310

315

320

308-310 82 place, depends more upon the
general effect exhibited by the painter, than
the exact expression of the peculiarities, or
minute discriminations of

319 82 It were certainly

320 82 that were interesting

322-323 82 which sets the artist to work;
and yet, the high value we set on such

291-298 Algarotti, Ch. viii.

yet, our high estimation of such pictures, without considering or per-
haps without knowing the subject, shews how much our attention is
engaged by the art alone. 325

PERHAPS nothing that we can say will so clearly shew the advantage
and excellence of this faculty, as that it confers the character of Genius
on works that pretend to no other merit; in which is neither expression,
character, or dignity, and where none are interested in the subject. We
cannot refuse the character of Genius to the marriage of Paulo Vero- *Plate XVI*
nese, without opposing the general sense of mankind, (great author-
ities have called it the Triumph of Painting,) or, to the altar of St.
Augustine at Antwerp, by Rubens, which equally deserves that title, *Plate XIX*
and for the same reason. Neither of those pictures have any interest-
ing story to support them. That of Paulo Veronese, is only a represen- 335
tation of a great concourse of people at a dinner; and the subject of
Rubens, if it may be called a subject where nothing is doing, is an
assembly of various Saints that lived in different ages. The whole excel-
lence of those pictures consists in mechanical dexterity, working how-
ever under the influence of that comprehensive faculty which I have 340
so often mentioned.

IT is by this, and this alone, that the mechanical power is ennobled,
and raised much above its natural rank. And it appears to me, that with
propriety it acquires this character, as an instance of that superiority
with which mind predominates over matter, by contracting into one 345
whole what nature has made multifarious.

THE great advantage of this idea of a whole is, that a greater quan-
tity of truth may be said to be contained and expressed in a few lines
or touches, than in the most laborious finishing of the parts, where this
is not regarded. It is upon this foundation that it stands; and the just- 350
ness of the observation would be confirmed by the ignorant in art, if

333 82 deserves the same title 346-347 82 nature has made many.
340 82 of this comprehensive The great
 349 82 finishing the parts

330-333 On Veronese's "Marriage at Cana" see VIII, 377n. The Altar of St. Augustine at
Antwerp by Rubens was painted about 1628; it is also known as the "Marriage of St. Catherine."
Reynolds has a long passage on the picture in "Journey to Flanders and Holland" (*Works*, II,
308-314).

332 De Piles, *Art of Painting*, p. 204, says concerning the "Marriage at Cana": "it wants
very little of being the Triumph of Painting it self."

337 Reynolds seriously misinterprets the picture when he says "nothing is doing." The
painting represents the marriage of St. Catherine, and all of the figures are clearly shown
reacting to this event.

it were possible to take their opinions unseduced by some false notion of what they imagine they ought to see in a Picture. As it is an art, they think they ought to be pleased in proportion as they see that art osten-
355 tatiously displayed; they will, from this supposition, prefer neatness, high-finishing, and gaudy colouring, to the truth, simplicity, and unity of nature. Perhaps too, the totally ignorant beholder, like the ignorant artist, cannot comprehend a whole, nor even what it means. But if false notions do not anticipate their perceptions, they who are capable of
360 observation, and who, pretending to no skill, look only straight forward, will praise and condemn in proportion as the Painter has succeeded in the effect of the whole. Here general satisfaction, or general dislike, though perhaps despised by the Painter, as proceeding from the ignorance of the principles of art, may yet help to regulate his con-
365 duct, and bring back his attention to that which ought to be his principal object, and from which he has deviated for the sake of minuter beauties.

AN instance of this right judgment I once saw in a child, in going through a gallery where there were many portraits of the last ages,
370 which, though neatly put out of hand, were very ill put together. The child paid no attention to the neat finishing or naturalness of any bit of drapery, but appeared to observe only the ungracefulness of the persons represented, and put herself in the posture of every figure which she saw in a forced and aukward attitude. The censure of nature, unin-
375 formed, fastened upon the greatest fault that could be in a picture, because it related to the character and management of the whole.

I SHOULD be sorry, if what has been said should be understood to have any tendency to encourage that carelessness which leaves work in an unfinished state. I commend nothing for the want of exactness; I
380 mean to point out that kind of exactness which is the best, and which is alone truly to be so esteemed.

So far is my disquisition from giving countenance to idleness, that there is nothing in our art which enforces such continual exertion and circumspection, as an attention to the general effect of the whole. It
385 requires much study and much practice; it requires the Painter's en-

352-353	82	false idea of		378	82	leaves works in
364	82	art, yet may help		380	82	point to that
369-370	82	last age, which		384-385	82	circumspection. It requires
372-373	82	of the figures, and put		385-386	82	Painter's *whole* attention; whereas
374	82	forced aukward				

202

tire mind; whereas the parts may be finishing by nice touches, while his mind is engaged on other matters; he may even hear a play or a novel read without much disturbance. The artist who flatters his own indolence, will continually find himself evading this active exertion, and applying his thoughts to the ease and laziness of highly finishing the parts; producing at last what Cowley calls "laborious effects of idleness." 390

No work can be too much finished, provided the diligence employed be directed to its proper object; but I have observed that an excessive labour in the detail has, nine times in ten, been pernicious to the general effect, even when it has been the labour of great masters. It indicates a bad choice, which is an ill setting out in any undertaking. 395

To give a right direction to your industry has been my principal purpose in this discourse. It is this, which I am confident often makes the difference between two Students of equal capacities, and of equal industry. While the one is employing his labour on minute objects of little consequence, the other is acquiring the art, and perfecting the habit, of seeing nature in an extensive view, in its proper proportions, and its due subordination of parts. 400

Before I conclude, I must make one observation sufficiently connected with the present subject. 405

The same extension of mind which gives the excellence of Genius to the theory and mechanical practice of the art, will direct him likewise in the method of study, and give him the superiority over those who narrowly follow a more confined track of partial imitation. Whoever, in order to finish his education, should travel to Italy, and spend his whole time there only in copying pictures, and measuring statues or buildings, (though these things are not to be neglected,) would return with little improvement. He that imitates the Iliad, says Dr. Young, is 410

386 82 be finished by

389-390 82 evading this laborious atten-
tion, and

390-393 82 of finishing the parts.
No work

396 82 been the work of

401 82 industry. Whilst the one

412 82 pictures, measuring

391-392 Abraham Cowley, "Davideis, A Sacred Poem of the Troubles of David," in *Works*, Bk. I, l. 714. Greenway (p. 272) notes that Johnson quoted a few lines with this passage in his life of Cowley.

414-415 Edward Young, *Conjectures on Original Composition. In a Letter to the Author of Sir Charles Grandison* (London, 1759), p. 21: "He that imitates the divine Iliad, does not imitate Homer. . . . Imitate; but imitate not the Composition, but the Man."

415 not imitating Homer. It is not by laying up in the memory the particular details of any of the great works of art, that any man becomes a great artist, if he stops without making himself master of the general principles on which these works are conducted. If he even hopes to rival those whom he admires, he must consider their works as the means
420 of teaching him the true art of seeing nature. When this is acquired, he then may be said to have appropriated their powers, or at least the foundation of their powers, to himself; the rest must depend upon his own industry and application. The great business of study is, to form a *mind*, adapted and adequate to all times and all occasions; to which
425 all nature is then laid open, and which may be said to possess the key of her inexhaustible riches.

DISCOURSE XII

Delivered to the Students of The Royal Academy,

on the Distribution of the Prizes,

December 10, 1784

DISCOURSE XII

G<small>ENTLEMEN</small>,

I<small>N</small> consequence of the situation in which I have the honour to be
placed in this Academy, it has often happened, that I have been
consulted by the young Students who intend to spend some years in
Italy, concerning the method of regulating their studies. I am, as I
ought to be, solicitously desirous to communicate the entire result of
my experience and observation; and though my openness and facility
in giving my opinions might make some amends for whatever was
defective in them, yet I fear my answers have not often given satisfac-
tion. Indeed I have never been sure, that I understood perfectly what
they meant, and was not without some suspicion that they had not
themselves very distinct ideas of the object of their enquiry.

I<small>F</small> the information required was, by what means the path that leads
to excellence could be discovered; if they wished to know whom they
were to take for their guides; what to adhere to, and what to avoid;
where they were to bait, and where they were to take up their rest;
what was to be tasted only, and what should be their diet; such general
directions are certainly proper for a Student to ask, and for me, to the
best of my capacity, to give; but these rules have been already given:
they have in reality been the subject of almost all my Discourses from
this place. But I am rather inclined to think, that by *method of study*,
it was meant (as several do mean,) that the times and the seasons should
be prescribed, and the order settled, in which every thing was to be
done: that it might be useful to point out to what degree of excellence

5 84 communicate every result
6 84 observation; and my openness
7 84 opinions may make
7-8 84 whatever may be defective
8 84 not been often to their satisfaction
12-13 84 If the thing required was to point out the path that leads to excellence; if

16-17 84 diet: such general rules of con-duct, are
18-19 84 these have been already given; these Rules have
20-21 84 *study*, they meant
23 84 done. They probably considered, that it might

one part of the Art was to be carried, before the Student proceeded to
the next; how long he was to continue to draw from the ancient statues,
when to begin to compose, and when to apply to the study of colouring.

SUCH a detail of instruction might be extended with a great deal of
plausible and ostentatious amplification. But it would at best be use-
less. Our studies will be for ever, in a very great degree, under the
direction of chance; like travellers, we must take what we can get,
and when we can get it; whether it is, or is not administered to us
in the most commodious manner, in the most proper place, or at the
exact minute when we would wish to have it.

TREATISES on education and method of study, have always appeared
to me to have one general fault. They proceed upon a false supposi-
tion of life; as if we possessed not only a power over events and cir-
cumstances, but had a greater power over ourselves than I believe any
of us will be found to possess. Instead of supposing ourselves to be
perfect patterns of wisdom and virtue, it seems to me more reasonable
to treat ourselves (as I am sure we must now and then treat others)
like humoursome children, whose fancies are often to be indulged in
order to keep them in good-humour with themselves and their pur-
suits. It is necessary to use some artifice of this kind in all processes
which by their very nature are long, tedious, and complex, in order
to prevent our taking that aversion to our studies, which the con-
tinual shackles of methodical restraint are sure to produce.

I WOULD rather wish a Student, as soon as he goes abroad, to employ
himself upon whatever he has been incited to by any immediate im-
pulse, than to go sluggishly about a prescribed task: whatever he does
in such a state of mind, little advantage accrues from it, as nothing
sinks deep enough to leave any lasting impression; and it is impossible
that any thing should be well understood, or well done, that is taken
into a reluctant understanding, and executed with a servile hand.

IT is desirable, and indeed is necessary to intellectual health, that
the mind should be recreated and refreshed with a variety in our
studies; that in the irksomeness of uniform pursuit we should be re-
lieved, (and if I may so say, deceived,) as much as possible. Besides;

25 84 long they were to continue
37 84 but as if we had greater
46 84 restraint is sure
51 84 impression behind it; and it

53-54 84 servile hand.
There is great advantage, and indeed it is
necessary towards intellectual

57 84 (and if I may say deceived)

34-46 Thompson (p. 341) relates the thought here to Johnson's in *Rasselas*, Chs. xvi, xx.

the minds of men are so very differently constituted, that it is impossible to find one method which shall be suitable to all. It is of no use to prescribe to those who have no talents; and those who have talents will find methods for themselves, methods dictated to them by their own particular dispositions, and by the experience of their own particular necessities.

However, I would not be understood to extend this doctrine to the younger Students: the first part of the life of a Student, like that of other school-boys, must necessarily be a life of restraint. The grammar, the rudiments, however unpalatable, must at all events be mastered. After a habit is acquired of drawing correctly from the model (whatever it may be) which he has before him, the rest, I think, may be safely left to chance; always supposing that the Student is *employed*, and that his studies are directed to the proper object.

A passion for his Art, and an eager desire to excel, will more than supply the place of method. By leaving a Student to himself he may possibly indeed be led to undertake matters above his strength: but the trial will at least have this advantage, it will discover to himself his own deficiences; and this discovery alone, is a very considerable acquisition. One inconvenience, I acknowledge, may attend bold and arduous attempts; frequent failure may discourage. This evil, however, is not more pernicious than the slow proficiency which is the natural consequence of too easy tasks.

Whatever advantages method may have in dispatch of business, (and there it certainly has many,) I have but little confidence of its efficacy in acquiring excellence in any Art whatever. Indeed, I have always strongly suspected, that this love of method, on which some persons appear to place so great dependance, is, in reality, at the bottom, a love of idleness; a want of sufficient energy to put themselves into immediate action: it is a sort of an apology to themselves for doing nothing. I have known Artists who may truly be said to have spent their whole lives, or at least the most precious part of their lives, in planning methods of study, without ever beginning; resolving, how-

69 84 rest I should think may	Another inconvenience may attend those bold
73-74 84 himself, he may possibly be	
76-77 84 considerable acquisition.	84-85 84 some people appear
	90 84 study, and never beginning

72-80 This paragraph is related to a passage Reynolds copied from Bacon's *Essays* (see Hilles, *Literary Career*, p. 214).

ever, to put it all in practice at some time or other,—when a certain
period arrives,—when proper conveniences are procured,—or when
they remove to a certain place better calculated for study. It is not
uncommon for such persons to go abroad with the most honest and
sincere resolution of studying hard, when they shall arrive at the end
of their journey. The same want of exertion, arising from the same
cause which made them at home put off the day of labour until they
had found a proper scheme for it, still continues in Italy, and they con-
sequently return home with little, if any, improvement.

IN the practice of art, as well as in morals, it is necessary to keep a
watchful and jealous eye over ourselves: idleness, assuming the specious
disguise of industry, will lull to sleep all suspicion of our want of an
active exertion of strength. A provision of endless apparatus, a bustle
of infinite enquiry and research, or even the mere mechanical labour
of copying, may be employed, to evade and shuffle off real labour,—
the real labour of thinking.

I HAVE declined for these reasons to point out any particular method
and course of study to young Artists on their arrival in Italy. I have
left it to their own prudence, a prudence which will grow and improve
upon them in the course of unremitted, ardent industry, directed by
a real love of their profession, and an unfeigned admiration of those who
have been universally admitted as patterns of excellence in the art.

IN the exercise of that general prudence, I shall here submit to their
consideration such miscellaneous observations as have occurred to me
on considering the mistaken notions or evil habits which have pre-
vented that progress towards excellence which the natural abilities
of several Artists might otherwise have enabled them to make.

FALSE opinions and vicious habits have done far more mischief to
Students, and to Professors too, than any wrong methods of study.

UNDER the influence of sloth, or of some mistaken notion, is that
disposition which always wants to lean on other men. Such Students
are always talking of the prodigious progress they should make if they
could but have the advantage of being taught by some particular
eminent Master. To him they would wish to transfer that care which

92 98 proper conveniences are

94 84 such people to go

98-100 84 in Italy.
In the practice

103 84 exertion of our strength

104 84 even a mere

110 84 unremitted, real industry

115-116 84 prevented the progress to-
wards that excellence

they ought and must take of themselves. Such are to be told, that after the rudiments are past, very little of our Art can be taught by others. The most skilful Master can do little more than put the end of the clue into the hands of his Scholar, by which he must conduct himself.

It is true, the beauties and the defects of the works of our predecessors may be pointed out; the principles on which their works are conducted, may be explained; the great examples of Ancient Art may be spread out before them; but the most sumptuous entertainment is prepared in vain, if the guests will not take the trouble of helping themselves.

Even the Academy itself, where every convenience for study is procured, and laid before them, may, from that very circumstance, from leaving no difficulties to be encountered in the pursuit, cause a remission of their industry. It is not uncommon to see young artists whilst they are struggling with every obstacle in their way, exert themselves with such success as to outstrip competitors possessed of every means of improvement. The promising expectation which was formed, on so much being done with so little means, has recommended them to a Patron who has supplied them with every convenience of study; from that time their industry and eagerness of pursuit has forsaken them; they stand still, and see others rush on before them.

Such men are like certain animals, who will feed only when there is but little provender, and that got at with difficulty through the bars of a rack, but refuse to touch it when there is an abundance before them.

Perhaps, such a falling off may proceed from the faculties being overpowered by the immensity of the materials; as the traveller despairs ever to arrive at the end of his journey when the whole extent of the road which he is to pass is at once displayed to his view.

Among the first moral qualities therefore, which a Student ought to cultivate, is a just and manly confidence in himself, or rather in

129 98 beauties and defects

131-132 84 explained; the Academy may spread out the great examples of Antient Art before them

137-139 84 from having no difficulties to encounter in their pursuit, be the cause of a slackening of their industry.
It is not uncommon to see Young Artists who, whilst they were struggling

140-141 84 outstrip their competitors who were in possession of every means of improvement, and from the promising

142-143 84 means, have been taken up by a Patron

144-145 84 has forsook them

148 98 when their is

149 84 Perhaps too, such

149 84 from their faculties

150-153 84 materials, it appearing hopeless when they see so far before them, ever to get at the end of their journey.
Among the first

155 the effects of that persevering industry which he is resolved to possess.

WHEN Raffaelle, by means of his connection with Bramante, the Pope's Architect, was fixed upon to adorn the Vatican with his works, he had done nothing that marked in him any great superiority over his contemporaries; though he was then but young, he had under his 160 direction the most considerable Artists of his age; and we know what kind of men those were: a lesser mind would have sunk under such a weight; and if we should judge from the meek and gentle disposition which we are told was the character of Raffaelle, we might expect this would have happened to him; but his strength appeared to increase 165 in proportion as exertion was required; and it is not improbable that we are indebted to the good fortune which first placed him in that conspicuous situation, for those great examples of excellence which he has left us.

THE observations to which I formerly wished, and now desire, to 170 point your attention, relate not to errors which are committed by those who have no claim to merit, but to those inadvertencies into which men of parts only can fall by the over-rating or the abuse of some real, though perhaps subordinate, excellence. The errors last alluded to are those of backward, timid characters; what I shall now speak of, 175 belong to another class; to those Artists who are distinguished for the readiness and facility of their invention. It is undoubtedly a splendid and desirable accomplishment to be able to design instantaneously any given subject. It is an excellence that I believe every Artist would wish to possess; but unluckily, the manner in which this dexterity is 180 acquired, habituates the mind to be contented with first thoughts without choice or selection. The judgment, after it has been long passive, by degrees loses its power of becoming active when exertion is necessary.

WHOEVER, therefore, has this talent, must in some measure undo

155	84	that unconquerable industry
158	84	had then done
164	84	would happen to him
165	84	improbable, but that
166	84	to that good
168-170	84	left behind him.

The observations to which I wish to point your attention, do not relate to errors which in general are committed

171-172 84 to such inadvertencies as men

174 84 to is that of backward, timid characters, those I

177 84 and a desirable

156-159 Raphael began work at the Vatican in the Stanza della Segnatura sometime in 1509 when twenty-six.

what he has had the habit of doing, or at least give a new turn to his 185
mind: great works, which are to live and stand the criticism of posterity,
are not performed at a heat. A proportionable time is required for
deliberation and circumspection. I remember when I was at Rome
looking at the fighting Gladiator, in company with an eminent
Sculptor, and I expressed my admiration of the skill with which the 190
whole is composed, and the minute attention of the Artist to the
change of every muscle in that momentary exertion of strength, he
was of opinion that a work so perfect required nearly the whole life
of man to perform.

I BELIEVE, if we look around us, we shall find, that in the sister art 195
of Poetry, what has been soon done, has been as soon forgotten. The
judgment and practice of a great Poet on this occasion is worthy
attention. Metastasio, who has so much and so justly distinguished
himself throughout Europe, at his outset was an *Improvvisatore*, or
extempore Poet, a description of men not uncommon in Italy: it is not 200
long since he was asked by a friend, if he did not think the custom of
inventing and reciting *extempore*, which he practised when a boy in
his character of an *Improvvisatore*, might not be considered as a happy
beginning of his education; he thought it, on the contrary, a disad-
vantage to him: he said that he had acquired by that habit, a careless- 205
ness and incorrectness, which it cost him much trouble to overcome,
and to substitute in the place of it a totally different habit, that of
thinking with selection, and of expressing himself with correctness
and precision.

185	84	or give	193	84	required near the whole
187	84	not done at a sit. A proportionable	198	98	and justly
188	84	when at Rome	205	84	him; that he
190-191	84	Sculptor, on remarking the skill with which the whole together is composed	206	84	which cost
			207	84	in its place a totally

189 The "Fighting Gladiator" is probably the "Borghese Warrior." It was found early in the 17th century and was in the possession of the Borghese family. Since 1808 it has been in the Louvre. Richardson (*Account of Statues*, p. 248) writes, "all his muscles seem to tremble with eagerness." See also III, n. 175-176.

190 Dimier suggests that Reynolds may be referring to Joseph Wilton (1722-1803). Wilton was one of the foundation members of the Royal Academy, where he exhibited from 1769 until 1783. He was in Rome in 1752, the last year of Reynolds' stay there.

198 Metastasio (Pietro Antonio Domenico Bonaventura Trapassi) was born in Rome in 1698 and died in Vienna in 1782. He was court poet at Vienna from 1730 to 1782 and collaborated with various composers in the production of numerous lyric dramas, cantatas, and oratorios. Charles Burney wrote his memoirs in 1796.

210 HOWEVER extraordinary it may appear, it is certainly true, that the inventions of the *Pittori improvvisatori*, as they may be called, have,—notwithstanding the common boast of their authors that all is spun from their own brain,—very rarely any thing that has in the least the air of originality: their compositions are generally common-
215 place; uninteresting, without character or expression; like those flowery speeches that we sometimes hear, which impress no new ideas on the mind.

I WOULD not be thought, however, by what has been said, to oppose the use, the advantage, the necessity there is, of a Painter's being readily
220 able to express his ideas by sketching. The further he can carry such designs, the better. The evil to be apprehended is, his resting there, and not correcting them afterwards from nature, or taking the trouble to look about him for whatever assistance the works of others will afford him.

225 WE are not to suppose, that when a Painter sits down to deliberate on any work, he has all his knowledge to seek; he must not only be able to draw *extempore* the human figure in every variety of action, but he must be acquainted likewise with the general principles of composition, and possess a habit of foreseeing, while he is composing,
230 the effect of the masses of light and shadow, that will attend such a disposition. His mind is entirely occupied by his attention to the whole. It is a subsequent consideration to determine the attitude and expression of individual figures. It is in this period of his work that I would recommend to every Artist to look over his porto-folio, or
235 pocket-book, in which he has treasured up all the happy inventions, all the extraordinary and expressive attitudes that he has met with in the course of his studies; not only for the sake of borrowing from those studies whatever may be applicable to his own work, but like-wise on account of the great advantage he will receive by bringing

212-213 84 notwithstanding their boast that it is all spun

214 84 originality of invention: their

215-218 84 expression of any kind; and appear, as we say sometimes of flowery speeches, to have no ideas annexed to the words.
I would

220-221 84 sketching, and the farther he can carry such designs, so much the better

221 98 be apprehend is

222 84 them afterward from

226 84 work, that he has

227-228 84 action, he

229-230 84 composition, and a habit of recollecting, whilst he is composing; of the effect

232 84 is an after consideration

237-238 84 from these studies

238-239 84 likewise for the great

the ideas of great Artists more distinctly before his mind, which will 240
teach him to invent other figures in a similar style.

Sɪʀ Francis Bacon speaks with approbation of the provisionary meth-
ods Demosthenes and Cicero employed to assist their invention; and
illustrates their use by a quaint comparison after his manner. These par-
ticular *Studios* being not immediately connected with our Art, I need 245
not cite the passage I allude to, and shall only observe that such prep-
aration totally opposes the general received opinions that are floating
in the world, concerning genius and inspiration. The same great man
in another place speaking of his own Essays, remarks, that they treat
of "those things, wherein both men's lives and persons are most con- 250
"versant, whereof a man shall find much in experience, but little in
"books:" they are then what an artist would naturally call invention;
and yet we may suspect that even the genius of Bacon, great as it was,
would never have been enabled to have made those observations, if his
mind had not been trained and disciplined by reading the observations 255
of others. Nor could he without such reading have known that those
opinions were not to be found in other books.

I ᴋɴᴏᴡ there are many Artists of great fame, who appear never to
have looked out of themselves, and who probably would think it derog-
atory to their character, to be supposed to borrow from any other 260
Painter. But when we recollect, and compare the works of such men
with those who took to their assistance the inventions of others, we
shall be convinced of the great advantage of this latter practice.

Tʜᴇ two men most eminent for readiness of invention, that occur to
me, are Luca Giordano and La Fage; one in painting, and the other in 265
drawing.

240-241 84 mind, and teach him to in-
vent other figures in that stile

243-244 84 and he illustrates

245-247 84 need not repeat, but only ob-
serve that it totally

248-258 84 and inspiration.
I know
[omits two sentences]

263 84 this practice

264-265 84 two most eminent men that
occur to me for readiness of invention, are
Luca

242-244 From Bacon's *Advancement of Learning.* See Hilles, *Literary Career,* p. 214.

250-252 The passage comes from the dedication written (but not used) to Prince Henry
for the *Essays.* For the text see James Spedding, *An Account of the Life and Times of Francis
Bacon* (Boston, 1878), I, 670. In 18th-century editions of Bacon's works the dedication fre-
quently appeared among the letters (see, e.g., London, 1753, II, 477).

265 Luca Giordano (1632-1705) was renowned for his ability to cover great stretches
of wall in record time, hence nicknamed "Fa presto." Raymond LaFage (1656-1690) was a
prolific draftsman.

To such extraordinary powers as were possessed by both of those Artists, we cannot refuse the character of Genius; at the same time, it must be acknowledged, that it was that kind of mechanick Genius which operates without much assistance of the head. In all their works, which are (as might be expected) very numerous, we may look in vain for any thing that can be said to be original and striking; and yet, according to the ordinary ideas of originality, they have as good pretensions as most Painters; for they borrowed very little from others, and still less will any Artist, that can distinguish between excellence and insipidity, ever borrow from them.

To those men, and all such, let us oppose the practice of the first of Painters. I suppose we shall all agree, that no man ever possessed a greater power of invention, and stood less in need of foreign assistance, than Raffaelle; and yet, when he was designing one of his greatest as well as latest works, the Cartoons, it is very apparent that he had the studies which he had made from Masaccio before him. Two noble figures of St. Paul, which he found there, he adopted in his own work: one of them he took for St. Paul preaching at Athens; and the other for the same Saint, when chastising the sorcerer Elymas. Another figure in the same work, whose head is sunk in his breast, with his eyes shut, appearing deeply wrapt up in thought, was introduced amongst the listeners to the preaching of St. Paul. The most material alteration that is made in those two figures of St. Paul, is the addition of the left hands, which are not seen in the original. It is a rule that Raffaelle observed, (and indeed ought never to be dispensed with,) in a principal figure, to shew both hands, that it should never be a question, what is become of the other hand. For the Sacrifice at Listra, he took the whole ceremony much as it stands in an ancient Bas-relievo, since published in the ADMIRANDA.

Plates V and IV (margin note, lines 282–284)

270 84 without a great deal of assistance

277 84 and to all

279 84 invention, and that less stood in

281 84 well as his latest

281-282 84 apparent he had

295-301 84 Admiranda.
Many other instances might be produced of this great Painter's not disdaining assistance. I have given examples from those Pictures only of Raffaelle which we have amongst us.
It may

282-283 Reynolds probably has in mind the figure of St. Paul from "St. Paul Visiting St. Peter in Prison" in the Brancacci Chapel. This particular part of the fresco cycle is actually by Filippino Lippi.

295 Pietro S. Bartoli and Giovanni P. Bellori, *Admiranda Romanarum antiquitatum* (Rome, 1693), Pl. 10.

I HAVE given examples from those pictures only of Raffaelle which we have among us, though many other instances might be produced of this great Painter's not disdaining assistance: indeed his known wealth was so great, that he might borrow where he pleased without loss of credit.

IT may be remarked, that this work of Masaccio, from which he has borrowed so freely, was a publick work, and at no farther distance from Rome, than Florence; so that if he had considered it a disgraceful theft, he was sure to be detected; but he was well satisfied that his character for Invention would be little affected by such a discovery; nor is it, except in the opinion of those who are ignorant of the manner in which great works are built.

THOSE who steal from mere poverty; who, having nothing of their own, cannot exist a minute without making such depredations; who are so poor that they have no place in which they can even deposit what they have taken; to men of this description nothing can be said: but such artists as those to whom I suppose myself now speaking, men whom I consider as competently provided with all the necessaries and conveniences of art, and who do not desire to steal baubles and common trash, but wish only to possess peculiar rarities which they select to ornament their cabinets, and take care to enrich the general store with materials of equal or of greater value than what they have taken; such men surely need not be ashamed of that friendly intercourse which ought to exist among Artists, of receiving from the dead and giving to the living, and perhaps to those who are yet unborn.

THE daily food and nourishment of the mind of an Artist is found in the great works of his predecessors. There is no other way for him to become great himself. *Serpens nisi serpentem comederit, non fit*

302-303 84 no further distance than Florence

304 97 atisfied

306 84 it, but in the

306 84 ignorant of the materials required, and the manner

311-312 84 said; but to such Artists as I

313-314 84 all common necessaries and conveniences, and

313-314 98 and conveniencies of

316-317 84 their cabinet, and who take care to give in return what is of equal

317 84 than that which they

318-319 84 intercourse that ought

319 84 receiving and giving assistance; receiving from

322-323 84 way of becoming great

298-300 While rereading Johnson's "Life of Cowley," Reynolds copied out the phrase "his known wealth was so great, that he might have borrowed without loss of credit" (I, 57). See Hilles, "Sir Joshua's Prose," p. 58.

323-324 Quoted from Bacon's *Essays* (see Hilles, *Literary Career*, pp. 214, 109).

draco, is a remark of a whimsical Natural History, which I have read, though I do not recollect its title; however false as to dragons, it is applicable enough to Artists.

RAFFAELLE, as appears from what has been said, had carefully studied the works of Masaccio; and indeed there was no other, if we except Michael Angelo, (whom he likewise imitated,) so worthy of his attention; and though his manner was dry and hard, his compositions formal, and not enough diversified, according to the custom of Painters in that early period, yet his works possess that grandeur and simplicity which accompany, and even sometimes proceed from, regularity and hardness of manner. We must consider the barbarous state of the Arts before his time, when skill in drawing was so little understood, that the best of the painters could not even foreshorten the foot, but every figure appeared to stand upon his toes; and what served for drapery, had, from the hardness and smallness of the folds, too much the appearance of cords clinging round the body. He first introduced large drapery, flowing in an easy and natural manner: indeed he appears to be the first who discovered the path that leads to every excellence to which the Art afterwards arrived, and may therefore be justly considered as one of the Great Fathers of modern Art.

THOUGH I have been led on to a longer digression respecting this great Painter than I intended, yet I cannot avoid mentioning another excellence which he possessed in a very eminent degree; he was as much distinguished among his contemporaries for his diligence and industry, as he was for the natural faculties of his mind. We are told, that his whole attention was absorbed in the pursuit of his art, and that he acquired the name of Masaccio*, from his total disregard to his dress,

*The addition of *accio* denotes some deformity or imperfection attending that person to whom it is applied.

324 98 *draco**,
*In Ben Jonson's CATILINE, we find this aphorism, with a slight variation:
"A serpent, ere he comes to be a dragon,
"Must eat a bat." M.

324 84 of whimsical

324-325 84 read, I do not recollect where; but however

333 84 which accompanies, and even sometimes proceeds from

334 84 manner. When we consider

335 84 before him, when

338-339 84 folds, more the appearance of

cords clinging round the body, than clothing of any kind. He first

341 84 first that discovered

343 84 as the Great Father of

345-346 84 another virtue which

350 84 Masaccio*,
*His family name is unknown; his christian name was Tomaso: as the English abbreviate this name by taking the first part, the Italians take the latter part only, as Massinello for Tomaso Annello.—The addition of accio implies some deformity or imperfection attending that person or thing to which it is applied.

his person, and all the common concerns of life. He is indeed a signal instance of what well-directed diligence will do in a short time; he lived but twenty-seven years; yet in that short space carried the art so far beyond what it had before reached, that he appears to stand alone as a model for his successors. Vasari gives a long catalogue of Painters and Sculptors, who formed their taste, and learned their Art, by study-ing his works; among those, he names Michael Angelo, Lionardo da Vinci, Pietro Perugino, Raffaelle, Bartolomeo, Andrea del Sarto, Il Rosso, and Pierino del Vaga.

THE habit of contemplating and brooding over the ideas of great geniusses, till you find yourself warmed by the contact, is the true method of forming an Artist-like mind; it is impossible, in the presence of those great men, to think, or invent in a mean manner; a state of mind is acquired that receives those ideas only which relish of grandeur and simplicity.

BESIDE the general advantage of forming the taste by such an inter-course, there is another of a particular kind, which was suggested to me by the practice of Raffaelle, when imitating the work of which I have been speaking. The figure of the Proconsul Sergius Paulus is taken from the Felix of Masaccio, though one is a front figure, and the other seen in profile; the action is likewise somewhat changed; but it is plain Raffaelle had that figure in his mind. There is a circumstance indeed, which I mention by the bye, which marks it very particularly; Sergius Paulus wears a crown of laurel; this is hardly reconcileable to strict propriety, and the *costume*, of which Raffaelle was in general a good observer; but he found it so in Masaccio, and he did not bestow so much pains in disguise as to change it. It appears to me to be an

355

360

365

370

375

352 84 instance what
356-357 84 Art, from studying his works; amongst those
362 84 an Artist's like mind
364 84 that is disposed to receive those
365-366 84 simplicity. Besides the

373 84 indeed otherwise of no great mo-ment, which marks
376-377 84 Masaccio, and that was the sole cause of its being found in his picture; he was not at so much pains of disguise
377 84 appears to be

355-359 The passage occurs in the penultimate paragraph of Vasari's life of Masaccio (I, 411).

370 Reynolds refers to the fresco "St. Peter before the Proconsul," another section of the Brancacci cycle that is by Filippino Lippi rather than Masaccio (see XII, 283). The relation between the two figures is not so close as Reynolds suggests.

375 *Costume* is probably italicized because it was a new word. It does not appear in John-son's *Dictionary* (1755).

excellent practice thus to suppose the figures which you wish to adopt in the works of those great Painters to be statues; and to give, as
380 Raffaelle has here given, another view, taking care to preserve all the spirit and grace you find in the original.

I should hope, from what has been lately said, that it is not necessary to guard myself against any supposition of recommending an entire dependence upon former masters. I do not desire that you should get
385 other people to do your business, or to think for you; I only wish you to consult with, to call in, as Counsellors, men the most distinguished for their knowledge and experience, the result of which counsel must ultimately depend upon yourself. Such conduct in the commerce of life has never been considered as disgraceful, or in any respect to imply
390 intellectual imbecility; it is a sign rather of that true wisdom, which feels individual imperfection; and is conscious to itself how much collective observation is necessary to fill the immense extent, and to comprehend the infinite variety, of nature. I recommend neither self-dependence nor plagiarism. I advise you only to take that assistance
395 which every human being wants, and which, as appears from the examples that have been given, the greatest Painters have not disdained to accept. Let me add, that the diligence required in the search, and the exertion subsequent in accommodating those ideas to your own purpose, is a business which idleness will not, and ignorance cannot,
400 perform. But in order more distinctly to explain what kind of borrowing I mean, when I recommend so anxiously the study of the works of great Masters, let us for a minute return again to Raffaelle, consider his method of practice, and endeavour to imitate him, in his manner of imitating others.

405 The two figures of St. Paul which I lately mentioned, are so nobly conceived by Masaccio, that perhaps it was not in the power even of Raffaelle himself to raise and improve them, nor has he attempted it; but he has had the address to change in some measure without diminishing the grandeur of their character; he has substituted, in the place of
410 a serene composed dignity, that animated expression which was necessary to the more active employment he has assigned them.

In the same manner he has given more animation to the figure of Sergius Paulus, and to that which is introduced in the picture of St.

381 84 grace that is in
396 84 given, that the greatest
398 84 exertion when found, in

404-405 84 imitating others.
 Of the two figures of St. Paul which I lately mentioned, they are

Paul preaching, of which little more than hints are given by Masaccio, which Raffaelle has finished. The closing the eyes of this figure, which in Masaccio might be easily mistaken for sleeping, is not in the least ambiguous in the Cartoon: his eyes indeed are closed, but they are closed with such vehemence, that the agitation of a mind *perplexed in the extreme* is seen at the first glance; but what is most extraordinary, and I think particularly to be admired, is, that the same idea is continued through the whole figure, even to the drapery, which is so closely muffled about him, that even his hands are not seen; by this happy correspondence between the expression of the countenance, and the disposition of the parts, the figure appears to think from head to foot. Men of superior talents alone are capable of thus using and adapting other men's minds to their own purposes, or are able to make out and finish what was only in the original a hint or imperfect conception. A readiness in taking such hints, which escape the dull and ignorant, makes in my opinion no inconsiderable part of that faculty of the mind which is called Genius.

It often happens that hints may be taken and employed in a situation totally different from that in which they were originally employed. There is a figure of a Bacchante leaning backward, her head thrown quite behind her, which seems to be a favourite invention, as it is so frequently repeated in bas-relievos, camæos and intaglios; it is intended to express an enthusiastick frantick kind of joy. This figure Baccio Bandinelli, in a drawing that I have of that Master, of the Descent from the Cross, has adopted, (and he knew very well what was worth borrowing,) for one of the Marys, to express frantick agony of grief. It is curious to observe, and it is certainly true, that the extremes of

420 84 admired, is to see the same idea continued

424-426 84 foot, and is not unlike the artifice so frequently practised by Poets, of making the sound correspond to the sense. Men of superior talents only are capable of thus using and bringing to bear other mens minds

427-429 84 conception. Let me remark, that a readiness in taking such hints, which are always missed by the dull and ignorant, makes no inconsiderable

431-433 84 employed for a purpose totally different from that which first suggested the idea.
There is

434 84 her, which we frequently see in antient Sculpture, and which seems

437-439 84 Bandinelle has adopted (and he knew very well what was worth borrowing) for one of the Marys, in a drawing that I have of that Master, of the Descent from the Cross, to express

418-419 *Othello* V.ii.345.

436-437 Baccio Bandinelli (1488-1560), influenced by Michelangelo.

I

contrary passions are with very little variation expressed by the same action.

IF I were to recommend method in any part of the study of a Painter, it would be in regard to invention; that young Students should not presume to think themselves qualified to invent, till they were acquainted with those stores of invention the world already possesses, and had by that means accumulated sufficient materials for the mind to work with. It would certainly be no improper method of forming the mind of a young Artist, to begin with such exercises as the Italians call a *Pasticcio* composition of the different excellencies which are dispersed in all other works of the same kind. It is not supposed that he is to stop here, but that he is to acquire by this means the art of selecting, first what is truly excellent in Art, and then what is still more excellent in Nature; a task, which, without this previous study, he will be but ill qualified to perform.

THE doctrine which is here advanced, is acknowledged to be new, and to many may appear strange. But I only demand for it the reception of a stranger; a favourable and attentive consideration, without that entire confidence which might be claimed under authoritative recommendation.

AFTER you have taken a figure, or any idea of a figure, from any of those great Painters, there is another operation still remaining, which I hold to be indispensably necessary, that is, never to neglect finishing from Nature every part of the work. What is taken from a model, though the first idea may have been suggested by another, you have a just right to consider as your own property. And here I cannot avoid mentioning a circumstance in placing the model, though to some it may appear trifling. It is better to possess the model with the attitude

441-443 84 passions are expressed by the same action.
 If I was to recommend

446-447 84 already possess, and

450 84 Pasticcio, a composition

452 84 but to acquire

456-459 84 here recommended, is acknowledged to be new, and may appear strange to many. As a stranger, then, receive it, without being required to place that entire

460-461 84 recommendation.
 I am aware of the danger of standing on new ground; it would have been much safer to have amused or rather abused your understanding with a rhapsody about genius and inspiration, of the enthusiasm and divine fury necessary to possess the soul of the Artist, than simply to endeavour to point out the more humble means by which Art is acquired.
 After you

463-464 84 finishing always from Nature this and every

464-465 84 is thus taken from a model, though the idea

467-468 84 circumstance about placing the model, though to many it may appear trifling.
 It is, rather to possess

you require, than to place him with your own hands: by this means
it happens often that the model puts himself in an action superior to 470
your own imagination. It is a great matter to be in the way of accident,
and to be watchful and ready to take advantage of it: besides; when
you fix the position of a model, there is danger of putting him in an
attitude into which no man would naturally fall. This extends even to
drapery. We must be cautious in touching and altering a fold of the 475
stuff, which serves as a model, for fear of giving it inadvertently a
forced form; and it is perhaps better to take the chance of another
casual throw, than to alter the position in which it was at first acci-
dentally cast.

REMBRANDT, in order to take the advantage of accident, appears 480
often to have used the pallet-knife to lay his colours on the canvass,
instead of the pencil. Whether it is the knife or any other instrument, it
suffices if it is something that does not follow exactly the will. Accident
in the hands of an Artist who knows how to take the advantage of its
hints, will often produce bold and capricious beauties of handling 485
and facility, such as he would not have thought of, or ventured, with
his pencil, under the regular restraint of his hand. However, this is fit
only on occasions where no correctness of form is required, such as
clouds, stumps of trees, rocks, or broken ground. Works produced in
an accidental manner, will have the same free unrestrained air as the 490
works of nature, whose particular combinations seem to depend upon
accident.

I AGAIN repeat, you are never to lose sight of nature; the instant
you do, you are all abroad, at the mercy of every gust of fashion, with-
out knowing or seeing the point to which you ought to steer. What- 495
ever trips you make, you must still have nature in your eye. Such
deviations as art necessarily requires, I hope in a future Discourse to
be able to explain. In the mean time, let me recommend to you, not

469-470 84 hands: it happens often by
this means the model

472-473 84 when you change the parts of
a model

474-475 84 attitude which no man would
naturally fall into.
This extends even to drapery touching

477-478 84 another throw, than alter

482-483 84 instrument, it is something

483-484 84 will. This in the hands

484-485 84 advantage of such strokes of
chance, will

486 84 or venture at, with

487-488 84 this can be practised on occa-
sion only where

489-493 84 ground. As it is produced in
the same accidental manner, it has the same
free unrestrained air as the works of Nature
herself.
I again

496 84 eye. Of such

to have too great dependance on your practice or memory, however strong those impressions may have been which are there deposited. They are for ever wearing out, and will be at last obliterated, unless they are continually refreshed and repaired.

IT is not uncommon to meet with artists who from a long neglect of cultivating this necessary intimacy with Nature, do not even know her when they see her; she appearing a stranger to them, from their being so long habituated to their own representation of her. I have heard Painters acknowledge, though in that acknowledgment no degradation of themselves was intended, that they could do better without Nature than with her; or as they expressed it themselves, *that it only put them out.* A Painter with such ideas and such habits, is indeed in a most hopeless state. *The art of seeing Nature,* or in other words, the art of using Models, is in reality the great object, the point to which all our studies are directed. As for the power of being able to do tolerably well, from practice alone, let it be valued according to its worth. But I do not see in what manner it can be sufficient for the production of correct, excellent, and finished Pictures. Works deserving this character never were produced, nor ever will arise, from memory alone; and I will venture to say, that an Artist who brings to his work a mind tolerably furnished with the general principles of Art, and a taste formed upon the works of good Artists, in short who knows in what excellence consists, will, with the assistance of Models, which we will likewise suppose he has learnt the art of using, be an over-match for the greatest Painter that ever lived who should be debarred such advantages.

OUR neighbours, the French, are much in this practice of *extempore* invention, and their dexterity is such as even to excite admiration, if not envy; but how rarely can this praise be given to their finished pictures!

THE late Director of their Academy, *Boucher,* was eminent in this

500 84 been made which

503 84 with Painters who

504-506 84 Nature, so long used to their own representation of her, she appears as a stranger, they do not even know her when they see her. I

508 84 they can do

515-516 84 it can any way contribute to-

wards producing more correct or more excellent finished

517-518 84 were, nor never will be produced by memory

519 84 mind furnished

520-521 84 upon the best works of the best Artists; in short, a man who knows in what the true excellence of the Art consists

way. When I visited him some years since, in France, I found him at work on a very large Picture, without drawings or models of any kind. On my remarking this particular circumstance, he said, when he was young, studying his art, he found it necessary to use models; but he had left them off for many years.

SUCH Pictures as this was, and such as I fear always will be produced by those who work solely from practice or memory, may be a convincing proof of the necessity of the conduct which I have recommended. However, in justice I cannot quit this Painter without adding, that in the former part of his life, when he was in the habit of having recourse to nature, he was not without a considerable degree of merit,— enough to make half the Painters of his country his imitators; he had often grace and beauty, and good skill in composition; but I think, all under the influence of a bad taste: his imitators are indeed abominable.

THOSE Artists who have quitted the service of nature, (whose service, when well understood, is *perfect freedom*) and have put themselves under the direction of I know not what capricious fantastical mistress, who fascinates and overpowers their whole mind, and from whose dominion there are no hopes of their being ever reclaimed, (since they appear perfectly satisfied, and not at all conscious of their forlorn situation,) like the transformed followers of Comus,—

Not once perceive their foul disfigurement;
But boast themselves more comely than before.

METHINKS, such men, who have found out so short a path, have no reason to complain of the shortness of life, and the extent of art; since life is so much longer than is wanted for their improvement, or indeed is necessary for the accomplishment of their idea of perfection. On the contrary, he who recurs to nature, at every recurrence renews his strength. The rules of art he is never likely to forget; they

530
535
540
545
550
555

543 84 taste, but his imitators

545 97 *freedom*, and

546 84 of one knows not

547-548 84 from which dominion it appears hopeless ever to be reclaimed

550 84 like the followers

555 84 than they use for their

530 Reynolds spent a month in Paris on his way back from Italy in 1752; he was also there late in 1768. The meeting with Boucher probably took place on the earlier occasion.

544-545 The parenthetical phrase comes from the Collect for Peace in the Order of Morning Prayer.

551-552 *Comus*, ll. 74-75.

are few and simple; but Nature is refined, subtle, and infinitely various, beyond the power and retention of memory; it is necessary, therefore, to have continual recourse to her. In this intercourse, there is no end of his improvement; the longer he lives, the nearer he approaches to the true and perfect idea of Art.

DISCOURSE XIII

Delivered to the Students of The Royal Academy,

on the Distribution of the Prizes,

December 11, 1786

DISCOURSE XIII

Gentlemen,

TO discover beauties, or to point out faults, in the works of cele-
brated Masters, and to compare the conduct of one Artist with
another, is certainly no mean or inconsiderable part of criticism; but
this is still no more than to know the art through the Artist. This test
of investigation must have two capital defects; it must be narrow, and
it must be uncertain. To enlarge the boundaries of the Art of Paint-
ing, as well as to fix its principles, it will be necessary, that, *that* art,
and *those* principles, should be considered in their correspondence with
the principles of the other arts, which like this, address themselves pri-
marily and principally to the imagination. When those connected and
kindred principles are brought together to be compared, another com-
parison will grow out of this; that is, the comparison of them all with
those of human nature, from whence arts derive the materials upon
which they are to produce their effects.

When this comparison of art with art, and of all arts with the nature
of man, is once made with success, our guiding lines are as well ascer-
tained and established, as they can be in matters of this description.

THIS, as it is the highest style of criticism, is at the same time the
soundest; for it refers to the eternal and immutable nature of things.

You are not to imagine that I mean to open to you at large, or to
recommend to your research, the whole of this vast field of science.
It is certainly much above my faculties to reach it; and though it may
not be above yours, to comprehend it fully, if it were fully and prop-
erly brought before you, yet perhaps the most perfect criticism requires
habits of speculation and abstraction, not very consistent with the
employment which ought to occupy, and the habits of mind which
ought to prevail in a practical Artist. I only point out to you these

13 86 derive their materials 25 86 not so consistent
19 86 soundest; as it

things, that when you do criticise, (as all who work on a plan, will criticise more or less,) your criticism may be built on the foundation of true principles; and that though you may not always travel a great way, the way that you do travel, may be the right road.

I observe, as a fundamental ground, common to all the Arts with which we have any concern in this discourse, that they address themselves only to two faculties of the mind, its imagination and its sensibility.

ALL theories which attempt to direct or to control the Art, upon any principles falsely called rational, which we form to ourselves upon a supposition of what ought in reason to be the end or means of Art, independent of the known first effect produced by objects on the imagination, must be false and delusive. For though it may appear bold to say it, the imagination is here the residence of truth. If the imagination be affected, the conclusion is fairly drawn; if it be not affected, the reasoning is erroneous, because the end is not obtained; the effect itself being the test, and the only test, of the truth and efficacy of the means.

THERE is in the commerce of life, as in Art, a sagacity which is far from being contradictory to right reason, and is superior to any occasional exercise of that faculty, which supersedes it; and does not wait for the slow progress of deduction, but goes at once, by what appears a kind of intuition, to the conclusion. A man endowed with this faculty, feels and acknowledges the truth, though it is not always in his power, perhaps, to give a reason for it; because he cannot recollect and bring before him all the materials that gave birth to his opinion; for very many and very intricate considerations may unite to form the principle, even of small and minute parts, involved in, or dependent on, a great system of things: though these in process of time are forgotten, the right impression still remains fixed in his mind.

THIS impression is the result of the accumulated experience of our whole life, and has been collected, we do not always know how, or when. But this mass of collective observation, however acquired, ought

29	86	less) it may be done on
31	86	be in the right
33	86	any thing to do in
37	98	falsely call rational
38-39	98	be the object or means of Art, independent of their known first effect on

42	86	imagination is affected
48	97	faculty; which
48	86	it; does
53	86	bring present before
56-57	86	things: but the right

to prevail over that reason, which however powerfully exerted on any particular occasion, will probably comprehend but a partial view of the subject; and our conduct in life as well as in the Arts, is, or ought to be, generally governed by this habitual reason: it is our happiness that we are enabled to draw on such funds. If we were obliged to enter into a theoretical deliberation on every occasion, before we act, life would be at a stand, and Art would be impracticable.

It appears to me therefore, that our first thoughts, that is, the effect which any thing produces on our minds on its first appearance, is never to be forgotten; and it demands for that reason, because it is the first, to be laid up with care. If this be not done, the Artist may happen to impose on himself by partial reasoning; by a cold consideration of those animated thoughts which proceed, not perhaps from caprice or rashness, (as he may afterwards conceit,) but from the fullness of his mind, enriched with the copious stores of all the various inventions which he had ever seen, or had ever passed in his mind. These ideas are infused into his design, without any conscious effort; but if he be not on his guard, he may reconsider and correct them, till the whole matter is reduced to a common-place invention.

This is sometimes the effect of what I mean to caution you against; that is to say, an unfounded distrust of the imagination and feeling, in favour of narrow, partial, confined, argumentative theories; and of principles that seem to apply to the design in hand; without considering those general impressions on the fancy in which real principles of *sound reason*, and of much more weight and importance, are involved, and, as it were, lie hid, under the appearance of a sort of vulgar sentiment.

Reason, without doubt, must ultimately determine every thing; at this minute it is required to inform us when that very reason is to give way to feeling.

Though I have often spoke of that mean conception of our art which confines it to mere imitation, I must add, that it may be narrowed to such a mere matter of experiment, as to exclude from it the application of science, which alone gives dignity and compass to any

64-65 86 reason, and it is our happiness we

70 86 be forgot; and

73 86 animated first thoughts which proceeded, not

75 86 with all the copious stores of various inventions that he

76 86 his thoughts. These

95 art. But to find proper foundations for science is neither to narrow or
to vulgarise it; and this is sufficiently exemplified in the success of
experimental philosophy. It is the false system of reasoning, grounded
on a partial view of things, against which I would most earnestly guard
you. And I do it the rather, because those narrow theories, so coinci-
100 dent with the poorest and most miserable practice, and which are
adopted to give it countenance, have not had their origin in the poor-
est minds, but in the mistakes, or possibly in the mistaken interpreta-
tions, of great and commanding authorities. We are not therefore in
this case misled by feeling, but by false speculation.

105 WHEN such a man as Plato speaks of Painting as only an imitative
art, and that our pleasure proceeds from observing and acknowledg-
ing the truth of the imitation, I think he misleads us by a partial the-
ory. It is in this poor, partial, and so far, false, view of the art, that Car-
dinal Bembo has chosen to distinguish even Raffaelle himself, whom
110 our enthusiasm honours with the name of Divine. The same sentiment
is adopted by Pope in his Epitaph on Sir Godfrey Kneller; and he
turns the panegyrick solely on imitation, as it is a sort of deception.

 I SHALL not think my time misemployed, if by any means I may
contribute to confirm your opinion of what ought to be the object of
115 your pursuit; because, though the best criticks must always have
exploded this strange idea, yet I know that there is a disposition towards
a perpetual recurrence to it, on account of its simplicity and superficial
plausibility. For this reason I shall beg leave to lay before you a few
thoughts on this subject; to throw out some hints that may lead your
120 minds to an opinion, (which I take to be the truth,) that Painting is
not only not to be considered as an imitation, operating by deception,
but that it is, and ought to be, in many points of view, and strictly
speaking, no imitation at all of external nature. Perhaps it ought to be

98 86 most cordially guard

104 86 by feelings, but

109-110 86 whom our adulation honours

117-118 86 superficial plausibility.
For which reason

105 Plato on painting: the primary passages are in *The Republic* X, passim.

108-110 *Opere del Cardinale Pietro Bembo* [Milan, 1809], V (Vol. I of the letters), 48.

111 Pope on Kneller:
 Living, great Nature fear'd he might outvie
 Her works; and dying, fears herself may die.
Dr. Johnson had pointed out that this couplet was borrowed from Bembo's distich on
Raphael ("Life of Pope," *Lives of the English Poets*, ed. G. B. Hill, III, 265).

as far removed from the vulgar idea of imitation, as the refined civil-
ized state in which we live, is removed from a gross state of nature; 125
and those who have not cultivated their imaginations, which the major-
ity of mankind certainly have not, may be said, in regard to arts, to
continue in this state of nature. Such men will always prefer imitation
to that excellence which is addressed to another faculty that they do
not possess; but these are not the persons to whom a Painter is to look, 130
any more than a judge of morals and manners ought to refer contro-
verted points upon those subjects to the opinions of people taken from
the banks of the Ohio, or from New Holland.

It is the lowest style only of arts, whether of Painting, Poetry, or
Musick, that may be said, in the vulgar sense, to be naturally pleasing. 135
The higher efforts of those arts, we know by experience, do not affect
minds wholly uncultivated. This refined taste is the consequence of
education and habit; we are born only with a capacity of entertaining
this refinement, as we are born with a disposition to receive and obey
all the rules and regulations of society; and so far it may be said to be 140
natural to us, and no further.

What has been said, may shew the artist how necessary it is, when
he looks about him for the advice and criticism of his friends, to make
some distinction of the character, taste, experience, and observation in
this Art, of those, from whom it is received. An ignorant uneducated 145
man may, like Apelles's critick, be a competent judge of the truth of
the representation of a sandal; or to go somewhat higher, like Moliere's
old woman, may decide upon what is nature, in regard to comick
humour; but a critick in the higher style of art, ought to possess the
same refined taste, which directed the Artist in his work. 150

To illustrate this principle by a comparison with other Arts, I shall
now produce some instances to shew, that they, as well as our own

126 86 their imagination, which

141-142 86 no farther.
What has

149-150 86 stile of Art, requires the same
refined taste, as that which

150-151 86 his work.
And to illustrate this principle by a parallel
from other

146-147 Reynolds refers to the anecdote concerning a shoemaker who corrected Apelles
in the representation of a sandal. Pliny *Historia naturalis* XXXV.xxxvi.85.

147-148 According to anecdote Molière tried out some of his comedies by reading them
to his maidservant La Foret. The source for the anecdote appears to be Boileau. See *Les
oeuvres de M. Boileau Despréaux* (Paris, 1766), II, 318 ("Réflexions critiques sur quelques
passages du Rhéteur Longin: Réflexion première").

Art, renounce the narrow idea of nature, and the narrow theories derived from that mistaken principle, and apply to that reason only which informs us not what imitation is, a natural representation of a given object, but what it is natural for the imagination to be delighted with. And perhaps there is no better way of acquiring this knowledge, than by this kind of analogy: each art will corroborate and mutually reflect the truth on the other. Such a kind of juxtaposition may likewise have this use, that whilst the Artist is amusing himself in the contemplation of other Arts, he may habitually transfer the principles of those Arts to that which he professes; which ought to be always present to his mind, and to which every thing is to be referred.

So far is Art from being derived from, or having any immediate intercourse with, particular nature as its model, that there are many Arts that set out with a professed deviation from it.

THIS is certainly not so exactly true in regard to Painting and Sculpture. Our elements are laid in gross common nature, an exact imitation of what is before us: but when we advance to the higher state, we consider this power of imitation, though first in the order of acquisition, as by no means the highest in the scale of perfection.

POETRY addresses itself to the same faculties and the same dispositions as Painting, though by different means. The object of both is to accommodate itself to all the natural propensities and inclinations of the mind. The very existence of Poetry depends on the licence it assumes of deviating from actual nature, in order to gratify natural propensities by other means, which are found by experience full as capable of affording such gratification. It sets out with a language in the highest degree artificial, a construction of measured words, such as never is, nor ever was used by man. Let this measure be what it may, whether hexameter or any other metre used in Latin or Greek,—or Rhyme, or blank Verse varied with pauses and accents, in modern languages,—they are all equally removed from nature, and equally a violation of common speech. When this artificial mode has been established as the vehicle of sentiment, there is another principle in the human mind, to which the work must be referred, which still renders it more artificial, carries it still further from common nature, and deviates only to render it more perfect. That principle is the sense of congruity, coherence, and

157 86 of getting at this 180 86 it will, whether
178 86 language to the highest

consistency, which is a real existing principle in man; and it must be gratified. Therefore having once adopted a style and a measure not found in common discourse, it is required that the sentiments also should be in the same proportion elevated above common nature, from the necessity of there being an agreement of the parts among themselves, that one uniform whole may be produced.

To correspond therefore with this general system of deviation from nature, the manner in which poetry is offered to the ear, the tone in which it is recited, should be as far removed from the tone of conversation, as the words of which that Poetry is composed. This naturally suggests the idea of modulating the voice by art, which I suppose may be considered as accomplished to the highest degree of excellence in the recitative of the Italian Opera; as we may conjecture it was in the chorus that attended the ancient drama. And though the most violent passions, the highest distress, even death itself, are expressed in singing or recitative, I would not admit as sound criticism the condemnation of such exhibitions on account of their being unnatural.

If it is natural for our senses, and our imaginations, to be delighted with singing, with instrumental musick, with poetry, and with graceful action, taken separately; (none of them being in the vulgar sense natural, even in that separate state;) it is conformable to experience, and therefore agreeable to reason as connected with and referred to experience, that we should also be delighted with this union of musick, poetry, and graceful action, joined to every circumstance of pomp and magnificence calculated to strike the senses of the spectator. Shall reason stand in the way, and tell us we ought not to like what we know we do like, and prevent us from feeling the full effect of this complicated exertion of art? This is what I would understand by poets and painters being allowed to dare every thing; for what can be more daring, than accomplishing the purpose and end of art, by a complication of means, none of which have their archetypes in actual nature?

So far therefore is servile imitation from being necessary, that whatever is familiar, or in any way reminds us of what we see and hear every day, perhaps does not belong to the higher provinces of art, either in poetry or painting. The mind is to be transported, as Shakspeare ex-

191-192 86 sentiments must themselves be

201 86 of the Opera

203 86 itself, is expressed

206 86 our imagination, to be

214 98 us that we

220 86 necessary. Whatever

presses it, *beyond the ignorant present*, to ages past. Another and a
higher order of beings is supposed; and to those beings every thing
which is introduced into the work must correspond. Of this conduct,
under these circumstances, the Roman and Florentine schools afford
sufficient examples. Their style by this means is raised and elevated
above all others; and by the same means the compass of art itself is
enlarged.

We often see grave and great subjects attempted by artists of another
school; who, though excellent in the lower class of art, proceeding on
the principles which regulate that class, and not recollecting, or not
knowing, that they were to address themselves to another faculty of
the mind, have become perfectly ridiculous.

The picture which I have at present in my thoughts is a sacrifice of
Iphigenia, painted by Jean Steen, a painter of whom I have formerly
had occasion to speak with the highest approbation; and even in this
picture, the subject of which is by no means adapted to his genius, there
is nature and expression; but it is such expression, and the countenances
are so familiar, and consequently so vulgar, and the whole accompa-
nied with such finery of silks and velvet, that one would be almost
tempted to doubt, whether the artist did not purposely intend to
burlesque his subject.

Instances of the same kind we frequently see in poetry. Parts of
Hobbes's translation of Homer are remembered and repeated merely
for the familiarity and meanness of their phraseology, so ill correspond-
ing with the ideas which ought to have been expressed, and, as I
conceive, with the style of the original.

We may proceed in the same manner through the comparatively
inferior branches of art. There are in works of that class, the same dis-
tinction of a higher and a lower style; and they take their rank and
degree in proportion as the artist departs more, or less, from common

Plate VIII

233 86 the same principles, and not
237 86 a painter whom
238 86 speak of with
247-248 86 corresponding to the ideas
249 86 conceive, to the style
253 86 as they depart, more

224 *Macbeth* I.v.57:
 beyond
 This ignorant present

236-237 Probably the picture now in the Rijksmuseum, Amsterdam, 1671. See Pl. VIII.

246 Thomas Hobbes, trans., *The Travels of Ulysses* (London, 1673) and *Homer's Iliads in English* (London, 1676).

nature, and makes it an object of his attention to strike the imagination of the spectator by ways belonging specially to art,—unobserved and untaught out of the school of its practice.

If our judgements are to be directed by narrow, vulgar, untaught or rather ill-taught reason, we must prefer a portrait by Denner or any other high finisher, to those of Titian or Vandyck; and a landskip of Vanderhyde to those of Titian or Rubens; for they are certainly more exact representations of nature.

If we suppose a view of nature represented with all the truth of the *camera obscura*, and the same scene represented by a great Artist, how little and mean will the one appear in comparison of the other, where no superiority is supposed from the choice of the subject. The scene shall be the same, the difference only will be in the manner in which it is presented to the eye. With what additional superiority then will the same Artist appear when he has the power of selecting his materials, as well as elevating his style? Like Nicolas Poussin, he transports us to the environs of ancient Rome, with all the objects which a literary education makes so precious and interesting to man: or, like Sebastian Bourdon, he leads us to the dark antiquity of the Pyramids of Egypt; or, like Claude Lorrain, he conducts us to the tranquillity of Arcadian scenes and fairy land.

Plates XX and X

Like the history-painter, a painter of landskips in this style and with this conduct, sends the imagination back into antiquity; and, like the Poet, he makes the elements sympathise with his subject: whether the clouds roll in volumes like those of Titian or Salvator Rosa,—or, like those of Claude, are gilded with the setting sun; whether the mountains

Plates XVII and XI

255

260

265

270

275

254 86 and make it an object of their attention

255-256 86 unobserved, untaught, out of the schools of

257 86 our judgment is to be directed by the narrow

258-259 86 any high

260-261 86 certainly a more exact representation of

265 86 of the subjects. The

272 86 Bourdon, when he

273 86 Lorrain, when he

278-279 86 like Claude

258 Probably Balthasar Denner (1685-1749), portrait and miniature painter.

259-260 Probably Jan van der Heyden (1637-1712), architecture, landscape, and still-life painter. In "A Journey to Flanders and Holland" [1781] (*Works*, II, 360) Reynolds comments on a view by Van der Heyden: "Notwithstanding this picture is finished as usual very minutely, he has not forgot to preserve, at the same time, a great breadth of light. His pictures have very much the effect of nature, seen in a camera obscura."

263 On the *camera obscura* or, more accurately, the *camera ottica* in the mid-18th century see F. J. B. Watson, *Canaletto* (London, [c.1949]), p. 10.

280 have sudden and bold projections, or are gently sloped; whether the branches of his trees shoot out abruptly in right angles from their trunks, or follow each other with only a gentle inclination. All these circumstances contribute to the general character of the work, whether it be of the elegant, or of the more sublime kind. If we add to this the

285 powerful materials of lightness and darkness, over which the Artist has complete dominion, to vary and dispose them as he pleases; to diminish, or increase them as will best suit his purpose, and correspond to the general idea of his work: a landskip thus conducted, under the influence of a poetical mind, will have the same superiority over the

290 more ordinary and common views, as Milton's *Allegro* and *Penseroso* have over a cold prosaick narration or description; and such a picture would make a more forcible impression on the mind than the real scenes, were they presented before us.

If we look abroad to other Arts, we may observe the same distinc-
295 tion, the same division into two classes, each of them acting under the influence of two different principles, in which the one follows nature, the other varies it, and sometimes departs from it.

THE Theatre, which is said *to hold the mirrour up to nature*, com-
prehends both those ideas. The lower kind of Comedy, or Farce, like
300 the inferior style of Painting, the more naturally it is represented, the better; but the higher appears to me to aim no more at imitation, so far as it belongs to any thing like deception, or to expect that the spec-
tators should think that the events there represented are really passing
Plates IV before them, than Raffaelle in his Cartoons, or Poussin in his Sacra-
and XIV ments, expected it to be believed, even for a moment, that what they exhibited were real figures.

FOR want of this distinction, the world is filled with false criticism. Raffaelle is praised for naturalness and deception, which he certainly has not accomplished, and as certainly never intended; and our late
310 great actor, Garrick, has been as ignorantly praised by his friend Field-
ing; who doubtless imagined he had hit upon an ingenious device, by

281-282 86 their trunk, or

302-303 86 or have any expectation that
the spectators should think the events

305 86 expected you were to believe,
even

298 *Hamlèt* III.ii.24.

310-314 Reynolds refers to *Tom Jones*, Bk. XVI, Ch. v, in which Tom, Partridge, and Mrs. Miller go to see a performance of *Hamlet*.

introducing in one of his novels, (otherwise a work of the highest merit,) an ignorant man, mistaking Garrick's representation of a scene in Hamlet, for reality. A very little reflection will convince us, that there is not one circumstance in the whole scene that is of the nature of deception. The merit and excellence of Shakspeare, and of Garrick, when they were engaged in such scenes, is of a different and much higher kind. But what adds to the falsity of this intended compliment, is, that the best stage-representation appears even more unnatural to a person of such a character, who is supposed never to have seen a play before, than it does to those who have had a habit of allowing for those necessary deviations from nature which the Art requires.

In theatrick representation, great allowances must always be made for the place in which the exhibition is represented; for the surrounding company, the lighted candles, the scenes visibly shifted in your sight, and the language of blank verse, so different from common English; which merely as English must appear surprising in the mouths of Hamlet, and all the court and natives of Denmark. These allowances are made; but their being made puts an end to all manner of deception: and further; we know that the more low, illiterate, and vulgar any person is, the less he will be disposed to make these allowances, and of course to be deceived by any imitation; the things in which the trespass against nature and common probability is made in favour of the theatre, being quite within the sphere of such uninformed men.

Though I have no intention of entering into all the circumstances of unnaturalness in theatrical representations, I must observe, that even the expression of violent passion, is not always the most excellent in proportion as it is the most natural: so great terror and such disagreeable sensations may be communicated to the audience, that the balance may be destroyed by which pleasure is preserved, and holds its predominancy in the mind: violent distortion of action, harsh screamings of the voice, however great the occasion, or however natural on such occasion, are therefore not admissible in the theatrick art. Many of these allowed deviations from nature arise from the necessity

315
320
325
330
335
340
345

323 86 must be

325-328 86 candles, for the scenes visibly shifted in your sight; and for the language of blank verse, which changes the common English, and which English itself must appear surprising in Hamlet

330 86 and farther, we

338 86 passion, will not be always

339 86 terror and disagreeable

341 86 balance would be

which there is, that every thing should be raised and enlarged beyond
its natural state; that the full effect may come home to the spectator,
which otherwise would be lost in the comparatively extensive space
of the Theatre. Hence the deliberate and stately step, the studied
350 grace of action, which seems to enlarge the dimensions of the Actor,
and alone to fill the stage. All this unnaturalness, though right and
proper in its place, would appear affected and ridiculous in a private
room; *quid enim deformius, quam scenam in vitam transferre?*

AND here I must observe, and I believe it may be considered as a
355 general rule, that no Art can be engrafted with success on another
art. For though they all profess the same origin, and to proceed from
the same stock, yet each has its own peculiar modes both of imitating
nature, and of deviating from it, each for the accomplishment of its
own particular purpose. These deviations, more especially, will not bear
360 transplantation to another soil.

IF a Painter should endeavour to copy the theatrical pomp and parade
of dress and attitude, instead of that simplicity, which is not a greater
beauty in life, than it is in Painting, we should condemn such Pictures
as painted in the meanest style.

365 So also Gardening, as far as Gardening is an Art, or entitled to that
appellation, is a deviation from nature; for if the true taste consists, as
many hold, in banishing every appearance of Art, or any traces of the
footsteps of man, it would then be no longer a Garden. Even though
we define it, "Nature to advantage dress'd," and in some sense it is
370 such, and much more beautiful and commodious for the recreation of
man; it is however, when so dress'd, no longer a subject for the pencil
of a Landskip-Painter, as all Landskip-Painters know, who love to have
recourse to Nature herself, and to dress her according to the princi-
ples of their own Art; which are far different from those of Gardening,
375 even when conducted according to the most approved principles, and
such as a Landskip-Painter himself would adopt in the disposition of
his own grounds, for his own private satisfaction.

351-354 86 unnaturalness, ridiculous and 374 86 of his own Art
affected as it would appear in a private room,
is right and proper in its place.
 And here

353 The source is probably Bacon's *Advancement of Learning* (see Hilles, *Literary Career*, p. 110).

369 Pope, *Essay on Criticism*, l. 297.

I have brought together as many instances as appear necessary, to make out the several points which I wished to suggest to your consideration in this Discourse; that your own thoughts may lead you further in the use that may be made of the analogy of the Arts, and of the restraint which a full understanding of the diversity of many of their principles ought to impose on the employment of that analogy.

THE great end of all those arts is, to make an impression on the imagination and the feeling. The imitation of nature frequently does this. Sometimes it fails, and something else succeeds. I think therefore the true test of all the arts, is not solely whether the production is a true copy of nature, but whether it answers the end of art, which is to produce a pleasing effect upon the mind.

IT remains only to speak a few words of Architecture, which does not come under the denomination of an imitative art. It applies itself, like Musick (and I believe we may add Poetry,) directly to the imagination, without the intervention of any kind of imitation.

THERE is in Architecture, as in Painting, an inferior branch of art, in which the imagination appears to have no concern. It does not however acquire the name of a polite and liberal art, from its usefulness, or administering to our wants or necessities, but from some higher principle: we are sure that in the hands of a man of genius it is capable of inspiring sentiment, and of filling the mind with great and sublime ideas.

IT may be worth the attention of Artists, to consider what materials are in their hands, that may contribute to this end; and whether this art has it not in its power to address itself to the imagination with effect, by more ways than are generally employed by Architects.

To pass over the effect produced by that general symmetry and proportion, by which the eye is delighted, as the ear is with musick, Architecture certainly possesses many principles in common with Poetry and Painting. Among those which may be reckoned as the first, is, that of affecting the imagination by means of association of ideas. Thus, for instance, as we have naturally a veneration for antiquity, whatever building brings to our remembrance ancient customs and manners, such as the Castles of the Barons of ancient Chivalry, is sure

380-381 86 you farther in
387 86 solely what is
398 86 sure in the hands

405 86 effect that is produced
408 86 and Painting.
Amongst those

to give this delight. Hence it is that *towers and battlements** are so often selected by the Painter and the Poet, to make a part of the

415 composition of their ideal Landskip; and it is from hence in a great degree, that in the buildings of Vanbrugh, who was a Poet as well as an Architect, there is a greater display of imagination, than we shall find perhaps in any other; and this is the ground of the effect which we feel in many of his works, notwithstanding the faults with which many

420 of them are justly charged. For this purpose, Vanbrugh appears to have *Plate XXI* had recourse to some principles of the Gothick Architecture; which, though not so ancient as the Grecian, is more so to our imagination, with which the Artist is more concerned than with absolute truth.

THE Barbarick splendour of those Asiatick Buildings, which are now
425 publishing by a member of this Academy†, may possibly, in the same manner, furnish an Architect, not with models to copy, but with hints of composition and general effect, which would not otherwise have occurred.

IT is, I know, a delicate and hazardous thing, (and as such I have
430 already pointed it out,) to carry the principles of one art to another, or even to reconcile in one object the various modes of the same Art, when they proceed on different principles. The sound rules of the Grecian Architecture are not to be lightly sacrificed. A deviation from them, or even an addition to them, is like a deviation or addition to, or
435 from, the rules of other Arts, fit only for a great master, who is thoroughly conversant in the nature of man, as well as all combinations in his own Art.

*Towers and Battlements it sees
 Bosm'd high in tufted trees. MILTON. L'ALLEGRO.
†Mr. HODGES.

416 86 in buildings	435 86 great mind, which is	
418-419 98 effect we we feel	436 86 as well as a complete master of all	
421 98 some of the principles	combinations	

416 ff. On Reynolds' interest in and appreciation of Vanbrugh see R. C. Boys, "Sir Joshua Reynolds and the Architect Vanbrugh," *Michigan Academy of Science, Arts and Letters*, XXXIII (1947), 323-336.

424-428 Some Chinese gazebos had been built in England, especially in Kew Gardens, in the mid-18th century, but the first "Indian" buildings of any importance date from about 1803: Sezincote by Cockerell and Repton, and the Stables at Brighton by William Porden (see John N. Summerson, *Architecture in Britain, 1530 to 1830* [London, 1953], p. 296).

425n William Hodges (1744-1797), a pupil of Richard Wilson, visited India from 1780 to 1784. He became an academician in 1787. Reynolds refers to *Select Views of India* (London, 1786-1788).

DISCOURSE XIII

IT may not be amiss for the Architect to take advantage *sometimes* of that to which I am sure the Painter ought always to have his eyes open, I mean the use of accidents; to follow when they lead, and to improve them, rather than always to trust to a regular plan. It often happens that additions have been made to houses, at various times, for use or pleasure. As such buildings depart from regularity, they now and then acquire something of scenery by this accident, which I should think might not unsuccessfully be adopted by an Architect, in an original plan, if it does not too much interfere with convenience. Variety and intricacy is a beauty and excellence in every other of the Arts which address the imagination; and why not in Architecture?

THE forms and turnings of the streets of London, and other old towns, are produced by accident, without any original plan or design; but they are not always the less pleasant to the walker or spectator, on that account. On the contrary, if the city had been built on the regular plan of Sir Christopher Wren, the effect might have been, as we know it is in some new parts of the town, rather unpleasing; the uniformity might have produced weariness, and a slight degree of disgust.

I can pretend to no skill in the detail of Architecture. I judge now of the art, merely as a Painter. When I speak of Vanbrugh, I mean to speak of him in the language of our art. To speak then of Vanbrugh in the language of a Painter, he had originality of invention, he understood light and shadow, and had great skill in composition. To support his principal object, he produced his second and third groups or masses; he perfectly understood in *his* Art what is the most difficult in ours, the conduct of the back-ground, by which the design and invention is set off to the greatest advantage. What the back-ground is in Painting, in Architecture is the real ground on which the building is erected; and no Architect took greater care than he that his work should not appear crude and hard: that is, it did not abruptly start out of the ground without expectation or preparation.

438-440 86 *sometimes* (of what I am sure the Painter ought always to have his Eyes open to) I mean the use of accidents, and to follow

441 86 trust to a plan

457 97 Vnabrugh

466 86 care, that

443-448 On the development of irregular planning in architecture see Nikolaus Pevsner, "Richard Payne Knight," *Art Bulletin*, XXXI (1949), 294 ff. Pevsner assigns a key position to Vanbrugh in the development.

452-455 For an analysis of Wren's plan for rebuilding London after the Great Fire see Eduard F. Sekler, *Wren and His Place in European Architecture* (London, [1956]), Ch. iii.

THIS is a tribute, which a Painter owes to an Architect who com-
470 posed like a Painter; and was defrauded of the due reward of his merit
by the Wits of his time, who did not understand the principles of com-
position in poetry better than he; and who knew little, or nothing, of
what he understood perfectly, the general ruling principles of Archi-
tecture and Painting. His fate was that of the great Perrault; both were
475 the objects of the petulant sarcasms of factious men of letters; and both
have left some of the fairest ornaments which to this day decorate
their several countries; the façade of the Louvre, Blenheim, and castle
Howard.

Upon the whole, it seems to me, that the object and intention of all
480 the Arts is to supply the natural imperfection of things, and often to
gratify the mind by realising and embodying what never existed but
in the imagination.

It is allowed on all hands, that facts, and events, however they may
bind the Historian, have no dominion over the Poet or the Painter.
485 With us, History is made to bend and conform to this great idea of
Art. And why? Because these Arts, in their highest province, are not
addressed to the gross senses, but to the desires of the mind, to that
spark of divinity which we have within, impatient of being circum-
scribed and pent up by the world which is about us. Just so much as
490 our Art has of this, just so much of dignity, I had almost said of divin-
ity, it exhibits; and those of our Artists who possessed this mark of
distinction in the highest degree, acquired from thence the glorious
appellation of DIVINE.

474-477 Claude Perrault (1613-1688) was one of a commission including Charles LeBrun
and Louis LeVau appointed to design the east façade of the Louvre in 1667. Perrault has
generally been given credit for the design, but recent opinion tends to consider it a genuinely
co-operative venture, involving the talents of all three men. See Anthony Blunt, *Art and
Architecture in France, 1500 to 1700* (London, [1953]), p. 232.

477-478 Blenheim was begun in 1705 for the duke of Marlborough as a gift from a grateful
nation. Castle Howard, for the earl of Carlisle, was Vanbrugh's first large house design. It was
planned in 1699 and building commenced in 1701.

DISCOURSE XIV

Delivered to the Students of The Royal Academy,

on the Distribution of the Prizes,

December 10, 1788

DISCOURSE XIV

GENTLEMEN,

IN the study of our Art, as in the study of all Arts, something is the result of *our own* observation of Nature; something, and that not little, the effect of the example of those who have studied the same nature before us, and who have cultivated before us the same Art, with diligence and success. The less we confine ourselves in the choice of those examples, the more advantage we shall derive from them; and the nearer we shall bring our performances to a correspondence with nature and the great general rules of Art. When we draw our examples from remote and revered antiquity,—with some advantage undoubtedly in that selection, we subject ourselves to some inconveniences. We may suffer ourselves to be too much led away by great names, and to be too much subdued by overbearing authority. Our learning, in that case, is not so much an exercise of our judgment, as a proof of our docility. We find ourselves, perhaps, too much overshadowed; and the character of our pursuits is rather distinguished by the tameness of the follower, than animated by the spirit of emulation. It is sometimes of service, that our examples should be *near* us; and such as raise a reverence, sufficient to induce us carefully to observe them, yet not so great as to prevent us from engaging with them in something like a generous contention.

WE have lately lost Mr. Gainsborough, one of the greatest ornaments of our Academy. It is not our business here, to make panegyricks on the living, or even on the dead who were of our body. The praise of the former might bear the appearance of adulation; and the latter,

2-3 88 Nature, something, (and that is 12 88 and be
not little) the 24 98 bear appearance

21 Gainsborough died Aug. 2, 1788.

247

25 of untimely justice; perhaps of envy to those whom we have still the happiness to enjoy, by an oblique suggestion of invidious comparisons. In discoursing therefore on the talents of the late Mr. Gainsborough, my object is, not so much to praise or to blame him, as to draw from his excellencies and defects, matter of instruction to the Students in
30 our academy. If ever this nation should produce genius sufficient to acquire to us the honourable distinction of an English School, the name of Gainsborough will be transmitted to posterity, in the history of the Art, among the very first of that rising name. That our reputation in the Arts is now only rising, must be acknowledged; and we must
35 expect our advances to be attended with old prejudices, as adversaries, and not as supporters; standing in this respect in a very different situation from the late artists of the Roman School, to whose reputation ancient prejudices have certainly contributed: the way was prepared for them, and they may be said rather to have lived in the reputation
40 of their country, than to have contributed to it; whilst whatever celebrity is obtained by English Artists, can arise only from the operation of a fair and true comparison. And when they communicate to their country a share of their reputation, it is a portion of fame not borrowed from others, but solely acquired by their own labour and
45 talents. As Italy has undoubtedly a prescriptive right to an admiration bordering on prejudice, as a soil peculiarly adapted, congenial, and, we may add, destined to the production of men of great genius in our Art, we may not unreasonably suspect that a portion of the great fame of some of their late artists has been owing to the general readiness and
50 disposition of mankind, to acquiesce in their original prepossessions in favour of the productions of the Roman School.

On this ground, however unsafe, I will venture to prophecy, that two of the last distinguished Painters of that country, I mean Pompeio Battoni, and Raffaelle Mengs, however great their names may at pres-
55 ent sound in our ears, will very soon fall into the rank of Imperiale, Sebastian Concha, Placido Constanza, Massuccio, and the rest of their

45-46 98 an administration bordering

52-58 See II, n. 104-107. Reynolds' prediction has proved only partly true. Batoni and Mengs are in fact better known today than the other artists Reynolds mentions.

55-56 Francesco Fernandi, called Imperiale, was active in Rome in the early 18th century and a teacher of Pompeo Batoni; Sebastiano Conca (ca. 1680-1764) and Placido Costanzi (1690-1759) were also active mostly in Rome; Agostino Masucci (1691-1758) was a pupil and follower of Carlo Maratti.

immediate predecessors; whose names, though equally renowned in their lifetime, are now fallen into what is little short of total oblivion. I do not say that those painters were not superior to the artist I allude to, and whose loss we lament, in a certain routine of practice, which, to the eyes of common observers, has the air of a learned composition, and bears a sort of superficial resemblance to the manner of the great men who went before them. I know this perfectly well; but I know likewise, that a man, looking for real and lasting reputation, must un-learn much of the common-place method so observable in the works of the artists whom I have named. For my own part, I confess, I take more interest in, and am more captivated with, the powerful impression of nature, which Gainsborough exhibited in his portraits and in his landskips, and the interesting simplicity and elegance of his little ordi-nary beggar-children, than with any of the works of that School, since the time of Andrea Sacchi, or perhaps, we may say Carlo Maratti; two painters who may truly be said to be ULTIMI ROMANORUM.

I AM well aware how much I lay myself open to the censure and ridi-cule of the academical professors of other nations, in preferring the humble attempts of Gainsborough to the works of those regular grad-uates in the great historical style. But we have the sanction of all mankind in preferring genius in a lower rank of art, to feebleness and insipidity in the highest.

IT would not be to the present purpose, even if I had the means and materials, which I have not, to enter into the private life of Mr. Gains-borough. The history of his gradual advancement, and the means by which he acquired such excellence in his art, would come nearer to our purpose and wishes, if it were by any means attainable; but the slow progress of advancement is in general imperceptible to the man him-self who makes it; it is the consequence of an accumulation of various ideas which his mind has received, he does not perhaps know how or when. Sometimes indeed it happens, that he may be able to mark the time when, from the sight of a picture, a passage in an author, or a hint in conversation, he has received, as it were, some new and guid-ing light, something like inspiration, by which his mind has been expanded; and is morally sure that his whole life and conduct has been affected by that accidental circumstance. Such interesting accounts we may however sometimes obtain from a man who has acquired an un-

71 88 say of Carlo 83 98 purposes

common habit of self-examination, and has attended to the progress of
95 his own improvement.

IT may not be improper to make mention of some of the customs
and habits of this extraordinary man; points which come more within
the reach of an observer; I however mean such only as are connected
with his art, and indeed were, as I apprehend, the causes of his arriving
100 to that high degree of excellence, which we see and acknowledge in
his works. Of these causes we must state, as the fundamental, the love
which he had to his art; to which, indeed, his whole mind appears to
have been devoted, and to which every thing was referred; and this
we may fairly conclude from various circumstances of his life, which
105 were known to his intimate friends. Among others he had a habit of
continually remarking to those who happened to be about him, what-
ever peculiarity of countenance, whatever accidental combination of
figures, or happy effects of light and shadow, occurred in prospects,
in the sky, in walking the streets, or in company. If, in his walks, he
110 found a character that he liked, and whose attendance was to be ob-
tained, he ordered him to his house: and from the fields he brought
into his painting-room, stumps of trees, weeds, and animals of various
kinds; and designed them, not from memory, but immediately from the
objects. He even framed a kind of model of landskips, on his table;
115 composed of broken stones, dried herbs, and pieces of looking glass,
which he magnified and improved into rocks, trees, and water. How
far this latter practice may be useful in giving hints, the professors of
landskip can best determine. Like every other technical practice it
seems to me wholly to depend on the general talent of him who uses
120 it. Such methods may be nothing better than contemptible and mis-
chievous trifling; or they may be aids. I think upon the whole, unless
we constantly refer to real nature, that practice may be more likely
to do harm than good. I mention it only, as it shews the solicitude
and extreme activity which he had about every thing that related to his
125 art; that he wished to have his objects embodied as it were, and dis-
tinctly before him; that he neglected nothing which could keep his
faculties in exercise, and derived hints from every sort of combination.

WE must not forget whilst we are on this subject, to make some
remarks on his custom of painting by night, which confirms what I
130 have already mentioned, his great affection to his art; since he could

103　88　every thing he saw was　　　　114　88　of models of landskips
107-108　98　of figure, or

not amuse himself in the evenings by any other means so agreeable to himself. I am indeed much inclined to believe that it is a practice very advantageous and improving to an artist; for by this means he will acquire a new and a higher perception of what is great and beautiful in Nature. By candle-light, not only objects appear more beautiful, but from their being in a greater breadth of light and shadow, as well as having a greater breadth and uniformity of colour, nature appears in a higher style; and even the flesh seems to take a higher and richer tone of colour. Judgment is to direct us in the use to be made of this method of study; but the method itself is, I am very sure, advantageous. I have oftened imagined that the two great colourists, Titian and Correggio, though I do not know that they painted by night, formed their high ideas of colouring from the effects of objects by this artificial light: but I am more assured, that whoever attentively studies the first and best manner of Guercino, will be convinced that he either painted by this light, or formed his manner on this conception.

ANOTHER practice Gainsborough had, which is worth mentioning as it is certainly worthy of imitation; I mean his manner of forming all the parts of his picture together; the whole going on at the same time, in the same manner as nature creates her works. Though this method is not uncommon to those who have been regularly educated, yet probably it was suggested to him by his own natural sagacity. That this custom is not universal appears from the practice of a painter whom I have just mentioned, Pompeio Batoni, who finished his historical pictures part after part; and in his portraits completely finished one feature before he proceeded to another. The consequence was, as might be expected; the countenance was never well expressed; and, as the painters say, the whole was not well put together.

THE first thing required to excel in our art, or I believe in any art, is, not only a love for it, but even an enthusiastick ambition to excel in it. This never fails of success proportioned to the natural abilities with which the artist has been endowed by Providence. Of Gains-

131 98 the evening by

135 88 candle-light, objects not only appear

137-138 88 appears to me in

140 88 is (I am very sure of it) advantageous

153-154 88 of the painter whom I just now mentioned

158 88 whole not

145 On Guercino's "manners" see Denis Mahon, *Studies in Seicento Art and Theory* (London, 1947).

borough, we certainly know, that his passion was not the acquirement of riches, but excellence in his art; and to enjoy that honourable fame which is sure to attend it.—That *he felt this ruling passion strong in death*, I am myself a witness. A few days before he died, he wrote me a letter, to express his acknowledgements for the good opinion I entertained of his abilities, and the manner in which (he had been informed) I always spoke of him; and desired he might see me, once more, before he died. I am aware how flattering it is to myself to be thus connected with the dying testimony which this excellent painter bore to his art. But I cannot prevail on myself to suppress that I was not connected with him by any habits of familiarity; if any little jealousies had subsisted between us, they were forgotten, in those moments of sincerity; and he turned towards me as one, who was engrossed by the same pursuits, and who deserved his good opinion, by being sensible of his excellence. Without entering into a detail of what passed at this last interview, the impression of it upon my mind was, that his regret at losing life, was principally the regret of leaving his art; and more especially as he now began, he said, to see what his deficiencies were; which, he said, he flattered himself in his last works were in some measure supplied.

WHEN such a man as Gainsborough arrives to great fame, without the assistance of an academical education, without travelling to Italy, or any of those preparatory studies which have been so often recommended, he is produced as an instance, how little such studies are necessary; since so great excellence may be acquired without them. This is an inference not warranted by the success of any individual; and I trust it will not be thought that I wish to make this use of it.

IT must be remembered that the style and department of art which Gainsborough chose, and in which he so much excelled, did not re-

181-182 88 were supplied

165-166 Pope, *Epistles to Several Persons (Moral Essays)*, Ep. I, ll. 262-263:
And you! brave COBHAM, to the latest breath
Shall feel your ruling passion strong in death:

166-170 The letter Gainsborough wrote to Reynolds on this occasion is preserved in the Royal Academy: "Dear Sir Joshua,—I am just to write what I fear you will not read—after lying in a dying state for 6 months. The extreme affection which I am informed of by a Friend which Sir Joshua has expresd induces me to beg a last favor, which is to come once under my Roof and look at my things, my woodman you never saw, if what I ask now is not disagreeable to your feeling that I may have the honor to speak to you. I can from a sincere Heart say that I always admired and sincerely loved Sir Joshua Reynolds. Tho. Gainsborough" (Whitley, *Thomas Gainsborough*, p. 307).

quire that he should go out of his own country for the objects of his study; they were every where about him; he found them in the streets, and in the fields; and from the models thus accidentally found, he selected with great judgment such as suited his purpose. As his studies were directed to the living world principally, he did not pay a general attention to the works of the various masters, though they are, in my opinion, always of great use, even when the character of our subject requires us to depart from some of their principles. It cannot be denied, that excellence in the department of the art which he professed may exist without them; that in such subjects, and in the manner that belongs to them, the want of them is supplied, and more than supplied, by natural sagacity, and a minute observation of particular nature. If Gainsborough did not look at nature with a poet's eye, it must be acknowledged that he saw her with the eye of a painter; and gave a faithful, if not a poetical, representation of what he had before him.

THOUGH he did not much attend to the works of the great historical painters of former ages, yet he was well aware, that the language of the art, the art of imitation, must be learned somewhere; and as he knew that he could not learn it in an equal degree from his contemporaries, he very judiciously applied himself to the Flemish School, who are undoubtedly the greatest masters of one necessary branch of art; and he did not need to go out of his own country for examples of that school: from that he learnt the harmony of colouring, the management and disposition of light and shadow, and every means which the masters of it practised, to ornament and give splendour to their works. And to satisfy himself as well as others, how well he knew the mechanism and artifice which they employed to bring out that tone of colour which we so much admire in their works, he occasionally made copies from Rubens, Teniers, and Vandyck, which it would be no disgrace to the most accurate connoisseur to mistake, at the first sight, for the works of those masters. What he thus learned, he applied to the originals of nature, which he saw with his own eyes; and imitated, not in the manner of those masters, but in his own.

WHETHER he most excelled in portraits, landskips, or fancy-pictures,

| 200 | 88 | that the department | 202 | 88 | them, they are supplied |
| 201 | 88 | exist with great effect without | 219 | 98 | much admired in |

219-220 Gainsborough was certainly indebted to Rubens, in landscapes; Van Dyck, in portraits; and, to a much lesser extent, Teniers, in genre. On Gainsborough's copies of Rubens, Van Dyck, and Velazquez see Whitley, pp. 282, 322, 249.

it is difficult to determine: whether his portraits were most admirable for exact truth of resemblance, or his landskips for a portrait-like representation of nature, such as we see in the works of Rubens, Ruysdaal, and others of those Schools. In his fancy-pictures, when he had fixed on his object of imitation, whether it was the mean and vulgar form of a wood-cutter, or a child of an interesting character, as he did not attempt to raise the one, so neither did he lose any of the natural grace and elegance of the other; such a grace, and such an elegance, as are more frequently found in cottages than in courts. This excellence was his own, the result of his particular observation and taste; for this he was certainly not indebted to the Flemish School, nor indeed to any School; for his grace was not academical, or antique, but selected by himself from the great school of nature; and there are yet a thousand modes of grace, which are neither theirs, nor his, but lie open in the multiplied scenes and figures of life, to be brought out by skilful and faithful observers.

UPON the whole, we may justly say, that whatever he attempted he carried to a high degree of excellence. It is to the credit of his good sense and judgment that he never did attempt that style of historical painting, for which his previous studies had made no preparation.

AND here it naturally occurs to oppose the sensible conduct of Gainsborough in this respect, to that of our late excellent Hogarth, who, with all his extraordinary talents, was not blessed with this knowledge of his own deficiency; or of the bounds which were set to the extent of his own powers. After this admirable artist had spent the greatest part of his life in an active, busy, and we may add, successful attention to the ridicule of life; after he had invented a new species of dramatick painting, in which probably he will never be equalled, and had stored his mind with infinite materials to explain and illustrate the domestick and familiar scenes of common life, which were generally, and ought to have been always, the subject of his pencil; he very imprudently, or rather presumptuously, attempted the great historical style, for which his previous habits had by no means prepared him: he was indeed so entirely unacquainted with the principles of this style, that he was not

227 88 for the portrait-like 254 88 with such infinite

257 Hogarth's attempts in the "great historical style" are more numerous and more evenly distributed through his career than is often realized. Among the most notable are: "The Pool of Bethesda," ca. 1735; "The Good Samaritan," ca. 1735; "Paul before Felix," 1748; "The Ascension," 1756; "Sigismunda," 1759. For illustrations see R. B. Beckett, *Hogarth* (London, [1949]).

even aware, that any artificial preparation was at all necessary. It is to 260
be regretted, that any part of the life of such a genius should be fruit-
lesly employed. Let his failure teach us not to indulge ourselves in the
vain imagination, that by a momentary resolution we can give either
dexterity to the hand, or a new habit to the mind.

I HAVE, however, little doubt, but that the same sagacity, which 265
enabled those two extraordinary men to discover their true object, and
the peculiar excellence of that branch of art which they cultivated,
would have been equally effectual in discovering the principles of the
higher style; if they had investigated those principles with the same
eager industry, which they exerted in their own department. As Gains- 270
borough never attempted the heroick style, so neither did he destroy
the character and uniformity of his own style, by the idle affectation of
introducing mythological learning in any of his pictures. Of this boyish
folly we see instances enough, even in the works of great painters.
When the Dutch School attempt this poetry of our art in their land- 275
skips, their performances are beneath criticism; they become only an
object of laughter. This practice is hardly excusable, even in Claude
Lorrain, who had shewn more discretion, if he had never meddled with
such subjects.

OUR late ingenious academician, Wilson, has, I fear, been guilty, 280
like many of his predecessors, of introducing gods and goddesses, ideal
beings, into scenes which were by no means prepared to receive such
personages. His landskips were in reality too near common nature to
admit supernatural objects. In consequence of this mistake, in a very
admirable picture of a storm, which I have seen of his hand, many 285
figures are introduced in the fore-ground, some in apparent distress,
and some struck dead, as a spectator would naturally suppose, by the
lightning; had not the painter, injudiciously (as I think) rather chosen
that their death should be imputed to a little Apollo, who appears in
the sky, with his bent bow, and that those figures should be considered 290
as the children of Niobe.

To manage a subject of this kind, a peculiar style of art is required;
and it can only be done without impropriety, or even without ridicule,

266 88 discover the true

291 Wilson, who had died in 1782, painted several versions of the Niobe theme. For illustra-
tions and discussion see William G. Constable, *Richard Wilson* (Cambridge, [Mass.], 1953),
pp. 160 ff. and Pls. 18, 19, 20, 21.

when we adapt the character of the landskip, and that too, in all its
parts, to the historical or poetical representation. This is a very difficult
adventure, and it requires a mind thrown back two thousand years, and
as it were naturalized in antiquity, like that of Nicolo Poussin, to
atchieve it. In the picture alluded to, the first idea that presents itself, is
that of wonder, at seeing a figure in so uncommon a situation as that
in which the Apollo is placed; for the clouds on which he kneels, have
not the appearance of being able to support him; they have neither the
substance nor the form, fit for the receptacle of a human figure; and
they do not possess in any respect that romantick character which is
appropriated to such a subject, and which alone can harmonize with
poetical stories.

IT appears to me, that such conduct is no less absurd than if a plain
man, giving a relation of a real distress, occasioned by an inundation
accompanied with thunder and lightning, should, instead of simply
relating the event, take it into his head, in order to give a grace to his
narration, to talk of Jupiter Pluvius, or Jupiter and his thunder-bolts,
or any other figurative idea; an intermixture which, though in poetry,
with its proper preparations and accompaniments, it might be managed
with effect, yet in the instance before us would counteract the purpose
of the narrator, and instead of being interesting, would be only ridic-
ulous.

THE Dutch and Flemish style of landskip, not even excepting those
of Rubens, is unfit for poetical subjects; but to explain in what this
inaptitude consists, or to point out all the circumstances that give
nobleness, grandeur, and the poetick character, to style, in landskip,
would require a long discourse of itself; and the end would be then
perhaps but imperfectly attained. The painter who is ambitious of this
perilous excellence, must catch his inspiration from those who have
cultivated with success the poetry, as it may be called, of the art; and
they are few indeed.

I CANNOT quit this subject without mentioning two examples which
occur to me at present, in which the poetical style of landskip may be
seen happily executed; the one is Jacob's dream by Salvator Rosa, and

Plate XI

299-300 88 that of the Apollo 310 88 talk of Jupiter and his
304 98 such a object, and 318 98 ineptitude

327-328 The Salvator Rosa painting is now in the duke of Devonshire's collection, the
Bourdon in the National Gallery, London. The Bourdon was actually in Reynolds' possession.
See the collation for Malone's note to this passage in the 1798 edition.

256

the other the return of the Arc from captivity, by Sebastian Bourdon. *Plate XX*
With whatever dignity those histories are presented to us in the lan-
guage of Scripture, this style of painting possesses the same power of ₃₃₀
inspiring sentiments of grandeur and sublimity, and is able to com-
municate them to subjects which appear by no means adapted to receive
them. A ladder against the sky has no very promising appearance of
possessing a capacity to excite any heroick ideas; and the Arc, in the
hands of a second-rate master, would have little more effect than a ₃₃₅
common waggon on the highway; yet those subjects are so poetically
treated throughout, the parts have such a correspondence with each
other, and the whole and every part of the scene is so visionary, that
it is impossible to look at them, without feeling, in some measure, the
enthusiasm which seems to have inspired the painters. ₃₄₀

By continual contemplation of such works, a sense of the higher
excellencies of art will by degrees dawn on the imagination; at every
review that sense will become more and more assured, until we come to
enjoy a sober certainty of the real existence (if I may so express myself)
of those almost ideal beauties; and the artist will then find no difficulty ₃₄₅
in fixing in his mind the principles by which the impression is produced;
which he will feel, and practice, though they are perhaps too delicate
and refined, and too peculiar to the imitative art, to be conveyed to the
mind by any other means.

To return to Gainsborough: the peculiarity of his manner, or style, ₃₅₀
or we may call it—the language in which he expressed his ideas, has
been considered by many, as his greatest defect. But without altogether
wishing to enter into the discussion whether this peculiarity was a
defect or not, intermixed, as it was, with great beauties, of some of
which it was probably the cause, it becomes a proper subject of crit- ₃₅₅
icism and enquiry to a painter.

A NOVELTY and peculiarity of manner, as it is often a cause of our
approbation, so likewise it is often a ground of censure; as being
contrary to the practice of other painters, in whose manner we have
been initiated, and in whose favour we have perhaps been prepossessed ₃₆₀
from our infancy; for, fond as we are of novelty, we are upon the whole
creatures of habit. However, it is certain, that all those odd scratches *Plate XXIV*

328 88 other the journey of the arc, by
328 98 Bourdon*.
*This fine picture was in our author's col-
lection; and was bequeathed by him to Sir
George Beaumont, Bart. M.

337 88 have been such
345-346 88 difficulty of fixing
353-354 88 whether a defect
355-356 88 criticism and discussion to

and marks, which, on a close examination, are so observable in Gains-
borough's pictures, and which even to experienced painters appear
rather the effect of accident than design; this chaos, this uncouth and
shapeless appearance, by a kind of magick, at a certain distance assumes
form, and all the parts seem to drop into their proper places; so that
we can hardly refuse acknowledging the full effect of diligence, under
the appearance of chance and hasty negligence. That Gainsborough
himself considered this peculiarity in his manner and the power it
possesses of exciting surprise, as a beauty in his works, I think may be
inferred from the eager desire which we know he always expressed,
that his pictures, at the Exhibition, should be seen near, as well as at a
distance.

THE slightness which we see in his best works, cannot always be
imputed to negligence. However they may appear to superficial
observers, painters know very well that a steady attention to the general
effect, takes up more time, and is much more laborious to the mind,
than any mode of high finishing or smoothness, without such attention.
His *handling, the manner of leaving the colours,* or in other words, the
methods he used for producing the effect, had very much the appear-
ance of the work of an artist who had never learned from others the
usual and regular practice belonging to the art; but still, like a man of
strong intuitive perception of what was required, he found out a way
of his own to accomplish his purpose.

IT is no disgrace to the genius of Gainsborough, to compare him to
such men as we sometimes meet with, whose natural eloquence appears
even in speaking a language, which they can scarce be said to under-
stand; and who, without knowing the appropriate expression of almost
any one idea, contrive to communicate the lively and forcible impres-
sions of an energetick mind.

I THINK some apology may reasonably be made for his manner, with-
out violating truth, or running any risk of poisoning the minds of the
younger students, by propagating false criticism, for the sake of raising
the character of a favourite artist. It must be allowed, that this hatch-

366 88 appearance, at a certain distance,
by a kind of magic, assumes

380 The italics may be explained by the close relation to a passage in Richardson defining
"handling" as "the manner in which the colours are left by the pencil upon the picture" (*An
Essay on the Theory of Painting,* in *Works* [London, 1792], p. 69). The relation was pointed
out by Greenway.

ing manner of Gainsborough did very much contribute to the lightness of effect which is so eminent a beauty in his pictures; as on the contrary, much smoothness, and uniting the colours, is apt to produce heaviness. Every artist must have remarked, how often that lightness of hand which was in his dead-colour, or first painting, escaped in the finishing, when he had determined the parts with more precision; and another loss he often experiences, which is of greater consequence; whilst he is employed in the detail, the effect of the whole together is either forgotten or neglected. The likeness of a portrait, as I have formerly observed, consists more in preserving the general effect of the countenance, than in the most minute finishing of the features, or any of the particular parts. Now Gainsborough's portraits were often little more, in regard to finishing, or determining the form of the features, than what generally attends a dead colour; but as he was always attentive to the general effect, or whole together, I have often imagined that this unfinished manner contributed even to that striking resemblance for which his portraits are so remarkable. Though this opinion may be considered as fanciful, yet I think a plausible reason may be given, why such a mode of painting should have such an effect. It is presupposed that in this undetermined manner there is the general effect; enough to remind the spectator of the original; the imagination supplies the rest, and perhaps more satisfactorily to himself, if not more exactly, than the artist, with all his care, could possibly have done. At the same time it must be acknowledged there is one evil attending this mode; that if the portrait were seen, previous to any knowledge of the original, different persons would form different ideas, and all would be disappointed at not finding the original correspond with their own conceptions; under the great latitude which indistinctness gives to the imagination, to assume almost what character or form it pleases.

EVERY artist has some favourite part on which he fixes his attention, and which he pursues with such eagerness, that it absorbs every other consideration; and he often falls into the opposite error of that which he would avoid, which is always ready to receive him. Now Gainsborough having truly a painter's eye for colouring, cultivated those effects of the art which proceed from colours; and sometimes appears to be in-

404 88 either forgot or

404-405 88 portrait, for instance, consists

408 88 the forms of

418 88 could have possibly done

420-421 88 different people would

422 88 correspond to their own conception; under

259

different to or to neglect other excellencies. Whatever defects are acknowledged, let him still experience from us the same candour that we so freely give upon similar occasions to the ancient masters; let us not encourage that fastidious disposition, which is discontented with

435 every thing short of perfection, and unreasonably require, as we sometimes do, a union of excellencies, not perhaps quite compatible with each other.—We may, on this ground, say even of the divine Raffaelle, that he might have finished his picture as highly and as correctly as was his custom, without heaviness of manner; and that Poussin might have

440 preserved all his precision without hardness or dryness.

To shew the difficulty of uniting solidity with lightness of manner, we may produce a picture of Rubens in the Church of St. Judule, at Brussels, as an example; the subject is, *Christ's charge to Peter*; which, as it is the highest, and smoothest, finished picture I remember to have

445 seen of that master, so it is by far the heaviest; and if I had found it in any other place, I should have suspected it to be a copy; for painters know very well, that it is principally by this air of facility, or the want of it, that originals are distinguished from copies.—A lightness of effect, produced by colour, and that produced by facility of handling, are

450 generally united; a copy may preserve something of the one, it is true, but hardly ever of the other; a connoisseur therefore finds it often necessary to look carefully into the picture before he determines on its originality. Gainsborough possessed this quality of lightness of manner and effect, I think, to an unexampled degree of excellence; but, it must

455 be acknowledged, at the same time, that the sacrifice which he made to this ornament of our art, was too great; it was, in reality, preferring the lesser excellencies to the greater.

To conclude. However, we may apologize for the deficiencies of Gainsborough, (I mean particularly his want of precision and finish-

460 ing,) who so ingeniously contrived to cover his defects by his beauties; and who cultivated that department of art, where such defects are more

454　88　unexampled excellence

442-446 This painting is now in the Wallace Collection, London. It was supposedly painted about 1616 for Nicolas Damant, who placed it on an altar in the Chapel of the Holy Sacrament of the Collegiate Church of St. Gudule. Reynolds' opinion of the picture is shared by many modern critics, and it is not universally accepted as from Rubens' own hand. When Reynolds actually saw the picture in 1781, he made the following comment in his journal (*Works*, II, 259): "The characters heavy, without grace or dignity; the handling, on a close examination, appears tame even to the suspicion of its being a copy: the colouring is remarkably fresh. The name of Rubens would not stand high in the world, if he had never produced other pictures than such as this."

easily excused; You are to remember, that no apology can be made for this deficiency, in that style which this academy teaches, and which ought to be the object of your pursuit. It will be necessary for you, in the first place, never to lose sight of the great rules and principles of the art, as they are collected from the full body of the best general practice, and the most constant and uniform experience; this must be the ground-work of all your studies: afterwards you may profit, as in this case I wish you to profit, by the peculiar experience and personal talents of artists living and dead; you may derive lights, and catch hints from their practice; but the moment you turn them into models, you fall infinitely below them; you may be corrupted by excellencies, not so much belonging to the art as personal and appropriated to the artist; and become bad copies of good painters, instead of excellent imitators of the great universal truth of things.

465

470

475

DISCOURSE XV

Delivered to the Students of The Royal Academy,

on the Distribution of the Prizes,

December 10, 1790

DISCOURSE XV

GENTLEMEN,

THE intimate connection which I have had with the ROYAL ACAD-
EMY ever since its establishment, the social duties in which we
have all mutually engaged for so many years, make any profession of
attachment to this Institution, on my part, altogether superfluous; the
influence of habit alone in such a connection would naturally have
produced it.

AMONG men united in the same body, and engaged in the same pur-
suit, along with permanent friendship occasional differences will arise.
In these disputes men are naturally too favourable to themselves, and
think perhaps too hardly of their antagonists. But composed and con-
stituted as we are, those little contentions will be lost to others, and
they ought certainly to be lost amongst ourselves, in mutual esteem for
talents and acquirements: every controversy ought to be, and I am per-
suaded, will be, sunk in our zeal for the perfection of our common Art.

IN parting with the Academy, I shall remember with pride, affection,
and gratitude, the support with which I have almost uniformly been
honoured from the commencement of our intercourse. I shall leave
you, Gentlemen, with unaffected cordial wishes for your future con-
cord, and with a well-founded hope, that in that concord, the auspicious
and not obscure origin of our Academy may be forgotten in the
splendour of your succeeding prospects.

MY age, and my infirmities still more than my age, make it probable

1 ff. Early in 1790 Reynolds quarreled with the academicians over the election of one of
their members. The candidate Reynolds favored was defeated, and Reynolds actually resigned
for a brief period from the presidency. He was persuaded to come back, but the episode
formed the background for the opening remarks of the last discourse. There is a long account
of the affair in Leslie and Taylor, II, 553-585.

22 Reynolds was at this time sixty-seven. He had suffered a paralytic stroke in 1782. In
July 1789 the sight of one eye became impaired and was lost entirely after a few weeks. By
Dec. 1790 he was nearly blind.

that this will be the last time I shall have the honour of addressing you from this place. Excluded as I am, *spatiis iniquis*, from indulging my imagination with a distant and forward perspective of life, I may be excused if I turn my eyes back on the way which I have passed.

We may assume to ourselves, I should hope, the credit of having endeavoured, at least, to fill with propriety that middle station which we hold in the general connection of things. Our predecessors have laboured for our advantage, we labour for our successors; and though we have done no more in this mutual intercourse and reciprocation of benefits, than has been effected by other societies formed in this nation for the advancement of useful and ornamental knowledge, yet there is one circumstance which appears to me to give *us* an higher claim than the credit of merely doing our duty. What I at present allude to, is the honour of having been, some of us, the first contrivers, and all of us the promoters and supporters, of the annual Exhibition. This scheme could only have originated from Artists already in possession of the favour of the publick, as it would not have been so much in the power of others to have excited curiosity. It must be remembered, that for the sake of bringing forward into notice concealed merit, they incurred the risk of producing rivals to themselves; they voluntarily entered the lists, and ran the race a second time for the prize which they had already won.

When we take a review of the several departments of the Institution, I think we may safely congratulate ourselves on our good fortune in having hitherto seen the chairs of our professors filled with men of distinguished abilities, and who have so well acquitted themselves of their duty in their several departments. I look upon it to be of importance, that none of them should be ever left unfilled: a neglect to provide for qualified persons, is to produce a neglect of qualifications.

In this honourable rank of Professors, I have not presumed to class myself, though in the Discourses which I have had the honour of

34 98 appears to gives *us*		40 90 excited their curiosity
37-38 90 scheme must of course have originated		46-47 90 fortune of having

24 Virgil *Georgics* IV. 147-148:
 verum haec ipse equidem spatiis exclusus iniquis
 praetereo atque aliis post me memoranda relinquo.

49-51 The professorship of perspective had been vacant for several years. The quarrel with the academicians that Reynolds alludes to at the beginning of Discourse XV concerned a candidate, Bonomi, whom Reynolds wished to have fill the post.

delivering from this place, while in one respect I may be considered as a volunteer, in another view it seems as if I was involuntarily pressed into this service. If prizes were to be given, it appeared not only proper, but almost indispensibly necessary, that something should be said by the President on the delivery of those prizes; and the president for his own credit would wish to say something more than mere words of compliment, which, by being frequently repeated, would soon become flat and uninteresting, and by being uttered to many, would at last become a distinction to none: I thought, therefore, if I were to preface this compliment with some instructive observations on the Art, when we crowned merit in the Artists whom we rewarded, I might do something to animate and guide them in their future attempts.

I AM truly sensible how unequal I have been to the expression of my own ideas. To develope the latent excellencies, and draw out the interior principles, of our art, requires more skill and practice in writing, than is likely to be possessed by a man perpetually occupied in the use of the pencil and the pallet. It is for that reason, perhaps, that the sister Art has had the advantage of better criticism. Poets are naturally writers of prose. They may be said to be practising only an inferior department of their own art, when they are explaining and expatiating upon its most refined principles. But still such difficulties ought not to deter Artists who are not prevented by other engagements from putting their thoughts in order as well as they can, and from giving to the publick the result of their experience. The knowledge which an Artist has of his subject will more than compensate for any want of elegance in the manner of treating it, or even of perspicuity, which is still more essential; and I am convinced that one short essay written by a Painter, will contribute more to advance the theory of our art, than a thousand volumes such as we sometimes see; the purpose of which appears to be rather to display the refinement of the Author's own conceptions of impossible practice, than to convey useful knowledge or instruction of any kind whatever. An Artist knows what is, and what is not, within the province of his art to perform, and is not likely to be for ever teazing the poor Student with the beauties of mixed passions, or to perplex him with an imaginary union of excellencies incompatible with each other.

To this work, however, I could not be said to come totally unpro-

54 90 place, I may in one respect be
61 90 being given to
64-65 90 rewarded, we might do something to animate, and to guide

vided with materials. I had seen much, and I had thought much upon what I had seen; I had something of an habit of investigation, and a disposition to reduce all that I observed and felt in my own mind, to method and system; but never having seen what I myself knew, distinctly placed before me on paper, I knew nothing correctly. To put those ideas into something like order was, to my inexperience, no easy task. The composition, the *ponere totum* even of a single Discourse, as well as of a single statue, was the most difficult part, as perhaps it is of every other art, and most requires the hand of a master.

FOR the manner, whatever deficiency there was, I might reasonably expect indulgence; but I thought it indispensibly necessary well to consider the opinions which were to be given out from this place, and under the sanction of a Royal Academy; I therefore examined not only my own opinions, but likewise the opinions of others. I found in the course of this research, many precepts and rules established in our art, which did not seem to me altogether reconcileable with each other, yet each seemed in itself to have the same claim of being supported by truth and nature; and this claim, irreconcileable as they may be thought, they do in reality alike possess.

To clear away those difficulties, and reconcile those contrary opinions, it became necessary to distinguish the greater truth, as it may be called, from the lesser truth; the larger and more liberal idea of nature from the more narrow and confined; that which addresses itself to the imagination, from that which is solely addressed to the eye. In consequence of this discrimination, the different branches of our art, to which those different truths were referred, were perceived to make so wide a separation, and put on so new an appearance, that they seemed scarcely to have proceeded from the same general stock. The different rules and regulations, which presided over each department of art, followed of course: every mode of excellence, from the grand style of the Roman and Florentine schools down to the lowest rank of still life, had its due weight and value; fitted some class or other; and nothing was thrown away. By this disposition of our art into classes, that perplexity and confusion, which I apprehend every Artist has at some time

117-118 90 appearance as if they had
scarce proceeded

97 Horace *Ars poetica*, ll. 34-35: "infelix operis summa, quia ponere totum nesciet." Hilles (*Literary Career*, p. 129n) suggests Reynolds could have found the phrase in Dryden's translation of Du Fresnoy (London, 1695), p.133.

experienced from the variety of styles, and the variety of excellence 125
with which he is surrounded, is, I should hope, in some measure
removed, and the Student better enabled to judge for himself, what
peculiarly belongs to his own particular pursuit.

In reviewing my Discourses, it is no small satisfaction to be assured
that I have, in no part of them, lent my assistance to foster *newly-* 130
hatched unfledged opinions, or endeavoured to support paradoxes,
however tempting may have been their novelty, or however ingenious
I might, for the minute, fancy them to be; nor shall I, I hope, any
where be found to have imposed on the minds of young Students decla-
mation for argument, a smooth period for a sound precept. I have pur- 135
sued a plain and *honest method*; I have taken up the art simply as I
found it exemplified in the practice of the most approved Painters. That
approbation which the world has uniformly given, I have endeavoured
to justify by such proofs as questions of this kind will admit; by the
analogy which Painting holds with the sister Arts, and consequently 140
by the common congeniality which they all bear to our nature. And
though in what has been done, no new discovery is pretended, I may
still flatter myself, that from the discoveries which others have made
by their own intuitive good sense and native rectitude of judgment, I
have succeeded in establishing the rules and principles of our Art on 145
a more firm and lasting foundation than that on which they had for-
merly been placed.

Without wishing to divert the Student from the practice of his
Art to speculative theory, to make him a mere Connoisseur instead of
a Painter, I cannot but remark, that he will certainly find an account 150
in considering once for all, on what ground the fabrick of our Art is
built. Uncertain, confused, or erroneous opinions are not only detri-
mental to an Artist in their immediate operation, but may possibly have
very serious consequences; affect his conduct, and give a peculiar char-
acter (as it may be called) to his taste, and to his pursuits, through his 155
whole life.

125	90	stiles, the variety
133-134	90	be, nor I hope shall I any where
146	90	foundation than they
150	90	find his account
154	90	give the peculiar

129-147　For an analysis of the literary style of this passage see Hilles, "Sir Joshua's Prose," pp. 53-60.

130-131　Reynolds alludes to *Hamlet* I.iii.65 and II.ii.465.

I was acquainted at Rome in the early part of my life, with a Student of the French Academy, who appeared to me to possess all the qualities requisite to make a great Artist, if he had suffered his taste and feelings, and I may add even his prejudices, to have fair play. He saw and felt the excellencies of the great works of Art with which we were surrounded, but lamented that there was not to be found that Nature which is so admirable in the inferior schools; and he supposed with Felibien, Du Piles, and other Theorists, that such an union of different excellencies would be the perfection of Art. He was not aware, that the narrow idea of Nature, of which he lamented the absence in the works of those great Artists, would have destroyed the grandeur of the general ideas which he admired, and which was indeed the cause of his admiration. My opinions being then confused and unsettled, I was in danger of being borne down by this kind of plausible reasoning, though I remember I then had a dawning of suspicion that it was not sound doctrine; and at the same time I was unwilling obstinately to refuse assent to what I was unable to confute.

That the young Artist may not be seduced from the right path, by following what, at first view, he may think the light of Reason, and which is indeed Reason in part, but not in the whole, has been much the object of these Discourses.

I HAVE taken every opportunity of recommending a rational method of study, as of the last importance. The great, I may say the sole, use of an Academy is, to put, and for some time to keep, Students in that course; that too much indulgence may not be given to peculiarity, and that a young man may not be taught to believe, that what is generally good for others is not good for him.

I HAVE strongly inculcated in my former Discourses, as I do in this my last, the wisdom and necessity of previously obtaining the appropriated instruments of the Art, in a first correct design, and a plain manly colouring, before any thing more is attempted. But by this I would not wish to cramp and fetter the mind, or discourage those who follow (as most of us may at one time have followed) the suggestion of a strong inclination: something must be conceded to great and irresistible impulses: perhaps every Student must not be strictly bound to general methods, if they strongly thwart the peculiar turn of his own

159 90 qualities to make
167-168 90 grandeur of general
170-171 90 plausible reason, though

177 90 of those Discourses
181-182 90 peculiarity, nor a young man taught

mind. I must confess, that it is not absolutely of much consequence, whether he proceeds in the general method of seeking first to acquire mechanical accuracy, before he attempts poetical flights, provided he diligently studies to attain the full perfection of the style he pursues; whether like Parmegiano, he endeavours at grace and grandeur of manner before he has learned correctness of drawing, if like him he feels his own wants, and will labour, as that eminent Artist did, to supply those wants; whether he starts from the East or from the West, if he relaxes in no exertion to arrive ultimately at the same goal. The first publick work of Parmegiano is the St. Eustachius, in the church of St. Petronius in Bologna, and was done when he was a boy; and one of the last of his works is the Moses breaking the tables in Parma. In the former there is certainly something of grandeur in the outline, or in the conception of the figure, which discovers the dawnings of future greatness; of a young mind impregnated with the sublimity of Michael Angelo, whose style he here attempts to imitate, though he could not then draw the human figure with any common degree of correctness. But this same Parmegiano, when in his more mature age he painted the Moses, had so completely supplied his first defects, that we are here at a loss which to admire most, the correctness of drawing, or the grandeur of the conception. As a confirmation of its great excellence, and of the impression which it leaves on the minds of elegant spectators, I may observe, that our great Lyrick Poet, when he conceived his sublime idea of the indignant Welch bard, acknowledged, that though many years had intervened, he had warmed his imagination with the remembrance of this noble figure of Parmegiano.

WHEN we consider that Michael Angelo was the great archetype

195

200

Plate XII

205

210

215

203	90	and done	214-215	90	spectators, our great
205	90	outline, and in	215	90	conceived that sublime
211	90	are at			

201-204 It is not clear what picture Reynolds has in mind. Parmigianino does not appear to have painted a "S. Eustachius." There is a "St. Roch and Donor" in San Petronio, Bologna, by Parmigianino, but it is certainly not his first public work. The "Moses" is part of the decoration in the Church of Santa Maria della Steccata in Parma, executed from 1531 to 1539, but mostly after 1535.

215-218 Reynolds refers to Gray's "The Bard." In a letter of Aug. 27, 1756, Gray wrote to Bedingfield: "the thought, wch you applaud, in those lines, *Loose his beard* &c: is borrow'd from painting. Rafael in his Vision of Ezekiel (in the Duke of Orleans' Collection) has given the air of head, wch I tried to express, to God the Father; or (if you have been at Parma) you may remember Moses breaking the Tables by the Parmeggiano, wch comes still nearer to my meaning." *Correspondence of Thomas Gray*, ed. Paget Toynbee and Leonard Whibley (Oxford, 1935), II, 476. See also the note to the London 1768 edition of the *Poems*, p. 56.

220 to whom Parmegiano was indebted for that grandeur which we find in his works, and from whom all his contemporaries and successors have derived whatever they have possessed of the dignified and the majestick; that he was the bright luminary, from whom Painting has borrowed a new lustre; that under his hands it assumed a new appear-
225 ance, and is become another and superior art; I may be excused if I take this opportunity, as I have hitherto taken every occasion, to turn your attention to this exalted Founder and Father of modern Art, of which he was not only the inventor, but which, by the divine energy of his own mind, he carried at once to its highest point of possible
230 perfection.

THE sudden maturity to which Michael Angelo brought our Art, and the comparative feebleness of his followers and imitators, might perhaps be reasonably, at least plausibly explained, if we had time for such an examination. At present I shall only observe, that the subordi-
235 nate parts of our Art, and perhaps of other Arts, expand themselves by a slow and progressive growth; but those which depend on a native vigour of imagination generally burst forth at once in fullness of beauty. Of this Homer probably, and Shakspeare more assuredly, are signal examples. Michael Angelo possessed the poetical part of our art in a
240 most eminent degree; and the same daring spirit, which urged him first to explore the unknown regions of the imagination, delighted with the novelty, and animated by the success of his discoveries, could not have failed to stimulate and impel him forward in his career beyond those limits, which his followers, destitute of the same incentives, had not
245 strength to pass.

To distinguish between correctness of drawing, and that part which respects the imagination, we may say the one approaches to the mechanical (which in its way too may make just pretensions to genius) and the other to the poetical. To encourage a solid and vigorous course
250 of study, it may not be amiss to suggest, that perhaps a confidence in the mechanick produces a boldness in the poetick. He that is sure of the goodness of his ship and tackle puts out fearlessly from the shore; and he who knows, that his hand can execute whatever his fancy can suggest, sports with more freedom in embodying the visionary forms
255 of his own creation. I will not say Michael Angelo was eminently poet-ical, only because he was greatly mechanical; but I am sure that me-

228 90 which he, by the 239-240 90 part to a most
229 90 mind, carried 251 90 produces boldness

chanick excellence invigorated and emboldened his mind to carry painting into the regions of poetry, and to emulate that art in its most adventurous flights. Michael Angelo equally possessed both qualifications. Yet of mechanick excellence there were certainly great examples to be found in Ancient Sculpture, and particularly in the fragment known by the name of the Torso of Michael Angelo; but of that grandeur of character, air, and attitude, which he threw into all his figures, and which so well corresponds with the grandeur of his outline, there was no example; it could therefore proceed only from the most poetical and sublime imagination.

It is impossible not to express some surprise, that the race of Painters who preceded Michael Angelo, men of acknowledged great abilities, should never have thought of transferring a little of that grandeur of outline which they could not but see and admire in Ancient Sculpture, into their own works; but they appear to have considered Sculpture as the later schools of Artists look at the inventions of Michael Angelo, as something to be admired, but with which they have nothing to do: *quod super nos, nihil ad nos.*—The Artists of that age, even Raffaelle himself, seemed to be going on very contentedly in the dry manner of Pietro Perugino; and if Michael Angelo had never appeared, the Art might still have continued in the same style.

Beside Rome and Florence, where the grandeur of this style was first displayed, it was on this foundation that the Caracci built the truly great Academical Bolognian school, of which the first stone was laid by Pellegrino Tibaldi. He first introduced this style amongst them; and many instances might be given in which he appears to have possessed as by inheritance, the true, genuine, noble and elevated mind of Michael Angelo. Though we cannot venture to speak of him with the same fondness as his countrymen, and call him, as the Caracci did, *Nostro Michael Angelo riformato*, yet he has a right to be considered amongst the first and greatest of his followers: there are certainly many drawings and inventions of his, of which Michael Angelo himself might not disdain to be supposed the Author, or that they should be, as in fact they often are, mistaken for his. I will mention one particular instance,

260 90 Yet of the former there
265 90 example; they could

277-278 90 same stile.
Besides Rome

262 See X, 89*n*.
274 Minucius Felix *Octavius* xiii.1 (a Socratic proverb).

because it is found in a book which is in every young Artist's hands;—Bishop's Ancient Statues. He there has introduced a print, representing Polyphemus, from a drawing of Tibaldi, and has inscribed it with the name of Michael Angelo, to whom he has also in the same book attrib-

295 uted a Sybil of Raffaelle. Both these figures, it is true, are professedly in Michael Angelo's style and spirit, and even worthy of his hand. But we know that the former is painted in the *Institute a Bologna* by Tibaldi, and the other in the *Pace* by Raffaelle.

Plate I THE Caracci, it is acknowledged, adopted the mechanical part with
and II sufficient success. But the divine part which addresses itself to the imagination, as possessed by Michael Angelo or Tibaldi, was beyond their grasp: they formed, however, a most respectable school, a style more on the level, and calculated to please a greater number; and if excellence of this kind is to be valued according to the number, rather

305 than the weight and quality of admirers, it would assume even an higher rank in Art. The same, in some sort, may be said of Tintoret, Paulo Veronese, and others of the Venetian Painters. They certainly much advanced the dignity of their style by adding to their fascinating powers of colouring something of the strength of Michael Angelo; at the

310 same time it may still be a doubt how far their ornamental elegance would be an advantageous addition to his grandeur. But if there is any manner of Painting which may be said to unite kindly with his style, it is that of Titian. His handling, the manner in which his colours are left on the canvas, appears to proceed (as far as that goes) from a con-

315 genial mind, equally disdainful of vulgar criticism.

MICHAEL ANGELO's strength thus qualified, and made more palatable to the general taste, reminds me of an observation which I heard a learned critick* make, when it was incidentally remarked, that our

*Dr. Johnson.

306-307 90 same may be, in some sort, 317-318 90 I heard* a learned critic make
said of the Venetian

292-295 Jan de Bisschop [Joan Biskop], *Paradigmata graphices* (Amsterdam [1671]). The plates to which Reynolds refers are Nos. 14 (Polyphemus) and 22 (Sibyl).

297 Reynolds noted this painting in his Italian journals. See Dimier, p. 324.

298 The figure to which Reynolds refers is in the right corner of the wall devoted to the sibyls, painted by Raphael in a chapel of Santa Maria della Pace, Rome.

316-325 "Pope wrote for his own age and his own nation: he knew that it was necessary to colour the images and point the sentiments of his author [Homer]; he therefore made him graceful, but lost him some of his sublimity" (Johnson, "Life of Pope," III, 240). "Sir, it [Pope's translation of Homer] is the greatest work of the kind that has ever been produced" (Boswell, *Johnson*, III, 257).

translation of Homer, however excellent, did not convey the character, nor had the grand air of the original. He replied, that if Pope had not cloathed the naked majesty of Homer with the graces and elegancies of modern fashions, though the real dignity of Homer was degraded by such a dress, his translation would not have met with such a favourable reception, and he must have been contented with fewer readers.

MANY of the Flemish painters, who studied at Rome, in that great era of our art, such as Francis Floris, Hemskerk, Michael Coxis, Jerom Cock, and others, returned to their own country, with as much of this grandeur as they could carry. But like seeds falling on a soil not prepared or adapted to their nature, the manner of Michael Angelo thrived but little with them; perhaps, however, they contributed to prepare the way for that free, unconstrained, and liberal outline, which was afterwards introduced by Rubens, through the medium of the Venetian Painters.

THIS grandeur of style has been in different degrees disseminated over all Europe. Some caught it by living at the time, and coming into contact with the original author, whilst others received it at second hand; and being every where adopted, it has totally changed the whole taste and style of design, if there could be said to be any style before his time. Our art, in consequence, now assumes a rank to which it could never have dared to aspire if Michael Angelo had not discovered to the world the hidden powers which it possessed. Without his assistance we never could have been convinced, that Painting was capable of producing an adequate representation of the persons and actions of the heroes of the Iliad.

I WOULD ask any man qualified to judge of such works, whether he can look with indifference at the personification of the Supreme Being in the center of the Capella Sestina, or the figures of the Sybils which surround that chapel, to which we may add the statue of Moses; and whether the same sensations are not excited by those works, as what he may remember to have felt from the most sublime passages of Homer? I mention those figures more particularly, as they come nearer

335-336 90 disseminated all over Europe

326-328 Francis Floris I (1516-1570) went to Italy about 1540. Martin van Heemskerk (1498-1574) was probably in Rome during the early 1530's. Michiel Coxie (1499-1592) was in Rome about 1530. Hieronymus Cock (ca. 1510-1570) was probably in Rome between 1546 and 1548.

Plate XIII

to a comparison with his Jupiter, his demi-gods, and heroes; those Sybils and Prophets being a kind of intermediate beings between men and angels. Though instances may be produced in the works of other Painters, which may justly stand in competition with those I have mentioned, such as the Isaiah, and the vision of Ezekiel, by Raffaelle, the St. Mark of Frate Bartolomeo, and many others; yet these, it must be allowed, are inventions so much in Michael Angelo's manner of thinking, that they may be truly considered as so many rays, which discover manifestly the center from whence they emanated.

THE sublime in Painting, as in Poetry, so overpowers, and takes such a possession of the whole mind, that no room is left for attention to minute criticism. The little elegancies of art in the presence of these great ideas thus greatly expressed, lose all their value, and are, for the instant at least, felt to be unworthy of our notice. The correct judgment, the purity of taste, which characterise Raffaelle, the exquisite grace of Correggio and Parmegiano, all disappear before them.

THAT Michael Angelo was capricious in his inventions, cannot be denied; and this may make some circumspection necessary in studying his works; for though they appear to become him, an imitation of them is always dangerous, and will prove sometimes ridiculous. "Within that circle none durst walk but he." To me, I confess, his caprice does not lower the estimation of his genius, even though it is sometimes, I acknowledge, carried to the extreme: and however those eccentrick excursions are considered, we must at the same time recollect, that those faults, if they are faults, are such as never could occur to a mean and vulgar mind; that they flowed from the same source which produced his greatest beauties, and were therefore such as none but himself was capable of committing; they were the powerful impulses of a mind unused to subjection of any kind, and too high to be controled by cold criticism.

MANY see his daring extravagance, who can see nothing else. A young Artist finds the works of Michael Angelo so totally different

372-373 90 ridiculous. "In that dread
circle none durst tread but he."

357-358 Raphael's "Isaiah" (ca. 1512) in Sant'Agostino, Rome; "Vision of Ezekiel" (ca. 1510), Pitti, Florence; Fra Bartolommeo's "St. Mark" (ca. 1514), Pitti, Florence.

372-373 Dryden, "Prologue to *The Tempest*":
But *Shakespear*'s Magick could not copy'd be,
Within that Circle none durst walk but he.

from those of his own master, or of those with whom he is surrounded, that he may be easily persuaded to abandon and neglect studying a style, which appears to him wild, mysterious, and above his comprehension, and which he therefore feels no disposition to admire; a good disposition, which he concludes that he should naturally have, if the style deserved it. It is necessary therefore that Students should be prepared for the disappointment which they may experience at their first setting out; and they must be cautioned, that probably they will not, at first sight, approve.

IT must be remembered, that as this great style itself is artificial in the highest degree, it presupposes in the spectator, a cultivated and prepared artificial state of mind. It is an absurdity therefore to suppose that we are born with this taste, though we are with the seeds of it, which, by the heat and kindly influence of his genius, may be ripened in us.

A LATE Philosopher and Critick* has observed, speaking of taste, that *we are on no account to expect that fine things should descend to us*,—our taste, if possible, must be made to ascend to them. The same learned writer recommends to us *even to feign a relish, till we find a relish come; and feel, that what began in fiction, terminates in reality.* If there be in our Art, any thing of that agreement or compact, such as I apprehend there is in Musick, with which the Critick is necessarily required previously to be acquainted, in order to form a correct judgment; the comparison with this art will illustrate what I have said on these points, and tend to shew the probability, we may say the certainty, that men are not born with a relish for those arts in their most refined state, which as they cannot understand, they cannot be impressed with their effects. This great style of Michael Angelo is as far removed from the simple representation of the common objects of nature, as the most refined Italian musick is from the inartificial notes of nature, from whence they both profess to originate. But without such a supposed compact, we may be very confident that the highest state of

*James Harris, Esq.

394 98 that this 400 90 A* late Philosopher and Critic has
396-397 90 to suppose we

400-404 James Harris, "Rules Defended," *Philological Inquiries*, Pt. II, Ch. xii, in *The Works of James Harris, Esq.* (Oxford, 1841), p. 453. Both passages Reynolds quotes come from the same page in reverse order.

refinement in either of those arts will not be relished without a long and industrious attention.

IN pursuing this great Art, it must be acknowledged that we labour under greater difficulties than those who were born in the age of its discovery, and whose minds from their infancy were habituated to this style; who learnt it as language, as their mother tongue. They had no mean taste to unlearn; they needed no persuasive discourse to allure them to a favourable reception of it, no abstruse investigation of its principles to convince them of the great latent truths on which it is founded. We are constrained, in these later days, to have recourse to a sort of Grammar and Dictionary, as the only means of recovering a dead language. It was by them learned by rote, and perhaps better learned that way than by precept.

THE style of Michael Angelo, which I have compared to language, and which may, poetically speaking, be called the language of the Gods, now no longer exists, as it did in the fifteenth century; yet, with the aid of diligence, we may in a great measure supply the deficiency which I mentioned, of not having his works so perpetually before our eyes, by having recourse to casts from his models and designs in Sculpture; to drawings or even copies of those drawings; to prints, which however ill executed, still convey something by which this taste may be formed; and a relish may be fixed and established in our minds for this grand style of invention. Some examples of this kind we have in the Academy; and I sincerely wish there were more, that the younger Students might in their first nourishment, imbibe this taste; whilst others, though settled in the practice of the common-place style of Painters, might infuse, by this means, a grandeur into their works.

I SHALL now make some remarks on the course which I think most proper to be pursued in such a study. I wish you not to go so much to the derivative streams, as to the fountain-head; though the copies are not to be neglected; because they may give you hints in what manner you may copy, and how the genius of one man may be made to fit the peculiar manner of another.

To recover this lost taste, I would recommend young Artists to study the works of Michael Angelo, as he himself did the works of the

442-443 90 stile of Painting, might

432 Michelangelo's active career lies almost entirely within the 16th century.

450-454 The anecdote is related by Condivi, *Life of Michelagnolo*, p. 7; and Vasari, V, 233.

ancient Sculptors; he began, when a child, a copy of a mutilated Satyr's head, and finished in his model what was wanting in the original. In the same manner, the first exercise that I would recommend to the young artist when he first attempts invention, is to select every figure, if possible, from the inventions of Michael Angelo. If such borrowed figures will not bend to his purpose, and he is constrained to make a change to supply a figure himself, that figure will necessarily be in the same style with the rest, and his taste will by this means be naturally initiated, and nursed in the lap of grandeur. He will sooner perceive what constitutes this grand style by one practical trial than by a thousand speculations, and he will in some sort procure to himself that advantage which in these later ages has been denied him; the advantage of having the greatest of Artists for his master and instructor.

THE next lesson should be, to change the purpose of the figures without changing the attitude, as Tintoret has done with the Sampson of Michael Angelo. Instead of the figure which Sampson bestrides, he has placed an eagle under him, and instead of the jawbone, thunder and lightening in his right hand; and thus it becomes a Jupiter. Titian, in the same manner, has taken the figure which represents God dividing the light from the darkness in the vault of the Capella Sestina, and has introduced it in the famous battle of Cadore, so much celebrated by Vasari; and extraordinary as it may seem, it is here converted to a General, falling from his horse. A real judge who should look at this picture, would immediately pronounce the attitude of that figure to be in a greater style than any other figure of the composition. These two instances may be sufficient, though many more might be given in their works, as well as in those of other great Artists.

WHEN the Student has been habituated to this grand conception of the Art, when the relish for this style is established, makes a part of himself, and is woven into his mind, he will, by this time, have got a power of selecting from whatever occurs in nature that is grand, and corresponds with that taste which he has now acquired, and will pass over whatever is common-place and insipid. He may then bring to the mart such works of his own proper invention as may enrich and increase the general stock of invention in our Art.

458 90 change or supply 469 90 hand, and it

466-469 It is difficult to be sure what particular paintings Reynolds has in mind, but Tintoretto's debt to Michelangelo is readily admitted by all students.

I AM confident of the truth and propriety of the advice which I have recommended; at the same time I am aware, how much by this advice I have laid myself open to the sarcasms of those criticks who imagine our Art to be a matter of inspiration. But I should be sorry it should appear even to myself that I wanted that courage which I have recommended to the Students in another way: equal courage perhaps is required in the adviser and the advised; they both must equally dare and bid defiance to narrow criticism and vulgar opinion.

THAT the Art has been in a gradual state of decline, from the age of Michael Angelo to the present, must be acknowledged; and we may reasonably impute this declension to the same cause to which the ancient Criticks and Philosophers have imputed the corruption of eloquence. Indeed the same causes are likely at all times and in all ages to produce the same effects: indolence,—not taking the same pains as our great predecessors took,—desiring to find a shorter way,—are the general imputed causes. The words of Petronius* are very remarkable. After opposing the natural chaste beauty of the eloquence of former ages to the strained inflated style then in fashion, "neither," says he, "has "the art of Painting had a better fate, after the boldness of the Egyptians "had found out a compendious way to execute so great an art."

By *compendious*, I understand him to mean a mode of Painting, such as has infected the style of the later Painters of Italy and France; common-place, without thought, and with as little trouble, working as by a receipt; in contradistinction to that style for which even a relish cannot be acquired without care and long attention, and most certainly the power of executing cannot be obtained without the most laborious application.

I HAVE endeavoured to stimulate the ambition of Artists to tread in this great path of glory, and, as well as I can, have pointed out the track

*Pictura quoque non alium exitum fecit, postquam Ægyptiorum audacia tam magnæ artis compendiariam invenit.

500-502 90 pains—desiring to find a shorter way—is the general imputed cause. The words

510 90 contradistinction from that

512 90 executing, not without

504-506 Petronius *Satyricon* 2. Michael Heseltine in his translation (Loeb Classical Library [London, 1913], p. 5) renders the sentence: "The decadence in painting was the same, as soon as Egyptian charlatans had found a short cut to this high calling."

507-508 Hilles (*Literary Career*, pp. 125 f.) points out that Reynolds is here following Junius (p. 209) both for the reference to Petronius and the subsequent comments on "a compendious way."

which leads to it, and have at the same time told them the price at which it may be obtained. It is an ancient saying, that labour is the price which the Gods have set upon every thing valuable.

THE great Artist, who has been so much the subject of the present Discourse, was distinguished even from his infancy for his indefatigable diligence; and this was continued through his whole life, till prevented by extreme old age. The poorest of men, as he observed himself, did not labour from necessity, more than he did from choice. Indeed, from all the circumstances related of his life, he appears not to have had the least conception that his art was to be acquired by any other means than by great labour; and yet he, of all men that ever lived, might make the greatest pretensions to the efficacy of native genius and inspiration. I have no doubt that he would have thought it no disgrace, that it should be said of him, as he himself said of Raffaelle, that he did not possess his art from nature, but by long study*. He was conscious that the great excellence to which he arrived was gained by dint of labour, and was unwilling to have it thought that any transcendent skill, however natural its effects might seem, could be purchased at a cheaper price than he had paid for it. This seems to have been the true drift of his observation. We cannot suppose it made with any intention of depreciating the genius of Raffaelle, of whom he always spoke, as Condivi says, with the greatest respect: though they were rivals, no such illiberality existed between them; and Raffaelle on his part entertained the greatest veneration for Michael Angelo, as appears from the speech which is recorded of him, that he congratulated himself, and thanked God, that he was born in the same age with that painter.

IF the high esteem and veneration in which Michael Angelo has been held by all nations and in all ages, should be put to the account of prejudice, it must still be granted that those prejudices could not have been entertained without a cause: the ground of our prejudice then becomes

*Che Raffaelle non ebbe quest' arte da natura, ma per lungo studio.

526 98 than great labour

528 90 I can have

528-529 90 disgrace to have it said of him

529 90 of Raphael,* that

530 90 long study. He

541-542 90 the same age.
If the high

530 The quotation was on the title page of Richardson's *Theory of Painting*. It is taken from Condivi, p. 83.

535-537 The reference comes in the conclusion of Condivi, p. 83.

the source of our admiration. But from whatever it proceeds, or what-ever it is called, it will not I hope, be thought presumptuous in me to appear in the train, I cannot say of his imitators, but of his admirers. I have taken another course, one more suited to my abilities, and to the taste of the times in which I live. Yet however unequal I feel myself to that attempt, were I now to begin the world again, I would tread in the steps of that great master: to kiss the hem of his garment, to catch the slightest of his perfections, would be glory and distinction enough for an ambitious man.

I FEEL a self-congratulation in knowing myself capable of such sen-sations as he intended to excite. I reflect not without vanity, that these Discourses bear testimony of my admiration of that truly divine man, and I should desire that the last words which I should pronounce in this Academy, and from this place, might be the name of—MICHAEL ANGELO*.

*Unfortunately for mankind, these *were* the last words pronounced by this great painter from the Academical chair. He died about fourteen months after this Discourse was delivered.

THE END OF THE DISCOURSES

A Note on the Text and Collation

THE 1797 text used as a base for this edition, as well as carrying Reynolds' final revisions, is typographically the most accurate and attractive of all the early editions of the *Discourses*. There are, as one would expect in any book of the period, inconsistencies in spelling and punctuation, and also a small number of typographical errors. Some of the last were caught in the "Errata" issued with the edition, and those corrections have been made silently in this reprint. But for purposes of bibliographical accuracy all other corrections made in this printing of the 1797 edition are indicated in the collation, where the original form is given. No attempt has been made to modernize or render consistent the spelling and punctuation. The typography of the present edition has also been modeled on that of the 1797 printing.

The discourses were first printed separately as they were completed over the period 1769 to 1790. The first seven appeared in a collected edition in 1778. All fifteen were issued together in 1797, several years after Reynolds' death. He had, however, worked with his editor, Edmond Malone, in the preparation of this edition. The intention in the collation is to record all word changes made by Reynolds in the various editions of the discourses. The collation has been extended to include Malone's second edition of 1798, for, although Reynolds himself had nothing to do with its preparation, this is by far the most widely known edition of his works, and has been the source for nearly all subsequent reprints. Changes in spelling, punctuation, and paragraphing have not been recorded, as these were probably the result of the whims of the printers.

In theory this distinction between what is and is not recorded in the collation is clear enough, but in practice many difficulties arose. Some word changes are recorded that are probably the result of typographical error rather than editorial deliberation. Changes such as from "amongst" to "among" or "besides" to "beside" might be regarded as word or simply as spelling changes. In such instances the authority of *OED* has been taken. Changes involving tense, number, and word order have been recorded. The addition or omission of apostrophes has been accepted as a change in spelling and is not recorded.

No account has been taken in the collation of the few surviving manuscript fragments of the *Discourses*. Most of this manuscript material is preserved in the Royal Academy. The fragments have been carefully studied, printed, and compared with the published texts by F. W. Hilles in *The Literary Career of Sir Joshua Reynolds*, App. II.

In order to keep the body of the text unencumbered, footnote numbers have been omitted, and the annotations and the collation are related to the text by line number. In the collation the variant reading includes a word or two before and after the change. The various editions of the discourses are referred to by the last two digits of the date of publication (for example, the 1769 edition of the first discourse as "69"). The symbol "78S" is used for the 1778 collected edition of the first seven discourses. The only footnote symbols that occur in the body of the text are those added by Reynolds and Malone to the 1797 edition.

APPENDIX I

William Blake's Annotations to Reynolds' Discourses

THE three volumes of the second (1798) edition of Reynolds' *Discourses* which belonged to Blake are in the British Museum. Blake's marginalia are written in the first volume only, the notes on the other volumes being in the Note-Book with other epigrams, etc. relating to events which took place about 1808.

The text of the marginalia here printed is taken from *The Complete Writings of William Blake* edited by Geoffrey Keynes, London, 1966. For ease in reference, the passages have been keyed to the present edition of the *Discourses*. Most of the early annotations are to Edmond Malone's memoir of Reynolds included in the 1797 and 1798 editions of the *Discourses* but not here reprinted.

[*Written on the title page and preliminary leaves*]

This Man was Hired to Depress Art.
 This is the Opinion of Will Blake: my Proofs of this Opinion are given in the following Notes.

 Advice of the Popes who succeeded the Age of Rafael

 Degrade first the Arts if you'd Mankind Degrade.
 Hire Idiots to Paint with cold light & hot shade:
 Give high Price for the worst, leave the best in disgrace,
 And with Labours of Ignorance fill every place.

 Having spent the Vigour of my Youth & Genius under the Opression of Sr Joshua & his Gang of Cunning Hired Knaves Without Employment & as much as could possibly be Without Bread, The Reader must Expect to Read in all my Remarks on these Books Nothing but Indignation & Resentment. While Sr Joshua was rolling in Riches, Barry was Poor & Unemploy'd except by his own Energy; Mortimer was call'd a Madman, & only Portrait Painting applauded & rewarded by the Rich & Great. Reynolds & Gainsborough Blotted & Blurred one against the other & Divided all the English World between them. Fuseli, Indignant, almost hid himself. I am hid.

284

Appendix I

The Arts & Sciences are the Destruction of Tyrannies or Bad Governments. Why should A Good Government endeavour to Depress what is its Chief & only Support?

The Foundation of Empire is Art & Science. Remove them or Degrade them, & the Empire is No More. Empire follows Art & Not Vice Versa as Englishmen suppose.

"On peut dire que le Pape Léon Xme en encourageant les Études donna Les armes contre lui-même. J'ai oui dire à un Seigneur Anglais qu'il avait vu une Lettre du Seigneur Polus, ou de La Pole, depuis Cardinal, à ce Pape; dans laquelle, en le félicitant sur ce qu'il étendait le progrès de Science en Europe, il l'avertissait *qu'il était dangereux de rendre les hommes trop Savan[t]s.*"

VOLTAIRE, *Mœurs de Nations.* Tome 4.

O Englishmen! why are you still of this foolish Cardinal's opinion? Who will Dare to Say that Polite Art is Encouraged or Either Wished or Tolerated in a Nation where The Society for the Encouragement of Art Suffer'd Barry to Give them his Labour for Nothing, A Society Composed of the Flower of the English Nobility & Gentry?—Suffering an Artist to Starve while he Supported Really what They, under Pretence of Encouraging, were Endeavouring to Depress.—Barry told me that while he Did that Work, he Lived on Bread & Apples.

O Society for Encouragement of Art! O King & Nobility of England! Where have you hid Fuseli's Milton? Is Satan troubled at his Exposure?

Page 5

The course and order of study.—The different stages of Art.—Much copying discountenanced.—The Artist at all times and in all places should be employed in laying up materials for the exercise of his art.

To learn the Language of Art, "Copy for Ever" is My Rule.

Page 3

The regular progress of cultivated life is from necessaries to accommodations, from accommodations to ornaments.

The Bible says That Cultivated Life Existed First. Uncultivated Life comes afterwards from Satan's Hirelings. Necessaries, Accomodations & Ornaments are the whole of Life. Satan took away Ornament First. Next he took away Accomodations, & Then he became Lord & Master of Necessaries.

To give advice to those who are contending for royal liberality, has been for some years the duty of my station in the Academy.

Liberality! we want not Liberality. We want a Fair Price & Proportionate Value & a General Demand for Art.

Let not that Nation where Less than Nobility is the Reward, Pretend that Art is Encouraged by that Nation. Art is First in Intellectuals & Ought to be First in Nations.

Invention depends Altogether upon Execution or Organization; as that is right or wrong so is the Invention perfect or imperfect. Whoever is set to Undermine the Execution of Art is set to Destroy Art. Michael Angelo's Art depends on Michael Angelo's Execution Altogether.

[Annotations to "Some Account of Sir Joshua Reynolds", not reprinted in this edition]

But what most strongly confirmed him in his Love of the Art, was Richardson's Treatise on Painting; the perusal of which so delighted and inflamed his mind, that Raffelle appeared to him superior to the most illustrious names of ancient or modern time; a notion which he loved to indulge all the rest of his life.

Why then did he not follow Rafael's Track?

[*footnote*] "He [Thomas Hudson] enjoyed for many years the chief business of portrait-painting in the capital, . . . The better taste introduced by Sir Joshua Reynolds, put an end to Hudson's reign . . ."

Hudson Drew Correctly.

"It has frequently happened . . ., as I was informed by the keeper of the Vatican, that many of those whom he had conducted through the various apartments of that edifice, when about to be dismissed, have asked for the works of Raffaelle, and would not believe that they had already passed through the rooms where they are preserved; so little impression had those performances made on them."

Men who have been Educated with Works of Venetian Artists under their Eyes cannot see Rafael unless they are born with Determinate Organs.

"I remember very well my own disappointment, when I first visited the Vatican; but on confessing my feelings to a brother-student . . . he acknowledged that the works of Raffaelle had the same effect on him, or rather that they did not produce the effect which he expected;"

I am happy I cannot say that Rafael Ever was, from my Earliest Childhood, hidden from Me. I Saw & I Knew immediately the difference between Rafael & Rubens.

> Some look to see the sweet Outlines
> And beauteous Forms that Love does wear.
> Some look to find out Patches, Paint,
> Bracelets & Stays & Powder'd Hair.

"and on inquiring further of other students, I found that those persons only who from natural imbecility appeared to be incapable of ever relishing those divine performances, made pretensions to instantaneous raptures on first beholding them."

Here are Mocks on those who Saw Rafael.

". . . I found myself in the midst of works executed upon principles with which I was unacquainted: I felt my ignorance, and stood abashed."

A Liar! he never was Abashed in his Life & never felt his Ignorance.

Appendix I

"I proceeded to copy some of those excellent works. I viewed them again and again; . . . In a short time a new taste and new perceptions began to dawn on me. . . . The truth is, that if these works had really been what I expected, they would have contained beauties superficial and alluring, but by no means such as would have entitled them to the great reputation which they have so long and so justly obtained."

All this Concession is to prove that Genius is Acquired, as follows in the Next page.

". . . I am now clearly of opinion, that a relish for the higher excellencies of art is an acquired taste, which no man ever possessed without long cultivation . . . we are often ashamed of our apparent dulness; as if it were to be expected that our minds, like tinder, should instantly catch fire from the divine spark of Raffaelle's genius."

A Mock!

". . . but let it be always remembered, that the excellence of his style is not on the surface, but lies deep; and at the first view is seen but mistily."

A Mock!

"It is the florid style, which strikes at once, and captivates the eye for a time, . . ."

A Lie! The Florid Style, such as the Venetian & the Flemish, Never Struck Me at Once nor At-All.
The Style that Strikes the Eye is the True Style, But A Fool's Eye is Not to be a Criterion.

"The man of true genius, instead of spending all his hours . . . in measuring statues and copying pictures, soon begins to think for himself, . . . I consider *general copying as a delusive kind of industry:*"

Here he Condemns Generalizing, which he almost always Approves & Recommends.

"How incapable of producing any thing of their own, those are, who have spent most of their time in making finished copies, is an observation well known to all who are conversant with our art."

Finish'd! What does he Mean? Niggling without the Correct & Definite Outline? If he means That Copying Correctly is a hindrance, he is a Liar, for that is the only School to the Language of Art.

"It is the thoughts expressed in the works of Michael Angelo, Corregio, Raffelle, Parmegiano, and perhaps some of the old Gothick masters, and not the inventions of Pietro da Cortona, Carlo Maratti, Luca Giordano, and others that I might mention, which we seek after with avidity. From the former we learn to think originally."

Here is an Acknowledgment of all that I could wish. But if it is True, Why are we to be told that Masters who could Think had not the Judgment to Perform the Inferior Parts of Art, as Reynolds artfully calls them, But that we are to Learn to Think from Great Masters & to Learn to Perform from Underlings?

287

Learn to Design from Rafael & to Execute from Rubens . . .? [*the remainder has been cut away by the binder*]

He [Mr. Mudge, Prebendary of Exeter] was a learned and venerable old man; and as I thought, very much conversant in the Platonick Philosophy. . . .

Slang!

He had been originally a dissenting minister.

Villainy!

[*To a footnote concerning rumours that the Discourses had been written by Dr. Johnson or by Mr. Burke.*]

The Contradictions in Reynolds's Discourses are Strong Presumptions that they are the Work of Several Hands, But this is no Proof that Reynolds did not Write them. The Man, Either Painter or Philosopher, who Learns or Acquires all he knows from Others, Must be full of Contradictions.

[*To a footnote on George Michael Moser, Keeper of the Royal Academy.*]

I was once looking over the Prints from Rafael & Michael Angelo in the Library of the Royal Academy. Moser came to me & said: "You should not Study these old Hard, Stiff & Dry, Unfinish'd Works of Art—Stay a little & I will shew you what you should Study." He then went & took down Le Brun's & Rubens's Galleries. How I did secretly Rage! I also spoke my Mind. . . . [*a line cut away by the binder*] I said to Moser, "These things that you call Finish'd are not Even Begun; how can they then be Finish'd? The Man who does not know The Beginning never can know the End of Art."

"I consoled myself, however, by remarking that these ready inventors are extremely apt to acquiesce in *imperfection*."

Villiany! a Lie!

"How difficult it is for the artist who possesses this facility, to guard against carelessness and commonplace invention, is well known, and in a kindred art Metastasio is an eminent instance; who always complained of the great difficulty he found in attaining correctness, in consequence of having been in his youth an Improvisatore."

I do not believe this Anecdote.

"There is nothing in our art which enforces such continued exertion and circumspection, as an attention to the general effect of the whole. It requires much study and much practice; it requires the painter's entire mind: whereas the parts may be finishing by nice touches, while his mind is engaged on other matters; he may even hear a play or a novel read without much disturbance."

A Lie! Working up Effect is more an operation of Indolence than the Making out of the Parts, as far as Greatest is more than Least. I speak here of Rembrandt's

& Rubens's & Reynolds's Effects. For Real Effect is Making out the Parts, & it is Nothing Else but That.

[*To a footnote on the lost secrets of colour-mixing known to the old masters.*]

Oil colours will not do. Why are we told that Reynolds is a Great Colourist & yet inferior to the Venetians?

[*To a footnote concerning the fading of pictures by Reynolds.*]

I do not think that the Change is so much in the Pictures as in the Opinions of the Public.

[*footnote*] In a Letter to Mr. Baretti, June 10, 1761, Dr. Johnson says—"Reynolds is without a rival, and continues to add thousands to thousands."

How much did Barry Get?

Many of the pictures of Rubens being to be sold in 1783, in consequence of certain religious houses being suppressed by the Emperor, he [Reynolds] again in that year visited Antwerp and Brussels, and devoted several days to contemplating the productions of that great painter.

If Reynolds had Really admired Mich. Angelo, he never would have follow'd Rubens.

His [Reynolds's] deafness was originally occasioned by a cold that he caught in the Vatican, by painting for a long time near a stove, by which the damp vapours of that edifice were attracted, and affected his head. When in company with only one person, he heard very well, without the aid of a trumpet.

A Sly Dog! So can Every body; but bring Two People & the Hearing is Stopped.

[*To a quotation from Goldsmith's "Retaliation" giving the lines on Reynolds.*]

Such Men as Goldsmith ought not to have been Acquainted with such Men as Reynolds.

[*footnote*] It is clear from his manners and his writings that in the character of his eloquence he would have resembled the perspicuous and elegant Laelius, rather than the severe and vehement Galba.

He certainly would have been more like a Fool than a Wise Man.

[*footnote*] He was a great generalizer. . . . But this disposition to abstractions, to generalizing and classification, is the great glory of the human mind. . . .

To Generalize is to be an Idiot. To Particularize is the Alone Distinction of Merit. General Knowledges are those Knowledges that Idiots possess.

Such was his love of his art, and such his ardour to excel, that he often declared he had, during the greater part of his life, laboured as hard with his pencil, as any mechanick working at his trade for bread.

The Man who does not Labour more than the Hireling must be a poor Devil.

[*To a footnote giving a quotation from Pope appropriate to* "the ferocious and enslaved Republick of France," *ending with the lines:*]

> They led their wild desires to woods and caves
> And thought that all but savages were slaves.

When France got free, Europe, 'twixt Fools & Knaves,
Were Savage first to France, & after—Slaves.

[*To a footnote on the wealth and prosperity of England.*]

This Whole Book was Written to Serve Political Purposes.

[*To the account of Reynolds's death in* 1792.]

> When Sr Joshua Reynolds died
> All Nature was degraded;
> The King drop'd a tear into the Queen's Ear,
> And all his Pictures Faded.

[*To the account of his funeral, where the pall was*] borne up by three Dukes, two Marquisses, and five other noblemen.

A Mock!

[*In an account of Reynolds by Burke.*]
"Sir Joshua Reynolds was, on very many accounts, one of the most memorable men of his time."

Is not this a Manifest Lie?

Barry Painted a Picture for Burke, equal to Rafael or Mich. Ang. or any of the Italians. Burke used to shew this Picture to his Friends & to say, "I gave Twenty Guineas for this horrible Dawb, & if any one would give [*a line cut off by the binder*]
Such was Burke's Patronage of Art & Science.

DISCOURSE I

Page 12 [*facing Discourse I*]

I consider Reynolds's Discourses to the Royal Academy as the Simulations of the Hypocrite who smiles particularly where he means to Betray. His Praise of Rafael is like the Hysteric Smile of Revenge. His Softness & Candour, the hidden trap & the poisoned feast. He praises Michel Angelo for Qualities which

Michel Angelo abhorr'd, & He blames Rafael for the only Qualities which Rafael Valued. Whether Reynolds knew what he was doing is nothing to me: the Mischief is just the same whether a Man does it Ignorantly or Knowingly. I always consider'd True Art & True Artists to be particularly Insulted & Degraded by the Reputation of these Discourses, As much as they were Degraded by the Reputation of Reynolds's Paintings, & that Such Artists as Reynolds are at all times Hired by the Satans for the Depression of Art—A Pretence of Art, To destroy Art.

The Neglect of Fuseli's Milton in a Country pretending to the Encouragement of Art is a Sufficient Apology for My Vigorous Indignation, if indeed the Neglect of My own Powers had not been. Ought not the Employers of Fools to be Execrated in future Ages? They Will and Shall! Foolish Men, your own real Greatness depends on your Encouragement of the Arts, & your Fall will depend on [your del.] their Neglect & Depression. What you Fear is your true Interest. Leo X was advised not to Encourage the Arts; he was too Wise to take this Advice.

The Rich Men of England form themselves into a Society to Sell & Not to Buy Pictures. The Artist who does not throw his Contempt on such Trading Exhibitions, does not know either his own Interest or his Duty.

> When Nations grow Old, The Arts grow Cold
> And Commerce settles on every Tree,
> And the Poor & the Old can live upon Gold,
> For all are Born Poor, Aged Sixty three.

Reynolds's Opinion was that Genius May be Taught & that all Pretence to Inspiration is a Lie & a Deceit, to say the least of it. For if it is a Deceit, the whole Bible is Madness. This Opinion originates in the Greeks' Calling the Muses Daughters of Memory.
The Enquiry in England is not whether a Man has Talents & Genius, But whether he is Passive & Polite & a Virtuous Ass & obedient to Noblemen's Opinions in Art & Science. If he is, he is a Good Man. If Not, he must be Starved.

Page 14
After so much has been done by His Majesty....

3 Farthings!

Pages 15-16
Raffaelle, it is true, had not the advantage of studying in an Academy; but all Rome, and the works of Michael Angelo in particular, were to him an Academy. On the sight of the Capella Sistina, he immediately from a dry, Gothick, and even insipid manner, which attends to the minute accidental discriminations of particular and individual objects, assumed that grand style of painting which improves partial representation by the general and invariable ideas of nature.

Minute Discrimination is Not Accidental. All Sublimity is founded on Minute Discrimination.
I do not believe that Rafael taught Mich. Angelo, or that Mich Angelo taught Rafael, any more than I believe that the Rose teaches the Lilly how to grow, or the Apple tree teaches the Pear tree how to bear Fruit. I do not believe the tales of Anecdote writers when they militate against Individual Character.

Page 17

I would chiefly recommend that an implicit obedience to the Rules of Art, as established by the practice of the great Masters should be exacted from the young Students. That those models, which have passed through the approbation of ages, should be considered by them as perfect and infallible guides; as subjects for their imitation, not their criticism.

Imitation is Criticism.

Pages 17-18

A facility in composing—a lively, and what is called a masterly handling of the chalk or pencil are . . . captivating qualities to young minds.

I consider The Following sentence is Supremely Insolent for the following Reasons:—Why this Sentence should be begun by the Words "A Facility in Composing" I cannot tell, unless it was to cast a stigma upon Real Facility in Composition by Assimilating it with a Pretence to, & Imitation of, Facility in Execution; or are we to understand him to mean that Facility in Composing is a Frivolous pursuit? A Facility in Composing is the Greatest Power of Art, & Belongs to None but the Greatest Artists and the Most Minutely Discriminating & Determinate.

Page 18

By this useless industry they are excluded from all power of advancing in real excellence. Whilst boys, they are arrived at their utmost perfection; . . . and make the mechanical felicity the chief excellence of the art, which is only an ornament.

Mechanical Excellence is the Only Vehicle of Genius.

This seems to me to be one of the most dangerous sources of corruption . . . which has actually infected all foreign Academies. The directors . . . praised their dispatch at the expence of their correctness.

This is all False & Self-Contradictory.

But young men have not only this frivolous ambition of being thought masters of execution, inciting them on one hand, but also their natural sloth tempting them on the other.

Execution is the Chariot of Genius.

They wish to find some shorter path to excellence, . . . They must therefore be told again and again, that labour is the only price of solid fame, . . .

This is All Self-Contradictory, Truth & Falsehood Jumbled Together.

APPENDIX I

Pages 18-19

When we read the lives of the most eminent Painters, every page informs us that no part of their time was spent in dissipation . . . They pursued their studies . . .

The Lives of Painters say that Rafael Died of Dissipation. Idleness is one Thing & Dissipation Another. He who has Nothing to Dissipate Cannot Dissipate; the Weak Man may be Virtuous Enough, but will Never be an Artist.
Painters are noted for being Dissipated & Wild.

Page 19

When they [the old masters] conceived a subject, they first made a variety of sketches, then a finished drawing of the whole; after that a more correct drawing of every separate part—heads, hands, feet, and pieces of drapery; they then painted the picture, *and after all retouched it from life.*

This is False.

The Students instead of vying with each other which shall have the readiest hand, should be taught to contend who shall have the purest and most correct outline.

Excellent!

The error I mean is, that the students never draw exactly from the living models which they have before them. They make a drawing rather of what they think the figure ought to be, than of what it appears. I have thought this the obstacle that has stopped the progress of many young men . . . I very much doubt whether a habit of drawing correctly what we see, will not give a proportionable power of drawing correctly what we imagine.

This is Admirably Said. Why does he not always allow as much?

Pages 19-20

He who endeavours to copy nicely the figure before him, not only acquires a habit of exactness and precision, but is continually advancing in his knowledge of the human figure.

Excellent!

Page 24 [facing Discourse II]

The Labour'd Works of Journeymen employ'd by Correggio, Titian, Veronese & all the Venetians, ought not to be shewn to the Young Artist as the Works of original Conception any more than the Engravings of Strange, Bartollozzi, or Wollett. They are Works of Manual Labour.

DISCOURSE II

Page 5 [Contents]

The course and order of Study.—The different Stages of Art.—Much copying discountenanced.—The artist at all times and in all places should be employ'd in laying up materials for the exercise of his art.

What is Laying up materials but Copying?

Page 26

When the Artist is once enabled to express himself . . . he must then endeavour to collect subjects for expression; to amass a stock of ideas . . . to learn all that has been known and done before . . .

After having been a Fool, a Student is to amass a Stock of Ideas, &, knowing himself to be a Fool, he is to assume the Right to put other Men's Ideas into his Foolery.

Though the Student will not resign himself blindly to any single authority, when he may have the advantage of consulting many, he must still be afraid of trusting to his own judgment, and of deviating into any track where he cannot find the footsteps of some former master.

Instead of Following One Great Master he is to follow a Great Many Fools.

Page 27

A Student unacquainted with the attempts of former adventurers, is always apt to over-rate his own abilities; to mistake the most trifling excursions for discoveries of moment, and every coast new to him, for a new-found country.

Contemptible Mocks!

Page 28

The productions of such minds are seldom distingushed by an air of originality; they are anticipated in their happiest efforts; and if they are found to differ in anything from their predecessors, it is only in irregular sallies and trifling conceits.

Thus Reynolds Depreciates the Efforts of Inventive Genius. Trifling Conceits are better than Colouring without any meaning at all.

Page 29

How incapable those are of producing anything of their own, who have spent much of their time in making finished copies, is well known to all who are conversant with our art.

This is most False, for no one can ever Design till he has learn'd the Language of Art by making many Finish'd Copies both of Nature & Art & of whatever comes in his way from Earliest Childhood. The difference between a bad Artist & a Good One Is: the Bad Artist Seems to Copy a Great deal. The Good one Really Does Copy a Great deal.

The great use in copying, if it be at all useful, should seem to be in learning to colour; yet even colouring will never be perfectly attained by servilely copying the model before you.

Contemptible! Servile Copying is the Great Merit of Copying.

Page 30

Following these rules, and using these precautions, when you have clearly and distinctly learned in what good colouring consists, you cannot do better than have recourse to nature herself, who is always at hand, and in comparison of whose true splendour the best coloured pictures are but faint and feeble.

Appendix I

Nonsense! Every Eye Sees differently. As the Eye, Such the Object.

Instead of copying the touches of those great masters, copy only their conceptions . . . Labour to invent on their general principles and way of thinking.

General Principles Again! Unless You Consult Particulars You Cannot even Know or See Mich. Angl. or Rafael or any Thing Else.

Page 31

But as mere enthusiasm will carry you but a little way . . .

Meer Enthusiasm is the All in All! Bacon's Philosophy has Ruin'd England. Bacon is only Epicurus over again.

Page 32

Few have been taught to any purpose who have not been their own teachers.

True!

Page 33

A facility of drawing, like that of playing upon a musical instrument, cannot be acquired but by an infinite number of acts.

True!

Page 34

I would particularly recommend that after you return from the Academy . . . you would endeavour to draw the figure by memory.

Good advice!

But while I mention the port-crayon as the student's constant companion, he must still remember that the pencil is the instrument by which he must hope to obtain eminence.

Nonsense!

The Venetian and Flemish schools, which owe much of their fame to colouring, have enriched the cabinets of the collectors of drawings with very few examples.

—because they could not draw.

Page 35

Those of Titian, Paul Veronese, Tintoret, and the Bassans are in general slight and undetermined. Their sketches on paper are as rude as their pictures are excellent in regard to harmony of colouring. Correggio and Baroccio have left few, if any finished drawings behind them. And in the Flemish school, Rubens and Vandyck made their drawings for the most part in colour or in chiaro oscuro.

All the Pictures said to be by these Men are the Laboured fabrications of Journey-work. They could not draw.

Page 37

He who would have you believe that he is waiting for the inspiration of Genius, is in reality at a loss how to begin, and is at last delivered of his monsters, with difficulty and pain.

A Stroke at Mortimer!

Pages 36, 37

He regards all Nature with a view to his profession; and combines her beauties, or corrects her defects. . . .
The well-grounded painter . . . is contented that all shall be as great as himself, who have undergone the same fatigue . . .

The Man who asserts that there is no Such Thing as Softness in Art, & that every thing in Art is Definite & Determinate, has not been told this by Practise, but by Inspiration & Vision, because Vision is Determinate & Perfect, & he Copies That without Fatigue, Every thing being Definite & determinate. Softness is Produced alone by Comparative Strength & Weakness in the Marking out of the Forms. I say These Principles could never be found out by the Study of Nature without Con-or Innate Science.

DISCOURSE III

Page 40 [facing Discourse III]

A work of Genius is a Work "Not to be obtain'd by the Invocation of Memory & her Syren Daughters, but by Devout prayer to that Eternal Spirit, who can enrich with all utterance & knowledge & sends out his Seraphim with the hallowed fire of his Altar to touch & purify the lips of whom he pleases." MILTON. The following [Lecture *del.*] Discourse is particularly Interesting to Block heads, as it Endeavours to prove That there is No such thing as Inspiration & that any Man of a plain Understanding may by Thieving from Others become a Mich. Angelo.

Page 42

The wish of the genuine painter must be more extensive: instead of endeavouring to amuse mankind with the minute neatness of his imitations, he must endeavour to improve them by the grandeur of his ideas.

Without Minute Neatness of Execution The Sublime cannot Exist! Grandeur of Ideas is founded on Precision of Ideas.

Page 43

The Moderns are not less convinced than the Ancients of this superior power existing in the art; nor less sensible of its effects.

I wish that this was True.

Such is the warmth with which both the Ancients and Moderns speak of this divine principle of the art;

And such is the Coldness with which Reynolds speaks! And such is his Enmity.

but, as I have formerly observed, enthusiastick admiration seldom promotes knowledge.

Enthusiastic Admiration is the first Principle of Knowledge & its last. Now he begins to Degrade, to Deny & to Mock.

Though a student by such praise may have his attention roused . . . *He examines* his own mind, and perceives there nothing of that divine inspiration, with which, he is told, so many others have been favoured.

The Man who on Examining his own Mind finds nothing of Inspiration ought not to dare to be an Artist; he is a Fool & a Cunning Knave suited to the Purposes of Evil Demons.

He never travelled to heaven to gather new ideas; and he finds himself possessed of no other qualifications than what mere common observation and a plain understanding can confer.

The Man who never in his Mind & Thoughts travel'd to Heaven Is No Artist. Artists who are above a plain Understanding are Mock'd & Destroy'd by this President of Fools.

But on this, as upon many other occasions, we ought to distinguish how much is to be given to enthusiasm, and how much to reason . . . taking care . . . not to lose in terms of vague admiration, that solidity and truth of principle, upon which alone we can reason, and may be enabled to practise.

It is Evident that Reynolds Wish'd none but Fools to be in the Arts & in order to this, he calls all others Vague Enthusiasts or Madmen. What has Reasoning to do with the Art of Painting?

Page 44

. . . most people err, not so much from want of capacity to find their object, as from not knowing what object to pursue.

The Man who does not know what Object to Pursue is an Idiot.

This great ideal perfection and beauty are not to be sought in the heavens, but upon the earth.

A Lie!

They are about us, and upon every side of us.

A Lie!

But the power of discovering what is deformed in nature, or in other words, what is particular and uncommon, can be acquired only by experience;

A Lie!

and the whole beauty of the art consists, in my opinion, in being able to get above all singular forms, local customs, particularities, and details of every kind.

A Folly! Singular & Particular Detail is the Foundation of the Sublime.

All the objects which are exhibited to our view by nature, upon close examination will be found to have their blemishes and defects. The most beautiful forms have something about them like weakness, minuteness, or imperfection.

Minuteness is their whole Beauty.

Pages 44-45

This long laborious comparison should be the first study of the painter, who aims at the greatest style . . . he corrects nature by herself . . . This idea of the perfect state of nature, which the Artist calls the Ideal Beauty, is the great leading principle by which works of genius are conducted

Knowledge of Ideal Beauty is Not to be Acquired. It is Born with us. Innate Ideas are in Every Man, Born with him; they are truly Himself. The Man who says that we have No Innate Ideas must be a Fool & Knave, Having No Con-Science or Innate Science.

Page 45

Thus it is from a reiterated experience and a close comparison of the objects in nature, that an artist becomes possessed of the idea of that central form . . . from which every deviation is deformity.

One Central Form composed of all other Forms being Granted, it does not therefore follow that all other Forms are Deformity.
All Forms are Perfect in the Poet's Mind, but these are not Abstracted nor Compounded from Nature, but are from Imagination.

Page 46

Even the great Bacon treats with ridicule the idea of confining proportion to rules, or of producing beauty by selection.

The Great Bacon—he is Call'd: I call him the Little Bacon—says that Every thing must be done by Experiment; his first principle is Unbelief, and yet here he says that Art must be produc'd Without such Method. He is Like Sr Joshua, full of Self-Contradiction & Knavery.

There is a rule, obtained out of general nature, to contradict which is to fall into deformity.

What is General Nature? is there Such a Thing? what is General Knowledge? is there such a Thing? Strictly Speaking All Knowledge is Particular.

To the principle I have laid down, that the idea of beauty in each species of beings is an invariable one, it may be objected, that in every particular species there are various central forms, which are separate and distinct from each other, and yet are each undeniably beautiful.

Here he loses sight of A Central Form & Gets into Many Central Forms.

Page 47

It is true, indeed, that these figures are each perfect in their kind, though of different characters and proportions; but still none of them is the representation of an individual, but of a class.

Every Class is Individual.

APPENDIX I

Thus, though the forms of childhood and age differ exceedingly, there is a common form in childhood, and a common form in age, which is the more perfect, as it is more remote from all peculiarities.

There is no End to the Follies of this Man. Childhood & Age are Equally belonging to Every Class.

. . . though the most perfect forms of each of the general divisions of the human figure are ideal . . . yet the highest perfection of the human figure is not to be found in any one of them. It is not in the Hercules, nor in the Gladiator, nor in the Apollo.

Here he comes again to his Central Form.

There is, likewise, a kind of symmetry, or proportion, which may properly be said to belong to deformity. A figure lean or corpulent, tall or short, though deviating from beauty, may still have a certain union of the various parts.

The Symmetry of Deformity is a Pretty Foolery. Can any Man who Thinks Talk so? Leanness or Fatness is not Deformity, but Reynolds thought Character Itself Extravagance & Deformity. Age & Youth are not Classes, but [Situations *del.*] Properties of Each Class; so are Leanness & Fatness.

When the Artist has by diligent attention accquired a clear and distinct idea of beauty and symmetry; when he has reduced the variety of nature to the abstract idea . . .

What Folly!

Pages 48-49
. . . the painter . . . must divest himself of all prejudices in favour of his age or country; he must disregard all local and temporary ornaments, and look only on those general habits, which are every where and always the same . . .

Generalizing in Every thing, the Man would soon be a Fool, but a Cunning Fool.

Page 51
Albert Durer, as Vasari has justly remarked, would, probably, have been one of the first painters of his age . . . had he been initiated into those great principles of the art, which were so well understood and practised by his contemporaries in Italy.

What does this mean, "*Would have been*" one of the first Painters of his Age? Albert Durer *Is*, Not would have been. Besides, let them look at Gothic Figures & Gothic Buildings & not talk of Dark Ages or of any Age. Ages are all Equal. But Genius is Always Above The Age.

Page 52
I should be sorry, if what is here recommended, should be at all understood to countenance a careless or indetermined manner of painting. For though the painter is to overlook the accidental discriminations of nature, he is to exhibit distinctly, and with precision, the general forms of things.

Here he is for Determinate & yet for Indeterminate.
Distinct General Form Cannot Exist. Distinctness is Particular, Not General.

A firm and determined outline is one of the characteristics of the great style in painting; and let me add, that he who possesses the knowledge of the exact form which every part of nature ought to have, will be fond of expressing that knowledge with correctness and precision in all his works.

A Noble Sentence!
Here is a Sentence, Which overthrows all his Book.

Page 53

To conclude; I have endeavoured to reduce the idea of beauty to general principles.

[Sir Joshua proves *del.*] that Bacon's Philosophy makes both Statesmen & Artists Fools & Knaves.

DISCOURSE IV

Page 56 [*facing Discourse IV*]

The Two Following Discourses are Particularly Calculated for the Setting Ignorant & Vulgar Artists as Models of Execution in Art. Let him who will, follow such advice. I will not. I know that The Man's Execution is as his Conception & No Better.

Page 57

The value and rank of every art is in proportion to the mental labour employed in it, or the mental pleasure produced by it.

Why does he not always allow This?

I have formerly observed that perfect form is produced by leaving out particularities, and retaining only general ideas . . .

General Ideas again!

Invention in Painting does not imply the invention of the Subject; for that is commonly supplied by the Poet or Historian.

All but Names of Persons & Places is Invention both in Poetry & Painting.

Page 58

However, the usual and most dangerous error is on the side of minuteness, and therefore I think caution most necessary where most have failed.

Here is Nonsense!

The general idea constitutes real excellence. All smaller things, however perfect in their way, are to be sacrificed without mercy to the greater.

Sacrifice the Parts, What becomes of the Whole?

Appendix I

Page 59

Even in portraits, the grace, and, we may add, the likeness, consists more in taking the general air, than in observing the exact similitude of every feature.

How ignorant!

Page 60

A painter of portraits retains the individual likeness; a painter of history shews the man by shewing his actions.

If he does not shew the Man as well as the Action, he is a poor Artist.

He cannot make his hero talk like a great man; he must make him look like one. For which reason he ought to be well studied in the analysis of those circumstances which constitute dignity of appearance in real life.

Here he allows an Analysis of Circumstances.

Pages 61-62

Certainly, nothing can be more simple than monotony: and the distinct blue, red, and yellow colours which are seen in the draperies of the Roman and Florentine schools . . . have the effect of grandeur which was intended. Perhaps these distinct colours strike the mind more forcibly, from there not being any great union between them; as martial musick . . . has its effect from the sudden and strongly marked transitions from one note to another . . .

These are Fine & Just Notions. Why does he not always allow as much?

Page 62

In the same manner as the historical Painter never enters into the detail of colours, so neither does he debase his conceptions with minute attention to the discriminations of Drapery.

Excellent Remarks!

Carlo Maratti was of opinion, that the disposition of drapery was a more difficult art than even that of drawing the human figure . . .

I do not believe that Carlo Maratti thought so, or that any body can think so; the Drapery is formed alone by the Shape of the Naked.

Page 63

Though I can by no means allow them [the Venetians] to hold any rank with the nobler schools of painting, they accomplished perfectly the thing they attempted. But as mere elegance is their principal object . . . it can be no injury to them to suppose that their practice is useful only to its proper end.

They accomplish'd Nothing. As to Elegance they have not a Spark.

Pages 63-64

[To a question] on the conduct of Paul Veronese, who . . . had, contrary to the strict rules of art . . . represented the principal figure in the shade, . . . if they had ranked him as an ornamental Painter, there would have been no difficulty in answering: ". . . . His intention was

solely to produce an effect of light and shadow; . . . and the capricious composition of that picture suited very well with the style which he professed."

This is not a Satisfactory Answer. To produce an Effect of True Light & Shadow is Necessary to the Ornamental Style, which altogether depends on Distinctness of Form. The Venetian ought not to be call'd the Ornamental Style.

Page 64

The powers exerted in the mechanical part of the Art have been called the language of Painters. . . . The language of Painting must indeed be allowed these masters [the Venetians].

The Language of Painters cannot be allow'd them if Reynolds says right at p. 66; he there says that the Venetian Will Not Correspond with the Great Style. The Greek Gems are in the Same Style as the Greek Statues.

Pages 64-65

Such as suppose that the great style might happily be blended with the ornamental, that the simple, grave and majestick dignity of Raffaelle could unite with the glow and bustle of a Paolo, or Tintoret, are totally mistaken.

What can be better said on this Subject? but Reynolds contradicts what he says continually. He makes little Concessions that he may take Great Advantages.

Pages 65-66

However great the difference is between the composition of the Venetian, and the rest of the Italian schools, there is full as great a disparity in the effect of their pictures as produced by colours . . . yet even that skill, as they have employed it, will but ill correspond with the great style. Their colouring is not only too brilliant, but . . . too harmonious to produce that . . . effect, which heroic subjects require. . . .

Somebody Else wrote this page for Reynolds. I think that Barry or Fuseli wrote it, or dictated it.

Page 66

Michael Angelo . . . after having seen a picture by Titian, told Vasari . . . "that he liked much his colouring and manner"; but then he added, "that it was a pity the Venetian painters did not learn to draw correctly in their early youth, and adopt a better manner of study." By this it appears, that the principal attention of the Venetian painters, in the opinion of Michael Angelo, seemed to be engrossed by the study of colours, to the neglect of the ideal beauty of form . . .

Venetian Attention is to a Contempt & Neglect of Form Itself & to the Destruction of all Form or Outline Purposely & Intentionally.

On the Venetian Painter

He makes the Lame to walk we all agree,
But then he strives to blind those who can see.

Appendix I

But if general censure was given to that school from the sight of a picture of Titian . . .

As if Mich. Ang. had seen but One Picture of Titian's! Mich. Ang. knew & despised all that Titian could do.

If the Venetian's Outline was Right, his Shadows would destroy it & deform its appearance.

> A Pair of Stays to mend the Shape
> Of crooked, Humpy Woman
> Put on, O Venus! now thou art
> Quite a Venetian Roman.

Page 67

. . . when I speak of the Venetian painters, I wish to be understood to mean Paolo Veronese and Tintoret, to the exclusion of Titian; for . . . there is a sort of senatorial dignity about him . . .

Titian, as well as the other Venetians, so far from Senatorial Dignity appears to me to give always the Characters of Vulgar Stupidity.
Why should Titian & The Venetians be Named in a discourse on Art? Such Idiots are not Artists.

> Venetian, all thy Colouring is no more
> Than Boulster'd Plasters on a Crooked Whore.

The Venetian is indeed the most splendid of the schools of elegance . . .

Vulgarity & *not Elegance*; the Word Elegance ought to be applied to Forms, not to Colours.

Page 68

. . . painting is not merely a gratification of the sight.

Broken Colours & Broken Lines & Broken Masses are Equally Subversive of the Sublime.

Such excellence, . . . where nothing higher than elegance is intended, is weak and unworthy of regard, when the work aspires to grandeur and sublimity.

Well Said Enough!

. . . the Flemish school, of which Rubens is the head, was formed upon that of the Venetian . . .

How can that be call'd the Ornamental Style of which Gross Vulgarity forms the Principal Excellence?

Page 69

Some inferior dexterity, some extraordinary mechanical power is apparently that from which they seek distinction.

The Words, Mechanical Power, should not be thus Prostituted.

Page 70

An History-Painter paints man in general; a Portrait-painter, a particular man, and consequently a defective model.

A History Painter Paints The Hero, & not Man in General, but most minutely in Particular.

Page 72

. . . if a portrait-painter is desirous to raise and improve his subject . . . he leaves out all the minute breaks and peculiarities in the face, and changes the dress from a temporary fashion to one more permanent.

Folly! Of what consequence is it to the Arts what a Portrait Painter does?

Of those who have practised the composite style . . . perhaps the foremost is Correggio.

There is No Such Thing as A Composite Style.

Page 73

The errors of genius . . . are pardonable . . .

Genius has no Error; it is Ignorance that is Error.

. . . there is but one presiding principle, which regulates, and gives stability to every art. The works . . . which are built upon general nature, live for ever; while those which depend for their existence on particular customs and habits . . . can only be coeval with that which first raised them from obscurity.

All Equivocation & Self-Contradiction!

DISCOURSE V

Page 76 [facing Discourse V]

Gainsborough told a Gentleman of Rank & Fortune that the Worst Painters always chose the Grandest Subjects. I desired the Gentleman to Set Gainsborough about one of Rafael's Grandest Subjects, Namely Christ delivering the Keys to St Peter, & he would find that in Gainsborough's hands it would be a Vulgar Subject of Poor Fishermen & a Journeyman Carpenter.
The following Discourse is written with the same End in View that Gainsborough had in making the Above assertion, Namely To Represent Vulgar Artists as the Models of Executive Merit.

Page 77

. . . nothing has its proper lustre but in its proper place. That which is most worthy of esteem in its allotted sphere, becomes an object, not of respect, but of derision, when it is forced into a higher, to which it is not suited.

Concessions to Truth for the sake of Oversetting Truth.

Appendix I

Page 78

If you mean to preserve the most perfect beauty in its most perfect state, you cannot express the passions . . .

What Nonsense!
Passion & Expression is Beauty Itself. The Face that is Incapable of Passion & Expression is deformity Itself. Let it be Painted & Patch'd & Praised & Advertised for Ever, it will only be admired by Fools.

. . . some of the Cartoons and other pictures of Raffaelle . . . where the excellent master himself may have attempted this expression of passions above the powers of the art.

If Reynolds could not see variety of Character in Rafael, Others Can.

Page 79

We can easily, like the ancients, suppose a Jupiter to be possessed of all those powers and perfections which the subordinate Deities were endowed with separately. Yet, when they employed their art to represent him, they confined his character to majesty alone.

False! The Ancients were chiefly attentive to Complicated & Minute Discrimination of Character; it is the whole of Art.

Reynolds cannot bear Expression.

A statue in which you eandeavour to unite stately dignity, youthful elegance, and stern valour, must surely possess none of these to any eminent degree.

Why not? O Poverty!

The summit of excellence seems to be an assemblage of contrary qualities . . .

A Fine Jumble!

Page 80

If any man shall be master of such a transcendant, commanding, and ductile genius, as to enable him to rise to the highest, and to stoop to the lowest, flight of art, and to sweep over all of them unobstructed and secure, he is fitter to give example than to receive instruction.

Mocks!

Page 81

The principal works of modern art are in Fresco, a mode of painting which excludes attention to minute elegancies.

This is False. Fresco Painting is the Most Minute. Fresco Painting is Like Miniature Painting; a Wall is a Large Ivory.

Raffaelle . . . owes his reputation . . . to his excellence in the higher parts of the art [Fresco]: . . . though he continually . . . embellished his performances more and more with the addition of those lower ornaments, which entirely make the merit of some painters, yet he never arrived at . . . perfection . . .

Folly & Falsehood! The Man who can say that Rafael knew not the smaller beauties of the Art ought to be contemn'd, & I accordingly hold Reynolds in Contempt for this Sentence in particular.

Pages 81-82

He never acquired that nicety of taste in colours, that breadth of light and shadow . . . When he painted in oil, his hand seemed to be so cramped and confined, that he not only lost that facility and spirit, but . . . even that correctness of form.

Rafael did as he Pleased. He who does not admire Rafael's Execution does not Even see Rafael.

Page 82

I have no desire to degrade Raffaelle from the high rank which he deservedly holds . . .

A Lie!

Michael Angelo . . . did not possess so many excellencies as Raffaelle, but those which he had were of the highest kind . . .

According to Reynolds Mich. Angelo was worse still & knew Nothing at all about Art as an object of Imitation. Can any Man be such a fool as to believe that Rafael & Michael Angelo were Incapable of the meer Language of Art & That Such Idiots as Rubens, Correggio & Titian knew how to Execute what they could not Think or Invent?

He [Michael Angelo] never attempted those lesser elegancies and graces in the art.

Damned Fool!

If any man had a right to look down upon the lower accomplishments as beneath his attention, it was certainly Michael Angelo.

O Yes!

. . . he has rejected all the false, though specious ornaments, which disgrace the works even of the most esteemed artists.

Here is another Contradiction. If Mich. Ang. Neglected any thing that Titian or Veronese did, He Rejected it for Good Reasons. Sr Joshua in other Places owns that the Venetian Cannot Mix with the Roman or Florentine. What then does he Mean when he says that Mich. Ang. & Rafael were not worthy of Imitation in the Lower parts of Art?

APPENDIX I

Page 83

If we put these great artists in a light of comparison with each other, Raffaelle had more Taste and Fancy, Michael Angelo more Genius and imagination.

What Nonsense!

Pages 83-84

Michael Angelo's works have a strong, peculiar, and marked character: they seem to proceed from his own mind entirely, . . . Raffaelle's materials are generally borrowed, though the noble structure is his own.

If all this is True, Why does not Reynolds recommend The Study of Rafael & Mich. Angelo's Execution? at page 66 he allows that the Venetian Style will Ill correspond with the great Style.

Page 84

Such is the great style . . .: in this, search after novelty . . . has no place.

The Great Style is always Novel or New in all its Operations.

Pages 84-85

But there is another style, which . . . has still great merit . . . the original or characteristical style . . .

Original & Characteristical are the Two Grand Merits of the Great Style.

Page 85

One of the strongest-marked characters of this kind . . . is that of Salvator Rosa.

Why should these words be applied to such a Wretch as Salvator Rosa?
Salvator Rosa was precisely what he Pretended not to be. His Pictures are high Labour'd pretensions to Expeditious Workmanship. He was the Quack Doctor of Painting. His Roughnesses & Smoothnesses are the Production of Labour & Trick. As to Imagination, he was totally without Any.

He gives us a peculiar cast of nature, which . . . has that sort of dignity which belongs to savage and uncultivated nature.

Savages are Fops & Fribbles more than any other Men.

. . . what is most to be admired in him, is, the perfect correspondence which he observed between the subjects which he chose and his manner of treating them.

Handling is All that he has, & we all know this Handling is Labour & Trick. Salvator Rosa employ'd Journeymen.

Page 86

I will mention two other painters, who, though entirely dissimilar . . . have both gained reputation. . . . The painters I mean, are Rubens and Poussin. Rubens . . . I think . . . a

remarkable instance of the same mind being seen in all the various parts of the art. The whole is so much of a piece . . .

All Rubens's Pictures are Painted by Journeymen & so far from being all of a Piece, are The most wretched Bungles.

His Colouring, in which he is eminently skilled, is notwithstanding too much of what we call tinted.

To My Eye Rubens's Colouring is most Contemptible. His Shadows are of a Filthy Brown somewhat of the Colour of Excrement; these are fill'd with tints & messes of yellow & red. His lights are all the Colours of the Rainbow, laid on Indiscriminately & broken one into another. Altogether his Colouring is Contrary to The Colouring of Real Art & Science.
Opposed to Rubens's Colouring Sr Joshua has placed Poussin, but he ought to put All Men of Genius who ever Painted. Rubens & the Venetians are Opposite in every thing to True Art & they Meant to be so; they were hired for this Purpose.

Page 87

Poussin in the latter part of his life changed from his dry manner to one much softer and richer . . . as in the Seven Sacraments . . ., but neither these, nor any of his other pictures in this manner, are at all comparable to many in his dry manner which we have in England.

True!

The favourite subjects of Poussin were Ancient Fables; and no painter was ever better qualified to paint such subjects . . .

True!

Page 88

Poussin seemed to think that the style and the language in which such stories are told is not the worse for preserving some relish of the old way of painting . . .

True!

. . . if the Figures which people his pictures had a modern air or countenance, . . . if the landskip had the appearance of a modern view, how ridiculous would Apollo appear instead of the Sun . . .

These remarks on Poussin are Excellent.

Page 89

It is certain that the lowest style will be the most popular, as it falls within the compass of ignorance itself.

Well said!

Appendix I

Page 90

. . . our Exhibitions . . . have also a mischievous tendency, by seducing the Painter to an ambition of pleasing indiscriminately the mixed multitude of people who resort to them.

Why then does he talk in other places of pleasing Every body?

DISCOURSE VI

Page 6 [*Contents*]

Imitation.—Genius begins where rules end.—Invention;—Acquired by being conversant with the inventions of others.—The true method of imitating . . .

When a Man talks of Acquiring Invention & of learning how to produce Original Conception, he must expect to be call'd a Fool by Men of Understanding; but such a Hired Knave cares not for the Few. His Eye is on the Many, or, rather, on the Money.

Page 94

Those who have undertaken to write on our art, and have represented it as a kind of inspiration . . . seem to insure a much more favourable disposition from their readers . . . than he who attempts to examine, coldly, whether there are any means by which this art may be acquired . . .

Bacon's Philosophy has Destroy'd [*word cut away*] Art & Science. The Man who says that the Genius is not Born, but Taught—Is a Knave.

> O Reader, behold the Philosopher's Grave!
> He was born quite a Fool, but he died quite a Knave.

Page 95

. . . to owe nothing to another, is the praise which men . . . bestow sometimes upon others; and sometimes on themselves; and their imaginary dignity is naturally heightened by a supercilious censure of . . . the servile imitator.

How ridiculous it would be to see the Sheep Endeavouring to walk like the Dog, or the Ox striving to trot like the Horse; just as Ridiculous it is to see One Man Striving to Imitate Another. Man varies from Man more than Animal from Animal of different Species.

Page 96

But the truth is, that the degree of excellence which proclaims Genius is different, in different times and different places; and what shews it to be so is, that mankind have often changed their opinion upon this matter.

Never, Never!

Page 97

These excellencies were, heretofore, considered merely as the effects of genius; and justly, if genius is not taken for inspiration, but as the effect of close observation and experience.

Damn'd Fool!

He who first made any of these observations . . . had that merit, but probably no one went very far at once . . . others worked more and improved further . . .

If Art was Progressive We should have had Mich. Angelos & Rafaels to Succeed & to Improve upon each other. But it is not so. Genius dies with its Possessor & comes not again till Another is Born with It.

It must of necessity be, that even works of Genius, like every other effect, as they must have their cause, must likewise have their rules.

Identities or Things are Neither Cause nor Effect. They are Eternal.

Pages 98-99

. . . our minds should be habituated to the contemplation of excellence . . . we should to the last moment of our lives continue a settled intercourse with all the true examples of grandeur. Their inventions are not only the food of our infancy, but the substance which supplies the fullest maturity of our vigour.

Reynolds Thinks that Man Learns all that he knows. I say on the Contrary that Man Brings All that he has or can have Into the World with him. Man is Born Like a Garden ready Planted & Sown. This World is too poor to produce one Seed.

Page 99

The mind is but a barren soil; a soil which is soon exhausted, and will produce no crop, . . .

The mind that could have produced this Sentence must have been a Pitiful, a Pitiable Imbecillity. I always thought that the Human Mind was the most Prolific of All Things & Inexhaustible. I certainly do Thank God that I am not like Reynolds.

. . . or only one, unless it be continually fertilized and enriched with foreign matter.

Nonsense!

It is vain for painters or poets to endeavour to invent without materials on which the mind may work. . . . Nothing can come of nothing.

Is the Mind Nothing?

. . . we are certain that Michael Angelo, and Raffaelle, were equally possessed of all the knowledge in the art which had been discovered in the works of their predecessors.

If so they knew all that Titian & Correggio knew. Correggio was two years older than Mich. Angelo. Correggio born 1472, Mich. Angelo born 1474.

Page 100

. . . it is not to be understood, that I advise any endeavour to copy the exact peculiar colour and complexion of another man's mind. . . . His model may be excellent but the copy will be ridiculous.

Why then Imitate at all?

Appendix I

Page 101

Art in its perfection is not ostentatious; it lies hid, and works its effect, itself unseen. It is the proper study and labour of an artist to uncover and find out the latent cause of conspicuous beauties . . .

This is a Very Clever Sentence; who wrote it, God knows.

Page 102

Peculiar marks, I hold to be, generally, if not always, defects; . . .

Peculiar Marks are the Only Merit.

Peculiarities in the works of art, are like those in the human figure . . . they are always so many blemishes;

Infernal Falshood!

Page 103

Even the great name of Michael Angelo may be used, to keep in countenance a deficiency or rather neglect of colouring, and every other ornamental part of the art.

No Man who can see Michael Angelo can say that he wants either Colouring or Ornamental parts of Art in the highest degree, for he has Every Thing of Both.

. . . there is no defect that may not be excused, if it is a sufficient excuse that it can be imputed to considerable artists; . . .

He who Admires Rafael Must admire Rafael's Execution. He who does not admire Rafael's Execution Cannot Admire Rafael.

Page 105

. . . want of strength of parts. In this certainly men are not equal . . .

A Confession!

Page 107

In order to encourage you to imitation, to the utmost extent, let me add, that the very finished artists in the inferior branches of the art, will contribute to furnish the mind and give hints . . .

This Sentence is to Introduce another in Condemnation & Contempt of Alb. Durer.

Page 108

The works of Albert Durer, Lucas Van Leyden, the numerous inventions of Tobias Stimmer, and Jost Ammon, afford a rich mass of genuine materials . . .

A Polish'd Villain who Robs & Murders!

Page 109

The greatest style, if that style is confined to small figures, . . . would receive an additional grace by the elegance and precision of pencil so admirable in the works of Teniers . . .

What does Precision of Pencil mean? If it does not mean Outline, it means Nothing.

Jan Steen seems to be one of the most diligent and accurate observers . . . if [he] . . . had been blessed with Michael Angelo and Raffaelle for his masters . . . he now would have ranged with the great pillars and supporters of our Art.

Jan Steen was a Boor, & neither Rafael nor Mich. Ang. could have made him any better.

Page 110

Men who although thus bound down by the almost invincible powers of early habits have still exerted extraordinary abilities . . . and have . . . given . . . great force and energy to their works . . .

He who can be bound down is No Genius. Genius cannot be Bound; it may be Render'd Indignant & Outrageous.
"Opression makes the Wise Man Mad."

SOLOMON.

DISCOURSE VII

Page 116 [*facing Discourse VII*]

The Purpose of the following discourse is to Prove That Taste & Genius are not of Heavenly Origin & that all who have supposed that they Are so, are to be Consider'd as Weak headed Fanatics.
The Obligations Reynolds has laid on Bad Artists of all Classes will at all times make them his Admirers, but most especially for this discourse, in which it is proved that the Stupid are born with Faculties Equal to other Men, Only they have not Cultivated them because they thought it not worth the trouble.

Page 119

We will allow a poet to express his meaning, when his meaning is not well known to himself, with a certain degree of obscurity, as it is one source of the sublime.

Obscurity is Neither the Source of the Sublime nor of any Thing Else.

But when, in plain prose, we gravely talk of courting the muse in shady bowers; waiting the call and inspiration of Genius . . .; of attending to times and seasons when the imagination shoots with greatest vigour, . . . sagaciously observing how much the wild freedom and liberty of imagination is cramped by attention to established rules . . . we at best entertain notions not only groundless but pernicious.

The Ancients & the wisest of the Moderns were of the opinion that Reynolds condemns & laughs at.

Appendix I

Page 120

. . . scarce a poet is to be found . . . who . . . continued practising his profession to the very last, whose latter works are not as replete with the fire of imagination, as those which were produced in his more youthful days.

As Replete, but Not More Replete.

To understand literally these metaphors or ideas expressed in poetical language, seems to be equally absurd as to conclude . . .

The Ancients did not mean to Impose when they affirm'd their belief in Vision & Revelation. Plato was in Earnest: Milton was in Earnest. They believ'd that God did Visit Man Really & Truly & not as Reynolds pretends.

. . . that because painters sometimes represent poets writing from the dictates of a little winged boy or genius, that this same genius really did inform him in a whisper what he was to write; and that he is himself but a mere machine, unconscious of the operations of his own mind.

How very Anxious Reynolds is to Disprove & Contemn Spiritual Perception!

Pages 120-121

It is supposed . . . that under the name of genius great works are produced, and under the name of taste an exact judgement given, without our knowing why . . .

Who Ever said this?

Page 121

One can scarce state these opinions without exposing their absurdity . . .

He states Absurdities in Company with Truths & calls both Absurd.

. . . I am persuaded, that even among those few who may be called thinkers, the prevalent opinion allows less than it ought to the powers of reason . . .

The Artifice of the Epicurean Philosophers is to Call all other Opinions Unsolid & Unsubstantial than those which are derived from Earth.

We often appear to differ in Sentiments from each other, merely from the inaccuracy of terms.

It is not in Terms that Reynolds & I disagree. Two Contrary Opinions can never by any Language be made alike. I say, Taste & Genius are Not Teachable or Acquirable, but are born with us. Reynolds says the Contrary.

Pages 121-122

We apply the term TASTE to that act of the mind by which we like or dislike, whatever be the subject. . . . We are obliged to take words as we find them; all we can do is to distinguish the THINGS to which they are applied.

This is False; the Fault is not in Words, but in Things. Locke's Opinions of Words & their Fallaciousness are Artful Opinions & Fallacious also.

Page 122

It is the very same taste which relishes a demonstration in geometry, that is pleased with the resemblance of a picture to an original, and touched with the harmony of musick.

Demonstration, Similitude & Harmony are Objects of Reasoning. Invention, Identity & Melody are Objects of Intuition.

Colouring is true . . . from brightness, from softness, from harmony, from resemblance; because these agree with their object, NATURE, and therefore are true; as true as mathematical demonstration; . . .

God forbid that Truth should be Confined to Mathematical Demonstration!

But beside real, there is also apparent truth, or opinion, or prejudice. With regard to real truth, when it is known, the taste which conforms to it, is, and must be, uniform.

He who does not Know Truth at Sight is unworthy of Her Notice.

In proportion as these prejudices are known to be generally diffused . . . the taste which conforms to them approaches nearer to certainty, . . .

Here is a great deal to do to Prove that All Truth is Prejudice, for All that is Valuable in Knowledge is Superior to Demonstrative Science, such as is Weighed or Measured.

Page 123

As these prejudices become more narrow, . . . this secondary taste becomes more and more fantastical; . . .

And so he thinks he has proved that Genius & Inspiration are All a Hum.

Having laid down these positions, I shall proceed with less method . . .

He calls the Above proceeding with Method!

We will take it for granted, that reason is something invariable and fixed in the nature of things; . . .

Reason, or A Ratio of All we have Known, is not the Same it shall be when we know More; he therefore takes a Falshood for granted to set out with.

. . . we will conclude, that whatever goes under the name of taste, which we can fairly bring under the dominion of reason, must be considered as equally exempt from change.

Now this is Supreme Fooling.

The arts would lie open for ever to caprice and casualty, if those who are to judge of their excellencies had no settled principles by which they are to regulate their decisions, . . .

He may as well say that if Man does not lay down settled Principles, The Sun will not rise in a Morning.

Appendix I

Page 124

My notion of nature comprehends not only the forms which nature produces, but also the nature and internal fabrick and organization . . . of the human mind and imagination.

Here is a Plain Confession that he Thinks Mind & Imagination not to be above the Mortal & Perishing Nature. Such is the End of Epicurean or Newtonian Philosophy; it is Atheism.

Page 126

This [Poussin's Perseus and Medusa's head] is undoubtedly a subject of great bustle and tumult, and that the first effect of the picture may correspond to the subject, every principle of composition is violated; . . . I remember turning from it with disgust . . .

Reynolds's Eye could not bear Characteristic Colouring or Light & Shade.

This conduct of Poussin I hold to be entirely improper to imitate. A picture should please at first sight, and appear to invite the spectator's attention; . . .

Please Whom! Some Men cannot see a Picture except in a Dark Corner.

No one can deny, that violent passions will naturally emit harsh and disagreeable tones: . . .

Violent Passions Emit the Real, Good & Perfect Tones.

Page 129

If it be objected that Rubens judged ill at first in thinking it necessary to make his work so very ornamental, this puts the question upon new ground.

Here it is call'd Ornamental that the Roman & Bolognian Schools may be Insinuated not to be Ornamental.

Nobody will dispute but some of the best of the Roman or Bolognian schools would have produced a more learned and more noble work.

Learned & Noble is Ornamental.

This leads us to another important province of taste, that of weighing the value of the different classes of the art, . . .

A Fool's Balance is no Criterion because, tho' it goes down on the heaviest side, we ought to look what he puts into it.

Page 137

If an European, when he has cut off his beard, . . . or bound up his own natural hair in regular hard knots, as unlike nature as he can possibly make it; . . . meets a Cherokee Indian, who has . . . laid on with equal care and attention his yellow and red oker . . . ; whoever of these two despises the other for this attention to the fashion of his country . . . is the barbarian.

Excellent!

315

Page 142

In the midst of the highest flights of fancy or imagination, reason ought to preside from first to last, . . .

If this is True, it is a devilish Foolish Thing to be an Artist.

DISCOURSE VIII

Page 144 [*facing Discourse VIII*]

Burke's Treatise on the Sublime & Beautiful is founded on the Opinions of Newton & Locke; on this Treatise Reynolds has grounded many of his assertions in all his Discourses. I read Burke's Treatise when very Young; at the same time I read Locke on Human Understanding & Bacon's Advancement of Learning; on Every one of these Books I wrote my Opinions, & on looking them over find that my Notes on Reynolds in this Book are exactly Similar. I felt the Same Contempt & Abhorrence then that I do now. They mock Inspiration & Vision. Inspiration & Vision was then, and now is, & I hope will always Remain, my Element, my Eternal Dwelling place; how can I then hear it Contemned without returning Scorn for Scorn?

Page 6 [*Contents*]

The principles of art . . . have their foundation in the mind; such as novelty, variety and contrast; these in their excess become defects. . . .

Principles, according to Sr Joshua, become defects.

Page 145

I have recommended in former discourses, that Artists should . . . form an idea of perfection from the different excellencies which lie dispersed in the various schools of painting.

In another discourse he says that we cannot Mix the Florentine & Venetian.

Page 147

An instance occurs to me of two painters (Rembrandt and Poussin,) of characters totally opposite to each other in every respect, . . . Rembrandt's manner is absolute unity . . . Poussin . . . has scarce any principal mass of light at all . . .

Rembrandt was a Generalizer. Poussin was a Particularizer.

. . . the works of Poussin being as much distinguished for simplicity, as those of Rembrandt for combination.

Poussin knew better that [than] to make all his Pictures have the same light & shadows. Any fool may concentrate a light in the Middle.

Page 150

. . . the portraits of Titian, where dignity . . . has the appearance of an unalienable adjunct; . . .

Dignity an Adjunct!

APPENDIX I

Pages 151-152

When a young artist is first told, that his composition and his attitudes must be contrasted, . . . and that the eye must be gratified with a variety of colours;—when he is told this, with certain animating words, of Spirit, Dignity, Energy, Grace, greatness of Style, and brilliancy of Tints, he becomes suddenly vain of his newly acquired knowledge, . . .

Mocks!

Page 152

The Art in its infancy, like the first work of a Student, was dry, hard, and simple, But this kind of barbarous simplicity, would be better named Penury, as it proceeds from mere want;

Mocks!

. . . their simplicity was the offspring, not of choice, but of necessity.

A Lie!

But however they may have strayed, we cannot recommend to them to return to that simplicity . . . but to deal out their abundance with a more sparing hand, . . .

Abundance of Stupidity!

Page 153

. . . it is not enough that a work be learned; it must be pleasing.

If you Endeavour to Please the Worst, you will never Please the Best. To please All Is Impossible.

Pages 154-155

St. Paul preaching at Athens in one of the Cartoons, far from any affected academical contrast of limbs, stands equally on both legs, . . . add contrast, and the whole energy and unaffected grace of the figure is destroyed.

Well Said!

Page 155

It is given as a rule by Fresnoy, That "the principal figure of a subject must appear in the midst of the picture, under the principal light, to distinguish it from the rest."

What a devil of a Rule!

Page 158

. . . What those proportions are, cannot be so well learnt by precept as by observation on pictures, and in this knowledge bad pictures will instruct as well as good.

Bad Pictures are always Sr Joshua's Friends.

It ought, in my opinion, to be indispensably observed, that the masses of light in a picture be always of warm mellow colour, yellow, red, or a yellowish-white, and that the blue, the grey, or the green colours be kept almost entirely out of these masses, and be used only to support and set off these warm colours; . . .

Colouring formed upon these Principles is destructive of All Art, because it takes away the possibility of Variety & only promotes Harmony or Blending of Colours one into another.

Page 159

The conduct of Titian in the picture of Bacchus and Ariadne, has been much celebrated, and justly, for the harmony of colouring.

Such Harmony of Colouring is destructive of Art. One Species of General Hue over all is the Cursed Thing call'd Harmony; it is like the Smile of a Fool.

The illuminated parts of objects are in nature of a warmer tint than those that are in the shade: . . .

Shade is always Cold, & never, as in Rubens & the Colourists, Hot & Yellowy Brown.

Page 160

. . . that fulness of manner which . . . is found in perfection in the best works of Correggio, and . . . of Rembrandt. This effect is produced by melting and losing the shadows in a ground still darker than those shadows; . . .

All This is Destructive of Art.

Page 161

. . . a picture which I have of Rubens: it is a representation of a Moonlight. . . . The Moon in this picture does not preserve so great a superiority in regard to its lightness over the object which it illumines, as it does in nature; . . . If Rubens had preserved the same scale of gradation of light between the Moon and the objects, which is found in nature, the picture must have consisted of one small spot of light only, . . .

These are Excellent Remarks on Proportional Colour.

Page 162

Reason and common sense tell us, that before, and above all considerations, it is necessary that the work should be seen . . . with pleasure and satisfaction.

If the Picture ought to be seen with Ease, surely The Nobler parts of the Picture, such as the Heads, ought to be Principal; but this Never is the Case except in the Roman & Florentine Schools. Note: I Include the Germans in the Florentine School.

Pages 163-164

It is true, sketches, or such drawings as painters generally make for their works, give this pleasure of imagination to a high degree. From a slight undetermined drawing . . . the imagination supplies more than the painter himself, probably, could produce, . . .

What Falshood!

Appendix I

Page 164

. . . every thing shall be carefully and distinctly expressed, as if the painter knew, with correctness and precision, the exact form and character of whatever is introduced into the picture.

Excellent, & Contrary to his usual Opinions!

Pages 164-165

Mr. Falconet has observed . . . that the circumstances of covering the face of Agememnon was probably not in consequence of any fine imagination of the painter, . . . but merely copied from the description of the sacrifice, as it is found in Euripides . . . Falconet does not at all acquiesce in the praise that is bestowed on Timanthes; . . .

I am of Falconet's opinion.

APPENDIX II

William Hazlitt's Essays on Reynolds' Discourses, written for The Champion 1814–15

THE text here printed is from *The Complete Works of William Hazlitt*, edited by P. P. Howe, London, 1933, Vol. XVIII. The page references to the *Discourses* have been changed to correlate with the present edition.

INTRODUCTION TO AN ACCOUNT OF SIR JOSHUA REYNOLDS' DISCOURSES: I

The Champion. *November 27, 1814.*

THE general merit of these Discourses is so well established that it would be needless to enlarge on it here. The graces of the composition are such, that scholars have been led to suspect that it was the style of Burke (the first prose-writer of our time) carefully subdued, and softened down to perfection: and the taste and knowledge of the subject displayed in them are so great, that this work has been, by common consent, considered as a text-book on the subject of art, in our English school of painting, ever since its publication. Highly elegant and valuable as Sir Joshua's opinions are, yet they are liable (so it appears to us) to various objections; and it becomes more important to state these objections, because, as it generally happens, the most questionable of his precepts are those which have been the most eagerly adopted, and carried into practice with the greatest success. The errors, if they are such, which we shall attempt to point out, are not casual, but systematic. There is a fine-spun metaphysical theory, either not very clearly understood, or not very correctly expressed, pervading Sir Joshua's reasoning; and which appears to have led him in several of the most important points to conclusions, either false or only true in part.[1] The rules thus laid down, as general and comprehensive maxims, are in fact founded on a set of half principles, which are true only as far as they imply a negation of the opposite errors, but contain in themselves the germ of other errors just as fatal: which, if strictly and literally understood, cannot be defended, and which by being taken in an equivocal sense, of course leave the student as much to seek as ever. The English school of painting is universally reproached by foreigners with the slovenly and unfinished state in which they send their productions into the world, with their ignorance of academic rules and neglect of the subordinate

[1]This theory will be found contained in Richardson's Essay on Painting, and in Coypel's Discourses to the French Academy.

320

details; in other words, with aiming at *effect* only in all their works of art: and though it is by no means necessary that we should adopt the defects of the French and German painters, yet we might learn from them to correct our own. There was no occasion to encourage our constitutional indolence and impatience by positive rules, or to incorporate our vicious habits into a system. Or if our defects were to be retained, at least they ought to have been tolerated only for the sake of certain collateral and characteristic excellences out of which they might be thought to spring. Thus a certain degree of precision or regularity might be sacrificed rather than impair that boldness, vigour, and originality of conception, in which the strength of the national genius might be supposed to lie. But the method of instruction pursued in the Discourses seems calculated for neither of these objects. Without endeavouring to overcome our habitual defects, which might be corrected by proper care and study, it damps our zeal, ardour, and enthusiasm. It places a full reliance neither on art nor nature, but consists in a kind of fastidious tampering with both. Both genius and industry are put out of countenance in turn. The height of invention is made to consist in compiling from others, and the perfection of imitation is not copying from nature. We lose the substance of the art in catching at a shadow, and are thought to embrace a cloud for a Goddess!

That we may not seem to prejudge the question, we shall state at once, and without further preface, the principal points in the Discourses which we deem either wrong in themselves, or liable to misconception and abuse. They are the following:—

1. *That genius or invention consists chiefly in borrowing the ideas of others, or in using other men's minds.*

2. *That the great style in painting depends on leaving out the details of particular objects.*

3. *That the essence of portrait consists in giving the general character, rather than the individual likeness.*

4. *That the essence of history consists in abstracting from individuality of character and expression as much as possible.*

5. *That beauty or ideal perfection consists in a central form.*

6. *That to imitate nature is a very inferior object in art.*

All of these positions appear to require a separate consideration, which we shall give them in the following articles on this subject.

II: ON GENIUS AND ORIGINALITY

The Champion. *December* 4, 1814.

It is a leading and favourite position of the Discourses that genius and invention are principally shewn in borrowing the ideas, and imitating the excellences of others. Differing entirely from those 'who have undertaken to write on the art of painting, and have represented it as a kind of *inspiration*, as a *gift* bestowed

upon peculiar favourites at their birth,' Sir Joshua proceeds to add, 'I am, on the contrary, persuaded, that by imitation only,' (that is, of former masters,) 'variety and even originality of invention is produced. I will go further! even genius, at least what is generally called so, is the child of imitation.' 'There can be no doubt but that he who has most materials has the greatest means of invention; and if he has not the power of using them, it must proceed from a feebleness of intellect.' 'Study is the art of using other men's minds.' 'It is from Raphael's having taken so many models, that he became himself a model for all succeeding painters; always imitating, and always original.' Vol. i. p. 94, 96, 99, 104. All that Sir Joshua says on this subject, is either vague and contradictory, or has an evident bias the wrong way. That genius either consists in, or is in any proportion to, the knowledge of what others have done, in any branch of art or science, is a paradox which hardly admits serious refutation. The answer is indeed so obvious and so undeniable, that one is almost ashamed to give it. As it happens in all such cases, an advantage is taken of the old-fashioned simplicity of truth to triumph over it. It is another of Sir Joshua's theoretical opinions, often repeated, and almost as often retracted in his lectures, that there is no such thing as genius in the first formation of the human mind. That is not the question here, though perhaps we may recur to it. But, however a man may come by the faculty which we call *genius*, whether it is the effect of habit and circumstances, or the gift of nature, yet there can be no doubt, that what is meant by the term, is a power of original observation and invention. To take it otherwise, is a solecism in language, and a misnomer in art. A work demonstrates genius exactly as it contains what is to be found no where else, or in proportion to what we add to the ideas of others from our own stores, and not to what we receive from them. It may contain also what is to be found in other works, but it is not that which stamps it with the character of genius. The contrary view of the question can only tend to deter those who have genius from using it, and to make those who are without genius, think they have it. It is attempting to excite the mind to the highest efforts of intellectual excellence, by denying the chief ground-work of all intellectual distinction. It is from the same general spirit of distrust of the existence or power of genius that Sir Joshua exclaims with confidence and triumph, 'There is one precept, however, in which I shall only be opposed by the vain, the ignorant, and the idle. I am not afraid that I shall repeat it too often. YOU MUST HAVE NO DEPENDENCE ON YOUR OWN GENIUS. If you have great talents, industry will improve them. If you have but moderate abilities, it will supply their deficiency. Nothing is denied to well directed labour; nothing can be obtained without it. Not to enter into metaphysical discussions on the nature and essence of genius, I will venture to assert, that assiduity unabated by difficulty, and a disposition eagerly directed to the object of its pursuit, will produce effects similar to those which some call the *result of natural powers*.' P. 35. Yet so little influence had the metaphysical theory, which he wished to hold *in terrorem* over the young enthusiast, on Sir Joshua's habitual unreflecting good sense, that he afterwards, in speaking of the attainments of Carlo Maratti, which, as well as those of Raphael, he attributes to his imitation of others, says, 'It is true there is nothing very captivating in Carlo Maratti; but this proceeded from a want which cannot be completely supplied, that is, *want of strength of parts. In this, certainly, men are not equal;* and a man can bring home wares only in proportion to the capital with which he goes to market. Carlo, by diligence, made the most of what he had: but there was undoubtedly a heaviness about him,

which extended itself uniformly to his invention, expression, his drawing, colouring, and the general effect of his pictures. The truth is, he never equalled any of his patterns in any one thing, and he added little of his own.' P. 105-106. Poor Carlo, it seems, then, was excluded from the benefit of the sweeping clause in this general charter of dulness, by which all men are declared to be equal in natural powers, and to owe their superiority only to superior industry. What is here said of Carlo Maratti is, however, an exact description of the fate of all those, who, without any genius of their own, pretend to avail themselves of the genius of others. Sir Joshua attempts to confound genius and the want of it together, by shewing, that some men of great genius have not disdained to borrow largely from their predecessors, while others, who affected to be entirely original, have really invented little of their own. This is from the purpose. If Raphael, for instance, had only copied his figure of St. Paul from Mascacio, or his groupe, in the sacrifice of Lystra, from the ancient bas-relief, without adding other figures of equal force and beauty, he would have been considered as a mere plagiarist. As it is, the pictures here referred to, would undoubtedly have displayed more genius, that is, more originality, if those figures had also been his own invention. Nay, Sir Joshua himself, in giving the preference of genius to Michael Angelo, does it on this very ground, that 'Michael Angelo's works seem to proceed from his own mind entirely, and that mind so rich and abundant, that he never needed, or seemed to disdain to look abroad for foreign help;' whereas, 'Raffaelle's materials are generally borrowed, though the noble structure is his own.' On the justice of this last statement, we shall remark presently. Perhaps Reynolds's general account of the insignificance of genius, and the all-sufficiency of the merits of others, may be looked upon as an indirect apology for the gradual progress of his own mind, in selecting and appropriating the beauties of the great artists who went before him: he appears anxious to describe and dignify the process, from which he himself derived such felicitous results, but which, as a general system of instruction, can only produce mediocrity and imbecility. It is a lesson which a well-bred drawing-master might with great propriety repeat by rote to his fashionable pupils, but which a learned professor, whose object was to lead the aspiring mind to the heights of fame, ought not to have offered to the youth of a nation. 'You must have no dependence on your own genius,' is, according to Sir Joshua, the universal foundation of all high endeavours, the beginning of all true wisdom, and the end of all true art. Would Sir Joshua have given this advice to Michael Angelo, or to Raphael, or to Correggio? Or would he have given it to Rembrandt, or Rubens, or Vandyke, or Claude Lorraine, or to our own Hogarth? Would it have been followed, or what would have been the consequence, if it had?—That we should never have heard of any of these personages, or only heard of them as instances to prove that nothing great can be done without genius and originality! We are at a loss to conceive where, upon the principle here stated, Hogarth would have found the materials of his *Marriage à la Mode*? or Rembrandt his Three Trees? or Claude Lorraine his Enchanted Castle, with that one simple figure in the foreground,—

Sole sitting by the shores of old romance?

Or from what but an eye always intent on nature, and brooding over 'beauty, rendered still more beautiful' by the exquisite feeling with which it was contem-

323

plated, did he borrow his verdant landscapes and his azure skies, the bare sight of which wafts the imagination to Arcadian scenes, 'thrice happy fields, and groves, and flowery vales,' breathing perpetual youth and freshness? If Claude had gone out to study on the banks of the Tyber with Sir Joshua's first precept in his mouth, 'Individual nature produces little beauty,' and had returned poring over the second, which is like unto it, 'You must have no dependence on your own genius,' the world would have lost one perfect painter.[2] Rubens would have shared the same fate, with all his train of fluttering Cupids, warriors and prancing steeds, panthers and piping Bacchanals, nymphs, fawns and satyrs, if he had not been reserved for 'the tender mercies' of the modern French critics, David and his pupils, who think that the Luxembourg gallery ought to be destroyed, to make room for their own execrable performances. Or we should never have seen that fine landscape of his in the Louvre, with a rainbow on one side, the whole face of nature refreshed after the shower, and some shepherds under a group of trees piping to their heedless flock, if instead of painting what he saw and what he felt to be fine, he had set himself to solve the learned riddle proposed by Sir Joshua, whether *accidents in nature* should be introduced in landscape, since Claude has rejected them. It is well that genius gets the start of criticism; for if these two great landscape painters, not being privileged to consult their own taste and inclinations, had been compelled to wait till the rules of criticism had decided the preference between their different styles, instead of having both, we should have had neither. The folly of all such comparisons consists in supposing that we are reduced to a single alternative in our choice of excellence, and the true answer to the question, 'Which do you like best, Rubens's landscapes or Claude's?' is the one which was given on another occasion—both. If it be meant which of the two an artist should imitate, the answer is, the one which he is likely to imitate best. As to Rembrandt, he would not have stood the least chance with this new theory of art. But the warning sounds, 'you must have no dependence on your own genius,' never reached him in the little study where he watched the dim shadows cast by his dying embers on the wall, or at other times saw the clouds driven before the storm, or the blaze of noon-day brightness bursting through his casement on the mysterious gloom which surrounded him. What a pity that his old master could not have received a friendly hint from Sir Joshua, that getting rid of his vulgar musty prejudices, he might have set out betimes for the regions of *virtu*, have scaled the ladder of taste, have measured the antique, lost himself in the Vatican, and after 'wandering through dry places, seeking he knew not what, and finding nothing,' have returned home as great a critic and painter as so many others have done! Of Titian, Vandyke, or Correggio we shall say nothing here, as we have said so much in another place.

A theory, then, by which these great artists could have been lost to themselves and to the art, and which explains away the two chief supports and sources of all art, *nature* and *genius*, into an unintelligible jargon of words, cannot be intrinsically true. The principles thus laid down may be very proper to conduct the machinery of a royal academy, or to precede the distribution of prizes to the

[2]This painter's book of studies from nature, commonly called *Liber Veritatis*, disproves the truth of Sir Joshua's assumption, that his landscapes are mere general compositions, for the finished pictures are nearly fac-similes of the original sketches, and what is added to them in point of regularity (if this addition was any advantage) was at least the result of his own genius.

students, or to be the topics of assent and congratulation among the members themselves at their annual exhibition dinner: but they are so far from being calculated to foster genius or to direct its course, that they can only blight or mislead it, wherever it exists, and 'lose more men of talents to this nation,' by the dissemination of false principles, than have been already lost to it by the want of any.

But it may be said, that though the perfection of portrait or landscape may be derived from the immediate study of nature, yet higher subjects are not to be found in it; that there we must raise our imaginations by referring to artificial models; and that Raphael was compelled to go to Michael Angelo and the antique. Not to insist that Michael Angelo himself, according to Sir Joshua's account, formed an exception to this rule, it has been well observed on this statement, that what Raphael borrowed was to conceal or supply his natural deficiencies: what he excelled in was his own. Raphael never had the grandeur of form of Michael Angelo, nor the correctness of form of the antique. His expression was perfectly different from both, and perhaps better than either, certainly better than what we have seen of Michael Angelo in the prints from him compared with those from Raphael in the Vatican. In Raphael's faces, particularly his women, the expression is superior to the form; in the antique statues, the form is evidently the principal thing. The interest which they excite is in a manner external, it depends on a certain grace and lightness of appearance, joined with exquisite symmetry and refined susceptibility to voluptuous emotions, but there is no pathos; or if there is, it is the pathos of present and physical distress, rather than of sentiment. There is not that deep internal interest which there is in Raphael; which broods over the suggestions of the heart with love and fear till the tears seem ready to gush out, but that they are checked by the deeper sentiments of hope and faith. What has been remarked of Leonardo da Vinci, is still more true of Raphael, that there is an angelic sweetness and tenderness in his faces peculiarly adapted to his subjects, in which natural frailty and passion are purified by the sanctity of religion. They answer exactly to Milton's description of the 'human face divine.' The ancient statues are finer objects for the eye to contemplate: they represent a more perfect race of physical beings, but we have no sympathy with them. In Raphael, all our natural sensibilities are raised and refined by pointing mysteriously to the interests of another world. The same intensity of passion appears also to distinguish Raphael from Michael Angelo. Michael Angelo's forms are grander, but they are not so full of expression. Raphael's, however ordinary in themselves, are full of expression even to o'erflowing: every nerve and muscle is impregnated with feeling, or bursting with meaning. In Michael Angelo, on the contrary, the powers of body and mind appear superior to any events that can happen to them, the capacity of thought and feeling is never full, never tasked or strained to the utmost that it will bear. All is in a lofty repose and solitary grandeur which no human interests can shake or disturb. It has been said that Michael Angelo painted *man*, and Raphael *men*; that the one was an epic, the other a dramatic painter. But the distinction we have made is perhaps truer and more intelligible, *viz.* that the former gave greater dignity of form, and the latter greater force and refinement of expression. Michael Angelo borrowed his style from sculpture, which represented in general only single figures, (with subordinate accompaniments,) and had not to express the conflicting actions and passions of a multitude of persons. He is much more picturesque than Raphael. The whole figure of his Jeremiah droops and hangs

down like a majestic tree surcharged with showers. His drawing of the human figure has all the characteristic freedom and boldness of Titian's landscapes.[3]

To return to Sir Joshua. He has given one very strange proof that there is no such thing as genius, namely, that 'the degrees of excellence which proclaims genius is different in different times and places.' If Sir Joshua had aimed at a confutation of himself, he could not have done it more effectually. For what is it that makes the difference but that which originates in a man's self, *i.e.*, is first done by him, is genius, and when it is no longer original, but borrowed from former examples, it ceases to be genius, since no one can establish this claim by following the steps of others, but by going before them? The test of genius may be different, but the thing itself is the same,—a power at all times to do or to invent what has not before been done or invented. It is plain from the passage above cited what influenced Sir Joshua's mind in his views on this subject. He quarrelled with genius from being annoyed with premature pretensions to it. He was apprehensive that if genius were allowed to stand for any thing, industry would go for nothing in the minds of 'the vain, the ignorant, and the idle.' But as genius will do little without labour in an art so mechanical as painting, so labour will do still less without genius. Indeed, wherever there is true genius, there will be true labour, that is, the exertion of that genius in the field most proper for it. Sir Joshua, from his unwillingness to admit one extreme, has fallen into the other, and has mistaken the detection of an error for a demonstration of the truth. 'The human understanding,' says Luther, 'resembles a drunken clown on horseback; if you set it up on one side, it tumbles over on the other.'

III: ON THE IMITATION OF NATURE

The Champion. *December 25, 1814.*

THE imitation of nature is the great object of art. Of course, the principles by which this imitation should be regulated, form the leading topic of Sir Joshua Reynolds's lectures. It is certain that the mechanical imitation of individual objects, or the parts of individual objects, does not always produce beauty or grandeur; or, generally speaking that *the whole of art does not consist in copying nature*. Reynolds seems hence disposed to infer, that the whole of art consists in *not* imitating individual nature. This is also an error, and an error on the worst side.

Sir Joshua's general system may be summed up in two words,—'*That the great style in painting consists in avoiding the details, and peculiarities of particular objects.*' This sweeping principle he applies almost indiscriminately to portrait, history, and landscape;—and he appears to have been led to the conclusion itself, from supposing the imitation of particulars to be inconsistent with general truth and effect. It will not be unimportant to inquire how far this opinion is well-founded: for it appears to us, that the highest perfection of the art depends, not on the separation, but on the union (as far as possible) of general truth and effect with individual distinctness and accuracy.

[3]Sir Joshua considers it as a great disadvantage to Raphael in studying from the antique, that he had not the facilities afforded by modern prints, but was forced to seek out, and copy them one by one with great care. We should be disposed to reverse this conclusion.

First, it is said that the great style in painting, as it relates to the immediate imitation of external nature, consists in avoiding the details of particular objects.

It consists neither in giving nor avoiding them, but in something quite different from both. Any one may avoid the details. So far, there is no difference between the Cartoons, and a common signpainting. Greatness consists in giving the larger masses and proportions with truth;—this does not prevent giving the smaller ones too. The utmost grandeur of outline, and the broadest masses of light and shade, are perfectly compatible with the greatest minuteness and delicacy of detail, as may be seen in nature. It is not, indeed, common to see both qualities combined in the imitations of nature, any more than the combination of other excellences; nor are we here saying to which the principal attention of the artist should be directed; but we deny, that, considered in themselves, the absence of the one quality is necessary or sufficient to the production of the other.

If, for example, the form of the eye-brow is correctly given, it will be perfectly indifferent to the truth or grandeur of the design, whether it consist of one broad mark, or is composed of a number of hair-lines, arranged in the same order. So, if the lights and shades are disposed in fine and large masses, the breadth of the picture, as it is called, cannot possibly be affected by the filling up of those masses with the details;—that is, with the subordinate distinctions which appear in nature. The anatomical details in Michael Angelo, the ever-varying outline of Raphael, the perfect execution of the Greek statues, do not assuredly destroy their symmetry or dignity of form;—and in the finest specimens of the composition of colour, we may observe the largest masses combined with the greatest variety in the parts, of which those masses are composed.

The *gross* style consists in giving no details,—the *finical* in giving nothing else. Nature contains both large and small parts,—both masses and details; and the same may be said of the most perfect works of art. The union of both kinds of excellence, of strength with delicacy, as far as the limits of human capacity and the shortness of human life would permit, is that which has established the reputation of the greatest masters. Farther,—their most finished works are their best. The predominance, however, of either excellence in these masters, has, of course, varied according to their opinion of the relative value of these different qualities,—the labour they had the time or patience to bestow on their works,—the skill of the artist, or the nature and extent of his subject. But, if the rule here objected to,—that the careful imitation of the parts injures the effect of the whole,—be at once admitted, slovenlinesss would become another name for genius, and the most unfinished performance would necessarily be the best. That such has been the confused impression left on the mind by the perusal of Sir Joshua's discourses, is evident from the practice as well as the conversation of many (even eminent) artists. The late Mr. Opie proceeded entirely on this principle. He left many admirable studies of portraits, particularly in what relates to the disposition and effect of light and shade. But he never finished any of the parts, thinking them beneath the attention of a great man. He went over the whole head the second day as he had done the day before, and therefore made no progress. The picture at last, having neither the lightness of a sketch, nor the accuracy of a finished work, looked course, laboured, and heavy.

'Would you then have an artist finish like Denner?' is the triumphant appeal which is made as decisive against all objections. To which, as it is an appeal to authority, the proper answer seems to be,—'No; but we would have him finish like Titian or Correggio.' Denner is an example of finishing not to be followed,

but shunned, because *he did nothing but finish*; because he finished ill, and because he finished to excess;—for in all things there is a certain proportion of means to ends. He pored into the littlenesses of objects, till he lost sight of nature, instead of imitating it. He represents the human face, perhaps, as it might appear through a magnifying-glass, but certainly not as it ever appears to us. It is the business of painting to express objects as they appear naturally, not as they may be made to appear artificially. His flesh is as blooming and glossy as a flower or a shell. Titian's finishing, on the contrary, is equally admirable, because it is engrafted on the most profound knowledge of effect, and attention to the character of what he represents. His pictures have the exact look of nature, the very tone and texture of flesh. The endless variety of his tints is blended into the greatest simplicity. There is a proper degree both of solidity and transparency. All the parts hang together: every stroke tells, and adds to the effect of the rest.

To understand the value of any excellence, we must refer to the use which has been made of it, not to instances of its abuse. If there is a certain degree of ineffectual microscopic finishing, which we never find united with an attention to other higher and more indispensable parts of the art, we may suspect that there is something incompatible between them, and that the pursuit of the one diverts the mind from the attainment of the other. But this is the real point to stop at— where alone we should limit our theory or our efforts. Wherever different excellences have been actually united to a certain point of perfection, to that point (abstractedly speaking) we are sure that they may, and ought to be united again. There is no occasion to add the incitements of indolence, affectation, and false theory, to the other causes which contribute to the decline of art!

Sir Joshua seems, indeed, to deny that Titian finished much, and says that he produced, by two or three strokes of his pencil, effects which the most laborious copyists would in vain attempt to equal. It is true that he availed himself, in a considerable degree, of what is called *execution*, to facilitate his imitation of nature, but it was to facilitate, not to supersede it. By the methods of scumbling or glazing, he often broke the masses of his flesh,—or by laying on lumps of colour produced particular effects, to a degree that he could not otherwise have reached without considerable loss of time. We do not object to execution: it saves labour, and shews a mastery both of hand and eye. But then there is nothing more distinct than execution and *daubing*. Indeed, it is evident, that the only use of execution is to give the details more compendiously, and sometimes, even more happily. Leave out all regard to the details, reduce the whole into crude unvarying masses, and it becomes totally useless; for these can be given just as well without execution as with it. Titian, however, made a very moderate, though a very admirable use of this power; and those who copy his pictures will find, that the simplicity is in the results, not in the details.

The other Venetian painters made too violent a use of execution, unless their subjects formed an excuse for them. Vandyke successfully employed it in giving the last finishing to the details. Rembrandt employed it still more, and with more perfect truth of effect.—Rubens employed it equally, but not so as to produce an equal resemblance of nature. His pencil ran away with his eye.—To conclude our observations on this head, we will only add, that while the artist thinks that there is any thing to be done, either to the whole or to the parts of his picture, which can give it still more the look of nature, if he is willing to proceed, we would not advise him to desist.—This rule is still more necessary to the young

student, for he will relax in his attention as he grows older. And again, with respect to the subordinate parts of a picture, there is no danger that he will bestow a disproportionate degree of labour upon them, because he will not feel the same interest in copying them, and because a much less degree of accuracy will serve every purpose of deception;—the nicety of our habitual observations being always in proportion to our interest in the objects.—Sir Joshua somewhere objects to the attempt to deceive by painting; and his reason is, that wax-work, which deceives most effectually, is a very disagreeable as well as contemptible art. It might be answered, first, that nothing is much more unlike nature than such figures generally are, and farther, that they only produce the appearance of prominence and relief, by having it in reality,—in which they are just the reverse of painting.

Secondly, with regard to EXPRESSION, we can hardly agree with Sir Joshua that '*the perfection of imitation consists in giving the general idea or character, not the peculiarities of individuals.*'—We do not think this rule at all well-founded with respect to portrait-painting, nor applicable to history to the extent to which Sir Joshua carries it. For the present, we shall confine ourselves to the former of these.

No doubt, if we were to chuse between the general character and the peculiarities of feature, we ought to prefer the former. But they are so far from being incompatible with, that they are not without some difficulty distinguishable from, each other. There is indeed a general look of the face, a predominant expression arising from the correspondence and connection of the different parts, which it is always of the first and last importance to give; and without which no elaboration of detached parts, or marking of the peculiarity of single features, is worth any thing; but which at the same time, is certainly not destroyed, but assisted, by the careful finishing, and still more by giving the exact outline of each part.

It is on this point that the French and English schools differ, and (in my opinion) are both wrong. The English seem generally to suppose, that, if they only leave out the subordinate parts, they are sure of the general result. The French, on the contrary, as idly imagine, that by attending to each separate part, they must infallibly arrive at a correct whole,—not considering that, besides the parts, there is their relation to each other, and the general character stamped upon them by the mind itself, which to be seen must be felt,—for it is demonstrable that all expression and character are perceived by the mind, and not by the eye only. The French painters see only lines, and precise differences;—the English only general masses, and strong effects. Hence the two nations constantly reproach one another with the difference of their styles of art; the one as dry, hard and minute, the other as gross, gothic, and unfinished; and they will probably remain for ever satisfied *with each other's defects*, which afford a very tolerable fund of consolation on either side.

There is something in the two styles, which arises, perhaps, from national countenance as well as character:—the French physiognomy is frittered away into a parcel of little moveable compartments and distinct signs of intelligence,—like a telegraphic machinery. The English countenance, on the other hand, is too apt to sink into a lumpish mass, with very few ideas, and those set in a sort of stupid stereotype.

To return to the proper business of portrait-painting. We mean to speak of it, not as a lucrative profession, nor as an indolent amusement, (for we interfere

with no man's profits or pleasures), but as a *bona fide* art, the object of which is to exercise the talents of the artist, and to add to the stock of ideas in the public. And in this point of view, we should imagine that that is the best portrait which contains the fullest representation of individual nature.

Portrait-painting is the biography of the pencil, and he who gives most of the peculiarities and details, with most of the general character,—that is of *keeping*, —is the best biographer, and the best portrait-painter. What if Boswell (the prince of biographers) had not given us the scene between Wilkes and Johnson at Dilly's table, or had not introduced the little episode of Goldsmith strutting about in his peach-coloured coat after the success of his play,—should we have had a more perfect idea of the general character of those celebrated persons from the omission of these particulars? Or if Reynolds had not painted the former as '*blinking Sam*,' or had given us such a representation of the latter as we see of some modern poets in some modern magazines, the fame of that painter would have been confined to the circles of fashion,—where they naturally look for the same selection of beauties in a portrait, as of topics in a dedication, or a copy of complimentary verses!

It has not been uncommon that portraits of this kind, which professed to admit all the peculiarities, and to heighten all the excellences of a face, have been elevated by ignorance and affectation, to the dignified rank of historical portrait. But in fact they are merely *caricature transposed*: that is, as the caricaturist makes a mouth wider than it really is, so the painter of *flattering likenessess* (as they are termed) makes it not so wide, by a process just as mechanical, and more insipid. Instead, however, of objecting captiously to common theory or practice, it will perhaps be better to state at once our own conceptions of historical portrait. It consists, then, in seizing the predominant form or expression, and preserving it with truth throughout every part. It is representing the individual under one consistent, probable, and striking view; or shewing the different features, muscles, &c. in one action, and modified by one principle. A face thus painted, is *historical*;—that is, it carries its own internal evidence of truth and nature with it; and the number of individual peculiarities, as long as they are true to nature, cannot lessen, but must add to the general strength of the impression.

To give an example or two of what we mean. We conceive that the common portrait of Oliver Cromwell would be less valuable and striking if the wart on the face were taken away. It corresponds with the general roughness and knotti-ness of the rest of the face;—or if considered merely as an accident, it operates as a kind of circumstantial evidence of the genuineness of the representation. Sir Joshua Reynolds's portrait of Dr. Johnson has altogether that sluggishness of outward appearance,—that want of quickness and versatility,—that absorption of faculty, and look of purblind reflection, which were characteristic of his mind. The accidental discomposure of his wig indicates his habits. If, with the same felicity and truth of conception, this portrait (we mean the common one reading) had been more made out, it would not have been less historical, though it would have been more like and natural.

Titian's portraits are the most historical that ever were painted; and they are so for this reason, that they have most consistency of form and expression. His portraits of Hippolito de Medici, and of a young Neapolitan nobleman in the Louvre, are a striking contrast in this respect. All the lines of the face in the one;—the eye-brows, the nose, the corners of the mouth, the contour of the

face,—present the same sharp angles, the same acute, edgy, contracted expression. The other face has the finest expansion of features and outline, and conveys the most exquisite idea possible of mild, thoughtful sentiment. The harmony of the expression constitutes as great a charm in Titian's portraits, as that of colour. The similarity sometimes objected to them, is partly national, and partly arises from the class of persons whom he painted. He painted only Italians; and in his time none but persons of the highest rank, senators or cardinals, sat for their pictures.

Sir Joshua appears to have been led into several errors by a false use of the terms *general* and *particular*. Nothing can be more different than the various application of both these terms to different things, and yet Sir Joshua constantly uses and reasons upon them as invariable. There are three senses of the expression *general character*, as applied to ideas or objects. In the first, it signifies the general appearance or aggregate impression of the whole object, as opposed to the mere detail of detached parts. In the second, it signifies the class, or what a number of such objects have in common with one another, to the exclusion of their characteristic differences. In this sense it is tantamount to *abstract*. In the third it signifies what is usual or common, in opposition to mere singularity, or accidental exceptions to the ordinary course of nature. The general idea or character of a particular face, *i.e.* the aggregate impression resulting from all the parts combined, is surely very different from the abstract idea, or what it has in common with several others. If on giving the former all character depends; to give nothing but the latter is to take away all character. The more a painter *comprehends* of what he sees, the more valuable his work will be: but it is not true that his excellence will be the greater, the more he *abstracts* from what he sees.—There is an essential distinction which Sir Joshua has not observed. The details and peculiarities of nature are only inconsistent with abstract ideas, and not with general or aggregate effects. By confounding the two things, Sir Joshua excludes the peculiarities and details not only from his historical composition, but from an enlarged view and comprehensive imitation of individual nature.

We have here attempted to give some account of what should be meant by the *ideal* in portrait-painting: in our next and concluding article on this subject, we shall attempt an explanation of this term, as it applies to historical painting.

IV: ON THE IDEAL

The Champion. *January* 8, 1815.

For I would by no means be thought to comprehend those writers of surprising genius, the authors of immense romances, or the modern novel and Atalantis writers, who, without any assistance from nature or history, record persons who never were, or will be, and facts which never did, nor possibly can happen: whose heroes are of their own creation, and their brains the chaos whence all their materials are collected. Not that such writers deserve no honour; so far from it, that perhaps they merit the highest. One may apply to them what Balzac says of Aristotle, that they are *a second nature*; for they have no communication with the first, by which authors of an inferior class, who cannot stand alone, are obliged to support themselves, as with crutches. FIELDING's *Joseph Andrews*, vol. ii.

What is here said of certain writers of romance, would apply equally to a great number of painters of history. These persons, not without the sanction of

high authority, have come to the conclusion that they had only to quit the vulgar path of truth and reality, in order that they 'might ascend the brightest heaven of invention,'—and that to get rid of nature was all that was necessary to the loftiest flights of art, as the soul disentangled from the load of matter soars to its native skies. But this is by no means the truth. All art is built upon nature; and the tree of knowledge lifts its branches to the clouds, only as it has struck its roots deep into the earth. He is the greatest artist, not who leaves the materials of nature behind him, but who carries them with him into the world of invention; —and the larger and more entire the masses in which he is able to apply them to his purpose, the stronger and more durable will his productions be. Sir Joshua Reynolds admits that the knowledge of the individual forms and various combinations of nature, is necessary to the student, but it is only in order that he may *avoid* them, and steering clear of all representation of things as they actually exist, wander up and down in the empty void of his own imagination, having nothing better to cling to, than certain shadowy middle forms, made up of an abstraction of all others, and containing nothing in themselves. Stripping nature of substance and accident, he is to exhibit a decompounded, disembodied, vague, ideal nature in her stead, seen through the misty veil of metaphysics, and covered with the same fog and haze of confusion, while

> Obscurity her curtain round him draws,
> And siren sloth a dull quietus sings.

The concrete, and not the abstract, is the object of painting, and of all the works of imagination. History-painting is *imaginary* portrait-painting. The portrait-painter gives you an individual, such as he is in himself, and vouches for the truth of the likeness as a matter of fact: the historical painter gives you the individual such as he is likely to be,—that is, approaches as near to the reality as his imagination will enable him to do, leaving out such particulars as are inconsistent with the pre-conceived idea,—as are merely trifling and accidental,— and retaining all such as are striking, probable, and consistent. Because the historical painter has not the same immediate data to go upon, but must connect individual nature with an imaginary subject, is that any reason why he should discard individual nature altogether, and thus leave nothing for his imagination, or the imagination of the spectator to work upon? Portrait and history differ as a narration of facts or a probable fiction differ; but abstraction is the essence of neither. That is not the finest historical head which has least the look of nature, but which has most the look of nature, if it has the look of history also. But it has the look of nature, *i.e.* of striking and probable nature,—as it has a marked and decided character, and not a character of indifference: and as the features and expression are consistent with themselves, not as they are common to others. The ideal is that which answers to the idea of something, and not to the idea of any thing, or of nothing. Any countenance strikes most upon the imagination, either in a picture or in reality, which has most distinctness from others, and most identity with itself. The keeping in the character, not the want of character, is the essence of history. Without some such limitation as we have here given, on the general statement of Sir Joshua, we see no resting-place where the painter or the poet is to make his stand, so as not to be pushed to the utmost verge of naked commonplace inanity,—nor do we understand how there should be any such thing as poetry or painting tolerated. A *tabula rasa*, a verbal definition, the bare

name, must be better than the most striking description or representation;—the argument of a poem better than the poem itself,—or the catalogue of a picture than the original work. Where shall we stop in the easy down-hill pass of effeminate, unmeaning insipidity? There is one circumstance, to be sure, to recommend the system here objected to, which is, that he who proposes this ideal perfection to himself, can hardly fail to succeed in it. An artist who paints on the infallible principle of not imitating nature, in representing the meeting of Telemachus and Calypso, will not find it difficult to confound all difference of sex or passion, and in pourtraying the form of Mentor, will leave out every distinctive mark of age or wisdom. In representing a Grecian marriage he will refine on his favourite principles till it will be possible to transpose the features of the bridegroom and the bride without the least violation of propriety; all the women will be like the men; and all like one another, all equally young, blooming, smiling, elegant, and insipid. On Sir Joshua's theory of the *beau ideal*, Mr. Westall's pictures are perhaps the best that ever were painted, and on any other theory, the worst; for they exhibit an absolute negation of all expression, character, and discrimination of form and colour.

We shall endeavour to explain our doctrine by some examples which appear to us either directly subversive of, or not very obviously included in, Sir J. Reynolds's theory of history painting, or of the principles of art in general. Is there any one who can possibly doubt that Hogarth's pictures are perfectly and essentially *historical*?—or that they convey a story perfectly intelligibly, with faces and expressions which every one must recognize? They have evidently a common or general character, but that general character is defined and modified by individual peculiarities, which certainly do not take away from the illusion or the effect any more than they would in nature. There is, in the polling for votes, a fat and a lean lawyer, yet both of them are lawyers, and lawyers busy at an election squabble. It is the same with the voters, who are of all descriptions, the lame, the blind, and the halt, yet who all convey the very feeling which the scene inspires, with the greatest variety and the greatest consistency of expression. The character of *Mr. Abraham Adams* by Fielding, is somewhat particular, and even singular: yet it is not less intelligible or striking on that account; and his lawyer and his landlady, though copied from individuals in real life, had yet, as he himself observes, existed four thousand years, and would continue to make a figure in the world as long as certain passions were found united with certain situations, and operating on certain dispositions.

It will, we suppose, be objected that this, though history and invention, is not high history, or poetical invention. We would answer then at once by appealing to Shakespeare. It will be allowed that his characters are poetical as well as natural; yet the individual portrait is almost as striking as the general expression of nature and passion. It is this and this only which distinguishes him from the French school. Dr. Johnson, proceeding on the same theoretical principles as his friend Sir Joshua, affirms, that the excellence of Shakespeare's characters consists in their generality. We grant in one sense it does; but we will add that it consists in their particularity also. Are the admirable descriptions of the kings of Thrace and Inde in Chaucer's Knight's Tale, less poetical or historical, or ideal, because they are distinguished by traits as characteristic as they are striking;—in their lineaments, their persons, their armour, their other attributes, the one black and broad, the other tall, and fair, and freckled, with yellow crisped locks that glittered as the sun. The four white bulls, and the lions which accompany them

are equally fine, but they are not fine because they present no distinct image to the mind. The effect of this is somehow lost in Dryden's Palamon and Arcite, and the poetry is lost with it.

Much more is it necessary to combine individuality with the highest works of art in painting, 'whose end and use both at the first, now is, and was, to hold as 'twere the mirror up to nature.' The painter gives the degree and peculiarity of expression where words in a manner leave off, and if he does not go beyond mere abstraction, he does nothing. The cartoons of Raphael, and his pictures in the Vatican, are sufficiently historical, yet there is hardly a face or figure in any of them which is any thing more than fine and individual nature finely disposed. The late Mr. Barry, who could not be suspected of a prejudice on this side of the question, speaks thus of them,—'In Raphael's pictures (at the Vatican) of the Dispute of the Sacrament and the School of Athens, one sees all the heads to be entirely copied from particular characters in nature, nearly proper for the persons and situation which he adapts them to; and he seems to me only to add and take away what may answer his purpose in little parts, features, &c.: conceiving, while he had the head before him, ideal characters and expressions, which he adapts these features and peculiarities of face to. This attention to the particulars which distinguish all the different faces, persons and characters, the one from the other, gives his pictures quite the verity and unaffected dignity of nature, which stamp the distinguishing differences betwixt one man's face and body and another's.'

If any thing is wanting to the conclusiveness of this testimony, it is only to look at the pictures themselves, particularly the Miracle of the Conversion, and the Assembly of Saints, which are little else than a collection of divine portraits, in natural and expressive attitudes,—full of the loftiest thought and feeling, and as varied as they are fine. It is this reliance on the power of nature, which has produced those master-pieces by the prince of painters, in which expression is all in all;—where one spirit—that of truth—pervades every part, brings down heaven to earth, mingles cardinals and popes with angels and apostles, and yet blends and harmonises the whole by the true touches and intense feeling of what is beautiful and grand in nature. It is no wonder that Sir Joshua, when he first saw Raphael's pictures in the Vatican, was at a loss to discover any great excellence in them, if he was looking out for his theory of the ideal, of neutral character and middle forms.

Another authority, which has been in some measure discovered since the publication of Sir Joshua's Discourses, is to be found in the Elgin Marbles, taken from the Acropolis, and supposed to be the works of the celebrated Phidias. The process of fastidious refinement, and flimsy abstraction, is certainly not visible there. The figures have all the ease, the simplicity, and variety of nature, and look more like living men turned to stone than any thing else. Even the details of the subordinate parts, the loose folds in the skin, the veins under the belly or on the sides of the horses, more or less swelled as the animal is more or less in action, are given with scrupulous exactness. This is true nature, and true history. In a word, we can illustrate our position here better than we could with respect to painting, by saying that these invaluable remains of antiquity are precisely like casts taken from nature.—Michael Angelo and the antique may still be cited against us, and we wish to speak on this subject with great diffidence. We confess, they appear to us much more artificial than the others, but we do not think that this is their excellence. For instance, it strikes us that there

is something theatrical in the air of the *Apollo*, and in the *Hercules* an ostentatious and over-laboured display of the knowledge of the muscles. Perhaps the fragment of the *Theseus* at Lord Elgin's has more grandeur as well as more nature than either of them. The form of the limbs, as affected by pressure or action, and the general sway of the body, are better preserved in it. The several parts in the later Greek statues are more balanced, made more to tally like modern periods; each muscle is more equally brought out, and highly finished, and is so far better in itself, but worse as a part of a whole. If these wonderful productions have a fault, it is the want of simplicity, of a due subordination of parts, which sometimes give them more a look of perfect lay-figures put into attitudes, than of real imitations of nature. The same objection may be urged against the works of Michael Angelo, and is indeed the necessary consequence either of selecting from a number of different models, or of proceeding on a scientific knowledge of the structure of the different parts; for the physical form is something given and defined, but motion is various and infinite. The superior symmetry of form, common to the ancient statues, we have no hesitation in attributing to the superior symmetry of the models in nature, and to the superior opportunity for studying them.

In general, we would be understood to mean, that the ideal is not a voluntary fiction of the brain, a fanciful piece of patch-work, a compromise between the defects of nature, or an artificial balance struck between innumerable deformities, (as if we could form a perfect idea of beauty though we never had seen any such thing,) but a preference of what is fine in nature to what is less so. There is nothing fine in art but what is taken almost immediately and entirely from what is finer in nature. Where there have been the finest models in nature, there have also been the finest works of art. The Greek statues were copied from Greek forms. Their portraits of individuals were often superior to their personifications of their gods; the head of the *Antinous*, for example, to that of the Apollo. Raphael's expressions were taken from Italian faces; and we have heard it observed, that the women in the streets of Rome seem to have walked out of his pictures in the Vatican.

If we are asked, then, what it is that constitutes historic expression or ideal beauty, we should answer, not (with Sir Joshua) abstract expression or middle forms, but consistency of expression in the one, and symmetry of form in the other.

A face is historical, which is made up of consistent parts, let those parts be ever so peculiar or uncommon. Those details or peculiarities only are inadmissible in history, which do not arise out of any principle, or tend to any conclusion,—which are merely casual, insignificant, and unconnected,—which do not *tell*; that is, which either do not add to, or which contradict the general result,—which are not integrant parts of one whole, however strange or irregular that whole may be. That history does not require or consist in the middle form or central features is proved by this, that the antique heads of fauns and satyrs, of *Pan* or *Silenus*, are perfectly grotesque and singular; yet are as undoubtedly historical, as the Apollo or the Venus, because they have the same predominant, intelligible, characteristic expression throughout. *Socrates* is a person whom we recognise quite as familiarly from our general acquaintance with human nature, as *Alcibiades*.[4] The simplicity or the fewness of the parts of a head facilitates

[4] The pictures of Rubens at Blenheim are another proof of this, and certainly finer than the Luxembourg gallery.

this effect, but is not necessary to it. The head of a negro, a mulatto, &c., introduced into a picture is always historical, because it is always distinct from the rest, and uniform with itself. The face covered with a beard is historical for the same reason, because it presents distinct and uniform masses. Again, a face, not so in itself, becomes historical by the mere force of passion. The same strong passion moulds the features into the same emphatic expression, by giving to the mouth, the eyes, the forehead, &c., the same expansion or contraction, the same voluptuous movement or painful constraint. All intellectual and impassioned faces are historical;—the heads of philosophers, poets, lovers, and madmen. Passion sometimes produces beauty by this means, and there is a beauty of form, the effect entirely of expression; as a smiling mouth, not beautiful in common, becomes so by being put into that action.

Sir Joshua was probably led to his opinions on art in general by his theory of beauty, which he makes to consist in a certain central form, the medium of all others. In the first place, this theory is questionable in itself: or if it were not so, it does not include many other things of much more importance in historical painting (though perhaps not so in sculpture[5]) namely, character, which necessarily implies individuality; expression, which is the excess of thought or feeling, strength or grandeur of form, which is excess also.—There seems, however, to be a certain symmetry of form, as there is a certain harmony of sounds or colours, which gives pleasure, and produces beauty, independently of custom. Custom is undoubtedly one source or condition of beauty, but it appears to be rather its limit than its essence; that is, there are certain given forms and proportions established by nature in the structure of each thing, and sanctioned by custom, without which there can only be distortion and incongruity, but which alone do not produce beauty. One kind is more beautiful than another; and the objects of the same kind are not beautiful merely as we are used to them. The rose or lily is more beautiful than the daisy, the swan than the crow, the greyhound than the beagle, the deer than the wild goat; and we invariably prefer the Greek to the African face, though our own inclines more to the latter. We admire the broad forehead, the straight nose, the small mouth, the oval chin. Regular features are those which record and assimilate most to one another. The Greek face is made up of smooth flowing lines, and correspondent features; the African face of sharp angles and projections. A row of pillars is beautiful for the same reason. We confess, on this subject of beauty, we are half-disposed to fall into the mysticism of Raphael Mengs, who had some notion about a principle of *universal harmony*, if we did not dread the censure of an eminent critic.

[5]Michael Angelo took his ideas of painting from sculpture, and Sir Joshua from Michael Angelo.

PLATES

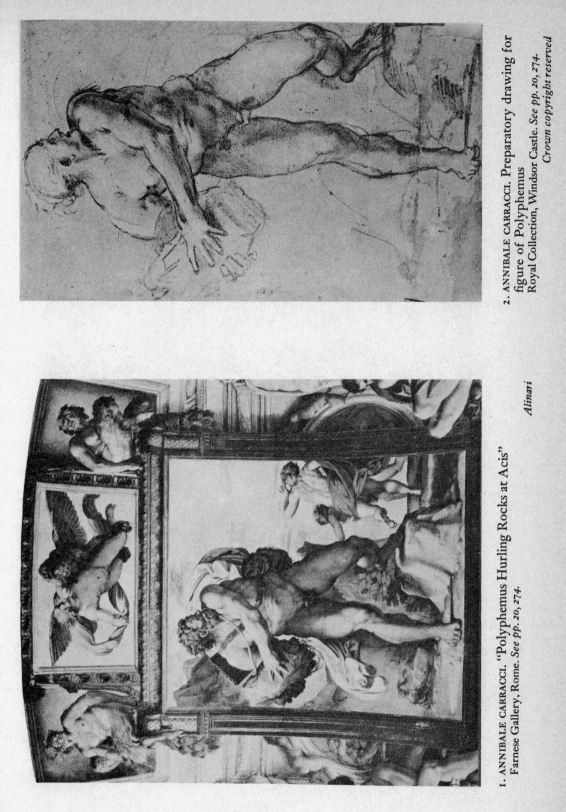

2. ANNIBALE CARRACCI. Preparatory drawing for figure of Polyphemus Royal Collection, Windsor Castle. *See pp. 20, 274.*

Alinari

1. ANNIBALE CARRACCI. "Polyphemus Hurling Rocks at Acis" Farnese Gallery, Rome. *See pp. 20, 274.*

PLATE I

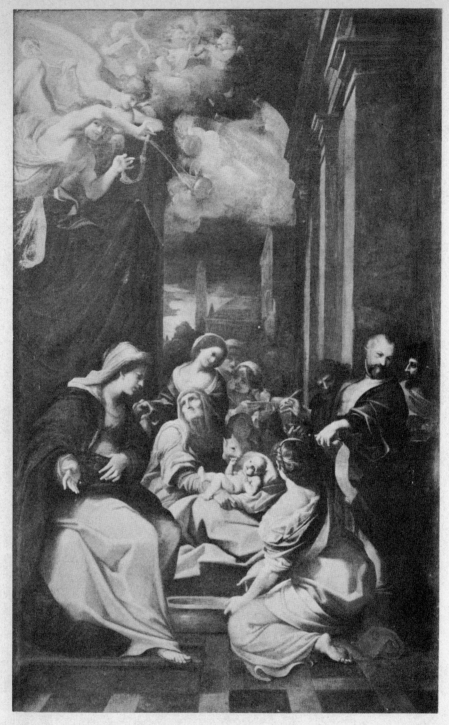

3. LODOVICO CARRACCI. "The Birth of St. John the Baptist"
Pinacoteca, Bologna. *See pp. 33, 80, 274.*

Alinari

PLATE II

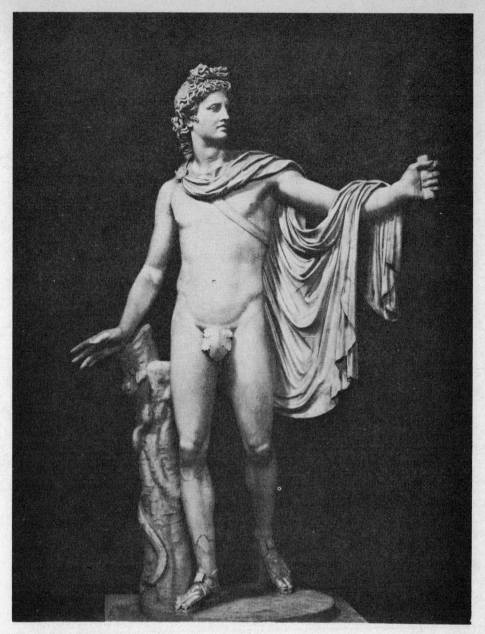

4. "Apollo Belvedere"
 Vatican. *See pp. 47, 151, 178, 184.*

Alinari

PLATE III

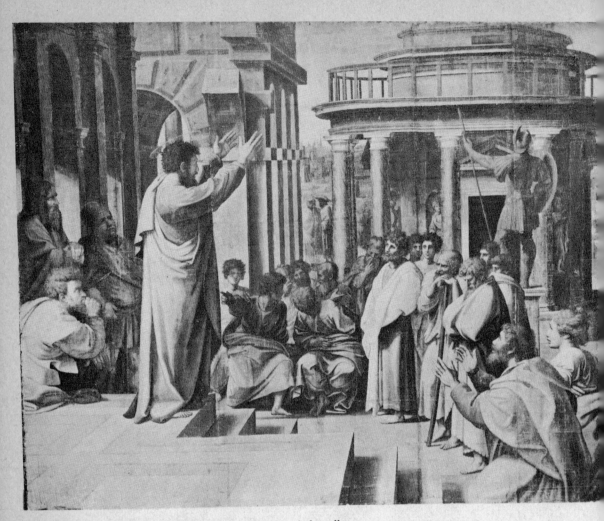

5. RAPHAEL AND ASSISTANTS. "St. Paul Preaching at Athens"
Victoria and Albert Museum, London. *See pp. 59, 78, 81, 156, 194, 216, 238.*

PLATE IV

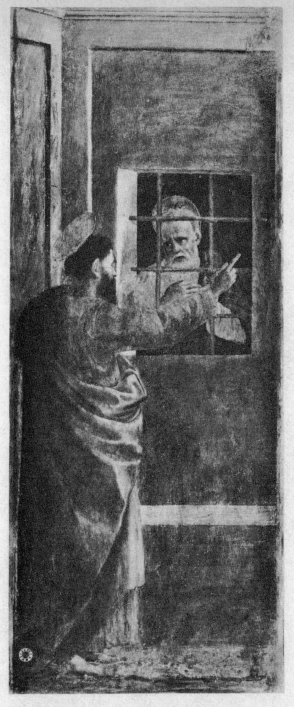

6. FILIPPINO LIPPI. "St. Paul Visiting St. Peter in Prison"

S. Maria del Carmine, Florence. *See p. 216.*

Anderson

PLATE V

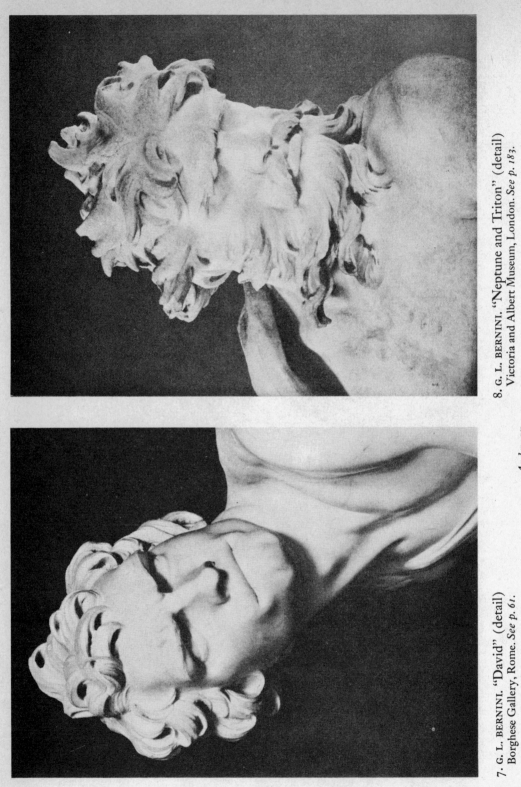

7. G. L. BERNINI. "David" (detail)
Borghese Gallery, Rome. *See p. 61.*

8. G. L. BERNINI. "Neptune and Triton" (detail)
Victoria and Albert Museum, London. *See p. 183.*

Anderson

PLATE VI

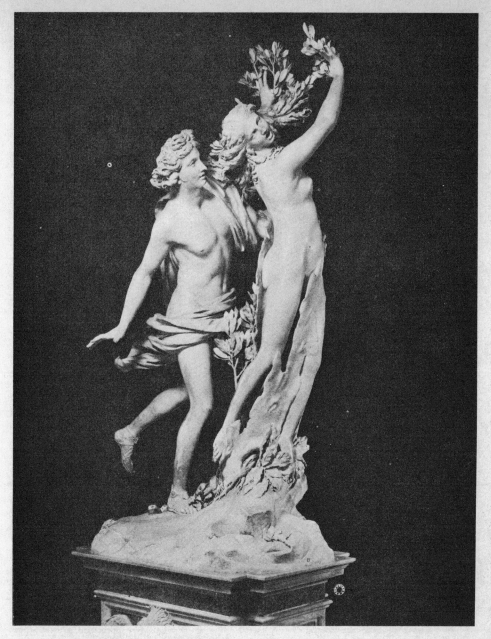

9. G. L. BERNINI. "Apollo and Daphane"
Borghese Gallery, Rome. *See p. 183.*

Anderson

PLATE VII

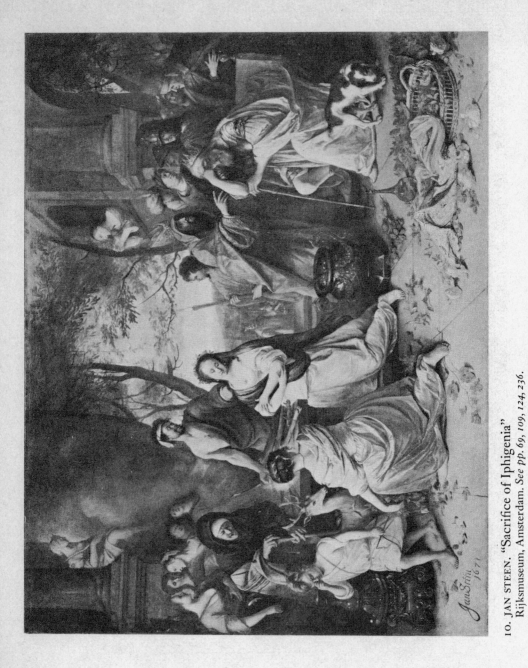

10. JAN STEEN. "Sacrifice of Iphigenia"
Rijksmuseum, Amsterdam. *See pp. 69, 109, 124, 236.*

PLATE VIII

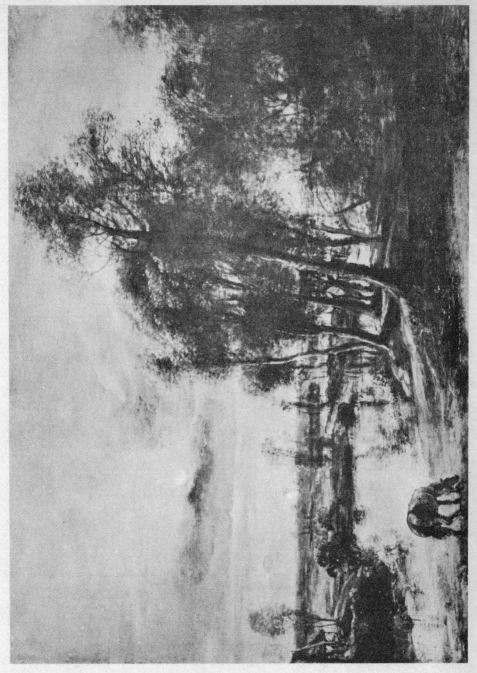

11. RUBENS. "Landscape by Moonlight"
Count Antoine Seilern, London. See pp. 69, 161.

PLATE IX

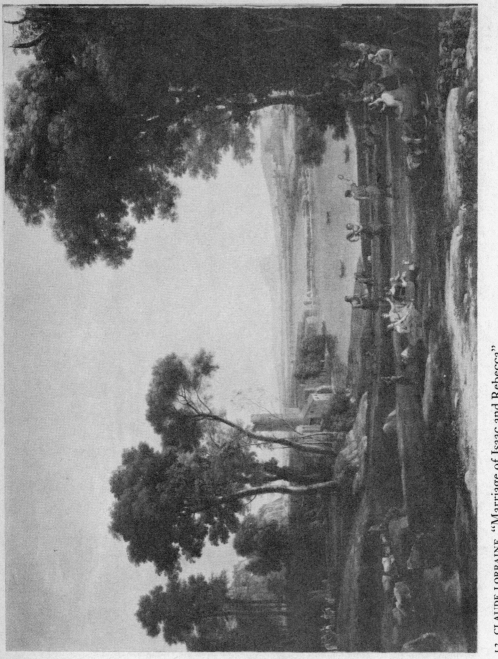

12. CLAUDE LORRAINE. "Marriage of Isaac and Rebecca"
National Gallery, London. See pp. 70, 237. Reproduced by courtesy of the Trustees, the National Gallery, London

PLATE X

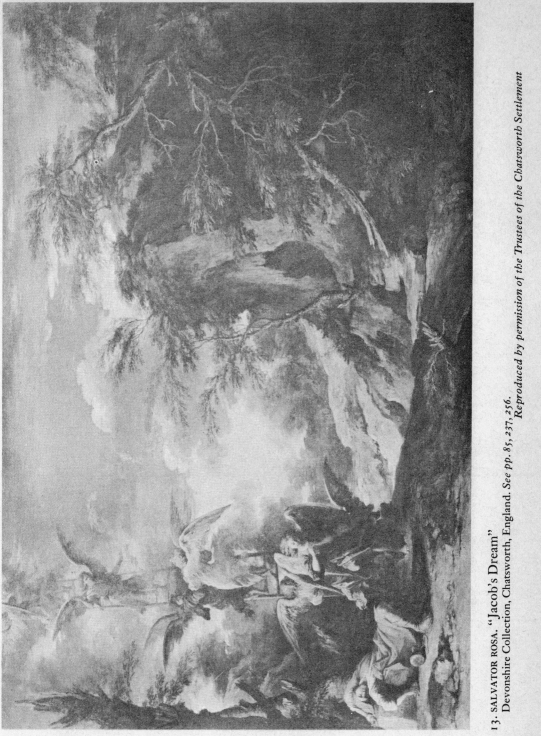

13. SALVATOR ROSA. "Jacob's Dream"
Devonshire Collection, Chatsworth, England. *See pp. 85, 237, 256.*
Reproduced by permission of the Trustees of the Chatsworth Settlement

PLATE XI

14. PARMIGIANINO. "Moses Breaking the Tables"
S. Maria della Steccata, Parma. *See pp. 72, 271.*

FOTO G.F.N.

PLATE XII

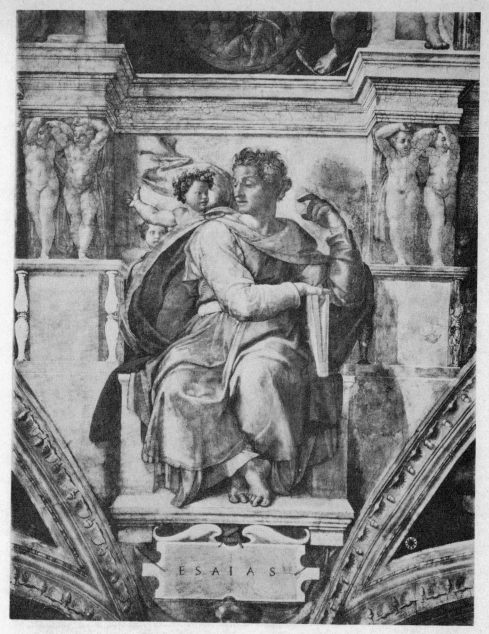

15. MICHELANGELO. "Isaiah"
Sistine Chapel, Vatican. *See pp. xxxii, 81, 82, 276.*

Anderson

PLATE XIII

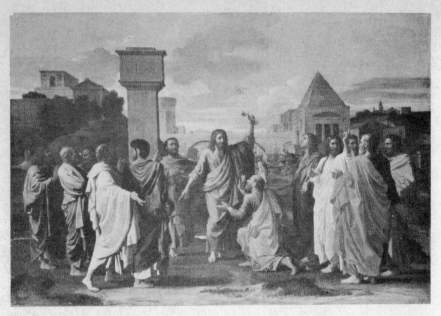

16. POUSSIN. "Ordination"
 The Earl of Ellesmere, on loan to the National Gallery of Scotland. *See pp. 63, 86,
 87, 109, 147, 150, 238.*

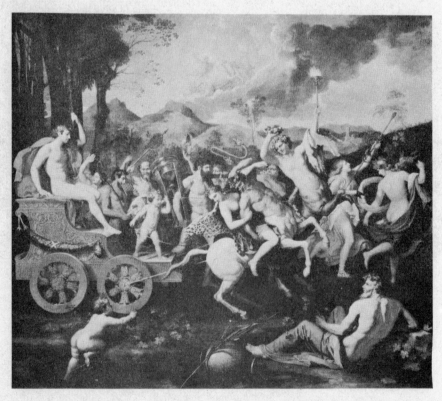

17. POUSSIN. "Triumph of Bacchus"
 Nelson Gallery–Atkins Museum (Nelson Fund), Kansas City, Missouri. *See pp. 125,
 147.*

PLATE XIV

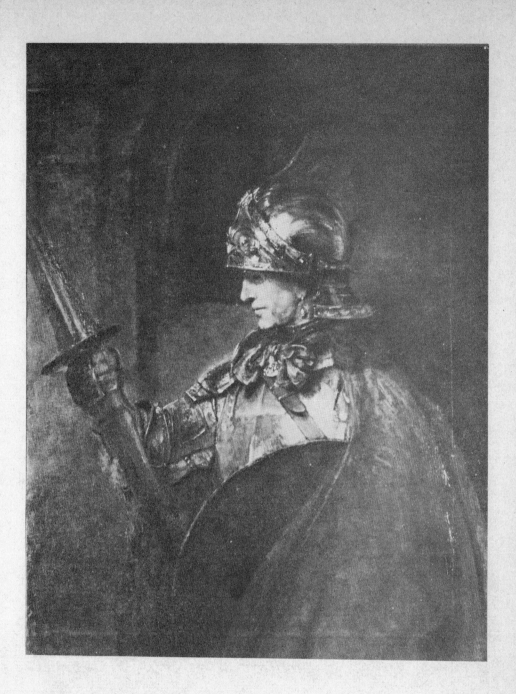

18. REMBRANDT. "Man in Armour"
Glasgow Art Gallery, Glasgow. *See pp. 147, 160, 162.*

PLATE XV

19. VERONESE. "Marriage at Cana"
Louvre, Paris. *See pp. 63, 65, 108, 157, 201.*

Alinari

PLATE XVI

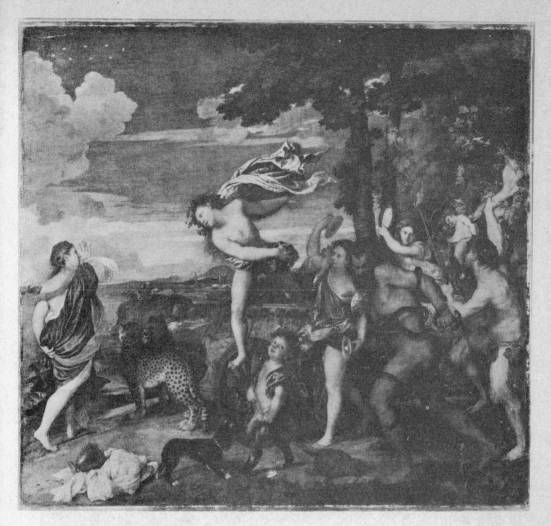

20. TITIAN. "Bacchus and Ariadne"
National Gallery, London. *See pp. 66, 159, 195, 237.*
Reproduced by courtesy of the Trustees, the National Gallery, London

PLATE XVII

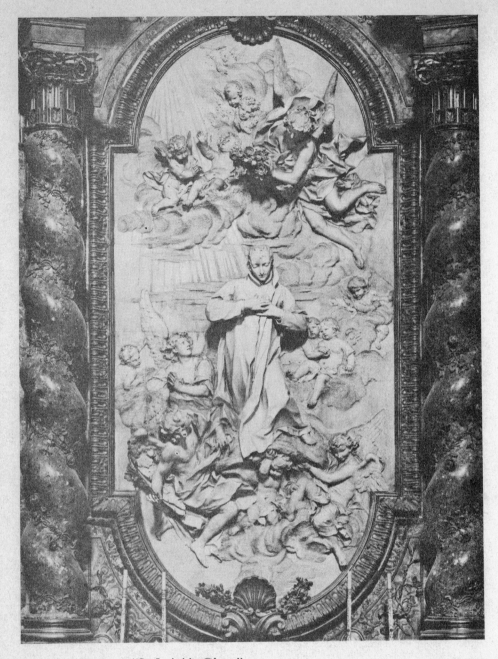

21. PIERRE LEGROS II. "St. Luigi in Glory"
 S. Ignazio, Rome. *See p. 186.*

Alinari

PLATE XVIII

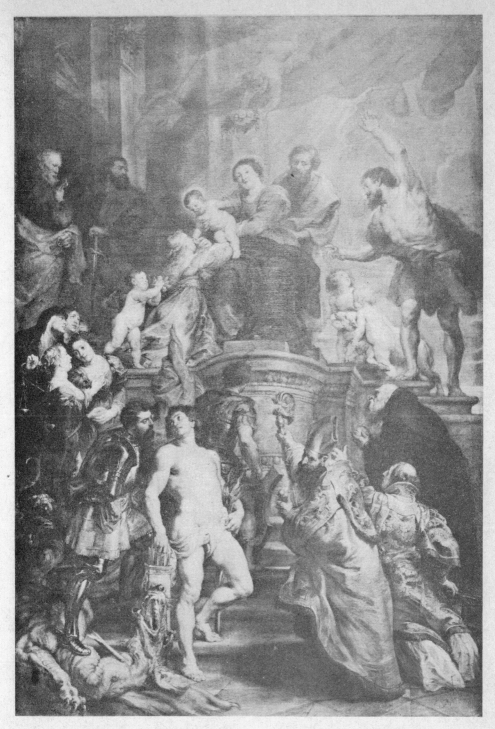

22. RUBENS. "Marriage of St. Catherine"
Church of St. Augustine, Antwerp. *See pp. 86, 201.*

Bulloz

PLATE XIX

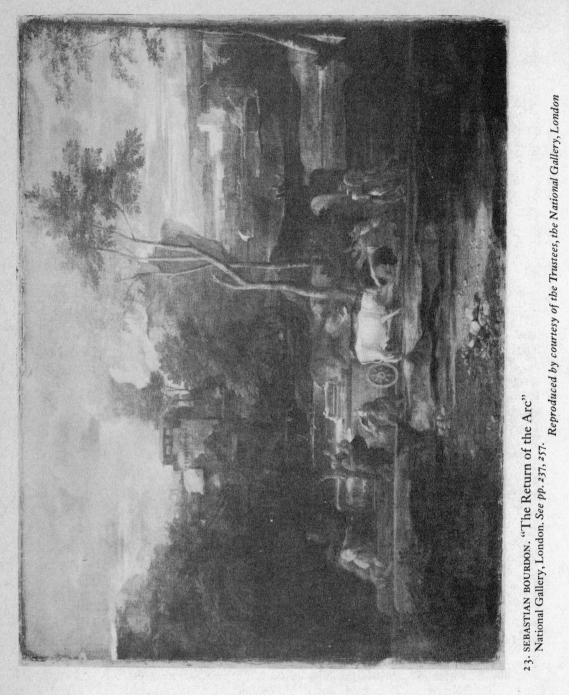

23. SEBASTIAN BOURDON. "The Return of the Arc"
National Gallery, London. See pp. 237, 257. Reproduced by courtesy of the Trustees, the National Gallery, London

PLATE XX

24. SIR JOHN VANBRUGH.
Vanbrugh Castle, Greenwich. *See p. 242.*

PLATE XXI

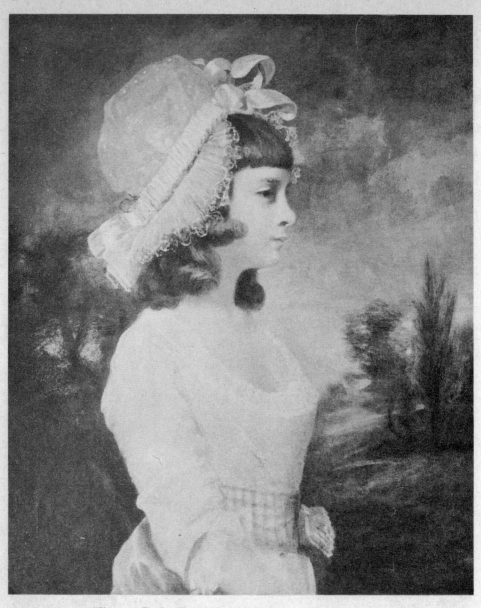

25. REYNOLDS. "Theresa Parker"
Henry E. Huntington Library and Art Gallery, San Marino, California. *See p. xxxii.*

PLATE XXII

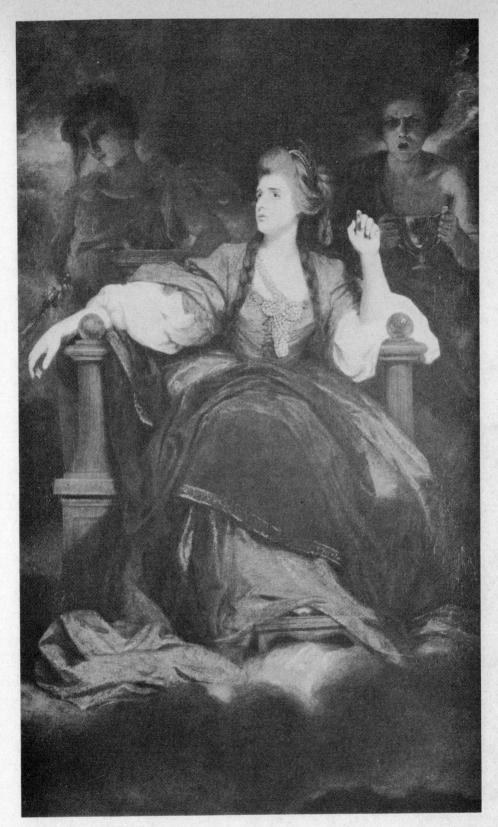

26. REYNOLDS. "Mrs. Siddons as the Tragic Muse"
Henry E. Huntington Library and Art Gallery, San Marino, California. *See pp. xxxii, 72.*

PLATE XXIII

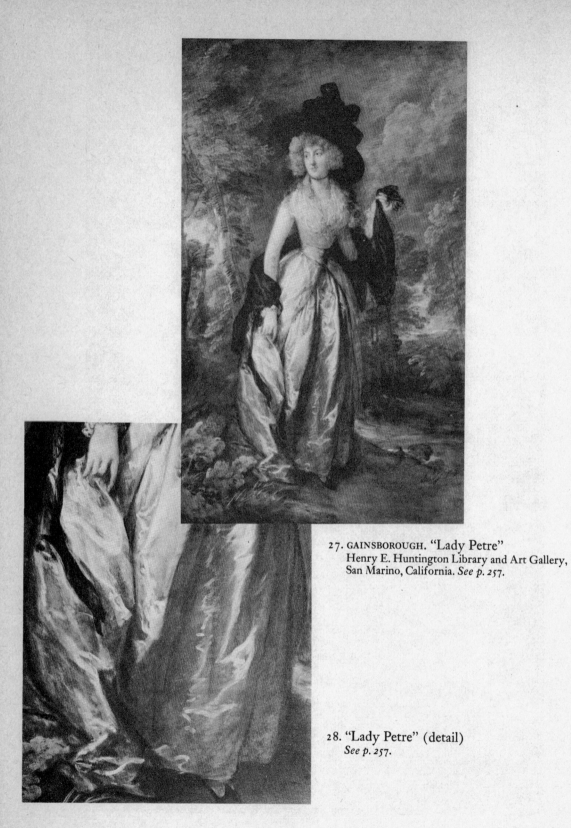

27. GAINSBOROUGH. "Lady Petre"
Henry E. Huntington Library and Art Gallery,
San Marino, California. *See p. 257.*

28. "Lady Petre" (detail)
See p. 257.

PLATE XXIV

Selected Bibliography

THE bibliography is organized in three sections: Reynolds' own writings; the principal books he read or may have read as preparation for writing the *Discourses;* and writings about Reynolds, the *Discourses*, and related art criticism. The bibliography does not pretend to be exhaustive in any of these areas. A complete formal bibliography of Reynolds' writings is included by F. W. Hilles in *The Literary Career of Sir Joshua Reynolds*, App. IV. Details concerning books Reynolds may have read in addition to those mentioned in the bibliography are contained in the annotations to the present edition. The majority of the books cited in this section of the bibliography are listed in editions used by Reynolds or are editions current in his day. But for convenience in reference, more modern editions of several of the standard works have been given. A discussion of the books known to have been in Reynolds' library is included by Hilles in Chapter vii, but many of these were of incidental importance as far as the *Discourses* are concerned. The list of secondary sources about Reynolds, the *Discourses*, and related art criticism is highly selective, but the material cited contains additional bibliographical information about scholarship in these areas.

Unless otherwise indicated, all references in the notes are to the editions listed in this bibliography.

A. The writings of Sir Joshua Reynolds

Three letters to the "Idler," Nos. 76, 79, 82, first pub. in *Universal Chronicle*, Sept. 29, Oct. 20, Nov. 10, 1759.

[The first discourse]. *A Discourse Delivered at the Opening of the Royal Academy, January 2, 1769.* London, 1769.

[The second discourse]. *A Discourse Delivered to the Students of the Royal Academy . . . December 11, 1769.* London, 1769.

[The third discourse]. *A Discourse . . . December 14, 1770.* London, 1771.

[The fourth discourse]. *A Discourse . . . December 10, 1771.* London, 1772.

[The fifth discourse]. *A Discourse . . . December 10, 1772.* London, 1763 [1773].

[The sixth discourse]. *A Discourse . . . Dec. the 10th, 1774.* London, 1775.

[The seventh discourse]. *A Discourse . . . December 10, 1776.* London, 1777.

Seven Discourses Delivered in the Royal Academy by the President. London, 1778.

[The eighth discourse]. *A Discourse . . . December 10, 1778.* London, 1779.

[The ninth and tenth discourses]. *A Discourse Delivered at the Opening of the Royal Academy, October 16, 1780 . . . [and A Discourse Delivered to the Students of the Royal Academy on the Distribution of the Prizes, December 11, 1780].* London, 1781.

[The eleventh discourse]. *A Discourse . . . December 10, 1782.* London, 1783.

The Art of Painting of Charles Alphonse du Fresnoy, trans. into English verse by William Mason, with annotations by Sir Joshua Reynolds. London, 1783.

[The twelfth discourse]. *A Discourse . . . December 10, 1784.* London, 1785.

[The thirteenth discourse]. *A Discourse . . . December 11, 1786.* London, 1786.

337

[The fourteenth discourse]. *A Discourse . . . Dec. 10th, 1788.* London, 1789.

[The fifteenth discourse]. *A Discourse . . . Dec. 10, 1790.* London, 1791.

The Works of Sir Joshua Reynolds, Knt. Late President of the Royal Academy: containing his Discourses, Idlers, A Journey to Flanders and Holland, (now first published,) and his commentary on du Fresnoy's Art of Painting; printed from his revised copies, (with his last corrections and additions,) in two volumes to which is prefixed an Account of the Life and Writings of the Author, by Edmond Malone, Esq. one of his executors. London, 1797. [First collected edition].

The Works of Sir Joshua Reynolds, Knight. . . . The second edition corrected. 3 vols. London, 1798. [References to Reynolds' *Works* in the annotations are to this edition, which is more generally available than the 1797 edition.]

The Literary Works of Sir Joshua Reynolds, ed. Henry William Beechey. 2 vols. London, 1835.

The Discourses of Sir Joshua Reynolds, illus. and ed. John Burnet. London, 1842.

Zur Aesthetik und Technik der bildenden Künste. Akademische Reden, ed. and trans. E. Leisching. Leipzig, 1893.

Discourses Delivered to the Students of the Royal Academy, ed. Roger Fry. London, 1905.

Reynolds Discours sur la peinture, ed. and trans. Louis Dimier. Paris, 1909.

Letters of Sir Joshua Reynolds, ed. Frederick Whiley Hilles. Cambridge, [Eng.], 1929.

Portraits by Sir Joshua Reynolds. Character Sketches of Oliver Goldsmith, Samuel Johnson, and David Garrick, together with Other Manuscripts of Reynolds Recently Discovered among the Private Papers of James Boswell and Now First Published, ed. Frederick W. Hilles. London, [1952].

B. Principal books Reynolds read or may have read in
preparation for writing the *Discourses*

Addison, Joseph. *The Works of the Late Right Honorable Joseph Addison, Esq.* Birmingham, 1761.

Akenside, Mark. *The Pleasures of Imagination.* London, 1744.

Algarotti, Conte Francesco. *An Essay on Painting Written in Italian.* London, 1764.

Bacon, Francis. *The Essays*, ed. Samuel Harvey Reynolds. Oxford, 1890.

Barry, James. *An Inquiry into the Real and Imaginary Obstructions to the Acquisition of the Arts in England.* London, 1775.

Beattie, James. *Essays: On Poetry and Music.* 3rd ed. London, 1779.

Beaumont, Sir Harry [Joseph Spence]. *Crito: Or, a Dialogue on Beauty.* 2nd ed. London, 1752.

Borghini, Raffaello. *Il Riposo.* 3 vols. Milan, 1807.

Burke, Edmund. *A Philosophical Enquiry into the Origin of Our Ideas of the Sublime and Beautiful.* London, 1757.

Condivi, Ascanio. *The Life of Michelagnolo Buonarroti*, trans. Herbert P. Horne. [Boston, 1904].

Dubos, Jean Baptiste. *Réflexions critiques sur la poésie et sur la peinture*. 3 vols. Paris, 1719.

Du Fresnoy, Charles Alphonse. *The Art of Painting*, trans. John Dryden. London, 1695.

Falconet, Etienne Maurice. *Œuvres d'Etienne Falconet, statuaire*. 6 vols. Lausanne, 1781.

Félibien, André "Conférences de l'Académie Royale" and "L'idée du peintre parfait" in *Entretiens sur les vies et sur les ouvrages des plus excellens peintres anciens et modernes*. 6 vols. Trévoux, 1725.

————. *The Tent of Darius Explain'd; or, The Queens of Persia at the Feet of Alexander*, trans. William Parsons. London, 1703.

Gerard, Alexander. *An Essay on Taste*. 3rd ed. Edinburgh, 1780.

Harris, James. *The Works of James Harris, Esq*. Oxford, 1841.

Hogarth, William. *The Analysis of Beauty*, ed. Joseph Burke. Oxford, 1955.

Hutcheson, Francis. *An Inquiry into the Original of Our Ideas of Beauty and Virtue*. London, 1725.

Johnson, Samuel. *Lives of the English Poets*, ed. George Birkbeck Hill. 3 vols. Oxford, 1905.

————. [*Rasselas*]. *The Prince of Abissinia*. London, 1759.

Junius, Franciscus. *The Painting of the Ancients, in Three Bookes: Declaring by Historicall Observations and Examples, the Beginning, Progresse, and Consumation of That Most Noble Art*. London, 1638.

Leonardo da Vinci. *Treatise on Painting*, trans. A. Philip McMahon. 2 vols. Princeton, 1956.

Lessing, Gotthold Ephraim. *Laokoon*. Berlin, 1766.

Locke, John. *The Works of John Locke*. 2nd ed., 3 vols. London, 1722.

Longinus, Cassius. . . . *On the Sublime*, trans. William Smith. London, 1739.

Observations on the Discourses Delivered at the Royal Academy. Addressed to the President. London, 1774.

Piles, Roger de. *The Art of Painting and the Lives of the Painters*. London, 1706.

————. "Observations on the Art of Painting," in Du Fresnoy, *The Art of Painting*. London, 1695.

————. *The Principles of Painting*. London, 1743.

Pope, Alexander. *The Works of Alexander Pope*. 9 vols. London, 1751.

Reid, Thomas. *Essays on the Intellectual Powers of Man*. Edinburgh, 1785.

Richardson, Jonathan. *An Account of Some Statues, Bas-Reliefs, Drawings and Pictures, in Italy, &c*. London, 1722.

————. *Explanatory Notes and Remarks on Milton's Paradise Lost*. London, 1734.

————. *The Works of . . . Jonathan Richardson*. [London], 1792.

Smith, Adam. *The Theory of Moral Sentiments*. London, 1759.

Testelin, Henri. *Sentimens des plus habiles peintres sur la pratique de la peinture et sculpture*. Paris, 1696.

Vasari, Giorgio. *Lives of the Most Eminent Painters, Sculptors, and Architects*, trans. Mrs. Jonathan Foster. 5 vols. London, 1878-81.

Walpole, Horace. *Anecdotes of Painting in England, with Some Account of the Principal Artists*, collected by G. Vertue. 4 vols. Strawberry-Hill, 1762-71.

Winckelmann, Johann Joachim. *Reflections on Painting and Sculpture of the Greeks*, trans. by H. Fuseli. London, 1765.

Young, Edward. *Conjectures on Original Composition. In a Letter to the Author of Sir Charles Grandison*. London, 1759.

C. Writings about Reynolds, the *Discourses*, and related art criticism

Bate, Walter Jackson. *From Classic to Romantic: Premises of Taste in Eighteenth-Century England*. Cambridge, [Mass.], 1946.

Blake, William. "Annotations to Reynolds's 'Discourses,'" in *The Writings of William Blake*, ed. Geoffrey Keynes. 3 vols. London, 1925.

Blunt, Anthony. *Artistic Theory in Italy: 1450-1600*. Oxford, 1940.

Boswell, James. *Boswell's Life of Johnson*, ed. George Birkbeck Hill. Rev. and enl. ed. by L. F. Powell. 6 vols. Oxford, 1934-50.

Boys, R. C. "Sir Joshua Reynolds and the Architect Vanbrugh," *Michigan Academy of Science, Arts and Letters*, XXXIII (1947), 323-336.

Burke, Joseph. . . . *Hogarth and Reynolds: A Contrast in English Art Theory*. London, 1943.

Clough, Wilson O. "Reason and Genius—An Eighteenth Century Dilemma," *Philological Quarterly*, XXIII (1944), 33-54.

Constable, William George. *Richard Wilson*. Cambridge, Mass., 1953.

Draper, John W. *Eighteenth Century English Aesthetics: A Bibliography*. Heidelberg, 1931.

Fontaine, André J. C. . . . *Les doctrines d'art en France; peintres, amateurs, critiques, de Poussin à Diderot*. Paris, 1909.

Gombrich, E. H. "Meditations on a Hobby Horse," in *Aspects of Form: A Symposium on Form and Nature in Art*, ed. Lancelot Law Whyte. London, 1952.

———. "Reynolds's Theory and Practice of Imitation," *Burlington Magazine*, LXXX (1942), 40-45.

Greenway, George L. *Alterations in the Discourses of Sir Joshua Reynolds*. New York, [privately printed], 1936.

———. "Some Predecessors of Sir Joshua Reynolds in the Criticism of the Fine Arts." Unpub. Ph.D. diss. Yale University, 1930.

Hilles, Frederick Whiley. *The Literary Career of Sir Joshua Reynolds*. Cambridge, [Eng.], 1936.

———. "Sir Joshua's Prose," in *The Age of Johnson*. New Haven, 1949.

Hipple, Walter J., Jr. *The Beautiful, the Sublime, & the Picturesque in Eighteenth-Century British Aesthetic Theory*. Carbondale, Ill., 1957.

———. "General and Particular in the *Discourses* of Sir Joshua Reynolds: A Study in Method," *The Journal of Aesthetics and Art Criticism*, XI (1953), 231-247.

Hudson, Derek. *Sir Joshua Reynolds.* London, [1958].

Kallich, Martin. "The Meaning of Archibald Alison's *Essay on Taste*," *Philological Quarterly*, XXVII (1948), 314-324.

Lamb, Sir Walter Rangeley Maitland. *The Royal Academy: A Short History of Its Foundation and Development.* London, 1951.

Lee, Rensselaer W. "Ut Pictura Poesis: The Humanistic Theory of Painting," *Art Bulletin*, XXII (1940), 197-269.

Leslie, Charles Robert and Tom Taylor. *Life and Times of Sir Joshua Reynolds.* 2 vols. London, 1865.

Macklem, Michael. "Reynolds and the Ambiguities of Neo-Classical Criticism," *Philological Quarterly*, XXXI (1952), 383-398.

Mahon, Denis. "Eclecticism and the Carracci: Further Reflections on the Validity of a Label," *Journal of the Warburg and Courtauld Institutes*, XVI (1953), 303-341.

————. *Studies in Seicento Art and Theory.* London, 1947.

Mitchell, Charles. "Benjamin West's 'Death of General Wolfe' and the Popular History Piece," *Journal of the Warburg and Courtauld Institutes*, VII (1944), 20-33.

————. "Three Phases of Reynolds's Method," *Burlington Magazine*, LXXX (1942), 35-40.

Monk, Samuel H. *The Sublime: A Study of Critical Theories in XVIII-Century England.* New York, 1935.

Northcote, James. *The Life of Sir Joshua Reynolds.* 2nd ed., 2 vols. London, 1818.

Olson, Elder. Introduction to *Longinus on the Sublime . . . and Sir Joshua Reynolds Discourses on Art.* Chicago, 1945.

Panofsky, Erwin. "*Idea.*" Leipzig, 1924.

Sandby, William. *The History of the Royal Academy of Arts from Its Foundation in 1768 to the Present Time.* 2 vols. London, 1862.

Strange, Sir Robert. *An Inquiry into the Rise and Establishment of the Royal Academy of Arts.* London, 1775.

Thompson, E. M. S. "The *Discourses* of Sir Joshua Reynolds," *PMLA*, XXXII (1917), 339-366.

Todd, William B. "Reynolds's Discourses. 1769-1791," *The Book Collector*, VII (1958), 417-418 [Note 103].

Waterhouse, Ellis Kirkham. *Reynolds.* London, 1941.

Whitley, William Thomas. *Thomas Gainsborough.* London, 1915.

Wind, Edgar. "'Borrowed Attitudes' in Reynolds and Hogarth," *Journal of the Warburg and Courtauld Institutes*, II (1938), 182-185.

————. "Humanitätsidee und heroisiertes Porträt," *Vorträge der Bibliothek Warburg*, 1931.

————. "The Revolution of History Painting," *Journal of the Warburg and Courtauld Institutes*, II (1938), 116-127.

INDEX

Academy: advantage of, 14-15; continental academies, 16n, 112n; conference at French, 63-64. *See also* Royal Academy

Addison, Joseph, 121n, 197n

Admiranda Romanarum antiquitatum, 216 and n

Agesilaus, 60

Akenside, Mark: cited, 139n

Albani, Francesco, 105

Alberti, Leone Battista: cited, 65n

"Aldobrandi Marriage," 87 and n

Alexander the Great, 60

Algarotti, Conte Francesco: quotes Pliny, 211n; on Bouchardon reading Homer, 83n; on continental academies, 112n; on "Laocoon," 128n; on Luxembourg gallery, 128n; on "Apollo Belvedere," 179n; on Titian's landscapes, 200 and n

Allemand, Maurice, 69n

Amman, Jost, 108 and n

Amsterdam: Rijksmuseum, 236n

Andrea del Sarto, 219

Antwerp: Church of St. Augustine, 201n

Apelles, 30n, 46, 233 and n

"Apollo Belvedere": as ideal form, 46n, 47; proportions of, 179 and n; drapery of, 184; mentioned, 151, 178

Architecture: new orders of, 139; and imagination, 241; Gothic, 242; Asiatic, 242; 241-244 passim

Aristotle, xix, 142

Ashburnham, earl of, 125

Association: importance for Reynolds, xxv-xxvi; in Reynolds' paintings, xxxiv; fashion and custom, 49; and Van Dyck habit, 139; in architecture, 139, 241-242

Athena (Minerva), 42 and n

Bacon, Francis: on beauty by rules, 46 and n; studied by Reynolds, 209n, 215 and n, 217n, 240n; on Demosthenes and Cicero, 215 and n

Bamboccio (Pieter van Laer), 109 and n

Bandinelli, Baccio, 221 and n

Barbieri, Giovanni Francesco. *See* Guercino

Barocci, Federico, 35 and n

Barry, James, [3n], 15n, 16n, 32n, 37n, 72n

Bartoli, Pietro S., 216n

Bartolommeo, Fra: studied by Raphael, 15n, 104; his St. Mark, 276 and n; mentioned, 219

Bassani family (Gerolamo, Francesco, Giambattista, Leandro), 35 and n, 104n

Bassano, Giacomo, 68, 104, 130-131

Bate, Walter J., xxxin; cited, xxxin, 45n

Batoni, Pompeo, 28n, 248 and n, 251

Beattie, James, xxvin

Beaumont, Sir Harry. *See* Spence, Joseph

Beckett, R. B.: cited, 254n

Bedinfield, Edward, 271n

Bellini, Giovanni, 195

Bellori, Giovanni P., 216n

Belotto, Bernardo, 28n

"Belvedere Torso," 177 and n, 273

Bembo, Cardinal, 232 and n

Bernini, Gian Lorenzo: his "David," 61 and n; his "Neptune," 61n, 183 and n; seeks to make stone flutter, 182-183; his "Apollo and Daphne," 183 and n

Bisschop (Biskop), Jan de, 274 and n

Blake, William, xxvii-xxviii, 37n

Blenheim Palace, 244 and n

Blunt, Anthony: cited, 244n

Bocconi, Settimo: cited, 46n

Bodmer, Heinrich: cited, 33n

Boileau-Despréaux, Nicolas, 142, 233n

Bologna, Giovanni, 182

Bologna: Institute, 274
 Pinakothek, 33n, 78n

Bonomi, Joseph, 266n

"Borghese Warrior." *See* "Gladiator"

Bosch (Boucher), 108n

Boswell, James, [3n], 129n

Botticelli, Sandro, 70n

Bouchardon, Edme, 83 and n

Boucher, François, 108 and n, 224-225, 225n

Bourdon, Sebastian, 63, 237, 256n, 257

Bourguignon (Bourgognone), le. *See* Courtois, Jacques

"Boxers" ("Wrestlers"), 181

Boys, R. C.: cited, 242n

Bramante, Donato, 212

Bramer, Leonard, 105

Brescia, S.S. Nazaro e Celso, 196n

Brighton: stables at, 242n

Brouwer, Adriaen, 51, 109

Buonarroti, Michelangelo. *See* Michelangelo Buonarroti

Burke, Edmund: friend of Reynolds, xxiv, 118n; studied by Reynolds, 45n, 132n; commends Reynolds' discourse, 110n; on sublime, 119n; on taste, 134n; his *Sublime and Beautiful*, 162 and n

Burney, Charles: cited, 213n

Burrel, Sir Peter, 125

Caldara, Polidoro. *See* Polidoro Caldara of Caravaggio

Caliari, Benedetto, 104n

Caliari, Carlo, 104n

Caliari, Gabriele, 104n

Camera obscura, 237 and n

Canaletto (Antonio Canale), xv, 28n

Cantarini, Simone, 104
Caravaggio, Michelangelo Merisi da, xxxiii, 67n, 71n
Carlisle, earl of, 244n
Carracci, Annibale: draws from living model, 20; his drawings, 20n; on number of figures for picture, 65 and n; mentioned, 32n, 67n, 86
Carracci, Lodovico: note on, 32n; his style commended, 32-33; compared with Titian, 32-33; his paintings, 33; and ornamental style, 80; work in oil and fresco, 82
Carracci: their academy, 273
Cartoons. See Raphael
Castle Howard, 244 and n
Cavalucci, Antonio, 28n
Cavedone, Giacomo, 105 and n
Caylus, Anne Claude, Comte de, 20 and n
Chambers, Sir William, 169n
Chantilly: drawing at, 20n
Characteristic style. See Style
Chardin, Jean-Baptiste Siméon, xv
Charles I, king of England, 60n
Charles II, king of Spain, 67n
Chatsworth: Devonshire collection, 256n
Cheere, Sir Henry, 187n
Chéron, Elisabeth Sophie, 104 and n
Chéron, Louis, 104 and n
Chiari, Giuseppe, 105
Cicero, 42-43, 100 and n, 133 and n, 142, 163 and n, 215
Claude Lorrain: his practice in landscape, 69-70; preferred to Luca Giordano, 130; his tranquil scenes, 237; his gilded clouds, 237; his mythological landscapes, 255; mentioned, 52
Claudian, 149 and n
Clement VII, pope, 177n
Clough, Wilson O., xxxin
Cock, Hieronymous, 275 and n
Cockerell, S. P., 242n
Colonna collection, 177n
Coloring: rules of, 61-62. See also Copying; Poussin; Rubens; Titian; Veronese
Conca, Sebastiano, 248 and n
Condivi, Ascanio, 118n, 278n, 281 and n
Constable, W. G.: cited, 255n
Cooper, Joseph, 71n
Copying: selectivity in, 29; use of in learning to color, 29-30; should not be servile, 100. See also Imitation; Raphael
Corneille, Pierre, 142
Correggio, Antonio Allegri: few drawings by, 35; and composite style, 72; influence on Lodovico Carracci, 80; compared with Raphael, 81; figure proportions, 103, 179; fullness of objects, 160; his practice of inlaying, 160; his drawings, 198; painted at night, 251; his grace disappears before sublime, 276; mentioned, 105, 108

Costanzi, Placido, 248 and n
Courtois, Jacques (le Bourguignon), 51 and n
Cowley, Abraham, 203 and n
Coxie, Michiel, 275 and n
Coypel, Antoine, 108 and n, 150 and n
Crespi, Giuseppe Maria, xxxiv
Crosby, Sumner McK., xxxiin
Cumberland, duke of, 187n
Custom. See Association

Damant, Nicolas, 260n
Da Ponte. See Bassani family
David, J. L., xv
Davies, Martin: cited, 125n
Deformity: symmetry of, 47
Demosthenes, 215
Denner, Balthasar, 237 and n
De Piles, Roger. See Piles, Roger de
Diepenbeck, Abraham, 105
Dimier, Louis: his edition of Discourses, 63n, 83n, 104n, 150n, 196n, 213n; cited, 274n
"Discobolus," 180 and n
Domenichino (Domenico Zampieri), xxxiv, 105
Drapery, 62
Dress in sculpture, 156, 186-187
Dryden, John, 120, 133n, 142, 155n, 268n, 276n
Dublin: National Gallery, 125n
DuBos, Jean Baptiste, [3n]
Dürer, Albrecht, 46, 51 and n, 108, 160
Du Fresnoy. See Fresnoy, Charles Alphonse du
Dulin, Pierre, 125n
Dulwich Gallery, xxxiin
Dyck, Anthony van. See Van Dyck, Anthony

Eckhout. See Eeckhout, Gerbrand van den
Edinburgh: National Gallery, 87n
Eeckhout, Gerbrand van den, 105
Ellesmere, earl of, 87n
Euphranor, 79
Euripides, 89-90, 165 and n

Falconet, Etienne, 79n, 164-165, 164n
Félibien, André: on Veronese, 63n; on Le-Brun, 79n, 156 and n; on Titian, 159n; mentioned, 68n, 270; cited, 156n
Fernandi, Francesco. See Imperiale
Ferri, Ciro, 105
Fielding, Henry, 238 and n
Fischel, Oscar: cited, 82n
Flink (Flinck), Govert, 105
Florence:
 Brancacci Chapel, 216n, 219n
 Pitti Palace, 276n
 Uffizi, 70n, 179n, 181n

Floris, Francis, 275 and *n*
Fragonard, Jean-Honoré, xv
Franco, Battista, 66*n*, 141 and *n*
Freedberg, Sydney Joseph: cited, 179*n*
Fresco: used in the great style, 81
Fresnoy, Charles Alphonse du: on coloring, 136 and *n*; placement of principal figure, 155 and *n*; mentioned, 133*n*, 156, 268*n*
Fromentin, Eugène, 69*n*
Fry, Roger: his edition of *Discourses*, xxxi and *n*, 28*n*, 29*n*, 71*n*, 108*n*, 111*n*, 196*n*
Fuseli, Henry, 37*n*

Gainsborough, Thomas: on Reynolds' variety, xxxii; and fancy-dress portraits, 138*n*; "The Blue Boy," 158*n*; death of, 247*n*; among first of British school, 248; sketched from nature, 250; his model landscapes, 250; painted at night, 250; method of painting, 251, 257-258; writes to Reynolds, 252 and *n*; had no academic training, 252-253; copies other painters, 253 and *n*
Gardening, 240
Garrick, David, 238, 239
Gellée, Claude. *See* Claude Lorrain
Genius: not fettered by rules, 17; must be supported by industry, 18, 35; cannot be taught by rules, 44; possessed by Michelangelo, 83; a relative term, 96-97; relation to rules, 97-98; compared with taste, 120-121; excuses errors, 191
Gerard, Alexander, 134*n*, 136*n*; cited, 121*n*, 139*n*
Ghiberti, Lorenzo, 186
Giordano, Luca, 67 and *n*, 130, 215 and *n*
Giorgione, 160
Giulio Romano, 81 and *n*, 82*n*, 125
"Gladiator" ("Borghese Warrior"), 46*n*, 47, 151, 213 and *n*
Glasgow Art Gallery, 162*n*
Goldsmith, Oliver, xxiv, 93*n*, 118*n*, 130 and *n*
Gombrich, E. H.: cited, xx*n*, xxxi*n*
Gonse, Louis: cited, 63*n*
Gosse, Edmund, 111*n*
Gothic. *See* Architecture
Goya y Lucientes, Francisco José de, xv
Goyen, Jan van, 109
Grautoff, Otto, 87*n*
Gray, Thomas, 271 and *n*
Greenway, George L., 132*n*, 203*n*, 258*n*
Guardi, Francesco de', 28*n*
Guercino, 67*n*, 105, 251 and *n*

Hals, Frans, 109 and *n*
Hampton Court, 60*n*
Harris, James, 277 and *n*
Heemskerk, Martin van, 275 and *n*
"Hercules" (Farnese), 46-47, 46*n*
Heseltine, Michael, trans., 280*n*
Heyden, Jan van der, 237 and *n*

Hilles, F. W.: his *Literary Career of Sir Joshua Reynolds*, xxiii*n*, xxiv*n*, [3*n*], 14*n*, 28*n*, 30*n*, 36*n*, 49*n*, 100*n*, 118*n*, 133*n*, 156*n*, 195*n*, 209*n*, 215*n*, 217*n*, 268*n*, 280*n*; his *Letters of Reynolds*, xxvi*n*, 16*n*, 32*n*, 85*n*; his "Sir Joshua's Prose," 17*n*, 217*n*, 269*n*; his *Portraits by Reynolds*, xxxi*n*, 95*n*; his collection, 31*n*, 94*n*, 108*n*, 155*n*
Hind, Arthur M., 20*n*
Hipple, Walter J., xvii*n*; cited, 41*n*
History painting, 59-60
Hobbes, Thomas, trans., 236 and *n*
Hodges, William, 242 and *n*
Hogarth, William, xxxiv, 51, 254-255, 254*n*; cited, 184*n*
Holbein, Hans, xxxiii
Homer: and Phidias, 42*n*; effect on Bouchardon, 83 and *n*; use of contrast, 148; model for imitation, 203-204, 203*n*; translated by Hobbes, 236; translated by Pope, 274*n*; mentioned, 99, 120, 129*n*, 272, 275
Horace, 46*n*, 95*n*, 142, 178*n*, 268*n*
Hume, David, 134*n*
Hunter, Dr. William, 48*n*, 93*n*

Ideal beauty. *See* Style, great
Imagination: and art, xxv, 59, 230, 241; of Michelangelo, 83; and architecture, 241
Imitation: as plagiarism, 106-107. *See also* Copying
Imperiale (Francesco Fernandi), 248 and *n*
Invention: defined, 27, 58; and the subject, 57
"Ironical Discourse." *See* Reynolds, Sir Joshua

Jansen, Cornelius, 198 and *n*
Jansen, Hendrik, 108*n*
Johnson, Samuel: friend of Reynolds, xxiv, 118*n*; writes dedication for 1778 edition, [3*n*]; his *Rasselas*, 48*n*, 50*n*, 119*n*, 208*n*; professor at academy, 93*n*; his *Lives of the Poets*, 108*n*, 129*n*, 155*n*, 203*n*, 217*n*, 232*n*, 274*n*; corrects *Discourses*, 195*n*; his *Dictionary*, 219*n*; on Pope's Homer, 274-275
Jordaens, Jacob, 105 and *n*
Julius II, pope, 21*n*
Junius, Franciscus: his *Painting of the Ancients*, 21*n*, 30*n*, 36*n*, 42 and *n*, 48*n*, 133 and *n*, 163*n*, 280*n*
Jupiter, 42*n*, 79

Kansas City: Nelson Gallery, 125*n*
Kew Gardens, 242*n*
Kneller, Sir Godfrey, 232 and *n*

Lacedemonians, 107
LaFage, Raymond, 215 and *n*
Lamb, Walter R. M.: cited, 13*n*

Lanfranco, Giovanni, 105
"Laocoon," 128 and n, 151, 178, 180
LeBrun, Charles: studied Italians, 63; pupil of Vouet, 67n; his "Tent of Darius," 156, 158; of academic merit, 158; and façade of Louvre, 244n; mentioned, 63, 104n
Legros, Pierre, II, 184n, 185-186, 186n
Leo X, pope, 21 and n, 83
Leonardo da Vinci: and Raphael, 15n, 104; on wall images, 37 and n; rule for light and shadow, 154 and n; practice of inlaying, 160; mentioned, 219
Leslie, Charles Robert and Tom Taylor: their Life of Reynolds, 157n; cited, 196n, 199n
Lessing, Gotthold Ephraim, 128n, 180n
Le Sueur, Eustace, 63, 67n, 105, 150
LeVau, Louis, 244n
Leyden, Lucas van, 108
Lint, Hendrik Frans van, 199n
Lippi, Filippino, 216n, 219n
Livy, 35-36, 36n
Locke, John: cited, 137n, 139n
London:
 Buckingham House, 60n
 Cavendish Square, 187n
 National Gallery, 125n, 256n
 Somerset House, 169n
 Victoria and Albert Museum, 59n, 61n, 183n
 Wallace Collection, 260n
Longhi, Pietro, 28n
Longinus, 31n, 84 and n
Lucan, 149 and n
Lucas van Leyden. See Leyden, Lucas van
Luxembourg gallery. See Rubens

Mahon, Denis: cited, xxixn, 251n
Malone, Edmund, 5, 86n, 108n, 256n, 307
Mantegna, Andrea, 160
Mantua: Palazzo del Te, 81n
Maratti, Carlo: on drapery, 62; note on, 62n; influenced by other artists, 85; contrasted with Salvator Rosa, 85-86; of academic merit, 158; and Apostles in St. John Lateran, 185; last of Roman school, 249; mentioned, 105, 248n
Marieschi, Jacopo di Paolo, 28n
Masaccio, 216, 218, 219-221, 219n
Masucci, Agostino, 248 and n
Mazzola, Francesco. See Parmigianino
Mazzola-Bedoli, Girolamo, 104 and n
Mengs, Raphael, 28n, 111n, 248 and n
Metastasio, 213 and n
Michelangelo Buonarroti: Reynolds advocates study of, xx; Reynolds copies, xxxii; and Raphael, 15-16, 15n, 83-84, 104, 218; model for comparison, 30-31; compared with Venetians, 64; on Titian, 66 and n; influence on Parmigianino, 72; works in

fresco, 81; considered painting as sculpture, 82; his paintings in oil, 82; his genius and imagination, 83; deficient in coloring, 103; his "Moses," 178, 275; the Sistine Chapel, 275; his style, 278; copies satyr's head, 278-279; influenced Titian, 279; and Tintoretto, 279 and n; mentioned, 21n, 32n, 33, 66, 89, 99, 105, 109, 118n, 177, 219, 271, 272, 278n
Miel, Jan, 109 and n
Mignard, Pierre, I, 67n
Milton, John, 164 and n, 225 and n, 238, 242
Minerva. See Athena
Minucius Felix, 273n
Mitchell, Charles, xxxin; cited, 138n
Molière (Jean Baptiste Poquelin), 233 and n
Monot, Pierre Etienne, 184n, 185
Montesquieu, Charles Louis de Secondat, Baron de, [3n]
Mortimer, John Hamilton, 37n
Music: and imagination, 241

Naples: National Museum, 181n
Nattier, Jean Marc, xxxiv
Nature: as standard for art, 27; not to be too closely copied, 41; and ideal beauty, 44-45; central form of, 45; and taste, 123
Newton, Francis Milner, 21n
Northcote, James, 110n

Olsen, Elder, xviin
Olympia: Temple of Zeus, 42n, 181n
Opera: recitative in Italian, 235
Orders, architectural. See Architecture
Orleans collection, 15n, 87n, 271n
Ornamental style. See Style
Ostade, Isaac van, 51
Ovid, 178n

Pannini, Giovanni Paolo, 28n
Paris:
 Bibliothèque de l'Institut, 140n
 Louvre, collections, 128n, 156n, 157n, 213n
 Louvre, façade of, 244 and n
 Luxembourg, 128n
Parma: S. Maria della Steccata, 271n
Parmigianino: and composite style, 72; his popularity, 72n; his "Madonna of the Long Neck," 179 and n; his drawings, 198; his "St. Eustachius," 271; his paintings, 271n; his "Moses," 271 and n; and the sublime, 276; mentioned, 104, 108
Parsons, William, trans., 79n
Pencil, 34n
Penni, Giovanni Francesco, 82n
Penny, Edward, 53n, 93n
Perrault, Claude, 244 and n
Perugino, Pietro, 104, 160, 219, 273

Petronius, 280 and *n*

Pevsner, Nikolaus, 243*n*

Phidias, 31*n*, 42 and *n*, 45, 128

Philopoemen, 35-36

Pierino del Vaga, 219

Pietro da Cortona, 105

Pietro da Pietri, 105

Pigalle, Jean-Baptiste, 140*n*

Piles, Roger de: advocates imagination and fancy, xxvii; on number of figures in a painting, 65*n*; advice to portraitists, 149-150, 149*n*; on giving objects relief, 160 and *n*; on Veronese, 201*n*; mentioned, 128*n*, 133*n*, 270; cited, 37*n*

Pippi, Giulio. *See* Giulio Romano

Piranesi, Francesco, xv

Plato, xix, 142, 232 and *n*

Pliny, 21 and *n*, 79 and *n*, 100 and *n*, 106*n*, 163 and *n*, 164, 233*n*

Plutarch, 35, 107*n*

Poetry: compared with painting, 145-146, 234

Polidoro Caldara of Caravaggio, 87 and *n*

Polycletus, 31*n*

Pope, Alexander, 17*n*, 73*n*, 142, 232 and *n*, 240*n*, 252*n*, 274*n*, 275

Pope-Hennessy, John: cited, 60*n*

Porden, William, 242*n*

Portraiture: its rank as art, 52; and generality, 59, 200; compared with history painting, 70; and great style, 72, 88; manner of dress in, 140; Roger de Piles on, 149-150

Posse, Hans: cited, 65*n*

Poussin, Nicolas: studied Italians, 63; note on, 63*n*; on coloring, 68; and characteristic style, 86-88; his "Seven Sacraments," 87 and *n*, 238; and "Aldobrandini Marriage," 87*n*; dry and hard manner, 103; criticized, 109; comments on Giulio Romano, 125; his "Sacrifice to Silenus," "Triumph of Bacchus and Ariadne," "Perseus," 125 and *n*; his management of light and shadow, 147-148; his simplicity, 150; transports us to ancient Rome, 237; his mind naturalized in antiquity, 256; mentioned, xxix, 104, 125*n*, 126, 260

Pozzo, Cav. del (Andrea?), 87*n*

Primaticcio, Francesco, 105

Proclus, 42

Protogenes, 30*n*

Pugin, Augustus Welby Northmore, xxxv

Quintilian, 48*n*, 104 and *n*, 163 and *n*

Raphael: Reynolds advocates study of, xx; at top of academic hierarchy, xxviii; influenced by Michelangelo, 15-16, 83, 273; his early development, 15*n*; draws after living model, 20; drawing for "Disputa," 20 and *n*; model for comparison, 31; and great style, 59-60; his Cartoons, 59*n*, 78-79, 81 and *n*, 155, 156, 216, 219-220, 238; and Maratti, 62; and Venetians, 64-65; and historical portraits, 70*n*; his works in fresco, 81; his easel paintings, 81; works in oil and fresco compared, 82; the "Transfiguration," 82 and *n*; his taste and fancy, 83; compared with Michelangelo, 83-84; imitated Perugino, 103-104; studied the ancients, 107; his "School of Athens," 157 and *n*; his Stanza della Segnatura, 157*n*; works not minutely finished, 194-195; views nature as a whole, 196; his self-confidence, 212; his precocity, 212*n*; copies Masaccio, 216-217, 219-220; praised by Cardinal Bembo, 232; his "Sibyls," 274*n*; and sublime, 276; his "Isaiah" and "Vision of Ezekiel," 276 and *n*; possessed art by long study, 281; mentioned, 21*n*, 32*n*, 81*n*, 86, 87*n*, 99, 105, 109, 111 and *n*, 124, 198, 219, 232*n*, 260, 271*n*

Rasselas. See Johnson, Samuel

Réau, Louis: cited, 140*n*

Reid, Thomas, 121*n*, 134*n*

Rembrandt: Reynolds influenced by, xxxiv; imitates particular nature, 103, 124; management of light and shadow, 147-148; skill in giving objects fullness, 160; his "Achilles" ("A Man in Armour"), 162 and *n*; used pallet knife, 223; mentioned, 105

Reni, Guido, 67*n*, 78 and *n*, 86, 104, 105

Rennes: museum, 63*n*

Repton, Humphrey, 242*n*

Reynolds, Sir Joshua (references to works other than the *Discourses*): "Ironical Discourse," xxx; "Idler" papers, xxx-xxxi, 45*n*; "Theresa Parker," xxxii-xxxiii; "Mrs. Siddons as the Tragic Muse," xxxii-xxxiii; "Young Fortune Teller," xxxiii; "Mrs. Sheridan," xxxiv; "Journey to Flanders and Holland," 86*n*, 201*n*, 237*n*

Richardson, Jonathan, 15*n*, 65*n*, 128*n*, 180*n*, 213*n*, 258*n*, 281*n*; cited, 164*n*

Richter, Gisela M. A.: cited, 180*n*

Rigaud, Hyacinthe, 150

Romanelli, Giovanni Francesco, 105

Romano. *See* Giulio Romano

Rome:

 Aldobrandini villa, 159*n*

 Borghese gallery, 61*n*, 183*n*

 Corsini gallery, 78*n*

 Doria gallery, 87*n*

 Gesù, 186*n*

 Lancelotti palace, 180*n*

 Sant'Agostino, 276*n*

 S. Ignazio, 186*n*

 St. John Lateran, 184-185, 184*n*

 S. Maria della Pace, 274 and *n*

Rosa, Salvator: admired by Reynolds, xxix; and characteristic style, 85; his reputation in the 18th century, 85*n*; his clouds, 237; his "Jacob's Dream," 256 and *n*

Rosso (Giovanni Battista di Jacopo di Guasparre), 105, 219

Royal Academy: *Discourses* prepared for, xv; opening of, 13; visitors of, 16*n*; constitution of, 21*n*; council of, 21*n*; exhibitions at, 90; professorships at, 93*n*; doesn't teach narrow habits, 112; at Somerset House, 169*n*; Gainsborough exhibits at, 258; Reynolds' quarrel with, 265*n*

Rubens, Peter Paul: admired by Reynolds, xxix; his drawings, 34*n*, 35; carries ornamental style to Flanders, 67; his landscapes, 69; and the characteristic style, 86; his colors not blended, 103; mixed allegory and portraiture, 128; Luxembourg gallery (Marie de Medici series), 128*n*; his "Moonlit Landscape," 161; his Altar of St. Augustine ("Marriage of St. Catherine"), 201; Gainsborough and, 253 and *n*; his "Christ's Charge to Peter," 260 and *n*; mentioned, 68, 105, 129, 158, 237, 254, 256, 275

Ruisdael, Jacob, 254

Rules of art: not fetters to genius, 17; when they may be dispensed with, 17, 27; obedience to from young students, 17, 154; they cannot teach taste or genius, 44; and beauty, 46

Rusconi, Camillo, 184*n*, 185

Sacchi, Andrea, 105, 249

St. Paul, 60

Sandby, Thomas, 93*n*

Sandby, William, 21*n*; cited, 13*n*, 14*n*

Schidone, Bartolomeo, 105 and *n*

Seilern, Count Antoine, 161*n*

Sekler, E. F.: cited, 243*n*

Sezincote, 242*n*

Shakespeare: *Macbeth*, 64 and *n*, 148 and *n*, 236 and *n*; *1 Henry IV*, 89 and *n*; Hamlet, 126-127, 126*n*, 238 and *n*, 269*n*; *Othello*, 221*n*; mentioned, 239, 272

Sheridan, Mrs. Elizabeth Ann. *See* Reynolds, Sir Joshua

Sirani, Elisabetta, 104 and *n*

Sistine Chapel. *See* Michelangelo Buonarroti

Smith, Adam: cited, 45*n*, 139*n*

Spedding, James: cited, 215*n*

Spence, Joseph (Sir Harry Beaumont), 137*n*

Statius, 149 and *n*

Steele, Sir Richard, 49*n*

Steen, Jan, 109, 236

Stephens, F. G., 111*n*

Still life: its rank as art, 52

Stimmer, Tobias, 108 and *n*

Strange, Robert: cited, 14*n*

Studio. *See* Lint, Hendrik Frans van

Style: individualism in, xxv; Reynolds' divisions of, xxviii; grand, xxix; characteristic, xxix, 85; ornamental, xxix, Discourse III passim, Discourse IV passim; Reynolds' use of the word, 29*n*; defined, 32; great style defined, 43-45; mixed style, 71-72, 80; examples of the great style, 80-84

Sublime: action of, 65; obscurity one source of, 119; affects whole mind, 276

Summerson, John: cited, 242*n*

Tahiti (Otaheite), 137

Taine, Hippolyte Adolphe, 69*n*

Taste: not taught by rules, 44; possessed by Raphael, 83; defined, 118, 121-122; compared with genius, 120-121; fixed in nature of things, 134; in dress, 136-137

Taylor, Tom. *See* Leslie, Charles Robert and Tom Taylor

Teniers, David, the younger: commended, 109; copied by Gainsborough, 253 and *n*; mentioned, 51, 198 and *n*

Tertullian, 133 and *n*

Testelin, Henri, 68*n*

Thompson, E. M. S.: his "The *Discourses* of Reynolds," 48*n*, 50*n*, 119*n*, 121*n*, 134*n*, 208*n*

Tiarini, Alexander, 105 and *n*

Tibaldi, Pelegrino, 105, 273

Tiepolo, Giovanni Battista, xv, 28*n*

Timanthes, 163

Tintoretto, Jacopo (Robusti): on Titian and Michelangelo, 33; his drawings slight, 35; skill in mechanism of painting, 63; censured by Vasari, 66-67; his works to be studied, 108; neglects the passions, 131; studies Michelangelo, 279 and *n*; mentioned, 64, 141, 274

Titian: compared with Lodovico Carracci, 32-33; his drawings slight, 35; censured by Michelangelo, 66 and *n*; his senatorial dignity, 67; his portraits commended, 150; his "Bacchus and Ariadne," 159 and *n*; his works not minutely finished, 195; praised by Vasari, 195; compared with Raphael, 196; his "St. Sebastian," 196; like Virgil, 197; landscape in "S. Pietro Martire," 199-200, 199*n*; his clouds, 237; painted at night, 251; and Michelangelo, 274, 279; mentioned, 130, 141, 158, 160, 198, 237

Torso. *See* "Belvedere Torso"

Valerius Maximus, 89*n*, 163 and *n*

Vanbrugh, Sir John, xxv, 242-244, 242*n*, 243*n*

Van den Eeckhout, Gerbrand. *See* Eeckhout, Gerbrand van den

Van der Heyden, Jan. *See* Heyden, Jan van der

Vandervelde. *See* Velde, Willem van der, II

Vanderwerf. *See* Werff, Adrian and Pieter van der

Van Dyck, Anthony: Van Dyck habit, xxxiv, 138-139, 138 *n*; Reynolds influenced by, xxxiv; painted his studies, 35; exceeds Frans Hals, 109; copied by Gainsborough, 253 and *n*; mentioned, 159, 198, 237

Van Goyen, Jan. *See* Goyen, Jan van

Van Heemskerk, Martin. *See* Heemskerk, Martin van

Van Laer, Pieter. *See* Bamboccio

Van Leyden, Lucas. *See* Leyden, Lucas van

Van Lint, Hendrik Frans. *See* Lint, Hendrik Frans van

Van Ostade, Isaac. *See* Ostade, Isaac van

Varnish: effect on color, 30

Vasari, Giorgio: read by Reynolds, xxiii; on Raphael, 15*n*; on Dürer, 51 and *n*; on Titian, 66, 195-196; on Tintoretto, 66-67; on Michelangelo and Titian, 66*n*; on Michelangelo's paintings in oil, 82; on Battista Franco, 141; on Masaccio, 219 and *n*; on Michelangelo and satyr's head, 278*n*; on "Battle of Cadore," 279; referred to, 82, 196*n*

Vatican, 87*n*, 125*n*, 177*n*, 196*n*, 212*n*

Vecellio, Tiziano. *See* Titian

Velazquez, Diego Rodriguez de Silva y, 253*n*

Velde, Willem van der, II, 52 and *n*

Venice: S. Giorgio Maggiore, 157*n*

S.S. Giovanni e Paolo, 199*n*

Venus de Medici, 151, 176 and *n*, 178

Verdier, François, 104 and *n*

Veronese, Paul: his drawings slight, 35; skill in mechanism of painting, 63; his "Perseus and Andromeda," 63 and *n*, 157 and *n*; his "Supper at Emmaus," 63*n*; on the number of figures for a picture, 65; compared with Bassano, 68; his works to be studied, 108; neglects the passions, 131; his "Marriage at Cana," 157 and *n*, 201 and *n*; manipulation of light and shadow, 161; mentioned, 64, 66, 104, 141, 274

Versailles, 108*n*, 150*n*

Virgil, 129*n*, 197 and *n*, 266*n*

Visitors. *See* Royal Academy

Vitruvius, 117 and *n*

Voltaire, François Marie Adouet de, 83*n*, 140

Vouet, Simon, 67 and *n*, 105

Wale, S., 93*n*

Walpole, Horace, 71*n*

Waterhouse, E. K., xxxii*n*; cited, xxxiv*n*, 138*n*

Watson, F. J. B.: cited, 237*n*

Watteau, Antoine, 51, 89 and *n*, 108 and *n*

Wax: figures in unpleasing, 177

Wecter, Dixon, 45*n*

Werff, Adrian and Pieter van der, 198 and *n*

Whitley, William T., 138*n*; cited, 252*n*, 253*n*

Wilson, Richard, 242*n*, 255 and *n*

Wilton, Joseph, 213*n*

Winckelmann, Johann Joachim, [3*n*], 180*n*

Wind, Edgar, xxxii*n*; cited, 138*n*

Windsor Castle, 60*n*

Wittkower, Rudolf: cited, 20*n*, 183*n*

Wood, Robert: cited, 94*n*

Wren, Sir Christopher, 243 and *n*

"Wrestlers." *See* "Boxers"

Young, Edward, 203-204, 203*n*

Young, John, 158*n*

Zampieri, Domenico. *See* Domenichino

Zampieri frescos, 33*n*

Zeus. *See* Jupiter

Zeuxis, 49

Zuccerelli (Zuccarelli), Francesco, 28*n*